THE SYNAGOGUE

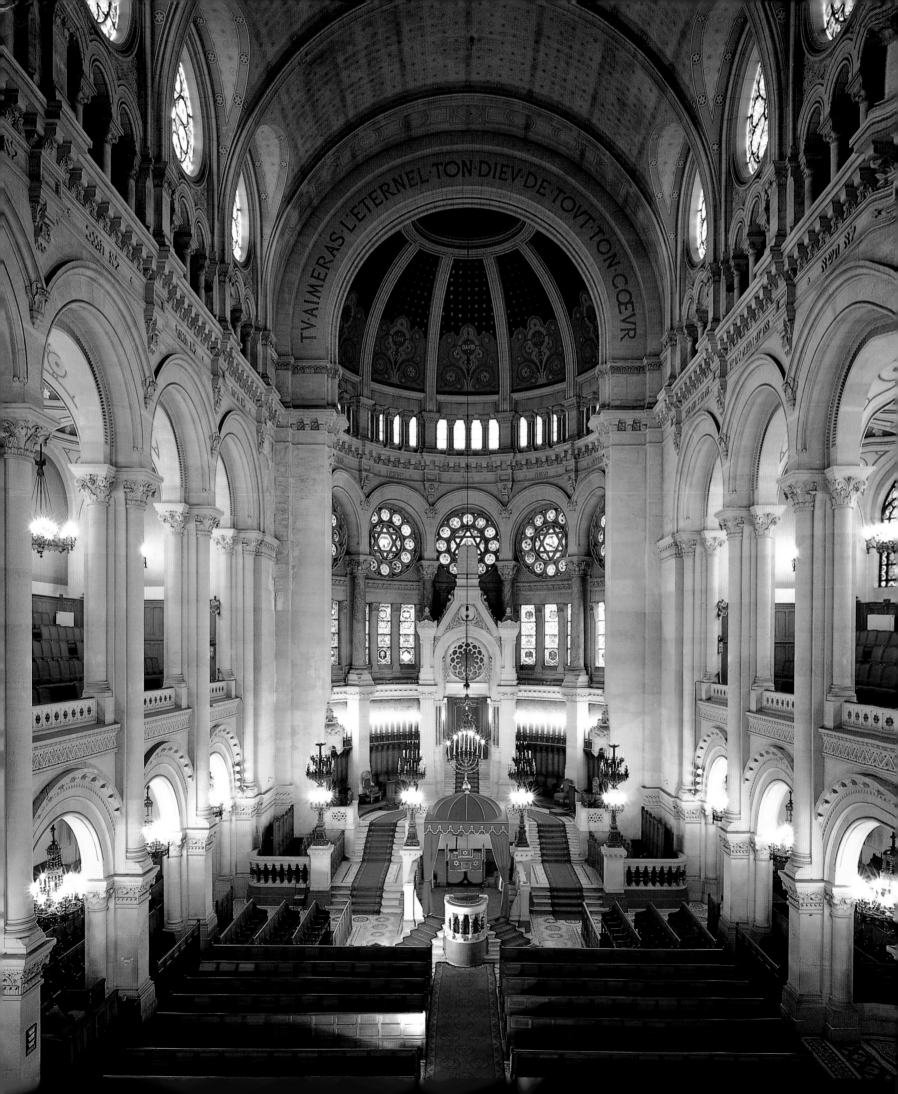

H·A·MEEK

THE SYNAGOGUE

Φ

TO BEATRICE
WITH LOVE

FRONTISPIECE
The synagogue in rue de la Victoire
(1861–74), Paris.
OPPOSITE
Roof detail from the Tempio Maggiore
(1874–82), Florence.

NOTE
The terms BCE (Before the Civil Era)
and CE (Civil Era) have been
used throughout this book to denote
BC and AD respectively.

Phaidon Press Limited
Regent's Wharf
All Saints Street
London N1 9PA

Phaidon Press Inc.
180 Varick Street
New York, NY 10014

www.phaidon.com

First published 1995
Reprinted 1995
Reprinted in paperback 2003
© 1995 Phaidon Press Limited

ISBN 0 7148 4329 6

A CIP catalogue record for this book
is available from the British Library

Printed in Hong Kong

CONTENTS

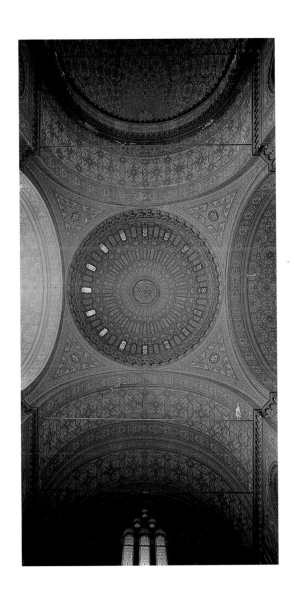

ONE

A MORNING IN SYNAGOGUE

OPPOSITE Three centuries have now passed, but the congregants at the Great Portuguese Synagogue (1671-5) in Amsterdam still see to read after dusk by candles at each seat.

In the winter, when the trees are bare, I can see the synagogue's rear wall from our living room window. It is in the next street and I can glimpse it between the houses opposite. Now it is midsummer, and the trees' exuberant foliage masks it. Never mind: it's only five minutes' walk away. It is midsummer, and it's a Saturday morning. The sabbath 'came in' late last night, with the lighting of candles and a blessing over bread and wine at home. It will 'go out' even later tonight, at about 11 o'clock, having lasted almost 25 hours. I put on a light summer hat which I bought in Italy: not a fashion accessory but an indispensable item of wear. Heads must be covered in synagogue. I leave the house and walk round to the *shool*, encountering one or two fellow congregants on the way. We greet each other with 'good *shabbes*'; keen Hebraists say '*shabbat shalom*'. There is a member of the management committee in the porch—we can no longer afford a commissionaire. He is there for security reasons. This is not much of a problem in the quiet suburb of a small English town, but I recall that they used to have an armed policeman outside the big synagogue in the rue de la Victoire, Paris, while a few years ago someone lobbed a hand grenade through the entrance of the Tempio Israelitico in Rome, with fatal consequences. Like most British synagogues, ours is a traditional one; that is, it is orthodox and not reform. This does not reflect an unremitting love of tradition so much as an indifference to change, even a kind of spiritual inertia. 'Anglo-Judaism,' wrote Rabbi David Miller in 1967, 'is a private pursuit, one among many competing interests. At worst, it is a whim or a hobby, such as bridge or gardening. At best, it is an elevated secondary activity, like freemasonry or civic affairs.' Perish the thought!

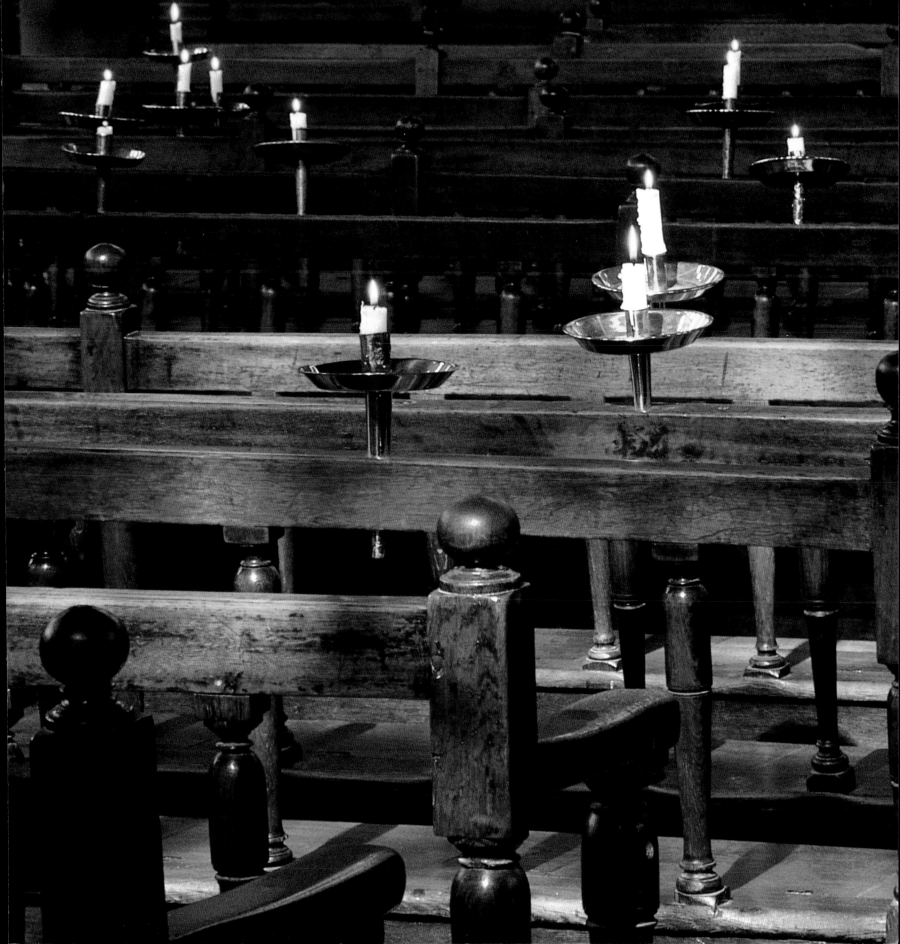

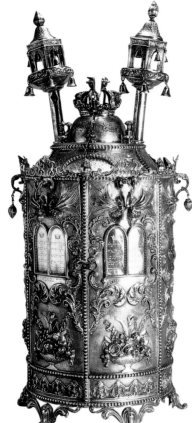

Let's move inside.

We are in a rectangular hall, lined on each side with six or seven rows of wooden seats that are separated by arm rests. In the middle of the hall, on its central axis but slightly displaced towards the short entrance wall, is a platform known as the *bimah*. This is surrounded by a marble balustrade and has a short flight of steps at its rear. The eastern wall, at the far end of the hall, is clad in the same kind of marble as the bimah, and tricked out, in modest pomp, with an order of Tuscan pilasters. These support an entablature, adorned in the centre by two tablets of stone, on which the opening words of each of the Ten Commandments are engraved in Hebrew. Beneath the tablets, in the middle of the east wall, a broad red velvet curtain masks a cupboard. This is the *ark*, in which the synagogue's greatest treasure is laid up: half a dozen scrolls of the law, each containing the text of the Pentateuch, written by hand on parchment in the original Hebrew. Each scroll is clad in a velvet mantle, its projecting roller ends surmounted by a silver crown, or by silver finials hung with little bells. A perpetual light in an ornate casing hangs before the ark.

Flanking the ark on either side, in the place of ultimate honour against the east wall, is a seat with a little half-door before it: one for the rabbi and one for any visiting dignitary. A short row of seats, similarly boxed in, is placed against the front wall of the bimah. Here sit the wardens: the president, vice-president, treasurer and secretary of the synagogue. They are the principal officers of the council of laymen, elected by the congregants to manage the synagogue.

A panelled gallery runs around three sides of the hall, though not around the east wall where the ark is. The gallery is where the women sit, since their close proximity to male congregants, the sight and sound of them, is thought to be inimical to concentration in prayer. Older synagogues actually banished women out of sight, often to separate rooms. The modern orthodox practice of stacking them up in galleries only serves to make them readily visible *en masse*, though inaudible.

The desire to promote concentration in prayer (in Hebrew *kavvanah*) may be the reason for the restrained impact of the interior. The uncluttered spaciousness of the hall is impressive, and the east wall has its marble cladding, but there are no adventitious aids to devotion such as pictures or statues. There are, indeed, three stained-glass windows at high level above the ark, but the images they depict are unlikely to excite fervour: Abraham's oak at Hebron, the seven-branched candle-

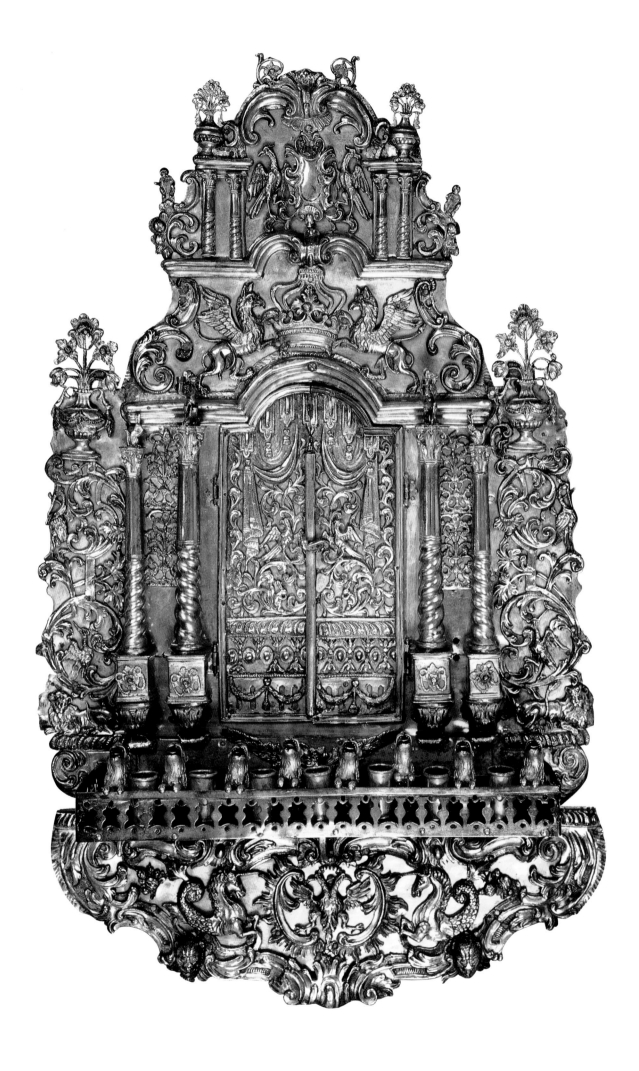

stick, and a basket among the rushes on the banks of the Nile. The great restraining factor here is the second of the Ten Commandments, which forbids the making of 'graven images' or the form of anything that is in heaven above or on earth below. However, this veto has not totally suppressed synagogue art, nor has it even prevented the representation of living creatures, as the folk art in the wooden synagogues of Poland testifies. On the other hand, it has hardly fostered artistic expression. The Islamic alternative, the splendid proliferation of calligraphy as a medium of decoration, has not been pursued by the Jews because the square Hebrew characters do not have the flexibility and ease of manipulation of the cursive Arabic script.

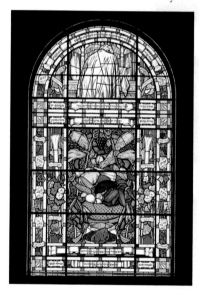

Jewish prayer has evolved over the millennia. The Bible contains numerous examples of extemporary prayer, one of the earliest and most intense being that of Hannah at Shiloh (I Samuel i 11). Regular daily prayers seem to have commenced after the destruction of the First Temple (in 587 BCE), when they were offered in lieu of animal sacrifices. 'Instead of bulls,' wrote Hosea (xiv 3), 'we will pay the offering of our lips.' Jewish liturgy today incorporates material taken directly from the Bible, most notably the *shema* prayer (Deuteronomy vi 4-9) and the Psalms, with further contributions from many subsequent periods down to the Middle Ages. Prayers are said three times a day: morning, afternoon and evening. You can pray by yourself at home, but the minimum number for public worship is ten males over the age of 13. This number constitutes a *minyan*, or quorum. Even if you had 500 women and nine men, you would be inquorate: one man short. 'Public worship' involves certain prayers, such as the *kaddish*, and (on occasion) a reading from the scroll of the law, which an individual at home, or an inquorate gathering, cannot undertake. But once you have a minyan, you're in business. You do not need a rabbi or a minister to conduct the service or to intercede on your behalf. Furthermore, you can conduct your service anywhere: in a railway carriage, on an aeroplane, even in the open air if the weather is suitable. You do not need a synagogue, though if it is one of the occasions when there is to be a reading from the scroll of the law, it would be somewhat awkward if there were no ark in which to keep your *sefer torah*. The Israel army has developed a field ark to cope with this.

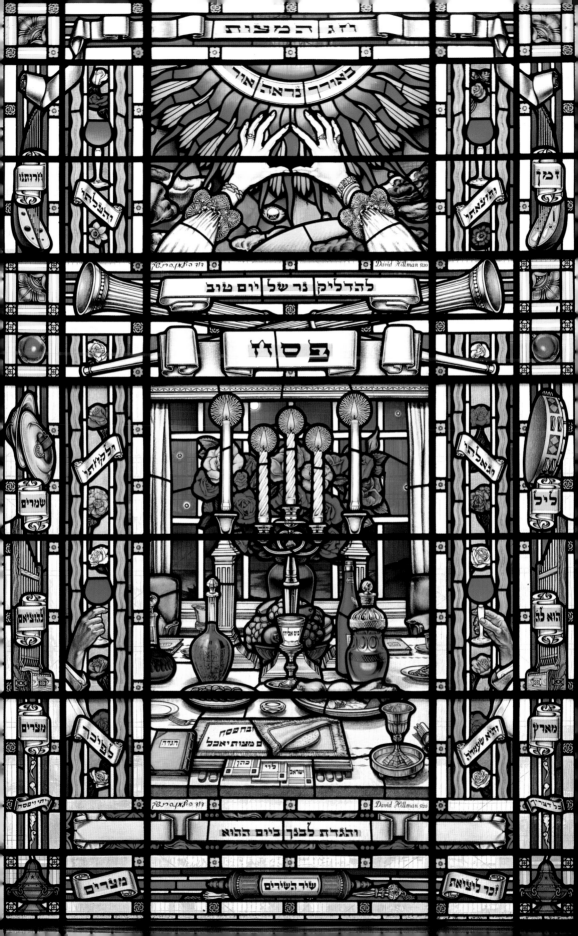

The sabbath morning service is the great occasion for reading the weekly portion from the scroll. The Pentateuch is divided into 54 portions, to be read over the cycle of the Jewish year. The Jewish calendar is lunar, not solar, and occasionally does indeed have 54 weeks, when an extra month has been intercalated in a leap year, to drag the months back into sync with the seasons. In ordinary years, therefore, portions are occasionally doubled up, to enable the 54 to be completed in the allotted time span.

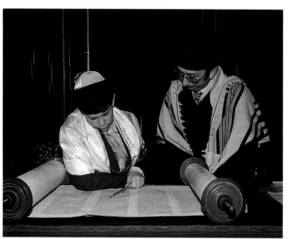

They have already started the service by the time I reach my seat. If the truth be told, they have been going for half an hour, but better late than never. I will not be the last to show up, and a synagogue is not a church. The prayers are led from the bimah by a cantor, or *chazan*. In our shool, he is a layman. In fact he is a retired fairground barker, but his command of prayer-book Hebrew and his familiarity with the traditional melodies and synagogue usage is as complete as any stipendiary minister's. He is concluding the cantor's repetition of the *amidah* prayer as I reach my seat, a seat that is hinged to give access to a book-box underneath. I lift the lid to retrieve my prayer book, Pentateuch and a velvet bag which contains my *tallis*, a fringed silk stole striped in blue at the ends. I take out the tallis and swing it onto my shoulders while reciting the appropriate benediction. Then I open my prayer book or *siddur* and find where we are up to.

In a few minutes the first part of the sabbath morning service has been completed, and we are ready to take a scroll from the ark and to start reading this week's portion. This ritual is carried out with some ceremony, and with duly organized participation by the congregants. Arthur gets to open the ark, while Fred lifts out a scroll and conveys it to the cantor. The distribution of these 'honours' is determined by the wardens sitting in the box in front of the bimah. This is the usual method, but in the synagogue in Madrid I was proffered a little bag by the *shammas* on entering and asked to pick a number. When it came to opening the ark, the shammas stood up at the front and called two numbers at random: *cuarenta dos, ochenta tres*. A Moroccan Jew in the row behind leaned forward and commiserated: '*Ah monsieur, vous n'avez pas de chance, cette semaine.*'

It is midsummer and this week's portion is *Behaalosecha*, corresponding in the

English Bible to Numbers viii-xii. The right to read from the unvowelled text of the scroll, in the appropriate chant, is nobody's monopoly. The ability to do so depends on a skill infrequently encountered amongst laymen in ordinary assimilated congregations. In our community only the rabbi possesses this skill, but I recently attended sabbath morning service in a Soho synagogue in London where the scroll was read with bell-like clarity and total accuracy by a boy of 13, the offspring of a devout *chevra* in Stamford Hill. The walk from home had taken him an hour and a half, clear proof of his devotion.

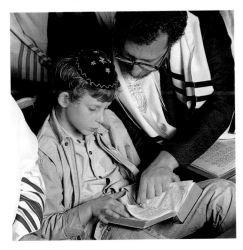

The weekly portion is divided into eight sections, and congregants participate in the reading vicariously. Before each portion is chanted, a congregant is called to the bimah. He recites a brief benediction, and follows the text in the scroll as the reader moves his silver pointer along. At the end of the section he recites another brief benediction. The first man to be 'called up' to recite the benediction is a Cohen—a descendant through the male line of Aaron, the first High Priest. Even after 3,500 years, awareness of this descent is undiminished and never challenged. A man may not know who his great-grandfather was, but he will know if he is a Cohen. The second to be called up is a Levite. He is a descendant of the third son of Jacob and Leah, whose tribe, according to the Pentateuch, performed subordinate work in the sanctuary from the time of Moses. A Levite may be a law lord or a cabinet-maker, he may be able to trace his family tree back five centuries or be hazy about who his maternal grandfather was; but he knows he is a Levite. The third category of Jew is the plain and simple Israelite, which is everybody else. Birth certificates in Israel are actually furnished with three little boxes, to be ticked as appropriate: Cohen/Levite/Israelite. At all events, it is not until the third *aliyah*, or call-up, that the ordinary Israelite gets a look in—unless there are no Cohens or Levites present.

This morning there are no problems, and the reading of the law proceeds smoothly. There are eight *aliyot* in all. The last to be summoned is a barmitzvah boy. His call-up is part of a rite of passage. Only males who have reached the age of 13 are eligible for this honour for it is at this age that they attain their religious majority, become liable for the observance of the innumerable do's and don'ts of

LEFT A father helping his son to study the haphtorah, to be recited at his barmitzvah. This passage from the Prophets is read from a printed book, with the vowel signs and cantillation marks of the Hebrew text printed in full. OPPOSITE A barmitzvah boy practising reading the maftir from a Torah scroll. This is the hard bit; the handwritten manuscript is devoid of punctuation, vowel signs and cantillation marks.

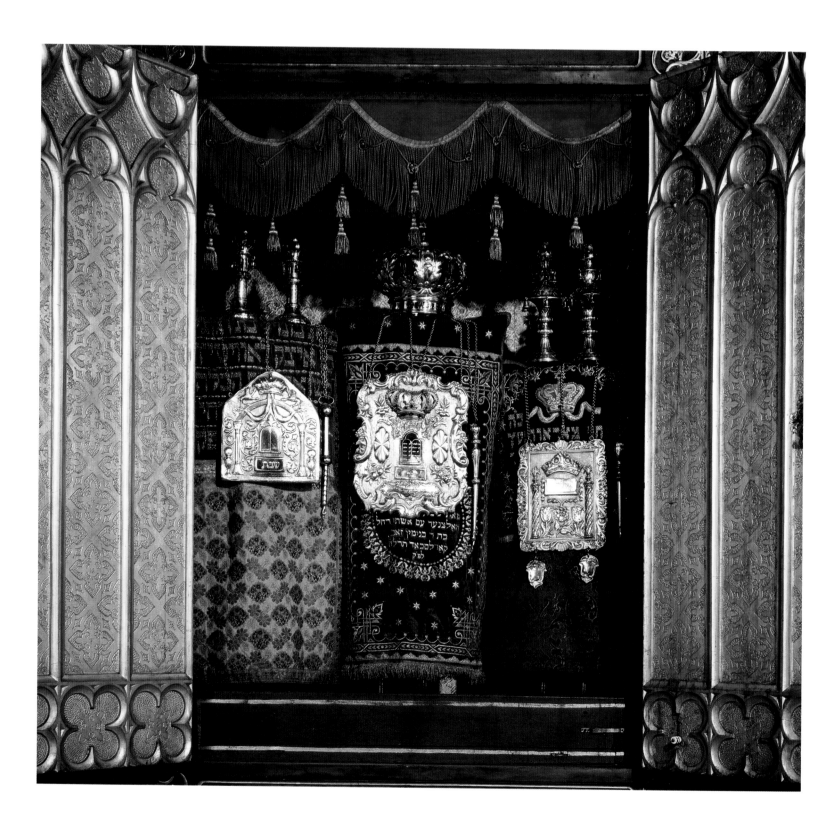

OPPOSITE Within the ark at the
Spanish Synagogue in Prague,
rest the Torah scrolls clad in their
mantles and adorned with breast-
plates and finials.
BELOW The *sefer torah*, or scroll of
the law, contains the whole of the

Pentateuch and is handwritten on
parchment by a scribe whose full-
time occupation this is. The scroll
is rolled open to show two
columns of text, with a silver point-
er ready to be used for following
one's place in the text.

BELOW RIGHT A decorative point-
er, ending in a tiny hand with an
outstretched index finger.

the Jewish religion, and are hence qualified to make up a *minyan*, the quorum for public worship.

The age of 13 is mentioned in the *Mishnah* (*c.* 200 CE) as that suitable for the fulfil-ment of the commandments, but the barmitzvah ceremony as we have it now hardly antedates the fourteenth century. Its modern apotheosis is amusingly des-cribed in Herman Wouk's novel *Marjorie Morningstar*, in which the celebrations outdo any wedding reception in lavishness. Young Sidney Wolfe's father has nei-ther the means nor the inclination to follow this example, though relations have flown in from Cape Town and Los Angeles.

Sidney mounts the steps of the bimah. There is a perceptible hush and ranks of female relatives crane forward in the gallery. The rabbi greets him cordially, and indicates with his silver pointer the commencement of the *maftir*, the last instalment to be read that morning from the scroll. Sidney touches the spot with the fringe of his tallis, which he then kisses; a vicarious embrace. Next he recites the blessing in a clear, high voice. It is listened to with an intensity that is palpable. The Hebrew words are the same as those his predecessors have declaimed this morning, some carefully, some carelessly, some confidently, others painfully squinting at the *aide-mémoire* propped up in a little frame at the reading desk. Sidney knows the words by heart; that's not the problem. The fact is that at

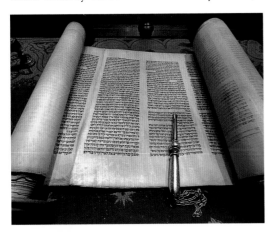

13 your voice is breaking, and there is always the risk that you might involun-tarily switch from alto to baritone in mid-note.

This vocal ambivalence is also re-flected on the social level. Yesterday Sidney was an adolescent schoolboy, enlivening the tedium of his homework with a quick bout on a computer game. Next week it will be much the same. But here and now, on the bimah, before the scroll of the law, he is the hero of the day, the cynosure of all eyes. He is making his debut not just on the bimah of his local synagogue, but on the stage of Israel where his role will continue for the rest of his life.

These philosophical considerations do not trouble Sidney, however. He has been cramming for the last eight months, and is determined to reap the benefit of all his hard work. The *maftir* only runs to three verses, and though the handwritten

BELOW An elaborate manuscript
page from the Kennicott Bible,
illustrating a menorah or can-
delabrum. The Kennicott Bible
(1476) is one of the most sumptu-
ously and extensively illustrated
manuscripts to survive the expul-

sion of the Jews from Spain in
1492.
OPPOSITE The illuminated heading
of Book II ('The Book of Love') of
Maimonides's *Mishneh Torah*,
from the studio of Mateo da Cam-
bio of Perugia, *c.* 1400. The illus-

tration shows a figure in a tallis
embracing the Torah scroll. The
text at the top, which reads 'How
I love thy law', is taken from the
Psalms.

text in the scroll is innocent of vowels, cantillation marks and punc-
tuation, Sidney has it by heart. Taking the place of the 'professional'
reader, in this case the rabbi, he launches in confidently, and in two
minutes has finished it without making any errors. He recites anoth-
er benediction and then his father intones 'Blessed be he who has
freed me from the responsibility for this child'. Thirteen words in
English; the matchless compactness of the Semitic languages
expresses it with just five in Hebrew.

While the scroll of the law is being elevated and displayed by his
Uncle Joe, and tied up, clad in its mantle and crowned by his cousin
Mick, Sidney is preparing to tackle the *haphtorah*. This is the passage
from the Prophets—extracted in this case from the book of Zechari-
ah—which reflects, however slightly, the sentiment of the weekly portion from the
scroll, or alludes to an incident in it. Although it is much longer than the maftir,
amounting to a whole page of text, the haphtorah is a less daunting task, as it is
chanted from an ordinary printed book that is furnished with vowels, cantillation
signs and punctuation marks. Sidney chants it with gusto, and draws to a tri-
umphant conclusion with the post-haphtorah blessings.

As he prepares to descend from the bimah, to shake hands with his friends and rel-
atives, and half-listen to a sermon while thinking about his barmitzvah presents,
his mother, sisters, aunts and female cousins gaze down from the gallery with
pride and gratification. Wherever their regular seats may be on other days,
no-one contests their occupancy of the front row today. But what of the
ladies behind? 'From all but the most expensive ladies' seats,' writes Vanessa Feltz,
'services are largely invisible and tantalisingly inaudible. Solemn davening [prayer]
is translated by geography into incomprehensible muttering. Sermons are
inevitably aimed solely at the men. Honours are exclusively reserved for men.
Worshipping has effectively become a private men-only club...why else are ladies'
galleries repositories for sincere and heartfelt fashion appraisal, recipe exchange
and ungodly gossip of the highest order?'

Though expressed with amusing irony, this is a serious question. One of the
answers may be the fact that all the prayers in a traditional synagogue are said in
Hebrew, though most prayer books nowadays are printed with a translation on the
facing page. If this is the case, why not say the prayers in English (or Hungarian, or
Greek)? Well, you can do that too, but the learned and pious compiler of the *Com-
plete Artscroll Siddur* explains in a foreword that if you pray in the vernacular, you

מה אהבתי תורתך כל היום
היא שיחתי

ספר שני

והוא ספר

אהבת

must understand every word you say, whereas if you pray in Hebrew, total comprehension is not necessary: the mere fact of your saying it in Hebrew suffices to open the gates of heaven. This statement may be founded on the firm authority of classical sources, but it reminds me uncomfortably of the mechanical functioning of the Tibetan prayer wheel.

The standard of decorum, both upstairs and down, varies widely from synagogue to synagogue. In the awesome precincts of the New West End Synagogue in London, propriety outstrips that of most cathedrals. At one time they even had a lady *shammas* upstairs who greeted each female congregant with a prayer book open at the right page and patrolled the gallery during the service to suppress chat. At the other end of the scale is the Chassidic *shtiebel* or conventicle, where fervour is the overwhelming emotion. This fervour reaches its peak at the autumn festival of *Simchas Torah*, the Rejoicing of the Law, which takes place on the day when the weekly readings of the Torah arrive at the end of the Pentateuch, and immediately start all over again at the beginning of Genesis i 1. Such an occasion was witnessed by the Austrian novelist Joseph Roth, who was himself born in the Galician town of Brody at a time when three-quarters of its population were Jewish:

> I saw how they danced. It was not the dance of a degenerate race. It was not just the power of a fanatical belief. It was a healthiness that triggered a religious outburst. The Chassidim held each other's hands, danced in a circle, broke the ring and clapped their hands, tossed their heads in time to right and left, grasped the torah scrolls, swung them round like girls and pressed them to their breasts, kissed them and wept for joy.... It moved me deeply that a whole people was offering its sensual pleasure to God, was making the book of the strictest laws its beloved and could no longer distinguish between bodily desire and spiritual enjoyment, but united both.

All this took place in a synagogue in front of the ark. Would it ever happen in a church? 'Comparisons are futile,' wrote Samson Raphael Hirsch, the founder of nineteenth-century German neo-orthodoxy. 'Judaism is not a religion, the synagogue is not a church, and the rabbi is not a priest. Judaism is not a mere adjunct to life: it comprises all of life.' So synagogues, although they are important institutions in Jewish life, are not its be-all and end-all, because traditional Judaism is not just a weekly appointment with God.

Judaism embraces every aspect of life, from civil law to dietary regulations, and finds ways of consecrating the secular, in the search to fulfil what it takes to be the

will of God, all day, every day, in ways you could hardly begin to imagine, from the moment you rise to the moment you fall asleep. In the *Laws and Customs of Israel*, a popular compilation from the classic sources which somebody gave me for *my* bar-mitzvah, we learn that you tie the shoelace of the left shoe first. This is because in tying knots the left hand (and hence, presumably, the left foot) is more esteemed, because the *tephillin* (the phylacteries) are placed on the left arm at morning prayer. With a wealth of commandments and prohibitions that makes the Egyptian *Book of the Dead* look like the directions for opening a milk carton, learning the form is obviously a major task. 'This book of the torah shall not depart out of thy mouth, but thou shalt meditate therein day and night', proclaims the Bible (Joshua i 8). Whatever book the writer was referring to then, the commandment has retrospectively been taken to include the whole of the Oral Law embodied in the Talmud. So how much time does this involve and may one, in fact, do anything else at all? Contemplating the magnitude of the task involved, Rabbi Baruch Ber Leibowitz, a disciple of Rabbi Chaim Soloveitchik of Brisk, gave it as his candid opinion that total devotion to Torah study was the intended requirement, and, as far as men were concerned, even working for a living was *bittul torah*, that is, wasting time that should be devoted to study. More moderate orthodox *responsa* may be found to the effect that one hour's study by day and another by night might suffice for the unacademic.

The fact that two such diverse opinions may be encountered in the heart of traditional Judaism shows that since antiquity there has been no formal governing body, comparable, say, to the papacy, empowered to make changes in Judaism. Some things stay the same in any case. The carping voices of the Israelites in the desert proclaimed: 'If only we had meat to eat! We remember the fish that we used to eat free in Egypt, the cucumbers, the melons, the leeks, the onions and the garlic...' in Numbers xi 4-6. These voices, even after 3,500 years, still catch the acrimonious tones and inflections of a synagogue annual general meeting with startling precision. In this respect the Israelites have remained the same. So has their religion in its devotion to legalistic minutiae, understood to be the detailed observance of God's will. The endless prescriptions of the biblical book of Leviticus find their echo 1,000 and more years later in the rabbinic debates so tersely reported in that Babylonian Hansard, the Talmud. But the tone changes.

The Pentateuch is a strange mixture of benevolence and ferocity. Its social provisions, its concern for the welfare of the widow, the orphan and the poor day-labourer, even its consideration for animals, are far beyond those of any of the

other peoples of antiquity. And yet, if you want to read a detailed account of God-sanctioned genocide, look no further than Numbers xxxi. In pursuance of the Lord's command to Moses, 'Avenge the children of Israel on the Midianites', every adult male is put to the sword. The women and children are then brought to the Israelite camp on the plains of Moab, where Moses expresses his displeasure to the officers of the host, 'the captains of thousands and the captains of hundreds', and tells them to finish the job properly by massacring all the Midianite widows and little boys. 'The war against the Midianites,' wrote Chief Rabbi J H Hertz, with notable understatement, 'presents peculiar difficulties.' These difficulties are experienced by those who find it hard to accept that Judaism is not monolithic. Its spirit has become milder over the endless centuries of its existence. The Midianites suffered their gruesome fate in the late second millennium BCE. Five hundred years later, however, the prophet Micah is expressing the core message of Judaism in these immortal words (vi 6-8):

> Wherewith shall I come before the Lord and bow myself before God on high? Shall I come before Him with burnt offerings, with calves of a year old? Will the Lord be pleased with thousands of rams, with ten thousands of rivers of oil?...It hath been told thee, O man, what is good and what the Lord doth require of thee: only to do justly, and to love mercy, and to walk humbly with thy God.

This world view that originally developed in Israel involved three concepts that were unique in antiquity: namely, the idea of a single God, who was both moral and universal. Ernest Renan contrasted this outlook with the cults of Greece, which he categorized as *de charmants enfantillages municipaux*. 'The prophets of Israel,' he wrote, 'are fiery *publicistes*, of the type we should call socialists or anarchists today [he was writing in 1883]. They are fanatics for social justice, loudly proclaiming that if the world is not just, or capable of becoming so, it had better be destroyed.'

The centuries pass; the light of prophecy dims and its place is taken by dry rabbinic debate. But the same unending search goes on to discover 'What the Lord doth require of you'. Its spirit is mild and reasonable, expressed though it may be in terse one-liners instead of rolling periods and inflamed rhetoric. 'A court that orders an execution once in seven years is branded a murderous court,' observes the Mishnah (Makkot i 10), adding, 'Rabbi Eleazar ben Azariah says: Or even once in seventy years.' Here, at last, in the first century CE, is the voice of normative modern Judaism: mild, reasonable, academic, humane. It is the voice of the men who built the synagogues.

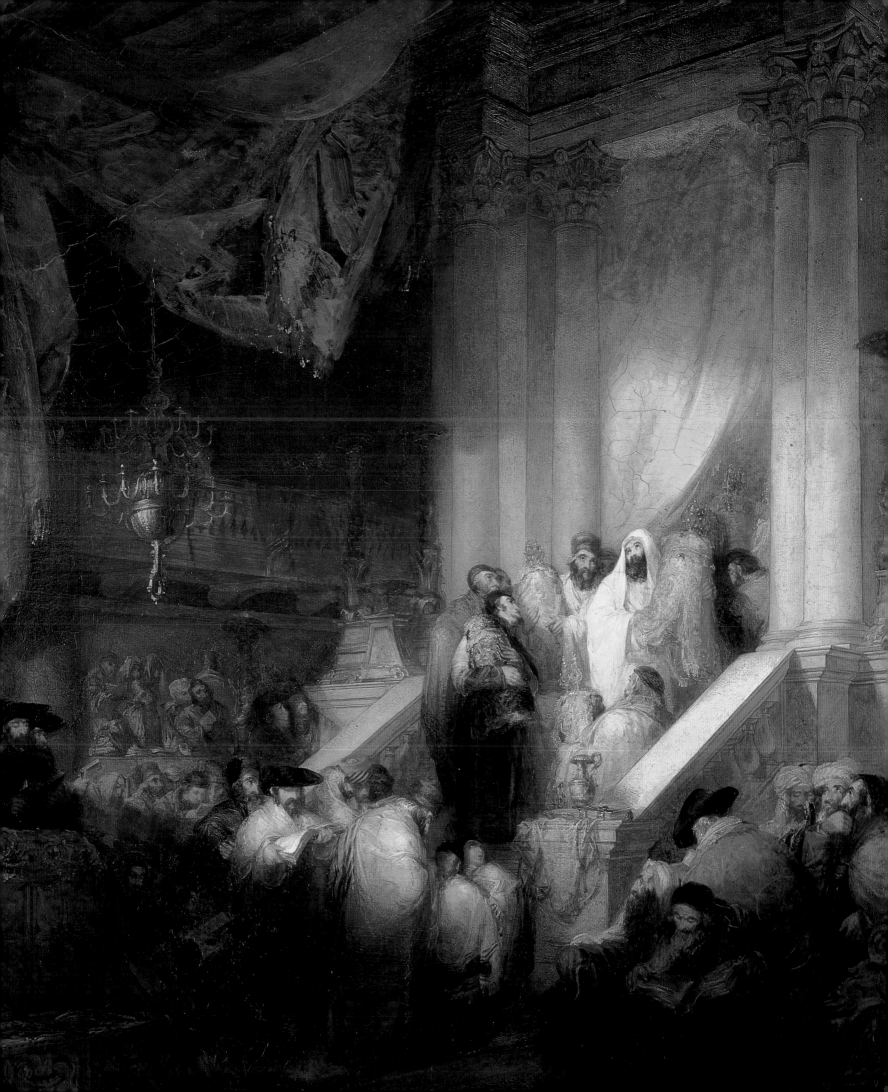

OPPOSITE A detail taken from Raphael's fresco showing the Prophet Isaiah, whose posture demonstrates the influence of Michelangelo's treatment of the prophets in the Sistine Chapel. The fresco can be found in the church of S. Agostino in Rome. The text in Isaiah's hand reads 'Open ye the gates, that the righteous nation which keeps the truth may enter in.' (Isaiah xxvi 2).

Until the beginning of the twentieth century, everybody was familiar with the history of the Jews. They had read about it in the Bible. Nowadays knowledge of the Bible is rare. Ask a class of streetwise ten-year-olds to tell you what Noah's Ark was, and your answers (if you manage to elicit any) will include suggestions that range from Disneyland features to attractions at Blackpool Pleasure Beach. The history the Jews wrote begins with God's creation of the world, seen as a carefully structured process taking seven days. The narrative moves forward, through tales of the Flood and the Tower of Babel, to concentrate on the forefathers of the Jewish people: Abraham, Isaac and Jacob. The transition from universal history, with its explanations of the diversity of races and languages, to the history of one particular people, begins with the divine call received by Abraham. God instructed him to leave his native town of Ur and to move to a land that he and his descendants would receive as a divine inheritance. We are talking here of a tradition that looks back 4,000 years and yet has led to wars in the twentieth century, and to incidents seen every week on the television news, as Abraham's descendants are resisted in their attempts to hold on to what they see as their patrimony.

Four thousand years! Around 2000 BCE a nomadic people known as the Amurru, or Amorites, overran the Sumerian city-state of Ur, in present-day Iraq, and took its king captive. It was shortly after this that Abraham must have started his journey through the Fertile Crescent of Mesopotamia, Syria and Canaan. At this time the Twelfth Dynasty was ruling in Egypt during the period of the Middle Kingdom. In India not even the first of the Vedic hymns had been composed. We are at

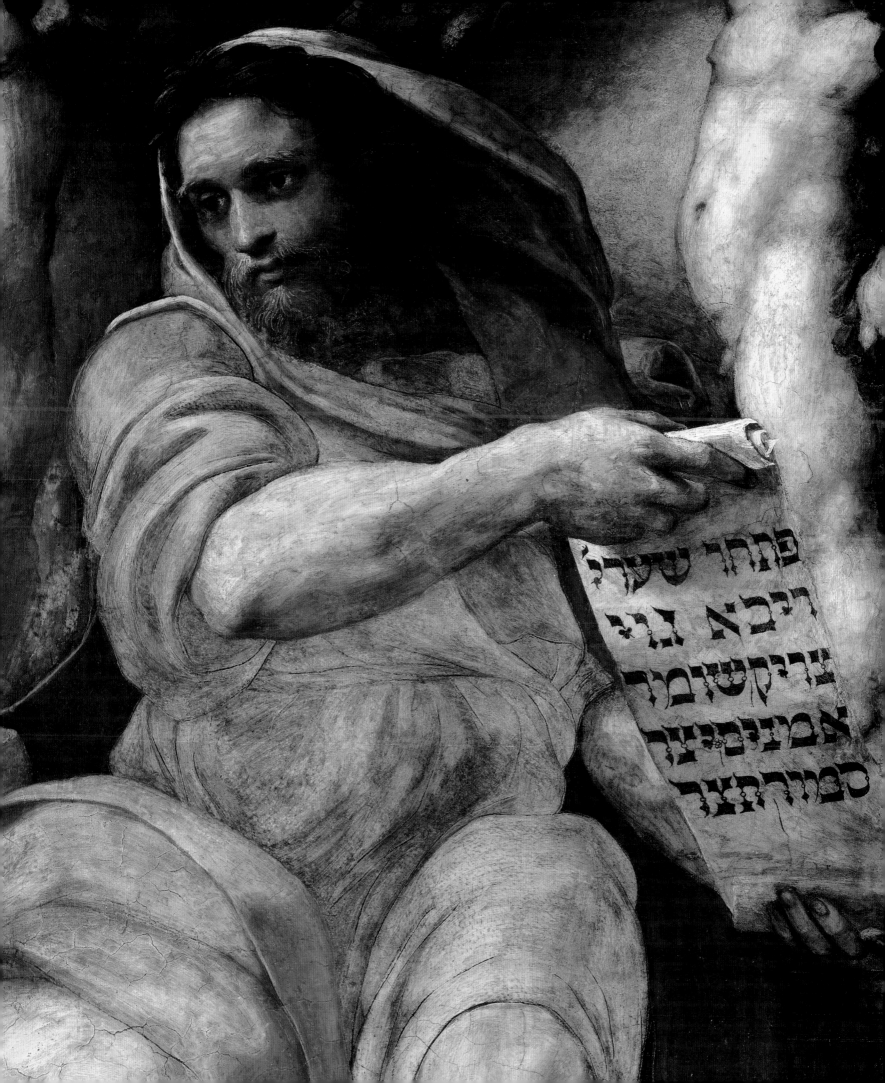

BELOW Abraham's gesture to Isaac, as depicted in this 1645 etching by Rembrandt, is the graphic expression of the words 'My son, God will provide himself a lamb for the burnt offering' (Genesis xxii 8), spoken in answer to his son's question. OPPOSITE A detail from the dramatic *Israelites Passing through the Wilderness* by William West (1801-61).

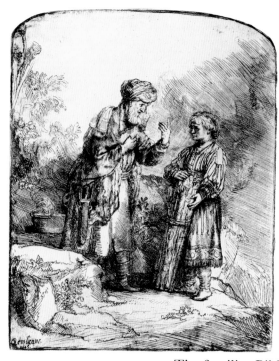

the birth of the oldest surviving world religion, one whose daily prayers, in the synagogues of the twentieth century, are specifically directed to 'the God of Abraham, Isaac and Jacob'.

These three patriarchs remained nomads, dwellers in tents, their increasing wealth represented by the number of their flocks and herds. God's covenant with Abraham, the promise of a land in exchange for the observance of a divinely specified way of life, was renewed with Isaac and Jacob. The Bible represents the patriarchs as being on close terms with a single personal God, who was not one of the powers of nature, but was above and beyond nature. As Abraham says, he was 'the God of heaven and the God of the earth' (Genesis xxiv 3). The patriarchal form of worship was very simple and not linked to any form of building or enclosure. An altar, generally of stone, would be erected on a high place, a burnt sacrifice made and prayers offered up.

The familiar Bible narrative recounts the eventual descent of Jacob and his family from the Promised Land into Egypt, where Joseph, Jacob's second youngest son, had become Viceroy. It was a time of famine, and the patriarch and his people were welcomed hospitably because of Joseph's great services to the state—a story told with numerous details that reveal a familiarity with Egyptian life and customs. The Egyptian records themselves are silent on this episode, but it is thought that the downfall of the Semitic Hyksos dynasties (*c.* 1550 BCE) marked the end of the Hebrews' good fortune. Whatever the cause, 'there arose a king who knew not Joseph'—perhaps Ramses II—and the people were enslaved. Ultimately, after a stay of 215 years, the Children of Israel left Egypt 'with signs and with wonders'. Their leader was Moses, born a Hebrew but raised as an Egyptian prince. The Hebrews had entered Egypt as the extended family of one man. They departed a nation: 600,000 men capable of bearing arms, as well as women and children and what the Bible calls 'a mixed multitude'. The parade at Mount Sinai, which took place a few months later, when Moses brought down the Tablets of the Law inscribed with the Ten Commandments, is not only a climactic point in the creation of the Hebrew nation but also a landmark in the moral history of mankind. On this occasion a stern but just God—a unique phenomenon in Man's conception of the divine—is represented as handing down to humanity a basic framework for ethical behaviour. Many more statutes and regulations were to follow (usually

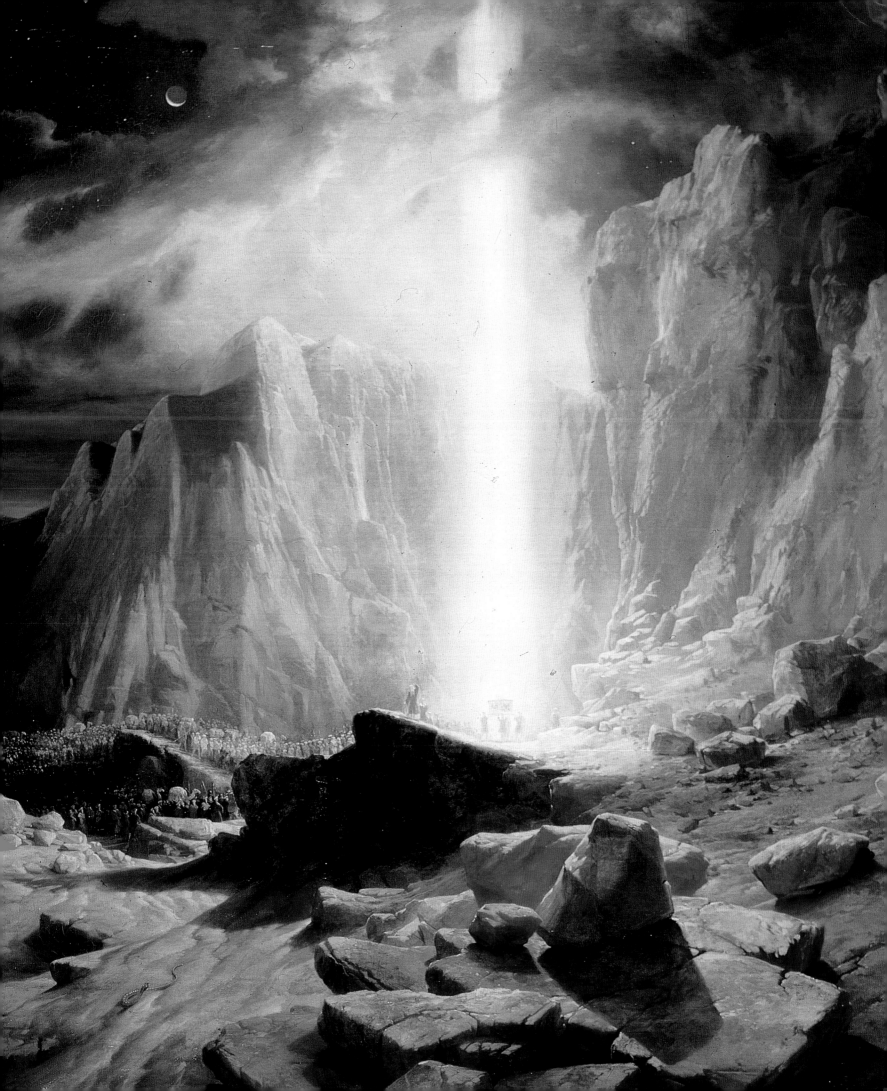

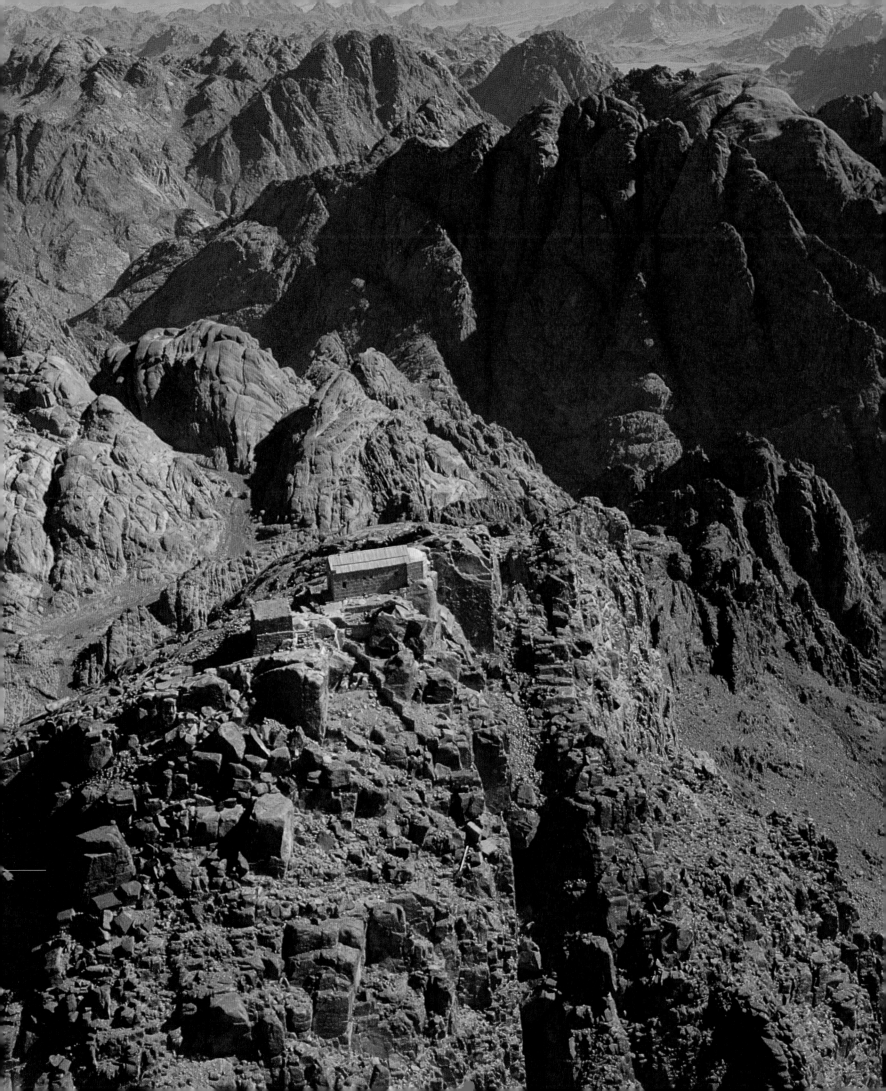

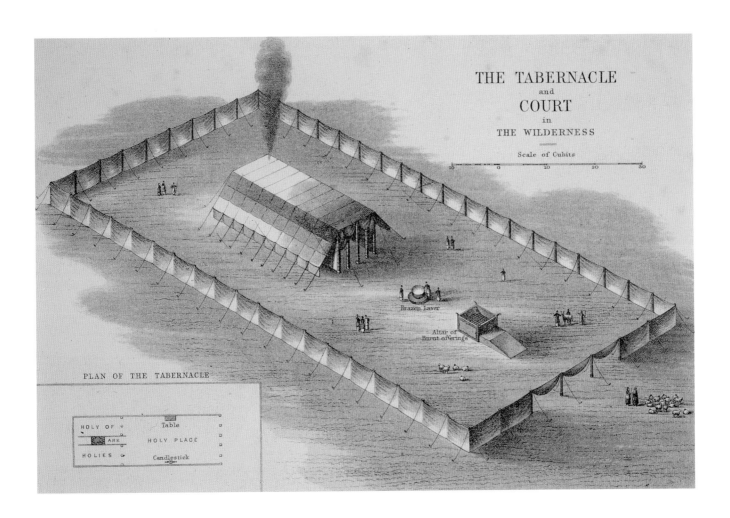

THE TABERNACLE
and
COURT
in
THE WILDERNESS

Scale of Cubits

PLAN OF THE TABERNACLE

Brazen Laver

Altar of
Burnt offerings

HOLY OF		Table	
ARK	HOLY PLACE		
HOLIES		Candlestick	

OPPOSITE An aerial view of Mount Sinai. On this craggy mountainside Moses received the Tablets of the Law inscribed with the Ten Commandments. The parade which took place at the mountain's foot marked a climactic point in the creation of the Hebrew nation.

ABOVE A nineteenth-century reconstruction of the Tabernacle. Note the unroofed enclosure made up of linen curtains hung from 60 wooden columns. The altar in the foreground is approached by a ramp.

introduced in the Pentateuch with the formula: 'And the Lord said unto Moses: Speak unto the Children of Israel and say...'), but the parade at Sinai, described with incomparable drama in the book of Exodus, where the action takes place amidst peals of thunder and the voice of the trumpet, is unique in world literature for the force and splendour of its presentation.

The encampment before Sinai continued for more than a year. During that period the Israelites had merely to 'lift up their eyes', in the biblical phrase, to see the mountain on which the theophany occurred and on which God's covenant with Abraham had been ratified with Moses. Eventually, however, the long march would have to be resumed. When that happened, would a link be broken? Some symbol of the divine presence might serve to maintain the bond, and, says the Italian scholar Umberto Cassuto, 'it was the function of the Tabernacle to serve as such a symbol'.

The Tabernacle was a tent, a portable sanctuary specifically designed for a nomadic people. It could be dismantled when necessary and transported from camp site to camp site. It was the first sanctuary the Hebrews ever constructed, and hence the forerunner of the Temple in Jerusalem and the ancestor, infinitely remote, of every synagogue ever built. The Bible proceeds to lay down, in amazing detail, exactly how the Israelites were to set it up. All the information is there in the book of Exodus, a full architectural specification of the materials, the dimensions and the method of construction, right down to the smallest detail. Since this description occurs in the Pentateuch, it is chanted in every synagogue in the world every time the annual reading reaches the *Terumah* portion, which is generally some time in February. From Lima to Singapore, from Stockholm to Johannesburg, Señor Mendes or Mr Rapoport is called to the bimah, touches the scroll with his tallis, recites the benediction and listens respectfully as the reader intones in classical Hebrew: '...Join five of the cloths by themselves, and the other six cloths by themselves; and fold over the sixth cloth at the front of the tent. Make fifty loops on the edge of the cloth of the other set. Make fifty copper clasps, and fit the clasps into the loops, and couple the tent together, so that it becomes one whole.' And so on, and so on: a technical specification, paragraph by paragraph, drawn up 3,000 years ago. If Mr Rapoport is an architect, a quantity surveyor or a building contractor, and his knowledge of Hebrew enables him to follow what is being read, he may perhaps wonder at the fate of specifications: the one he was checking through yesterday will be forgotten in two years' time. The one he is listening to now has been recited, year by year, for three millennia.

Or so it is generally thought. Biblical scholars, whose views change with the frequency of those of diet experts, have expressed their doubts. Julius Wellhausen, that abomination of the pious, thought the description was invented by the priests of the First Temple, hundreds of years later, to give their own sanctuary and its attendants a venerable provenance. An ingenious idea certainly, but perverse. Look at all those desert details: acacia wood, ramskins, lambskins, cloth woven from goats' hair. The whole idea of a sacred tent is ur-Semitic in any case: the Beduin of the 'Times of Ignorance', before the coming of Islam, used to carry them around, as Harry Orlinsky has pointed out.

Although the biblical specifications are copious, the passage of several millennia has made their interpretation uncertain in places. It would seem, however, that the book of Exodus is describing an unroofed enclosure 100 cubits long, 50 cubits wide (a double square) and 10 cubits high. (A cubit is 18 inches or 46 centimetres.) This enclosure was made up of linen curtains hung from 60 acacia wood columns, set into bronze bases. The columns or posts, which were fitted with silver collars and hooks to take the curtain cords, were braced with tent ropes and bronze pegs. Entrance into this enclosure was at the shorter east end, which had stubby return 'walls', leaving a central opening 20 cubits wide. This entrance was masked by a screen of fine linen, embroidered in blue, purple and scarlet, and suspended from four columns.

The eastern square of the enclosure constituted a forecourt in front of the actual sanctuary. This forecourt contained a bronze altar for sacrifices, which was aligned with the entrance, and behind it, a bronze wash basin in which Aaron and his sons could wash their hands and feet before performing a sacrifice.

In the western square—that half of the enclosure furthest from the entrance—stood the sanctuary proper. In describing its components, the Hebrew Bible makes use of the term *keresh*, which the Authorized Version translates as 'board', a meaning it retains in Modern Hebrew. A more likely translation in the context is 'frame'. We then get a structure 30 cubits long, 10 wide and 10 high, made up of gold-plated, acacia wood frames fitted into silver footings. Lateral rigidity was ensured by the use of gold-plated bars of wood, which passed through gold rings fitted to the frames. This modular system had 20 units on the long side walls, and eight on the rear wall. The front of the sanctuary had no frames but was closed off by a screen. While the main enclosure was open to the sky, the sanctuary was covered over by several sets of curtains laid on the gold-plated frames. The way the curtains were fitted together on their long sides is explained by the Bible in detail:

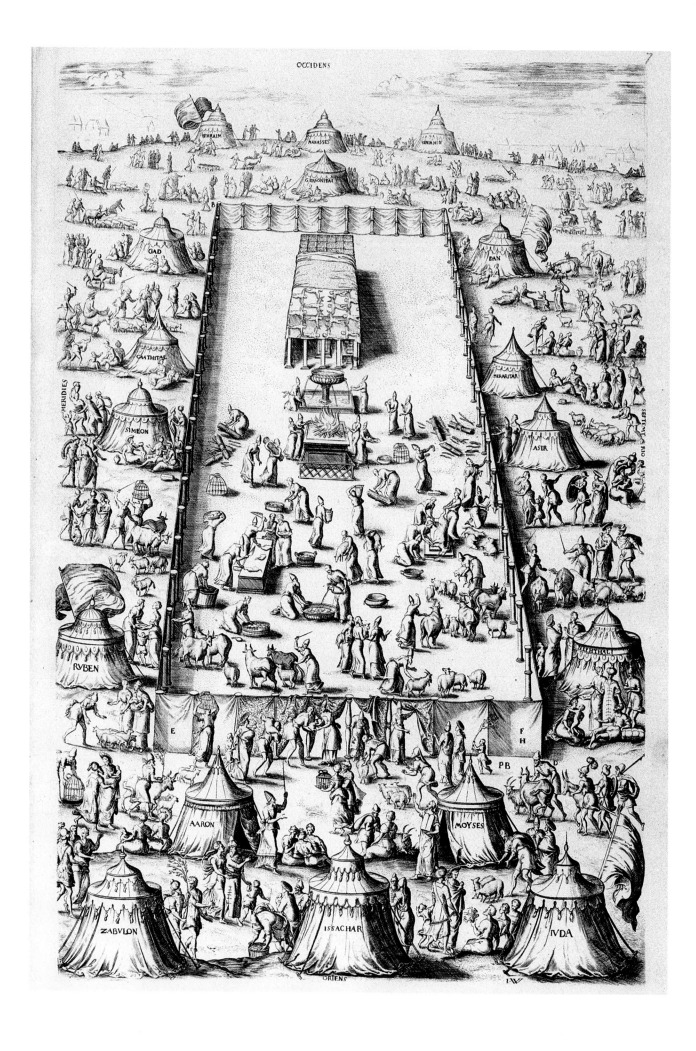

OPPOSITE This engraving from *Exemplar siue de sacris fabricis liber* by Benedictus Arias Montanus, 1572, depicts the Tabernacle surrounded by the tents of the 12 tribes. Within the sanctuary enclosure preparations are being made for a sacrifice.

BELOW A miniature from northern France, 1278. King Solomon is reading the Torah, in accordance with the instructions in Deuteronomy xvii 18-19 that a king shall write himself a copy of the Torah and 'read therein all the days of his life'.

it involved a system of gold clasps and loops of violet thread. Several layers of curtains were used. The innermost was of fine twisted linen in various colours with figures of cherubim woven in. Above this were 11 curtains of goats' hair, then one of woolly ramskins dyed red. The outside layer, the weather-proofing one, was of dugong or dolphin skin, though the Hebrew word *tahash* has been variously translated as seal or even badger.

Inside, a veil divided the sanctuary into two parts. It was placed so that the innermost part formed a perfect cube, known as the Holy of Holies. Here the Ark of the Covenant was placed. This was an oblong wooden box, overlaid inside and out with gold, and fitted with rings, through which carrying poles were slid. The box contained the two tablets of stone engraved with the Ten Commandments, which Moses had brought down from Sinai. These tablets were, in fact, the second set: the first had been smashed when the prophet saw the Children of Israel worshipping the golden calf. The broken pieces of the first set were also kept in the Ark, at least according to the Talmud (Berakoth 8b), where the circumstance is charmingly quoted by Rabbi Joshuah ben Levi as an analogy to endorse his admonition 'to respect an old man who has forgotten his learning'. The Ark supported the mercy seat, a slab of gold in one piece adorned with two figures of golden cherubim, who rose at each end, their faces turned inwards towards the seat, and their wings arched overhead.

The outer part of the sanctuary, the area between the Holy of Holies and the entrance curtain, had an altar for incense, a golden candelabrum and the 'Table of the Presence' for the *shewbread*. All the furnishings of the Tabernacle are specified in great detail in what is, in effect, a monologue beginning with the words 'The Lord spoke to Moses saying...'(Exodus xxv 1). But even these instructions are abbreviated, for occasionally further elaboration is side-stepped with the remark that Moses shall proceed 'as has been shown you in the Mount'. This remark lies at the foundation of the traditional Jewish belief that there are two Torahs: a written one (the Bible) and an oral one which is based on all the instructions Moses received during his 40 days on Mount Sinai. This oral tradition was ultimately reduced to writing in the Mishnah and its elaboration, the Talmud.

The era of the Judges (1196-1025 BCE) was one of continuous strife with the indigenous inhabitants of Canaan, which saw the emergence of 'mighty men of valour' such as Gideon, Jephthah and Samson. In an episode depicted in coloured marbles by Paolo di Martino on the famous pavement of Siena Cathedral, Samson is seen defeating the Philistines. Both sides wear the full accoutrement of fifteenth-century armour, although Samson wields his idiosyncratic weapon: the jawbone of an ass, as described in Judges xv 15.

Before describing the Tabernacle, I contrasted the doubts of the biblical critics with the evidence of the desert materials with which it was constructed. As Philo once pointed out, these materials 'were made of things grown from the earth; the purple colour is like that of water; the blue resembles the sky; and scarlet is like fire. Together, materials and colour represent the four elements.' But behind this Beduin craftwork there surely looms the presence of another powerful culture: that of Egypt. It was in Egypt that kings and gods had transportable pavilions formed from gold-plated wooden frames covered with elaborate hangings, while campaigning monarchs sat in two-roomed tents in the midst of their troops. And what of the golden cherubim poised over the Ark of the Covenant? This manifestly pagan feature was a source of embarrassment to later generations: Josephus said that they resembled no figures known to men and that in his day (first century CE) their form was utterly lost. But these cherubim do sound strangely similar to the winged goddesses that are found guarding the doors of Egyptian shrines. I should like to think of them as looking like those four exquisite divinities—Isis, Nephthys, Neith and Selkis—whose gilded figures in pleated dresses protect Tutankhamun's canopic shrine, their arms spread out and their heads turned watchfully to one side. Alas, the goddesses' lack of wings disqualifies them.

The Tabernacle stood in the centre of the Israelite camp. The various Levite clans were installed on three sides of it, while before the east or entrance front Moses, Aaron and Aaron's sons were encamped. Further back, all around, the 12 tribes of Israel were pitched, three to a side.

The Tabernacle served as the centre of the cult. Sacrifices were offered, incense burnt, and on the annual Day of Atonement the high priest entered the Holy of Holies and pronounced the ineffable name of God. But above and beyond that, the Tabernacle was seen as the actual dwelling place of God, both symbolically and literally. 'I appear,' says God, 'in the cloud above the Ark cover' (Leviticus xvi 2). Modern biblical scholarship has no time for such claims. 'Ancient Near Eastern typologies of exultation,' remarks W Gunther Plaut drily, 'demanded that the deity be enthroned in a house of its own.' Perhaps. But in centuries to come, when the God of Israel had been installed not in a desert tent, but in a stone temple in Jerusalem, the Jewish conception had developed to the point where Isaiah could exclaim (lxvi 1): 'Thus said the Lord: the heaven is my throne and the earth is my footstool: where could you build a house for me, what place could serve as my abode?'

Whenever the Children of Israel struck camp and moved on, the Tabernacle was

dismantled and packed up for transport. Though minute instructions for this procedure are given in the Bible (Numbers iv 4-33), critics with their pocket calculators have declared that the four wagons assigned to the task would have been inadequate. They have never watched a house mover stowing a pantechnicon. Six tribes marched in front; then came the Levites and the wagons with the Tabernacle parts, while another six tribes brought up the rear.

During the conquest of Canaan the Tabernacle was probably moved from place to place, according to where the Israelites were encamped. Afterwards it was brought to Shiloh, a central position which was within the territory of Ephraim, Joshuah's tribe.

The 200 years between the entry of the Israelites into Canaan and the rise of the Hebrew kingdom were rough and turbulent times, during which there was no unified central state. The 12 tribes were intermittently at war with the various other nations inhabiting the land. Particular trouble was encountered from one of the Sea Peoples known as the Philistines, and at the battle of Eben-Ezer they captured the Ark of the Covenant. It had been brought to the battlefield from Shiloh so that the Lord might be 'present among us and deliver us from the hands of our enemies'. The Philistines set the Ark beside an image of their god Dagon in his temple at Ashdod, where its presence caused such havoc that after seven months it was sent back, with two sets of golden ex-votos as an indemnity. For the journey the Ark was placed on a cart drawn by two milch cows, but lacking a drover. The cows lumbered straight along the road to Beth-Shemesh, where the people were out in the fields reaping the wheat harvest. They looked up and saw the Ark coming. The Levites gingerly took it down, while the people smashed up the cart and used its timbers to make a burnt offering of the unfortunate cows. This story was too powerful not to resurface. In fact it was adapted, two millennia later, by a medieval hagiologist describing the death of St Patrick. To settle the problem of two rival clans who were both demanding to bury him on their own land, the bier was placed on a cart harnessed to a yoke of oxen, who were given a whack and rumbled off without a drover. Where they stopped, the saint was buried and this spot became the site of Downpatrick Cathedral. A similar story links St Cuthbert with the site of Durham Cathedral.

The era of the Judges lasted for about 200 years, a period in which circumstances scarcely improved for the tribes of Israel, despite the emergence of heroic figures such as Deborah, Gideon, Jephthah and Samson. When the Philistines captured the Ark, they destroyed the sanctuary at Shiloh and gradually began to exert

control over the Negev. Judah's hold over its land was threatened, while Dan was actually displaced. It was at this conjuncture that the prophet Samuel was approached by the tribal elders and besought to 'make us a king to judge us like all the nations'. In this way the Kingdom of Israel was formed. Under David and Solomon (1000-922 BCE) it was transformed from a tribal society into one of the most powerful states in the eastern Mediterranean. It was governed from Jerusalem, which David conquered and made his capital after reigning at Hebron for six years.

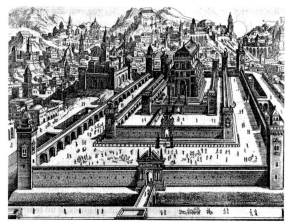

ABOVE A seventeenth-century Baroque engraving of Solomon's Temple. The successive courts represent increasing degrees of sanctity and hence correspondingly restricted availability of access. OPPOSITE Solomon's Temple, his palace and the Fortress Antonia, from *Retrato del Templo de Selomoh* by Jacob Judah León (Yakov Yehudah León), published in Middelburg in 1642. Rabbi León, of Amsterdam, constructed a model of the Temple in 1641, adding massive concave buttresses to the mighty substructure of the Temple Mount. These were to influence the design of the Great Portuguese Synagogue in Amsterdam (1671–5).

David's palace on Mount Zion was built by workmen from Tyre and constructed in stone and in timber from the cedars of Lebanon. 'When the King was settled in his palace', the Bible tells us (II Samuel vii 1-3), 'and the Lord had granted him safety from all the enemies around him, the king said to the prophet Nathan: "Here I am dwelling in a house of cedar, while the Ark of the Lord abides in a tent!" Nathan said to the king "Go and do whatever you have in mind, for the Lord is with you."' After an overnight visitation from God, however, Nathan advised against the project and so it devolved upon the king's son, Solomon.

Solomon's Temple took seven years to build, from the fourth to the eleventh year of his reign (*c.* 957-950 BCE). It was sited on what was originally the threshing floor of Araunah, where David had erected an altar to stay a plague. Solomon was helped by the Phoenicians: Hiram, King of Tyre, sent him cedar and cypress wood from Lebanon, floated down by sea as rafts, while stone was quarried 'in the mountains'. This presumably means the hill country of Canaan where limestone of a fine quality was found, which was soft when quarried but gradually hardened when exposed.

In some respects Solomon's building was a stone version of the sanctuary in the Tabernacle. It was a rectangular structure, the main unit measuring about 90 by 30 cubits overall, but it was wrapped around on three sides by a lower three-storey structure which gave the Temple total dimensions of 100 cubits long by 50 wide.

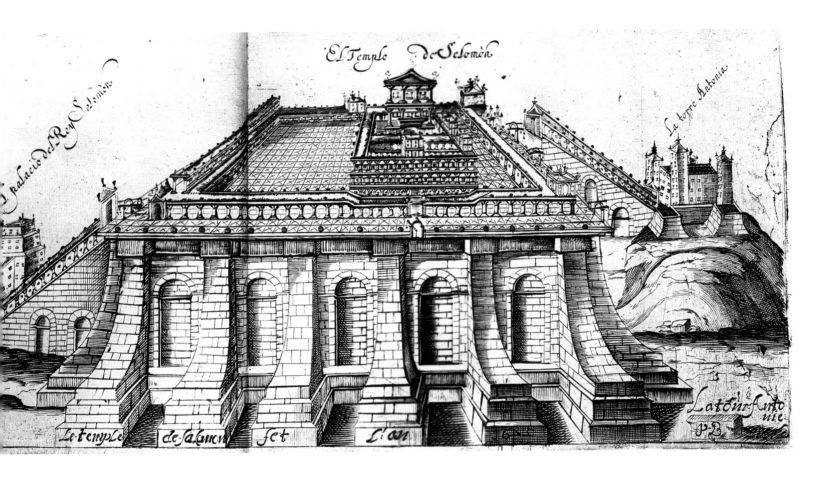

BELOW Interior view of the Temple, showing the shewbread tables in the *hekhal*. The cherubim can be seen in the *devir*, hovering over the mercy seat. In this illustration

from the Estienne Bible (Paris, 1540) the building has added Renaissance details.
OPPOSITE The exterior of the Temple, from the Estienne Bible.

The low-rise side blocks are shown with the offsets specified in the biblical description. The columns of Jachin and Boaz stand in a little yard before the entrance.

The internal width of the main block, 20 cubits, was about the maximum that could be spanned without intermediate support.

Entrance was at the east end—one of the two short sides—between two columns named Jachin and Boaz. Each column was 18 cubits high and surmounted by a capital 5 cubits high which was adorned with 'nets of checker-work and wreaths of chain-work'. These capitals were cast in brass by a Phoenician craftsman called Hiram or Huram of Tyre. Inside, the first room was the porch, or *'ulam*, measuring the standard 20 cubits wide but only 10 deep. This porch was the critical area that separated the sacred from the profane. A wall 6 cubits thick divided it off from the next room, the *hekhal* or holy place. In the middle of this wall was an opening 10 cubits wide, that could be closed off by two doors of cypress wood. The *hekhal*, where prayer was offered up, was the largest room, measuring 40 cubits long, 20 cubits wide and 30 high. With its clear span uninterrupted by supporting columns, it would have made a striking impression. The lighting was through clerestory windows, that is, windows sited at a high level to clear the flanking structures wrapped round the lower half of the building. These windows were broad within and narrow without, a circumstance that has exercised the ingenuity of countless generations of trite preachers.

The last chamber, beyond the hekhal, was the Holy of Holies, or *devir*, a perfect cube measuring 20 cubits. The 10-cubit difference in height between the hekhal and the devir is not explained in the Bible. Perhaps the floor level was raised, or the roof lowered. The Holy of Holies was where the Ark of the Covenant was placed. Its carrying poles were not unshipped, but touched the veil that hung across the entrance to the sanctuary. Two newly made olive wood cherubim spread their wings over the Ark. And, says the Book of Kings, 'there was nothing in the Ark save the two tablets of stone which Moses put there at Horeb [Sinai]'.

And that is the full picture. There was no huge chryselephantine statue of a goddess or wall-high tapestry of a Pantocrator, but a wooden box with two tablets in it: the word made stone. The Temple of Israel was different in the eyes of the people and the intentions of its builder from the shrines of other

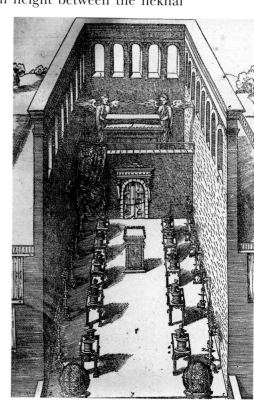

nations. God did not dwell in it, though his divine spirit, the *shechinah* may have rested there. 'Will God in very truth dwell on the earth?' asks Solomon in his dedicatory prayer (I Kings viii 27). 'Behold, heaven and the heaven of heavens cannot contain thee: how much less this house that I have builded!'

The Bible describes the equipment of the Temple in some detail. It included two altars: a small one before the Holy of Holies, made of cedar wood and overlaid with gold, and a large bronze altar for burnt offerings in the Temple court. Also in the court was what the Bible calls a brazen sea, an enormous basin 10 cubits in diameter and 5 cubits deep, weighing perhaps 33 tons. It was supported on the backs of 12 burnished brass oxen who stood in four groups of three each.

The brazen sea and its supporters have long since vanished, but we can still visit a reminder of it today. Some 2,000 years after Solomon's day, in the eleventh century, the Hispano-Jewish poet Solomon Ibn Gabirol wrote a poem about a palace in which this description appears:

> *And there is a full sea, matching Solomon's sea,*
> *yet not resting on oxen;*
> *but there are lions, in phalanx on its rim,*
> *seeming to roar for prey.*

These lines, rediscovered by the scholar Frederick Bargebuhr, are thought to refer to a feature of a fortified palace in Granada which belonged to the Jewish vizier of a short-lived Moorish dynasty—the Zirids. It is thought that the Fountain of the Lions currently found in the Alhambra, or at least the lions themselves, originally belonged to this eleventh-century Jewish palace. Their style is certainly more eleventh century than fourteenth century, the date of the Alhambra, in which they were, according to this theory, subsequently incorporated.

Are there any more reminiscences of Solomon's Temple to be seen today? To Helen Rosenau the twin columns, resembling Trajan's column in Rome, which Fischer von Erlach set in front of his Karlskirche in Vienna (begun in 1716) recalled

BELOW Lions from the fountain in the
Court of the Lions at the Alhambra,
Granada. Stylistically earlier than
the Alhambra itself, the lions may
have originally supported a 'sea'
at the palace of the Jewish vizier of
an eleventh-century Moorish

dynasty. Their re-use was perhaps
a conscious evocation of Solomon,
who was regarded as the embodi-
ment of ideal kingship in medieval
Jewish and Moslem legend.
OPPOSITE A reconstruction of the
Temple interior by Chipiez (1892).

We are in the *hekhal*, looking to-
wards the veil of the *devir* or Holy
of Holies. Chipiez has decorated
the walls with a variety of motifs
drawn from Egyptian and Western
Asiatic art.

the twin columns, Jachin and Boaz, that stood before the entrance to the Temple.
But the scale is far too great. Fischer was probably thinking of a couple of minarets
shooting up to give his building the tension and dynamism the Baroque style
demanded. He had illustrated Santa Sophia, Constantinople, tricked out with a
minaret at each corner, in his famous book on the world history of architecture.

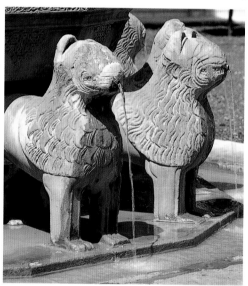

Free-standing columns on a more modest scale can be
seen flanking the entrance to the Royal Institute of
British Architects in Portland Place, London. Was Grey
Wornum thinking of Jachin and Boaz when he designed
them in 1932?

The Temple's days of glory were brief. After the
death of Solomon (922 BCE), his kingdom was split into
two states: Judah in the south, with its capital at
Jerusalem, and Israel in the north, ruled from Shechem.
The northern king Jeroboam could not hope to build
another Solomon's Temple, but he could, and did, start
up the pre-Temple shrines of Beth-El and Dan again.
The years passed. Kings rose, did what was evil in the
sight of the Lord and fell; queens schemed, introduced
Baal-worship and were overthrown; royal families were systematically wiped out,
and prophets expostulated. Meanwhile, at the crossroads of empire, the two little
states were harassed by both Egypt and Assyria. The Temple treasury was denud-
ed to pay tribute to foreign rulers who ranged from the stately Shesonk I of the
XXII Dynasty of Egypt to the rapacious scruffs of Aram-Damascus. Hezekiah
stripped the gold from the doors and doorposts of the Temple. Ahaz lifted the
brazen sea off its oxen and set it on a stone pavement.

Destruction finally came at the hands of Nebuchadnezzar, the most powerful
ruler of the New Babylonian Kingdom, who plundered Jerusalem twice in
the course of his wars with the XXVI Dynasty. The third time, in 586 BCE,
the whole city, with the royal palace and the Temple, was destroyed and the
people were taken into captivity. This catastrophe is commemorated every
year on the ninth day of the month of Av, when worshippers fast, sit on the ground
or perhaps on low stools as a sign of mourning, recite dirges and read the book of
Lamentations.

The Exile, or Babylonian Captivity, lasted barely 50 years, but the Jews learned
a great deal in that time, acquiring (in no particular order of importance) a taste

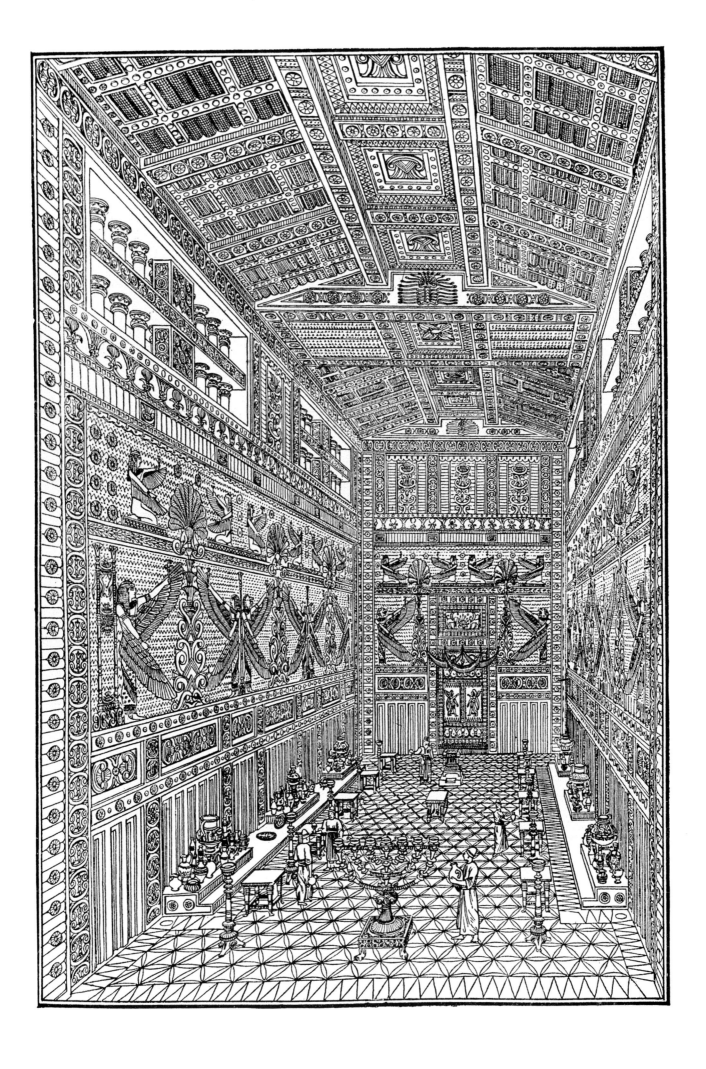

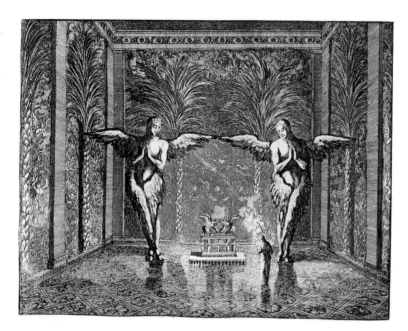

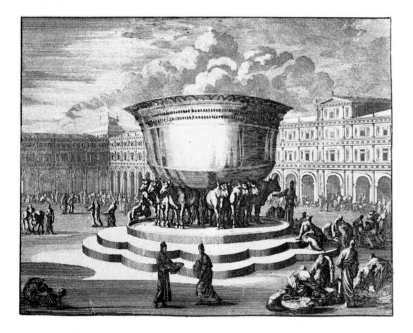

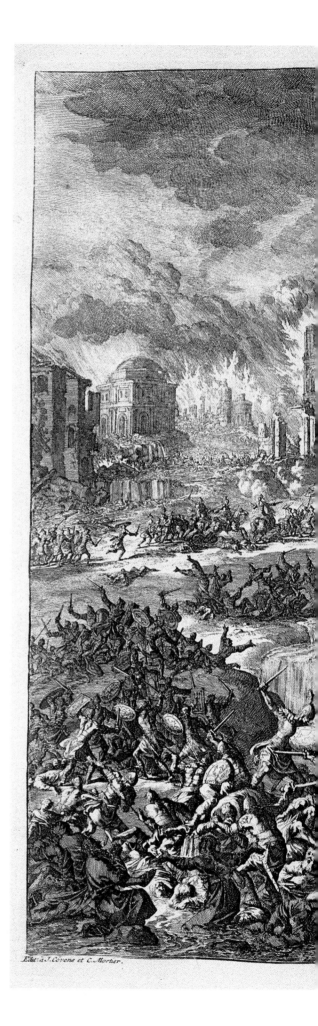

ABOVE Cherubim spread their wings over the Ark in the Holy of Holies and oxen bear the brazen sea on their shoulders, in two illustrations from *Afbeeldingen der merkwaardigste Geschiedenissen van het Oude en Nieuwe Testament* (Amsterdam, 1729) by Jan Luiken. **OPPOSITE** Another of Jan Luiken's illustrations shows the Destruction of the Temple. Luiken (1649-1712) first made his name as a lyric poet before turning to art. He became a master in the representation of great heaving masses of people, although he tended to re-use the same composition and even the same 'props' in his numerous etchings of biblical and historical scenes.

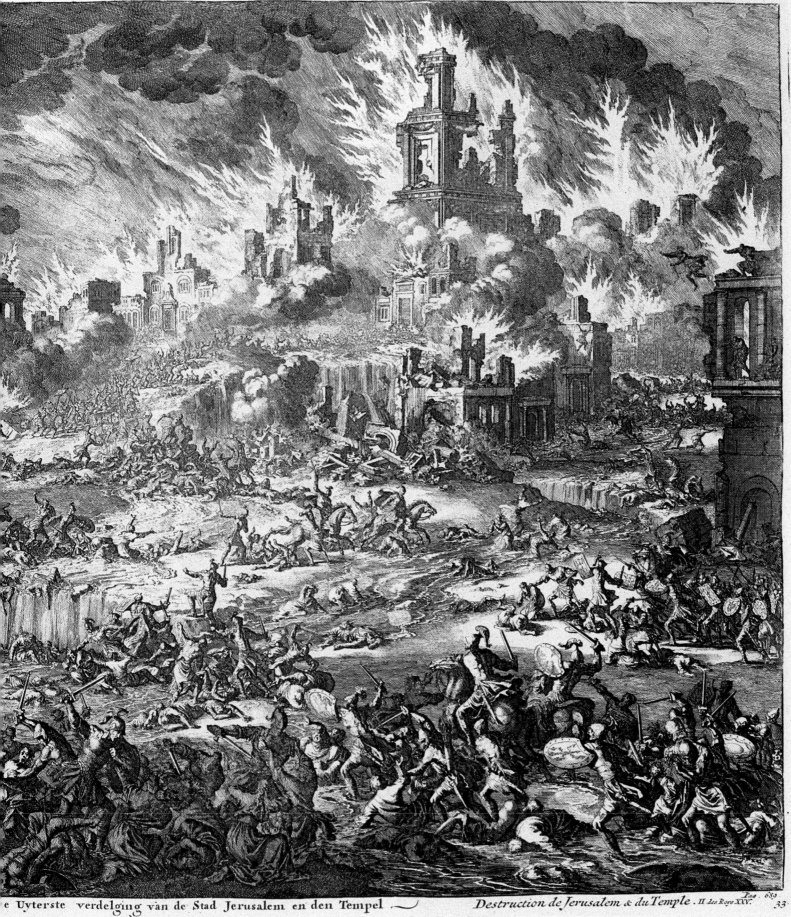

e Uyterste verdelging van de Stad Jerusalem en den Tempel ⌒ Destruction de Jerusalem & du Temple. II des Rois XXV.

Pag. 689

33

for commerce, ideas about angels and life after death, square letter script and the names of the months. With no Temple to focus religious devotion on, it is possible that the first synagogues were organized at this time for prayer services. This resulted in the creation of a general-purpose liturgy, as opposed to one for the exclusive use of the priesthood.

In 538 BCE Kurosh II, of the Achaemenid dynasty of Iran, whom we know more familiarly as Cyrus the Great of Persia, invaded Babylonia, diverted the course of the Euphrates and attacked the city of Babylon from the dry river bed. 'And in that night was Belshazzar the king...slain.' Thus Judah became part of the Persian empire. The prison-house of nations was unlocked, and an edict was signed permitting the exiles to return to their homeland.

A total of 40,000 Jews went back. The others had done rather nicely in Babylonia; to their children it was simply home, and they decided to stay. Those who returned, however, took with them the Temple vessels that Nebuchadnezzar had looted, and the promise of a grant from Cyrus to rebuild the Temple. Masons and carpenters were hired, and cedars of Lebanon were floated down to Jaffa once again. Work began in the second year of the exiles' return, and, says the prophet Ezra (iii 12), 'old men who had seen the first house wept with a loud voice when they saw the foundations of this house being laid'.

Matters did not go smoothly. The builders were approached by the Samaritans, who were descendants of the Hebrew survivors of the destruction of the northern kingdom of Israel by the Assyrians in 721 BCE. They had then intermarried with deportees from Assyria brought there by Esarhaddon in the early seventh century BCE. The Samaritans asked to take part in the rebuilding, but were snubbed by the Jewish prince Zerubbabel in tones that have taken on a deathly familiarity over the millennia: 'You have nothing to do with us in building a house to our God.' The intrigue and networking employed by the Samaritans in response to this rebuff brought a halt to building operations for 18 years. It was not until the prophets Haggai and Zechariah had exerted intense moral pressure that it proved possible to restart the work. Building took five years and was completed on 12 March 515 BCE. The dedicatory sacrifices included a hecatomb of bulls.

The detailed specification that we have for Solomon's Temple is absent for Zerubbabel's; or at least, it is not to be found in the Bible. Some details can be gleaned from the Jewish historian Josephus, and from a tractate of the Mishnah (Middoth) which records the dimensions, against the day of eventual rebuilding.

Once more we have a rectangular enclosure, in which a sense of direction is imparted as we move further in towards the holiest parts. This directionality was bequeathed to future generations of synagogues, in which one progresses towards the ark, and of churches, which climax in a high altar.

The basic rectangle of Zerubbabel's Temple is divided into an outer and an inner court. Within the inner court the Temple itself constitutes another rectangle, which is again divided into an outer sanctuary and a Holy of Holies. The early post-exilic Temple, despite the official Persian grant, could not have matched Solomon's Temple in the lavishness of its finishes and the use of gold plating. Gradually, however, as the country recovered from the Babylonian devastations and expatriate Jews prospered, much was done to embellish the original complex. The banker Alexander Lysimachus, brother of the philosopher Philo and one of the wealthiest Jews in Alexandria (first century BCE-first century CE) paid for the great gates between the outer and inner courts to be plated in silver and gold; 'the plates,' according to Josephus, 'being extremely thick'.

The Persian hold on Judah was broken by Alexander the Great (356-323 BCE). After his death, his empire was divided between his commanders. Two leading generals, Ptolemy and Seleucus, fought for control of Syria and Palestine. The ultimate winner was Ptolemy whose dynasty ruled for over 100 years (301-198 BCE) from its base in Egypt, until control over the ancient territories of Israel and Judah was wrested by the Seleucids. These Hellenistic kings respected the Temple, lavished gifts on it and exempted its functionaries from taxation.

Over the years the circumstance of Greek government and the culture of a corrupt Levantine Hellenism began to exert a strong influence on the upper levels of Jewish society, though not on the conservative masses. Antiochus IV Epiphanes, who came to the throne in 175 BCE, was pushing his luck, therefore when he attempted to hasten the process of acculturation by converting the Temple to the worship of Zeus. A revolt broke out, and under the leadership of Judas Maccabaeus the Greek armies were defeated. After this the Temple was purified and reconsecrated, events which (with their attendant miracles) are celebrated to this day in the winter festival of Chanukah.

The native Hasmonean dynasty founded by Judas lasted, with varying fortunes, until the first century BCE, when, wracked by internal dissensions, it was liquidated by the Roman general Pompey. Judaea was then reduced to the status of a division of the province of Syria, as part of Pompey's reorganization of the territories of the Near East in the wake of the power vacuum left by the fall of the Seleucids. The

BELOW The Roman aqueduct from the Herodian city of Caesarea conveyed water down from the mountain springs. Today the sand silting up the piers almost reaches the springing of the arches.
OPPOSITE A detail of *Belshazzar's*

Feast (c.1635) by Rembrandt. According to the Bible, the occasion of the feast was the overthrow of Babylon by Cyrus. Belshazzar sent for the gold and silver vessels looted from the Temple in Jerusalem and his guests drank from them. Suddenly a

hand appeared and wrote the words '*Mene, Mene, Tekel uPharsin*' on the wall meaning that the king had been measured and found wanting. Belshazzar was assassinated that same night and the city fell to the Persians.

legions marched into Judaea and laid siege to Jerusalem (63 BCE). When it fell, Pompey entered the Temple and penetrated the Holy of Holies, as Antiochus had done before him. No thunderbolt laid him low. The *shechinah* had departed.

Judaea played a minor role in the drama of the civil war that broke out between rival factions in the Roman republic. When the dust of battle had settled, Judaea emerged as a Roman client-kingdom with a new ruler: Herod I. He was the son of the chief minister of one of the last Hasmonean kings, by descent an Edomite, a member of the desert tribe conquered and converted to Judaism in about 120 BCE.

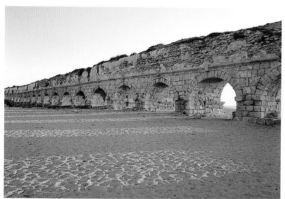

Herod was a ferociously efficient administrator who kept order in his territories with an iron hand, though modern scholars have dismissed as an improbable myth the 'massacre of the innocents' that St Matthew's Gospel charges him with instigating. Armed with his mercenary troops, Herod extended the boundaries of the Jewish kingdom to what they were in the palmy days of David and Solomon, and he used his influence as a king and a friend of the Emperor Augustus to protect Jews in the Diaspora. As we shall see, it did not require the fall of the Jewish state to provoke a widespread emigration of the Jews throughout the Roman Empire.

Herod was a keen builder. He presented temples, stoas and baths to Athens, Sparta and Rhodes, while at home he constructed the port of Caesarea, with its magnificent harbour, and restored the ancient city of Samaria, renamed Sebaste. His most imaginative architectural exploit was the fortress-villa which he erected on top and down the face of the rock of Masada, surveying the littoral of the Dead Sea.

Someone possessed of such *bâtissomanie* could hardly be expected to keep his hands off the Temple. Nor did he. Work began in 20 BCE. The area of the Temple Mount was doubled to 172,000 square yards (144,000 square metres), supported by substructures and enclosed by four huge buttress walls. The famous Western Wall is one of these. The size of the stones is formidable: the west wall has one 40 feet (12 metres) long, while another in the twenty-eighth course of the south wall, though only 24 feet (7 metres) long, is 6 feet (1.85 metres) high and must weigh 100 tons. The Temple Square on top—today's Haram esh-Sharif—was flagged and surrounded by columned porticos. It was open to everyone, including Gentiles. Within the square was a consecrated area, measuring 500 cubits by 500 cubits, marked

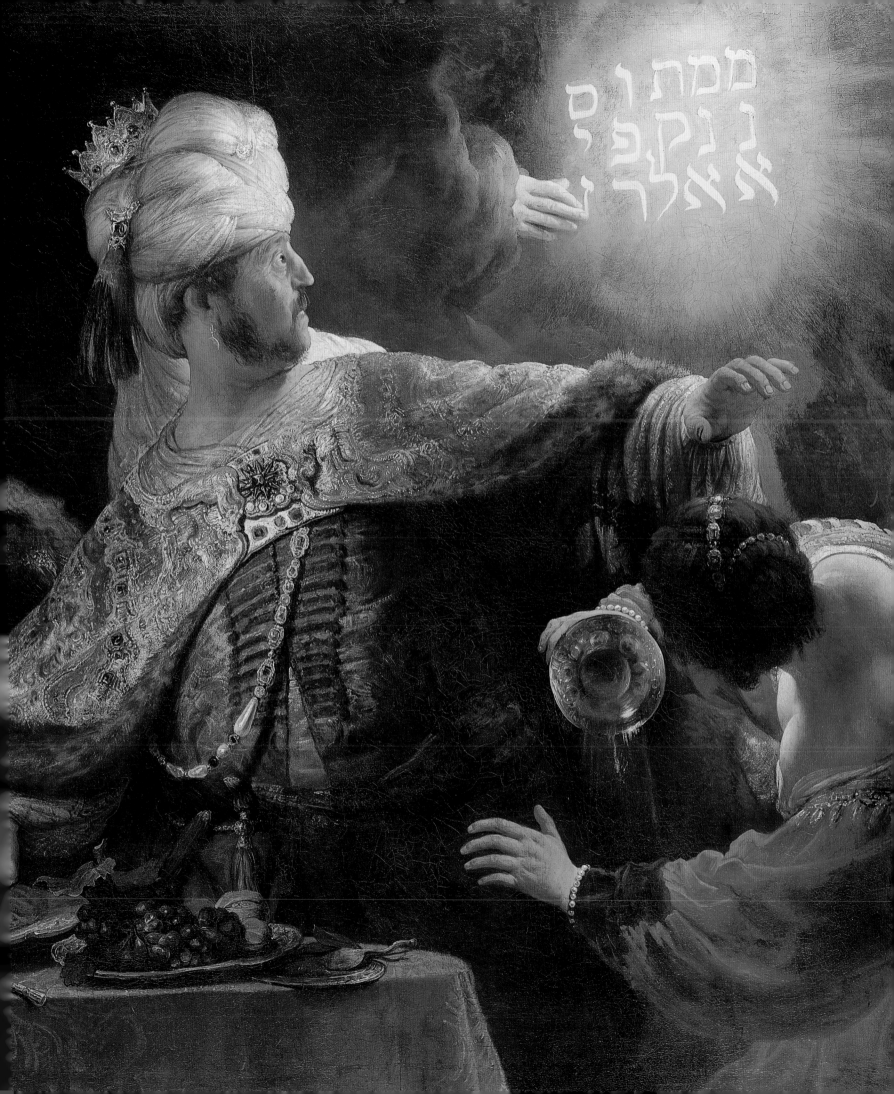

BELOW A plan of Herod's Temple according to the Talmud. The Talmud abounds with a wealth of details, derived from oral tradition, about the Temple, its layout, services, construction and even the repairs effected to it.

OPPOSITE Herod's Temple in Jerusalem. This reconstruction drawing by Melchior de Vogüé has been taken from *La Temple de Jérusalem* (Paris, 1864). The view shows the whole area of the Temple mount enclosed by four huge buttress walls.

off by a stone lattice, which Gentiles might not enter. A succession of courts was contained within this consecrated area, each of them of progressively increasing sanctity. First came the Court of the Women, then up a flight of semi-circular steps was the Court of the Israelites, which was accessible to all male Jews. Beyond was the Court of the Priests, marked off by a surrounding wall. Here stood the altar for sacrificial offerings, to which access for laymen was restricted. The sanctuary, or Temple itself, was built of white stone, and featured a 100-cubit-wide entrance unit or narthex, backing on to a narrower, 70-cubit-wide, *corps de logis* behind. The façade was articulated by a giant order of Corinthian columns. Inside, the entrance hall, which though very wide was only 11 cubits deep, was adorned with a series of gold crowns suspended from the cedarwood roof joists.

The great gates of the sanctuary stood beyond the entrance hall. When they were opened, says the Mishnah, you could hear the sound 20 miles away in Jericho. A golden vine stood here, trained on poles, 'and anyone who offered a leaf or a grape or a bunch used to bring it and hang it thereon' (Middoth iii 8). As always, the chamber of the sanctuary, its walls plated with gold, was divided off from the Holy of Holies at the far end by a curtain. In the nearer chamber stood the altar of incense and the golden candelabrum. Behind the curtain, the Holy of Holies was empty. The high priest entered it on the Day of Atonement to offer incense.

'He who has not seen Herod's Temple has never seen a beautiful building.' This, in its day, was a proverbial saying, the Talmud tells us. A team of 1,000 priests was trained in building skills so that they could work on the holiest parts, and they were still adding the finishing touches shortly before the Temple was destroyed.

The destruction of the Temple—the third, and to date, the last one—was the culminating disaster of the *Bellum Judaicum*, the war of the Jews against the Romans. Colonial peoples are supposed to look up with gratitude and admiration to their ruling race. Yet when the colonized have a higher civilization than the colonizers, or perceive themselves as having one, tensions arise. The *yishuv*, the

PLAN OF THE TEMPLE ACCORDING TO THE TALMUD.

(Designed by J. D. Eisenstein.)

NOTE. The smallness of the scale has rendered impossible the delineation of the full number of steps in each staircase. The exact position of the Temple upon Mount Moriah is indicated in the illustration given on the preceding page.

1 Eben Shetiyyah
2 Candlestick
3 Altar of Incense
4 Table of Showbread
5, 6 Chamber of Knives
7 Attic of Abtinas
8 Chamber of the Pancake Makers
9 Chamber of Phinehas the Vestment Keeper
10 Fifteen Semicircular Steps
11 Chamber of Lambs
12 Bath Chamber
13 Chamber of Showbread
14 Chamber of Stones of Defiled Altar

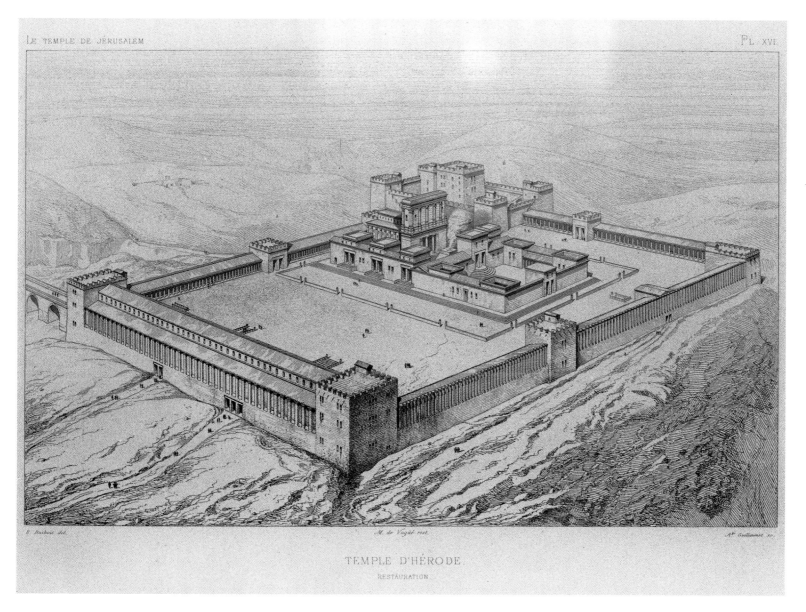

TEMPLE D'HÉRODE.
RESTAURATION

pioneering Zionists of Mandatory Palestine, regarded their cricket-playing, fox-hunting administrators with good-natured condescension. Unfortunately the Romans aroused a more bitter reaction. Not long after the death of Herod the Jewish kingdom was demoted again to the status of a province of Syria, ruled by a Roman procurator. These imperial officials ran an oppressive and rapacious administration, and in the year 66 the Jews rose in revolt. It took the Romans, first under Vespasian and then under his son Titus, four years to suppress them. In the end, Jerusalem was besieged, and the Temple set aflame. 'A runner brought the news to Titus as he was resting in his tent after the battle,' reports Josephus. 'He leapt up as he was and ran to the sanctuary to extinguish the blaze. His whole staff panted after him, followed by the excited legions with all the shouting and confusion inseparable from the disorganised rush of an immense army.' It was in vain. The Roman army had been given a bad time by the Jewish resistance, and was

FOLLOWING PAGES A relief on an inner face of the Arch of Titus in Rome. The spoils of Herod's Temple are depicted, including a seven-branched candelabrum, as they are paraded to honour Titus's triumph. Titus never saw his arch, since it was erected some time after his death in 81 CE.

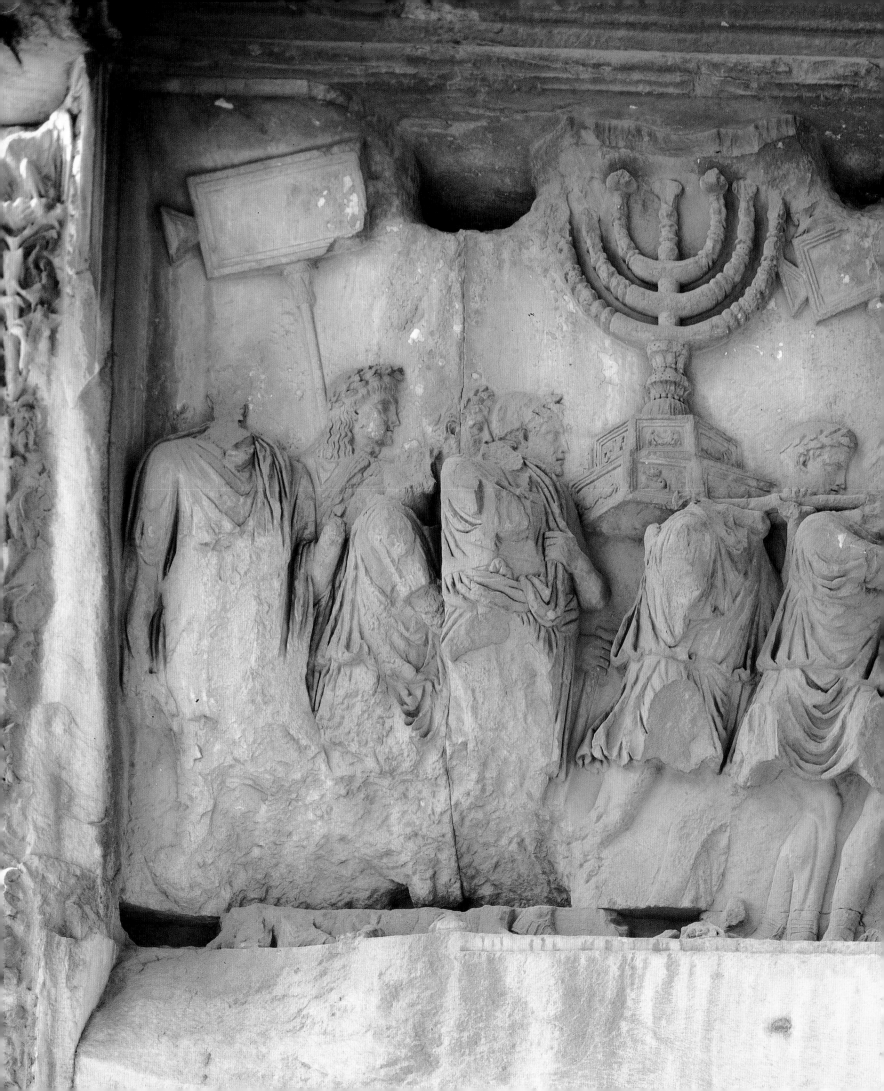

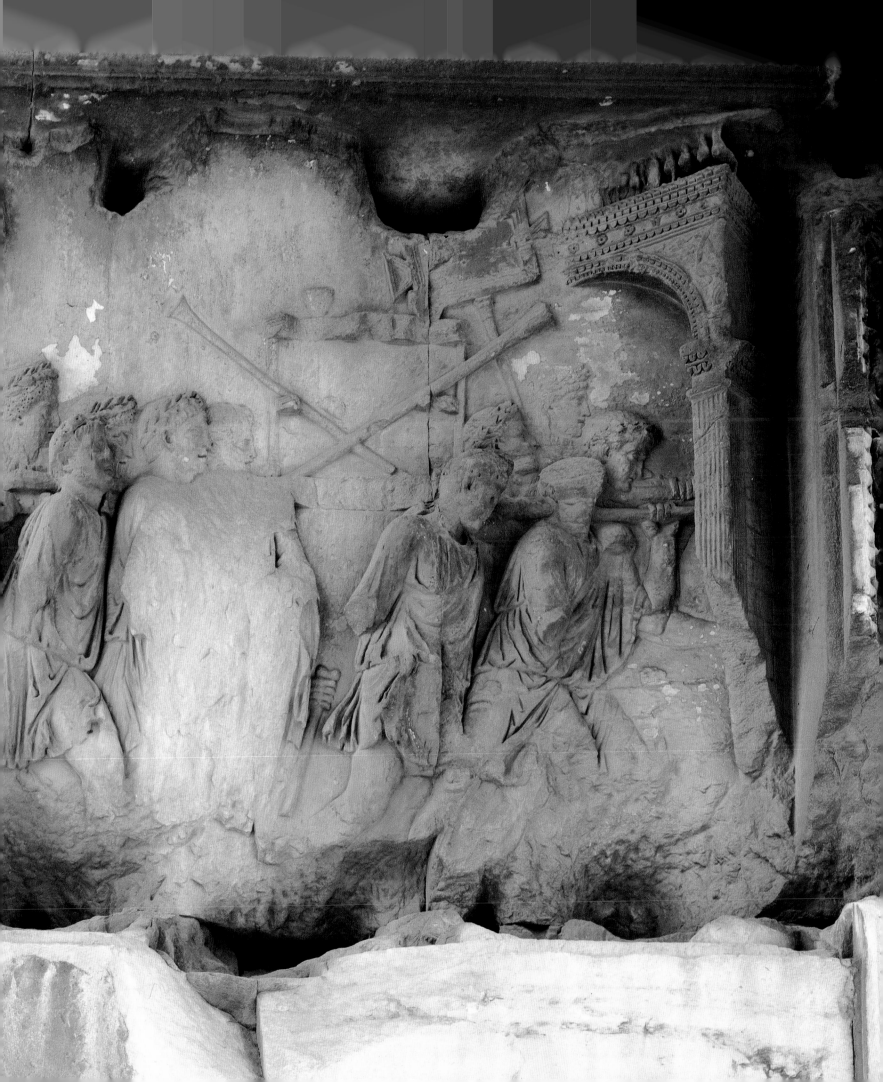

determined to wreak its revenge. 'Round the altar the heap of corpses grew higher and higher, while down the sanctuary steps poured a river of blood and the bodies of those killed at the top slithered to the bottom. The soldiers were like men possessed and there was no holding them, nor was there any arguing with the fire.' Not only the Temple, but most of Jerusalem, was reduced to rubble. The Jewish state was overthrown. A total of 110,000 people were killed or starved to death and

97,000 were enslaved and dispersed throughout the empire.

A memorial of this event can be seen in Titus's triumphal arch, erected in 81 on the summit of the Via Sacra in Rome, at the eastern end of the Forum Romanum. A frieze depicts soldiers marching and bearing aloft the seven-branched candelabrum, the golden table of the shewbread and other utensils from the Temple service.

It was 60 years after the destruction of Jerusalem, in the year 130, that the ruins were visited by the Emperor Hadrian, who decided to reconstruct the city. This scheme was overturned, however, by Bar Kochbar and his partisans, who attempted to rebuild the Temple. After Bar Kochbar's rising had been put down, a new pagan city was built named Aelia Capitolina, in which a temple dedicated to Jupiter Capitolinus was constructed on the site of the Temple.

Under the Emperor Constantine, in the fourth century, Christianity superseded the old Olympian religion as the official faith of the Roman Empire, and Jerusalem retrieved its ancient name. Later in the century the Emperor Julian ('the Apostate') reverted to paganism, and in 363 he proposed rebuilding the Temple, assigning the task to Alypius of Antioch, who had formerly been proprefect of Britain. 'But though Alypius applied himself vigorously to the work,' says Ammianus Marcellinus, 'and though the governor of the province cooperated with him, fearful balls of fire burst forth with continual eruptions close to the foundations, burning several of the workmen and making the spot altogether inaccessible.' Alypius recognized the operation of *force majeure* with a readiness that betrays his earlier experience in the British Civil Service, where the skill is endemic. He abandoned the project. To date, no-one has tried to resume it. The task would be complicated by the fact that another building now occupies the site: the Dome of the Rock.

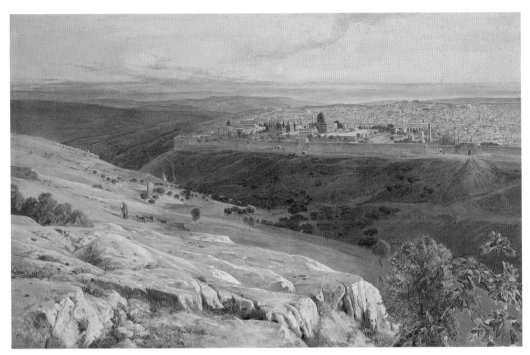

LEFT *Jerusalem from the Mount of Olives* (1859), painted in water-colour by Edward Lear. The most striking feature of this view is the contrast between the town and country, the densely built-up city and the absolutely untouched land-scape beyond the walls. This effect is now severely impaired through the modern development of the area, particularly since the unification of Jerusalem in 1967 and the subsequent erection of high-rise blocks within sight of the walls.

OPPOSITE The Dome of the Rock in Jerusalem was erected in 691 by 'Abd al-Malik on the site of the Temple. On Judgement Day souls will be weighed in scales hung from the three arches discernible at the head of the flight of approach steps.

In the course of their first victorious sally from the Arabian peninsula, the Arabs under Caliph 'Umar had captured Jerusalem from its Byzantine defenders in 638. About 50 years later, the reigning caliph, 'Abd al-Malik, whose seat was in Damascus, found himself confronted with a rival for his office, operating from Mecca. To preserve his flock from possible seditious influences while making the *hajj*, 'Abd al-Malik determined to create an alternative to the Ka'ba in Mecca as a goal of pilgrimage and direction for prayer. For this purpose he chose the *sakhrah* in Jerusalem. This is the irregular mass of rock on the Temple Mount that may once have served as the foundation for the altar of burnt offerings in the Court of Priests of Herod's Temple. That, at least, was its Jewish claim to fame. For the Moslems, it was the spot from which the Prophet, peace be on him and on his progeny, had ascended to the seventh heaven astride Al Burak, his winged horse with a woman's face and a peacock's tail.

Upon this site, accordingly, in the year 691 the Caliph erected his sanctuary. The rock is surmounted by a wooden dome about 67 feet (20.5 metres) in diameter, set on a high drum supported by a ring of four piers and 12 columns. This central cylinder is located within an octagon, between whose walls and the central feature there is an intermediate system of support: 24 arches borne on eight piers and 16 columns. This splendid building, decorated externally with mosaics, soon acquired

legendary status. The Crusaders, whose religious zeal outran their historical literacy, took it to be the very Temple of Solomon, and built several churches in Europe on its model. But the Jews were not deceived by it. They knew that the only accessible remains were the Western Wall of Herod's Temple. Accessible, but only just. As the buildings of the Moslem town pressed up to the Temple Mount, the only clear stretch was reached by an alley found towards the southern end of the Western Wall. Here generation after generation of Jews would come and pray. The American traveller John Lloyd Stephens saw them there in 1835. 'White bearded old men and smooth-cheeked boys were leaning over the same book; and Jewish maidens, in their long white robes, were standing with their faces against the walls, and praying through cracks and crevices...Now, as the Moslem lords it over the place where the Temple stood, and the Jews are not permitted to enter, they endeavour to insinuate their prayers through the crevices in the wall, that thus they may rise from the interior to the Throne of Grace.'

When Stephens wrote these words, the Greeks had just won their independence from the Ottoman Empire, thereby inaugurating an era that is still with us: the age of Romantic Nationalism. The path illuminated by the Greeks was taken by many others; and where the Czechs, Hungarians, Italians and Irish trod, could the Jews be far behind?

The rise of the Zionist movement was fuelled by a mixture of romantic nationalism, religious sentiment and economic and social misery. The trickle of pilgrims into the Turkish provincial backwater known as the sanjak of Jerusalem became, in the later nineteenth century, a steady stream of pioneers, spreading out north to the adjacent districts. When Palestine was wrested from the Turks by the British in 1917, it had a Jewish population of 80,000. When the British pulled out, 31 years later, in the most shambolic handover in post-imperial history, there were over half a million Jews in Palestine, a nation in the making.

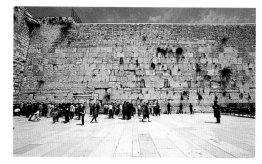

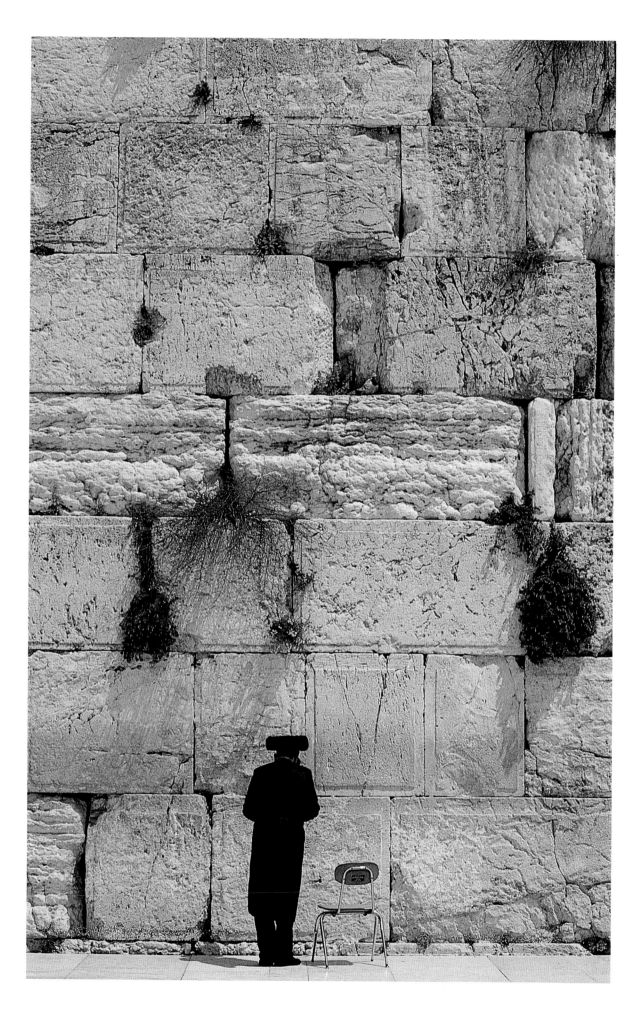

OPPOSITE ABOVE Slips of paper (*tsettelen*) bearing petitions or prayers, pushed into open masonry joints of the Western Wall of Herod's Temple, Jerusalem.

OPPOSITE BELOW Crowds gather at the Western Wall, now a magnet for Jewish visitors from all over the world, who are drawn here to pray. A massive plaza has been created where once a narrow terrace, reached through an alley, served as the only access.

LEFT Praying at the Western Wall. Note the huge size of the masonry blocks.

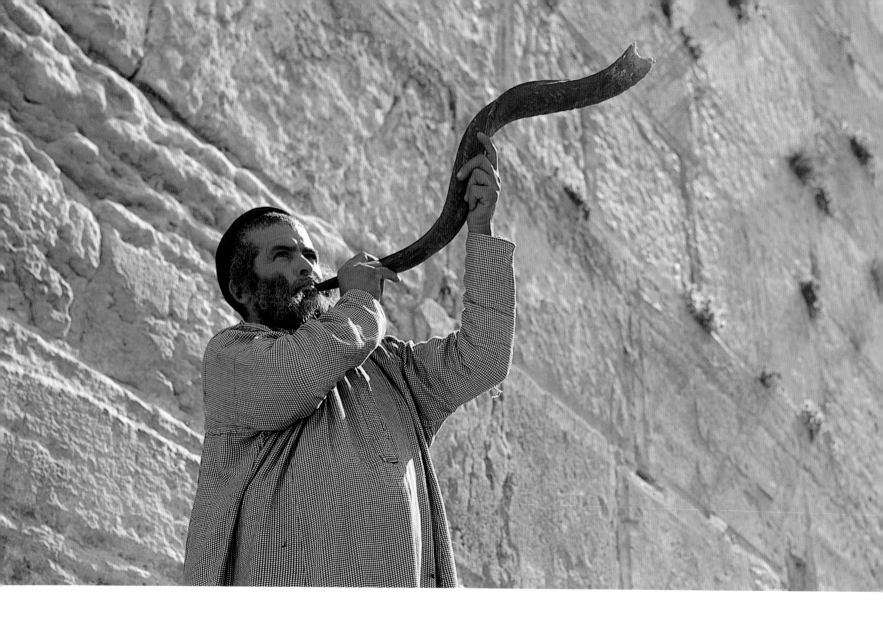

Sounding the *shofar* at the Western Wall to commemorate the New Year in Jerusalem. The horn, which utters a call to repentance, is made of a ram's horn as a reminder of the ram of Isaac.

In the war for the Land which followed, the Old City of Jerusalem fell to the Jordanians, who held it until 1967. During those 19 years they despoiled the Jewish part of the city and barred Jews from entry, and thus from access to the Western Wall. This lengthy interlude ended with the Six Day War. On 7 June 1967, after bitter fighting, the Arab Legion was defeated in Jerusalem. Paratroopers edged their way through the narrow lanes of the Old City. One unit made straight for the Western Wall. 'Near the entrance,' write Kollek and Pearlman, 'stood Arab legionaries, their hands raised in surrender. The first soldier through gave a great shout: "The Western Wall! I can see the Wall", and then the rest rushed through to touch and kiss the hallowed stones. Tough paratroopers, who had fought hard and non-stop for 32 hours, wept at the Temple wall over which their people had wailed for so many centuries.' The sound of the *shofar*, the ram's horn, was heard once again in a *tekiah gedolah*, or great blast, blown by Chief Rabbi Shlomo Goren of the Israel Army, in token of a religious and national consummation.

An early concern in the reunited city was to expose the whole of the Western

Wall, and entire city blocks were demolished to create a vast plaza in front of Herod's mighty buttress. This plaza is thronged continually nowadays by visitors and worshippers. Barmitzvahs are celebrated here, the services sometimes punctuated by the joyful ululations of oriental Jewesses. Supplicants push slips of paper— *tsettelen*—into the joints between the ancient stone blocks, for the attention of God.

But up above, in the Temple precinct, the Dome of the Rock and Al Aksa mosque still preside in sublime calm, where the Temple once stood. *Where the Temple should stand again, some say.* What? There are people who would demolish the Dome and rebuild Herod's, or even Solomon's Temple? You'd better believe it. The bulldozers are not exactly at the ready, with their engines running, but there are one or two chevras in Jerusalem who are hard at work studying—learning is the preferred term—all the classical texts which will prepare them for the holy task. They pore over the layout of the building, its volumetry, installations and equipment; what sacrifices to make, and when; what psalms to sing. And what, pray, is to be placed in the Holy of Holies? The Ark of the Covenant, of course. Thanks to the indefatigable researches of Graham Hancock, we know where it has come to rest: in the church of St Mary of Zion, at Axum. But surely? The Ethiopian authorities would not even let Hancock look at the Ark! Don't worry. We'll make them an offer they can't refuse.

In the meantime, however, you can pray at the Western Wall and push your tsettel in the cracks. If you cannot be there in person, there is a splendid new resource to help you. You can fax your tsettel, care of Bezek, Israel's Telecom. When the service opened in January 1993, 1,500 messages were received in the first week. Who could resist it? Here at last was the electronic realization of the ironical Yiddish catchphrase, 'Your word in God's ear'. No wonder they were faxing in desperately from India and Japan...

In the book he wrote in defence of Judaism and the Jewish people, Flavius Josephus, who was born about 37CE, remarks that 'ours is not a sea-going country. Neither commerce nor the intercourse it promotes with the outside world has any attraction for us' (*Contra Apionem* i 12). He goes on to say, 'our principal care is to educate our children well, and we think it the most necessary business of our whole life to observe the laws that have been given us, and to keep those rules of piety that have been handed down to us'. Both parts of this statement seem to ring true. As regards the indifference to commerce, no money was minted by any Jewish ruler until shortly before the beginning of the Christian era; the Jews were peasant proprietors. Josephus's observations on the aims of Jewish existence would be echoed today, word for word, by any pietist in London, New York or Jerusalem. He could, in fact, have condensed his remarks to three words: *torah* and *mitzvos*

How did this xenophobic, uncommercial, self-preoccupied people come to spread over the whole Greco-Roman world and beyond? It was not due to the overthrow of the Jewish state and the destruction of the Temple. The process had begun long before that. Josephus himself quotes an account by Strabo of a sedition raised in Cyrene in 87 BCE 'by our nation, of whom the habitable earth is full'. At the time of Christ a third of the population of Alexandria, in Egypt, was Jewish, and so Hellenized that they found it easier to read the Bible in the Greek Septuagint translation than in the original Hebrew.

In Rome itself there was an influx of Jews as early as the second century BCE. In fact, there were so many of them that a mass expulsion took place in 139 BCE for

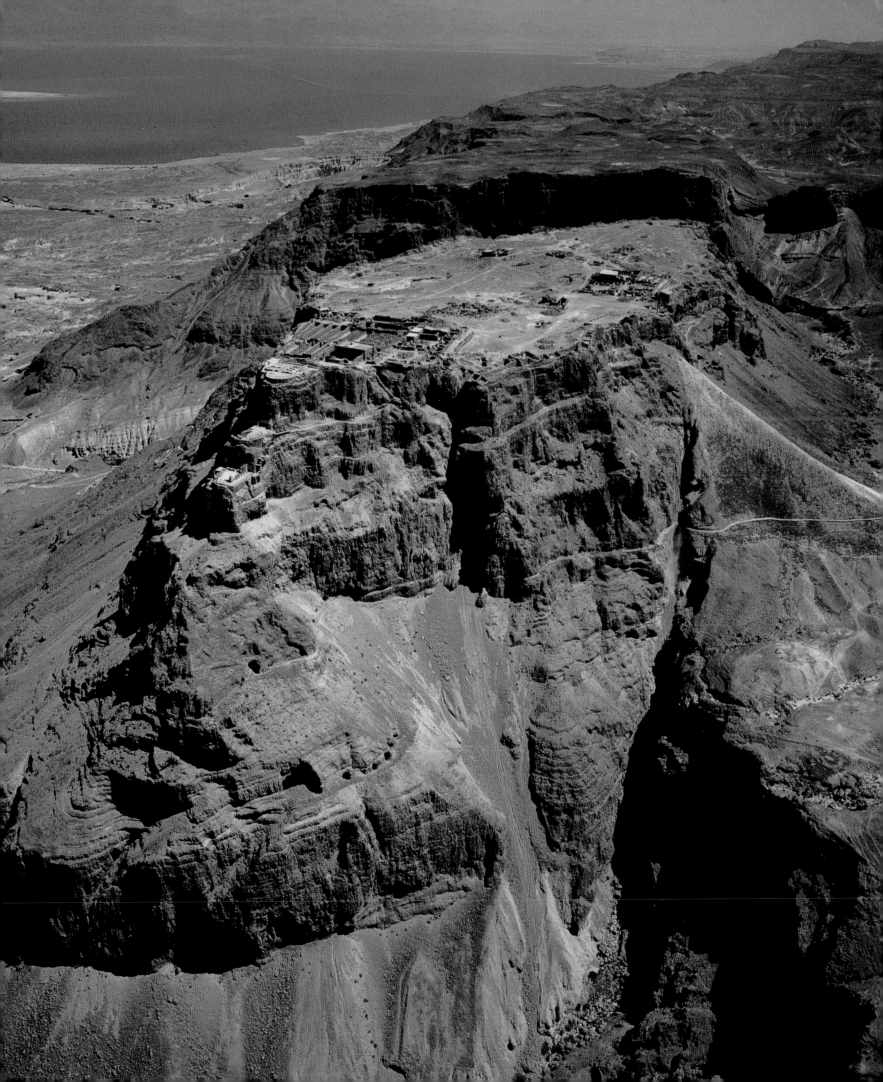

BELOW Column capital from the upper terrace at Masada, one of the architectural elements found in a heap of debris.
OPPOSITE The synagogue at Masada, excavated in the 1960s, was originally built for Herod and subsequently modified by the Zealots, who constructed the stone benches. It is oriented towards Jerusalem.

allegedly trying to propagate the Jewish religion. Yet numbers grew rapidly again, for when Lucius Valerius Flaccus was impeached in 59 BCE for extortion and misappropriating Temple funds while serving as a Roman provincial governor, the tribunal by the Aurelian steps in Rome was thronged with Jews. This circumstance was noted by Cicero, appearing for the defence, who referred to the Jews as 'that mob', adding for good measure, 'you know what a shower there is of them, how they pull together and how strong they are at public meetings'.

If, as Josephus claimed, his countrymen were preoccupied zealots, uninterested in commerce, what caused this mass emigration to the *oikoumene*, the inhabited world of the ancients? It has been calculated that only 2.5 million of the 8 million Jews alive in the first century CE actually lived in Palestine. A number of reasons suggest themselves for this. The Bible lays down that every seventh year the land must be left untilled, but this did not prove to be an effective alternative to the modern methods of crop rotation and the application of fertilizers to ensure the productivity of the soil. It may be that a growing population outstripped the capability of primitive agriculture to sustain it, for the Jews did not expose unwanted

infants on the mountain side as other nations did; no infant was unwanted. Another reason for the stream of exiles was a series of military defeats and the exactions of foreign administrators. There is also the matter of temperament. Some nations are diaspora-prone. Africa today is full of Greeks and Lebanese, south-east Asia teems with Chinese. With the Jews, it is happening all over again. Within three decades of the re-establishment of a Jewish state in 1948, the Israelis were swarming out, to open restaurants in San Francisco and to trade in Berlin.

This phenomenon of dispersal, whether voluntary or forced, ought to have led to the disappearance of the nation involved within a few generations. This, in fact, was the fate of one of the two kingdoms into which the Jewish state split after the death of Solomon. When the northern kingdom of Israel was overthrown by the Assyrians under Sargon II in 721 BCE, its population, which was derived from ten of the original 12 tribes, was deported. These people intermarried with other nations of the Assyrian Empire and then disappeared, though sightings have been intermittently reported from as far afield as Afghanistan and Hokkaido, while the British Israelites confidently assert that they finally settled in England (Saxons = Isaac's sons). The southern kingdom of Judah survived, however, and its 50-year captivity in Babylonia only served to strengthen the nation's devotion to its traditions and beliefs; a devotion that succeeding millennia have not dislodged.

The dispersal that took place in Hellenistic and Roman times meant that throughout the *oikoumene* there were far-flung Jewish communities which persisted as such and did not become absorbed into their host nations. Clearly, these communities could not participate in the rituals and sacrifices at Jerusalem, which were in any case a remote and vicarious form of worship.

Although the sacrifices and prayers at the Temple were offered to a single, incorporeal God, there was much in the religious procedure that resembled common pagan practice. Thus, in describing the customs of ancient Greek worship, E A Gardiner observes, 'the temple was in no case regarded as a place of assembly for worshippers; they met in the temenos outside. Most sacrifices too were offered at the altar which stood outside the temple, usually in front of it, though a small altar, mostly for incense or symbolic offerings, might be placed inside it.' The parallels

with Jerusalem Temple practice are obvious.

Before the destruction of the Temple in 70 CE, the Jews of the dispersion continued to send in contributions for its upkeep, sometimes to the exasperation of the Roman fiscal authorities who were supposed to control the movement of gold through the provinces. But from Gaul to Egypt, from Mesopotamia to Carthage, the scattered communities also needed a local focus for their religious and national self-expression. This could not be a mini Temple with sacrifices carried out by a priestly caste: the Torah forbids such manifestations save at the central sanctuary (Deuteronomy xii 4-14). Something more modest was needed: a place where daily prayers could be offered on a regular basis, and the scriptures read and expounded. I have already quoted Hosea's words in this connection: 'Instead of bulls we will pay the offering of our lips', and suggested that regular daily prayer might have started during the Babylonian exile. Tradition is vague here. But what is undeniable is that a new form of public worship grew up among the Jews of the diaspora which involved a congregation at a more direct and intimate level. 'Prayer,' writes Rabbi Isaac Levy, 'which till now had been given the status of a supplementary form of worship, became the dominant feature of public religious service.' That service was based on a gradually evolving liturgy and on Torah readings. This cir-

cumstance prompted H G Wells to observe in his *History of the World* that 'the Jewish religion, because it was a literature-sustained religion, led to the first efforts to provide elementary instruction for all the children of the community'. It led to more than that: it led to the development of a type of building that would house an interacting body of worshippers, as opposed to a remote temple in which mysteries were performed. This building in its turn would provide a model for the houses of prayer of Judaism's daughter religions, Christianity and Islam. After the destruction of the last Temple in 70 CE, the synagogue, in whatever local guise, was already in existence. It was

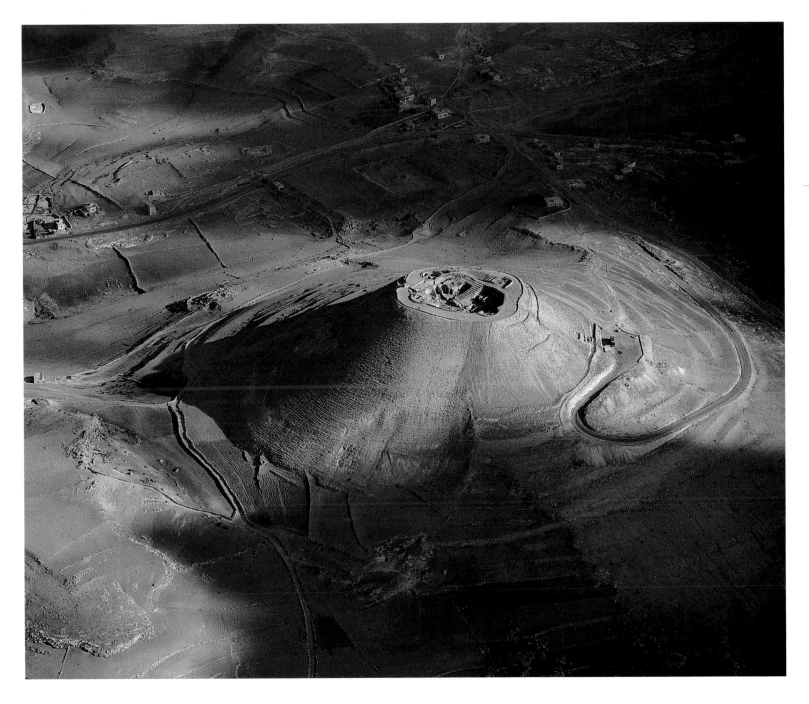

OPPOSITE ABOVE The remains of
the round tower in the Herodium;
the three other towers are semicir-
cular. In the foreground are the
traces of a colonnaded portico.
OPPOSITE BELOW Detail of the
colonnaded portico. The Herodi-
um served as a district headquar-
ters during Bar Kochbar's revolt
(132-5 CE).

ABOVE View from the air of the
Herodium, a fortress built by
Herod on top of a hill 12 km south
of Jerusalem, at the site of his
victory over his pursuers during his
flight from Jerusalem to Masada in
40 BCE. The hill was raised in
height by the use of debris. After
the fall of Jerusalem in 70 CE,
Herodium surrendered to the
legate Lucilius Bassus.

a familiar institution which took the place, *faute de mieux*, of the Jerusalem sanctuary whose restoration remained the object of messianic longing.

The architectural requirements of the new type of worship were modest enough: a roofed and enclosed space in which a congregation could hear the Torah read, join in the antiphonal rendering of prayers with the *baal tefillah* (precentor) or engage in silent devotion. Sometimes there were long stepped benches in stone along the walls; sometimes the congregation sat on the ground or stood.

The model for the early synagogues of the Greco-Roman world could not have been the pagan temple, which was an exclusionary type of structure like the Temple in Jerusalem. A more suitable prototype for a building to accommodate a collective act of worship was the *bouleuterion*, the Greek council chamber, which was designed for people to assemble in and for speeches to be heard. The *bouleuterion* in Athens was a square building, with benches running parallel along three outer walls. The fourth wall was a partition dividing off the entrance lobby; anyone addressing an assembly would stand in the middle of it. This type of plan is reflected in the archaeological remains of those synagogues of the epoch which have come to light. Most of them are to be found in the territory of present-day Israel and the adjoining lands.

Archaeology is one of the two sources of our knowledge of early synagogues. The other source is literature: the scattered references in the Talmud, the New Testament and writers such as Josephus and Philo. The two sources do not coincide: in fact, they hardly overlap. The synagogues referred to in ancient literature as standing in Egypt, Syria, Cyprus and Greece have all disappeared without trace, while the synagogues uncovered by the spade are not mentioned in the literature. The Acts of the Apostles, which describes Paul's missionary journeys, is in effect a first-century *Travel Guide to Vanished Communities*, since Paul begins each town visit with a trip to the local synagogue. Here, the executive, as a matter of courtesy, and in the mild hope of hearing something interesting,

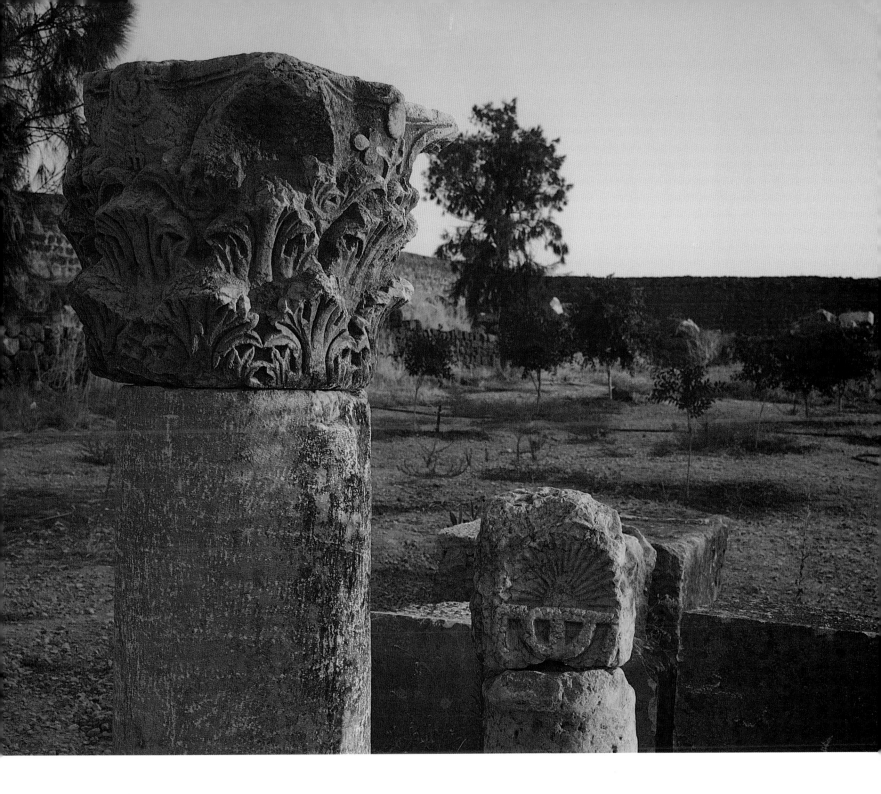

OPPOSITE ABOVE The columns at Chorazin run parallel to the east, north and west walls, with masonry benches and a three-door entrance wall facing south towards Jerusalem.

OPPOSITE BELOW The vintage. One of the symbols of the months of the year carved as a frieze on a zodiac tablet found in the ruins of the synagogue at Chorazin.

ABOVE Remains of the synagogue at Chorazin. Ancient synagogue ruins, no matter how fragmentary, have political overtones as well as religious and archaelogical significance. Their presence is regarded as proof of Jewish occupation of the area in the past and hence of the right to return there today.

would invite him to speak or 'to say some words of torah'. The *droshoh* or sermon Paul gave on these occasions, advocating the claims of an alleged messiah, who was recently deceased and subsequently resurrected, did not go down well and led to considerable acrimony.

For a more upbeat account of an ancient synagogue we must turn to a less prejudiced source: the Talmud, where at Sukkah 51b Rabbi Judah is in fine swaggering form, reportedly declaring:

> He who has not seen the double colonnade of Alexandria in Egypt has never seen the glory of Israel. It was said that it was like a huge basilica, one colonnade within the other, and it sometimes held twice the number of people that went forth in the Exodus. There were in it 71 gold chairs corresponding to the 71 members of the Great Sanhedrin, not one of them containing less than 21 talents of gold, and a wooden platform in the middle, on which the beadle stood with a scarf in his hand. When the time came to answer Amen, he waved his scarf and all the congregation duly responded. Moreover, they did not occupy their seats at random, but all the goldsmiths sat together, as did the metalworkers and weavers, so that when a poor man entered the place, he recognized the members of his craft and on applying to that quarter obtained a livelihood for himself and the members of his family.

This entertaining instance of ancient semaphore, cited as proof of the heroic dimensions of the Alexandrian synagogue, is on a par with many other tall stories to be found in the *aggadic*, or non-legalistic parts of the Talmud. Victor Tcherikover, who is interested in the passage for its sociological content, refers drily to its 'legendary details' which we may not credit. But those for whom the Talmud is an inexhaustible wellspring of thought and action have made use of precisely these details. They have deduced from them that it is permissible for someone listening to a radio broadcast of a religious service to chime in with an 'Amen' where appropriate, even though he is not present at the event in person, since the Alexandrians responded on the basis of a visual signal to a prayer or a blessing they could not hear.

The word in the Talmudic text which is usually translated as 'platform', appears as '*bimah*' in the original. Was this a bimah as we understand it nowadays, on which, for example, Sidney read his barmitzvah piece in Chapter 1? Or was it simply a stand on which the scarf-waver stood, like a policeman directing the traffic? Many of the early synagogues revealed by archaeology show no evidence of a bimah, but if these had been made of wood they might have perished without trace

anyhow. The Alexandrian synagogue was so huge that entire craft and trade guilds could be housed by sections. On a more modest scale, synagogues still exist today that are frequented solely by practitioners of particular crafts. I once welcomed in the Jewish New Year at a little synagogue in the Marais district of Paris that was virtually a furriers' shool. As well as synagogues for individual trades, there were also those which had been founded by *Landsmannschaften*, people coming from the same area. Imperial Rome had its synagogue of the Tripolitans, Jerusalem its synagogue of the Alexandrians, Mehuza of Babylon its synagogue of the Romans, and Tiberias its synagogue of the Babylonians. This practice still goes on. On Clapton Common in London you will find the Adeni Jews' synagogue; Manchester had its Telz and Kovno shool and many other East European strongholds of the Torah were briefly commemorated by congregational names in England and America.

The Alexandrian synagogue was commonly referred to as a basilica, a term used in Roman architecture to mean a large meeting hall. Basilicas 'were often oblong buildings with aisles and galleries and with an apse opposite the entrance'. This building type, as well as the bouleuterion mentioned earlier, seems to have served as the model for some of the early synagogues, especially those in Galilee and Golan. The basilica was also to provide the inspiration for Early Christian churches. The two rows of columns parallel with the long walls, and the third transverse one that are habitually encountered in these early synagogues imply the existence of galleries. In turn, this prompts the question of the separation of women, who are today banished to the galleries of orthodox synagogues. Rabbinical writers tend to insist that women were separated from men in ancient synagogues, as they had been in the Temple courts. Secular scholars cast doubt on this assertion, arguing that the presence of galleries is no proof that they were for the use of women; their function, says Professor Carol Krinsky, may not have been fixed until the religion itself became more clearly defined by the compilation of the Talmud.

Most of the ancient synagogues whose material remains survive are to be found in or adjoining the land of Israel. There are, indeed, traces elsewhere: at Ostia, the port of Rome; at Stobi in the Republic of Macedonia; and at Sardis in Asia Minor, now Anatolia, to name but three diaspora sites. In no other country than Israel, however, have they been sought with such anxious care. The quest that began in the nineteenth century with the Palestine Exploration Fund and similar 'Holy Land' organizations has become a national preoccupation in the State of Israel. The reason is obvious. A widespread distribution of numerous ancient Jewish sites

may be regarded as evidence that the country belonged of old to the Jewish people, whose modern claim to ownership is constantly being challenged by the indigenous inhabitants, the Palestinian Arabs.

Over 100 ancient synagogue sites have been discovered to date in Israel. The earliest are Herodian foundations, at Masada and at the Herodium near Jerusalem, but most date from the third century CE or later. This lengthy period of inactivity is explained by the repressive conditions that existed in the province after the overthrow of the Jewish state in 70, which were aggravated by Bar Kochbar's revolt in 132–5.

When building did begin again, some fairly massive structures were erected. They were characterized by monumental façades in a somewhat lumpish Roman colonial style, generally featuring a large central door and two small side ones. The south Syrian arcuated lintel also put in an appearance, characterized by an entablature, with all its mouldings, which is curved up into the tympanum of a pediment. This device is believed, on archaeological grounds, to have been used on the portico of the synagogue at Kefar Birim in northern Galilee, and on the gable of the one at Capernaum. Although of Assyrian origin, the arcuated lintel originally

surfaced in classical guise at Seeia, in the Hauran district of Syria, a fascinating meeting-point of various cultural influences. Here it was applied to a first-century BCE pagan temple.

Whatever the stylistic vocabulary and its nuances, there is no gainsaying the fact that it was often employed with a heavy hand. The culmination must be the façade of the synagogue built at Meiron, on a hill-top in Galilee, by Shalom ben Levi. Here the huge overscaled architrave of the central door includes a lintel that projects sideways beyond the jambs into the wall mass with a pair of fearsome lugs.

Compared with the sometimes dramatic impact of the façades, the interiors of these early synagogues (now only preserved in fragmentary states) must have left a calmer impression, one more conducive to devotion in prayer. The classical texts offer few hints about what is, or is not required. Scholars are fond of quoting the exiguous comments of the Tosefta that the synagogue should be built on high ground, that the ark should have its back to the sanctuary (of Jerusalem) and that

LEFT The synagogue at Sardis, in the province of Asia Minor (present-day Turkey) was rebuilt after an earthquake in 17 CE and stood, with various modifications, for 600 years. This view down the prayer hall, 54 metres long, looks towards the three entrance doors, with two pedimented shrines between them. The whole shool could accommodate a total of 1,000 worshippers.

OPPOSITE The shrine at the left in the Sardis synagogue is one of two built against the Jerusalem-oriented entry wall in the fourth century. It may have served to store Torah scrolls.

the synagogue gates should open towards the east. But it is uncertain when the Tosefta was compiled, and very probable that some of the Palestinian synagogues were built before its completion. The opinions the Tosefta expressed, however, were presumably current in the epoch leading up to its composition.

As has been pointed out earlier in this chapter, the prototype of the early synagogue was not the pagan temple, but the bouleuterion and the basilica. The use of the basilican plan for this purpose, says J B Ward-Perkins, 'should be regarded as one of the innumerable borrowings of this versatile and symbolically neutral architectural type for other purposes, without wider significance'.

The classical basilican plan, as found at Kefar Birim, for example, consists of a rectangular hall with three entrance doors at one of the short ends, and a broad central nave divided off from the side aisles by two rows of columns which join together across one of the short ends. Kefar Birim has a columned portico in front of the entrance. The internal columns supported a gallery, but whether it was intended for women or not is controversial. Variations on the standard plan include rectangles with a little apse at one of the short ends, as at Maon. There are also astylar types, such as that at Eshtemoa, in Judaea, which have a niche arrangement in the middle of one of the long walls—the so-called 'broadhouse' plan.

Architectural historians keen on classifying plan changes and linking them with

chronology have tried to work out a time sequence for the variations in type. They came unstuck, however, when excavations at Capernaum, thought on stylistic grounds to date from about 200 CE, revealed foundation deposits of coins dating from 200 years later. Thus it seems that the different plan shapes were being built contemporaneously rather than consecutively.

How were these early synagogues orientated? Their façades are turned towards Jerusalem; hence those in Galilee face south, and south would also be the direction of prayer, since praying towards the Temple (I Kings viii 30) or Jerusalem (Daniel vi 11) is enjoined in the Bible. This meant that congregants entering such synagogues would have to turn round, to face the entrance wall, just as the audience in the bouleuterion had to in order to look at a speaker who was addressing them. The switch to a northern entrance in Galilee was not made until the Byzantine period (fourth to sixth centuries).

Those synagogues with plain rectangular plans do not seem to have a fixed place for the ark, which must have been a portable box containing the scrolls, moved in for the services from an adjoining room. The niche in the long wall of the broadhouse type of synagogue was evidently used to accommodate Torah scrolls, though whether they were kept there permanently is uncertain. With the arrival of the semicircular apse, however, the scrolls appear to have found a permanent home, perhaps behind a simple curtain or marble screen, or in a fitted cupboard.

The pagan Romans were not too concerned about the religious practices of their subject peoples, provided they caused no public scandal. This attitude changed when Christianity became the state religion of the Empire in the early fourth century. Under the influence of the overt anti-semitism of the New Testament, Jews and Judaism began to suffer discrimination. It was forbidden to erect new synagogues and difficult to repair old ones. Forbidden, difficult; under the Byzantines these were not

ABOVE The façade of the Kefar Birim synagogue. The major central door is flanked by two lesser ones. The remains of a colonnaded portico stand in front.
RIGHT This mosaic at Khirbet Samara represents a synagogue ark, with a Syrian arcuated lintel rising above a shell. The curtain flicked over a column shaft discourages the view that a symbolic representation of the entrance to the *devir* in the Temple is intended.
OPPOSITE The central doorway of the second/third-century synagogue at Kefar Birim in northern Galilee. A heavily moulded relieving arch is set over a decorated lintel that projects into the wall mass to form lugs on the door frame.

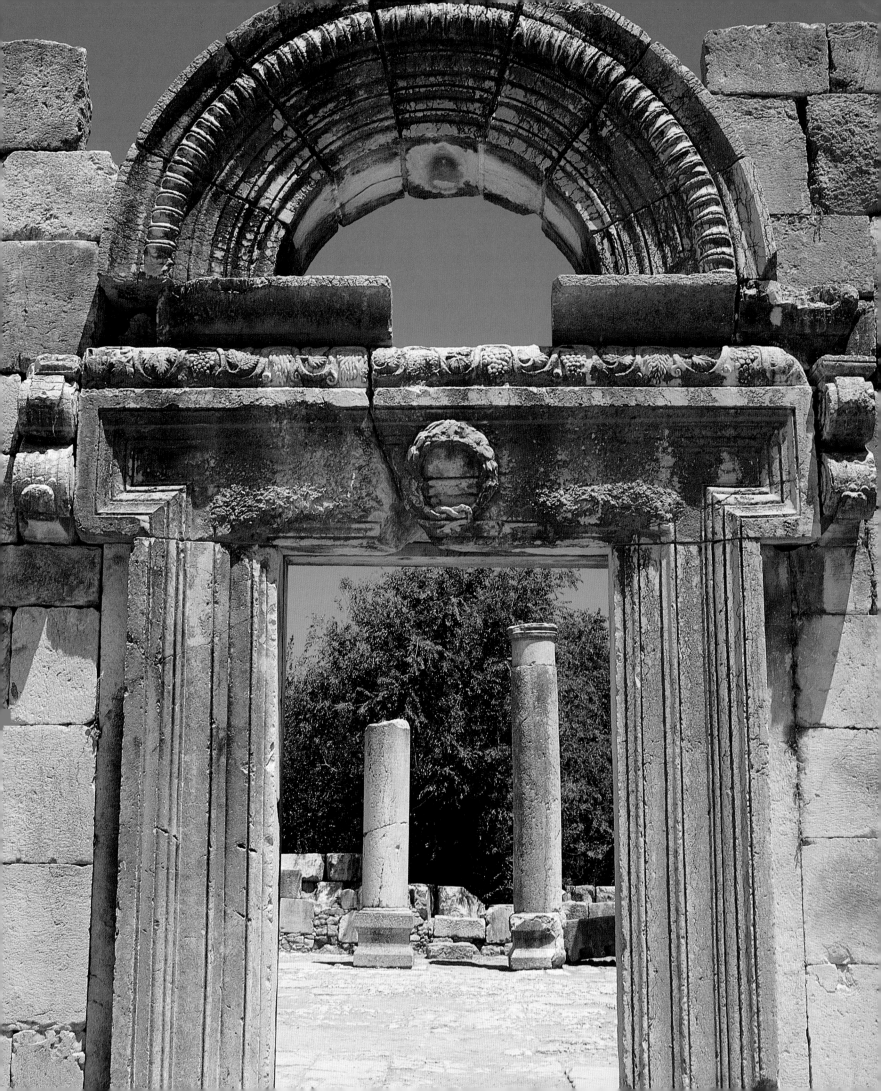

ABOVE The remains of the third/
fourth-century synagogue at Caper-
naum in Galilee, which has been
inexpertly restored by Italian friars.

OPPOSITE An aerial view of Caper-
naum synagogue, showing the
rectangular basilical hall with the
familiar arrangement of colonnades
along three sides. An annexe at
one corner of the hall was used for
storing Torah scrolls.

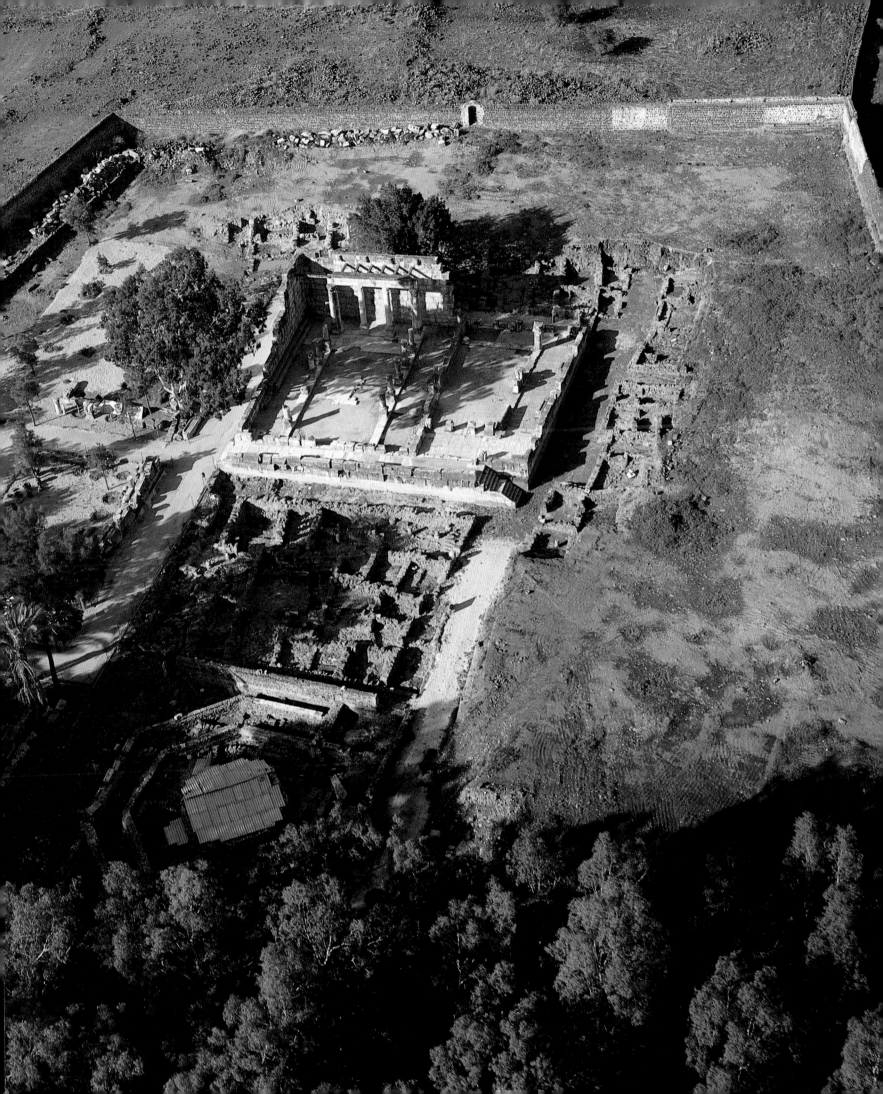

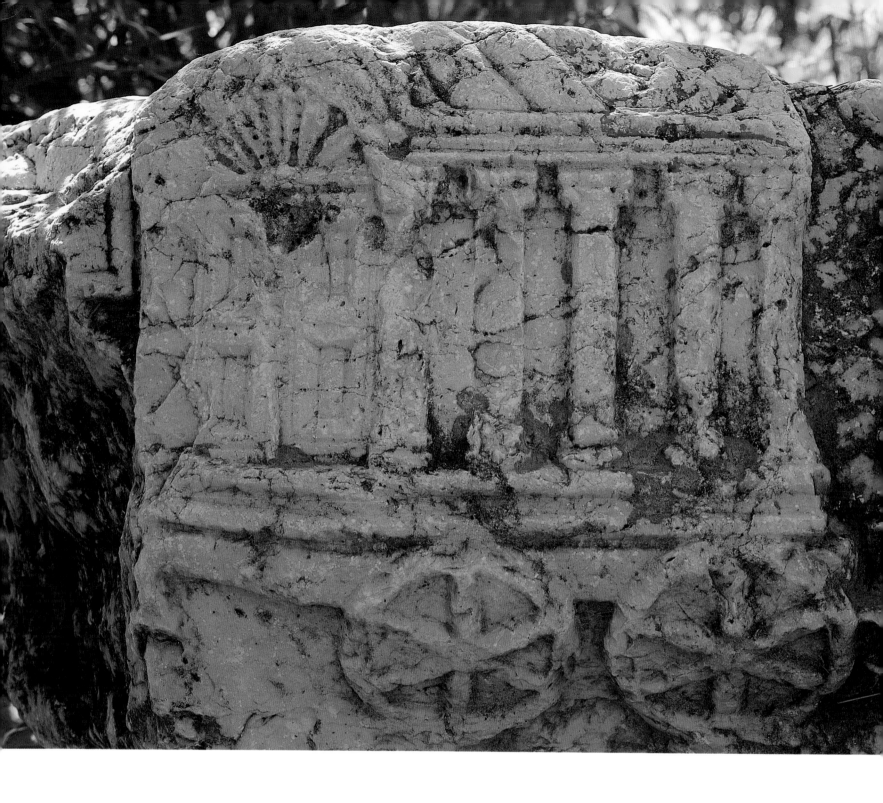
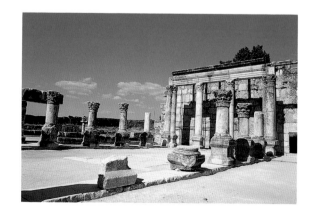

OPPOSITE ABOVE Carving found
outside the synagogue at Caper-
naum, depicting the Ark of the
Covenant on a wagon. The Ark
displays an order of Corinthian
pilasters.
OPPOSITE BELOW The prayer hall of
the synagogue at Capernaum.
Stone benches run along the east
and west walls.
LEFT A hexagram, or six-pointed
star, carved on a frieze at Caper-
naum. Its appearance here pre-
dates by 1,000 years its adoption
as a specifically Jewish symbol
(the 'Star of David').

absolute terms. Arrangements could be made, but discreetly, you understand: we
are not talking here about Philip II's Spain or Hitler's Germany. Thus synagogues
continued to be erected, but their exteriors were modest. Display was transferred
to the interiors. Hitherto these had been fairly austere, although decoration had
not been entirely excluded. Early synagogues featured stone friezes carved in relief
with representations of religious objects such as the shofar, *menorah* (candelabrum)
and the *ethrog* and *lulav*, fruits associated with the Festival of Tabernacles.

The synagogue at Dura Europos provides an early example of the extent to
which an interior might be embellished by representational art. Dura Euro-
pos was an outpost of the Roman Empire, a caravan town on the banks of the
Euphrates in Syria. Its site was discovered by chance in 1920, and the syna-
gogue came to light in the course of archaeological excavations in 1932. It was
of the broadhouse type, built in the year 245 and orientated towards the west, that
is, towards Jerusalem. Its walls were frescoed with scenes from the Bible (now in
the National Museum, Damascus) in a style that is derived from contemporary
Greek painting, but eschews such expedients as perspective. The subjects depicted
include the finding of Moses in the bulrushes, scenes from the priesthood of Aaron
and episodes from the Book of Esther. One of the most striking panels tells the

story of Ezekiel's vision of the Valley of Dry Bones. Ezekiel is dressed in Parthian garb, looking like a bearded Struwwelpeter. The device of continuous narrative is used, so that the prophet appears repeatedly in the same strip, directed by the hand of God reaching down from above.

Frescoes, however, were a rarity. A more common form of artistic expression was the mosaic pavement, which began to replace the plain stone floors in Palestinian synagogues. At first these pavements displayed only abstract designs, but from the fourth century onwards people and animals were introduced. An eclectic use

was made of those figures from pagan mythology which were commonly found in the decoration of Roman villas and houses throughout the *oikoumene*. The *pièce de résistance* is at Hammath, near Tiberias, where a third- or fourth-century mosaic features the signs of the zodiac, neatly labelled in Hebrew and arranged in 12 compartments around the outer ring of a circle. In this Jewish context, says Ernest Namenyi, the ring of the zodiac represents human destiny embraced within the cycle of nature. Perhaps it does, symbolically. But what it actually embraces on the floor at Hammath, in glittering polychrome mosaic, is a standing figure of Sol Invictus, the unconquered sun, his right hand raised in salute or benediction, with rays of light streaming from the aureole at his head. A comparable mosaic, dating from 200 or 300 years later, has been found at Beth Alpha, in the Jezreel Valley. It has the same deity in the centre, or to be precise the god Apollo, driving a chariot pulled by the horses of the sun. 'The Jews saw in it,' says Heinrich Strauss, 'the natural centrepiece of a decor that showed the signs of the zodiac as they were usually presented. The artistic form of expression was taken over, while the significance of the content was a matter of indifference.' This may well have been the case in the sixth century, when nobody believed in the sun god any longer. I have an uneasy feeling, however, that the earlier representation of Sol Invictus might have been intended as a graceful compliment to the slightly unhinged Roman Emperor Elagabalus (reigned 218-222), who was a priest of Elah-Gabel, the sun god of Emesa in Syria. The worship of this deity, says Gibbon, was the only serious business of the Emperor's reign.

We know who the mosaicists were at Beth Alpha, as they signed their work: Marianos and his son Hanina. Professor Meyer Schapiro has sympathetically divined a number of discreet subtleties in their design, including what has been

ABOVE A fresco from Dura Europos
synagogue (245 CE). Ezekiel,
dressed in Parthian costume,
experiences the vision of the Valley
of Dry Bones. He appears repeat-
edly in the same strip, directed by
the hand of God, at various stages
of his vision.

LEFT The Dura Europos frescoes,
displayed in the National Muse-
um, Damascus. A symbolic depic-
tion of the Temple appears above
the niche on the left.

OPPOSITE Carving at Ostia, depict-
ing a *menorah* (candelabrum),
lulav (palm branch), *ethrog* (citron)
and *shofar* (ram's horn trumpet).

ABOVE LEFT Mosaic at Hammath, near Tiberias, showing a seven-branched candelabrum, shofar, lulav and ethrog.

ABOVE RIGHT Mosaic at Hammath, near Tiberias, illustrating the zodiacal sign for Aries. The leaping goat has been entwined with a serpent.

OPPOSITE Mosaic of a vine trellis from the prayer hall of the sixth-century synagogue at Maon, near Nirim in south-west Israel. The trellis, which issues from a vase, embraces 55 medallions laid out in 11 rows of five and depicting birds, animals and various objects.

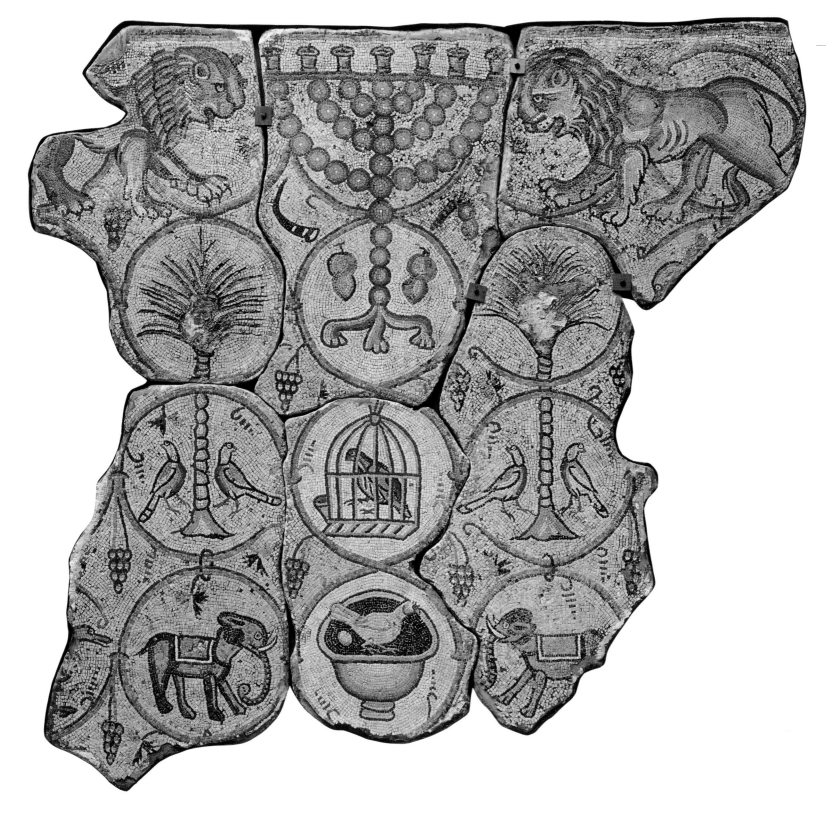

summarized as 'a peculiar liaison between the stripes of Abraham's robe, the lines of the altar and the flames, in a matching counterpoint of directions'. It has to be said, however, that something drastic has taken place between the classical mastery of Hammath and the jolly folk art of Beth Alpha, in which the lions flanking a depiction of the Ark have become mewling pussycats and the four chariot steeds are cartoon mokes. The most striking illustration, which portrays the sacrifice of Isaac, shows Abraham wielding the knife, his hand and arm shaped like a pump handle.

Does this indicate a loss of artistic ability in the last Byzantine century before the Arab invasion of 636? Nineteenth-century art historians would have answered with an unequivocal affirmative. We, however, are inhibited by the doctrines of the Vienna school, where Alois Riegl taught that this change 'should not be regarded as a decadence but as a change of will. The classical style was abandoned not because men could not do it, but because they did not want it.'

Kunstwollen or decadence; we are obviously approaching the end of an epoch.

LEFT & OPPOSITE Reconstruction (opposite) and photographs (left) of the mosaic floor at the sixth-century synagogue of Beth Alpha in the Jezreel Valley. Top register: the ark with lions, menorahs and birds. Central register: the ring of the zodiac, surrounding Apollo and his chariot, drawn by the horses of the sun. Bottom register: the sacrifice of Isaac.

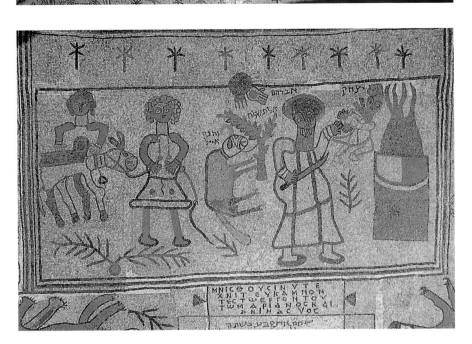

OPPOSITE The High Synagogue in
Prague was built to the designs of
Pankraz Roder in 1586. This orna-
mental stucco ceiling decorates a
lunette vault.

82

An ironical Muscovite, gazing through a window of his flat in the spring of 1952, exclaimed: 'Look, there's a cosmopolitan! And over there, look, there's another!' He was bandying the term 'rootless cosmopolitan' that Stalin had coined for use in his burgeoning anti-Jewish campaign, mercifully cut short by his death the next year. Two decades earlier, Hitler's National Socialists had used the word 'aliens' to describe the Jews in their midst. But who, in truth, were the aliens here? By the beginning of the fourth century there was already a Jewish community in Cologne, fully organized and with all the customary religious and lay leaders. This circumstance led the late Cecil Roth to write, in the 1930s: 'The aliens today are not the Jews, [who are] the only representatives per-haps in Rhineland of its inhabitants of sixteen centuries ago.' The Jewish pres-ence in Europe long antedates the barbarian invasions which led to the fall of the Roman Empire. In fact, as Roth recalled, Jews had settled in western Europe before many of its most typical inhabitants had emerged from Asia or commenced their *Völkerwanderungen*. The Jews watched the Visigoths absorb the Romans in Spain, and were there when the Moors defeated the Visigoths. They were living in France before the Franks came, in Hungary before the Magyars and in South Russia before the Slavs.

These were the Dark Ages, when Christianity began to spread and penetrate the pagan communities of Europe, introduced sometimes by persuasion and some-times by forced conversion, as in Saxony. With the growth of Christianity came a rising tide of intolerance. While all other peoples accepted the Gospel message, the Jews alone resisted and refused to receive the doctrine of the church. It was the

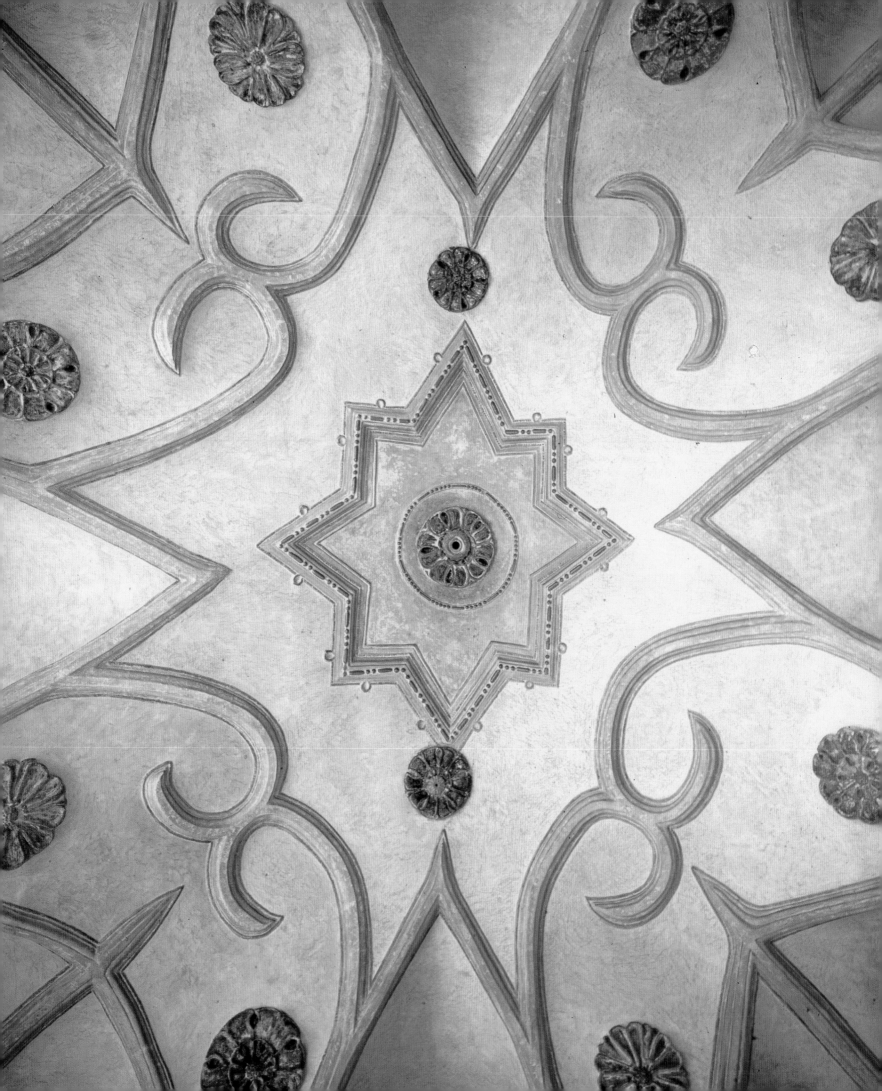

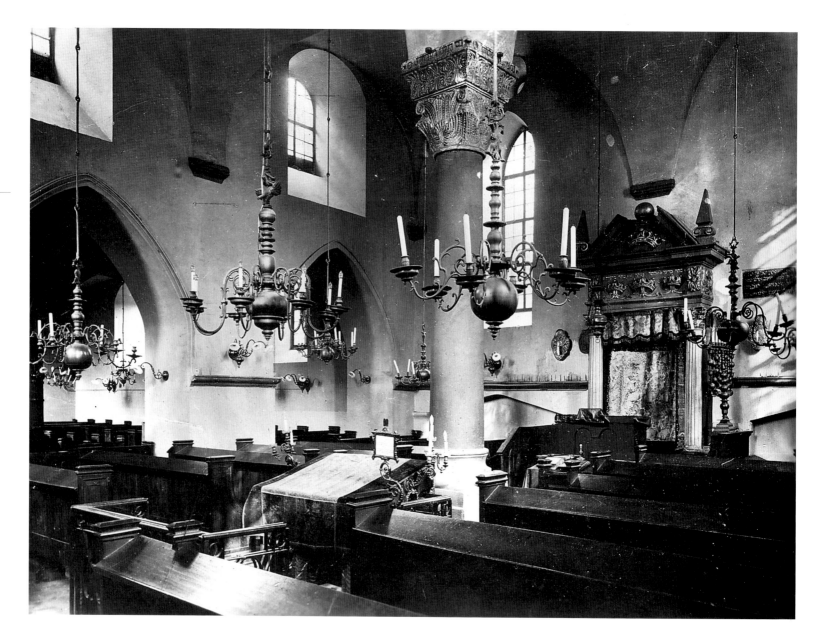

growing religious prejudice that made it unsafe for the Jews to live in rural isolation and ultimately drove them off the land.

The more enlightened rulers rose above this prejudice. When the bishop of Palermo seized a synagogue without papal authorization, he was reproved, in a letter dated June 598, by Pope Gregory I (Gregory the Great) who told him that Jews should not suffer in those things already conceded to them. Charlemagne found the Jews useful in matters of trade and finance, and indispensable in diplomacy. The extent to which this stratum of Jewish society made itself at home in Carolingian Burgundy may be seen in the apoplectic letter sent by Archbishop Agobard of Lyons (779-840) to Charlemagne's successor, Louis the Pious. Complaining about the Jews (to suit whose convenience, incidentally, market day had been switched from Saturday to Wednesday), he writes:

> They display the dresses that their wives, they claim, have received from your family and from the ladies of the palace; they boast of having received from you, contrary to the law, the right to build new synagogues.

Not everyone had it so good. There were many small communities who could not afford to build a synagogue, or were prevented by local circumstances from doing so. For these communities a room in a house had to serve, with a cupboard to hold the Torah scrolls. But whether the synagogue was a private house or a public building (erected after the grant of a 'privilege'), not one has survived. Material remains only begin with the early Middle Ages.

The homelands of the medieval synagogue were Sefarad and Ashkenaz. You will search in vain for these names in a gazetteer. They are Hebrew words, of biblical origin; the first came to be applied to Spain and Portugal, the second basically to Germany. Sefarad we shall deal with later. Ashkenaz, in its greatest medieval extent, stretched from England (whose francophone Jews arrived with the Normans) through northern France and western Germany, to Bohemia. The greatest concentration was in the Rhineland, at Speyer, Mainz and Worms.

Nothing is left of Mainz's medieval synagogue, while the remaining fragments of

OPPOSITE ABOVE The synagogue at Worms dates from 1175. This view of the men's prayer hall shows the eastern column which carries an inscription on the abacus of its capital. Gothic arches, dating from 1842, open into the women's section.

OPPOSITE BELOW The façade of the Worms synagogue, before it was destroyed and rebuilt.

LEFT The Romanesque entrance portal on the north side of the men's hall at Worms. Its decoration is similar to that on the portals at Worms Cathedral, which was being remodelled at the time the synagogue was built.

BELOW This view of the capital of
the eastern column of the twin
nave at Worms shows part of the
Hebrew inscription with its
numerologically coded message.
OPPOSITE ABOVE The Worms syna-
gogue is laid out with the men's

hall (I) as a central focus and the
Rashi chapel (V) and the women's
hall (II) opening off it.
OPPOSITE BELOW The Rashi chapel
at Worms was actually a bethme-
dresh built in 1624 against the
west wall of the men's hall.

The name is honorary; Rashi
(1040–1105), who was the
greatest Jewish Talmudic and bibli-
cal commentator of all time, had
studied at Worms, but died in
Troyes in 1105, before the syna-
gogue was built.

Speyer's are kept in a museum. But until Kristallnacht, 1938, Worms had a com-
plete working example. On that occasion, however, the Germans sacked the syna-
gogue and then completed its ruination in 1942. A repentant government carefully
rebuilt it in 1961, re-using such stones as could be salvaged. A similar resurrection
could not be visited on the congregants, however; most of them had been massa-
cred by a previous administration, as had their predecessors in 1096, 1146, 1196
and 1349.

The prayer hall at Worms was, and is now again, a roughly rectangular chamber
measuring 49 by 31 feet (15 x 9.5 metres). A system of groined vaults springs from
the walls, and is supported midway by two Romanesque columns on the long axis
of the plan. This simple articulation has provoked architectural historians into

paroxysms of classification, some calling it a double nave,
some two parallel naves and others two parallel aisles. Why
a plain hall with two columns down the middle needs strait-
jacketing within such terminology, I leave to subtler minds
than mine to ponder.

This hall of worship was built in 1175. It was intended for
the use of male congregants; women were catered for by
the addition of a separate room, which was abutted against
the original north wall like a projecting wing. This was
erected in 1213 as the gift of Meïr ben Joel and his wife
Judith. Some kind of parallel service must have been held
in the women's section, as the two halls were only intercon-
nected by five small windows and a door, until some outrageous liberal in the 1840s
broke through with a couple of pointed-arch openings.

The men's hall is entered by a door in the north wall; the women's annexe, when
it was constructed, was sited to one side of this wall and hence the door was left
undisturbed. The ark stands in the middle of east wall, while the bimah is locat-
ed between the two columns in the centre of the hall. The column nearest the ark
bore a Hebrew inscription on its abacus, the text of which was adapted from vari-
ous passages in the First Book of Kings that describe the building of Solomon's
Temple. In Classical Hebrew, as in Latin, letters of the alphabet are used to
express numbers; but, whereas in Latin seven letters may by ingenious combina-
tion produce (albeit laboriously) any number, in Hebrew every letter of the alpha-
bet has a numerical equivalent, from aleph (1) to tav (400). This provides a field day
for numerologists, who exploit it (in a pseudo-science known as *gematria*) to elicit

hidden meanings, accommodate contradictory statements and generally run circles round deceptively obvious meanings in the biblical texts. The awkward nuances of the Worms column inscription aroused the suspicions of Dr Otto Boecher, who totted up the numerical equivalents of all its component letters and found that they amounted to 4,935, which is the *annus mundi*, or Jewish calendar equivalent to 1175, the year the synagogue was built. There used to be another inscription, now lost, but copied in 1559, which stated as much in plain words.

The architectural vocabulary of the Worms synagogue is in keeping with its time and place. The main door, in the north wall of the men's hall, displays carved leaf and geometric decoration comparable to that seen on the portals of the contemporary Worms cathedral. The column capitals have two different designs, which are similar in style to designs found in the cathedrals of Worms and of Fritzlar, near Kassel. The plan of the synagogue does not resemble that of a church, but rather that of a chapter house, refectory or dormitory. As a comparison Rachel Wischnitzer has drawn attention to a chapter house from the twelfth-century abbey of Notre Dame de Pontault, in Gascony, now dismantled and re-erected at the Cloisters branch of New York's Metropolitan Museum which features two columns on its long axis and a bench running round the walls. A disadvantage of this layout when applied to a synagogue with a central bimah is that one of the columns blocks the bimah's view of the ark.

Even before its destruction in 1938-42 the synagogue at Worms had undergone a number of reconstructions and restorations. Its style, however, as betrayed in particular by its decorative details and window shapes, remained Romanesque (an epoch called Norman in English architecture). There are signs of transition to the Gothic in the slightly later women's prayer hall, which has Romanesque window

BELOW LEFT The west front of the
Altneuschul. The view is closed by
the Jewish Town Hall, its present
appearance due to an eighteenth-
century rebuild.
BELOW RIGHT The brick gable on
the west front of the Altneuschul.

OPPOSITE The interior of the Alt-
neuschul at Prague. The caged
bimah stands between two
columns on the central axis. The
groined vault, with its supernumer-
ary fifth rib, is clearly visible
above the round window.

heads on the east, while the west ones display Gothic mouldings.

But only 100 years after the men's hall at Worms was complet-
ed, the transition to total Gothic had been achieved: at the Alt-
neuschul, or Old-New shool, in Prague. This building ranks, says
Zdenka Münzer, 'among the most ancient jewels of early Gothic
style in Europe'. It is complete, and it is the real thing, not a
rebuild like Worms. When the Germans occupied Prague,
between 1939 and 1945, they diligently set about killing or send-
ing to their deaths as many Jews as they could lay their hands on,
but they did not damage the synagogues. Instead, they filled
them with Torah scrolls and liturgical objects gathered from the
martyred communities of Bohemia and Moravia, with the stated
intention of forming, in due course, a museum of an extinct race.

The Altneuschul is also composed of a rectangular chamber
with two columns, or rather octagonal piers, on the long axis—
the so-called double nave plan, but all the details are Gothic: the
rib mouldings of the vaults which rise from the piers to roof the
chamber in six bays, and the carved leaf-work that adorns the
corbels ringing the piers, from which the ribs spring (though
some of this may be a nineteenth-century copy of the original).

The system of cross-vaulting in the hall comprises six units in all, two to each of
the three bays. The ribs fly across from the two piers, and come to rest again on
corbels in the middle of the short walls, and on attached columns on the long ones.
Structural logic would suggest that the ribs of a cross vault would trace out the lines
of a cross (albeit in curved planes), but at the Altneuschul a fifth rib is inserted into
each unit, reaching out from the long walls. Why a fifth rib? The suggestion was
made, in a paper contributed in 1915 to a journal with the snappy title of *Mitteilung-
en der Gesellschaft zur Erforschung Jüdischer Kunstdenkmäler* that the extra rib was insert-

ed to avoid presenting the form of a cross
in the vault. This theory has been con-
tested by later writers, but the more I
think about it, the more probable it
seems, from two complementary points
of view: the sharp medieval eye for sym-
bolism, and the continuing Jewish preju-
dice against the cruciform. There are

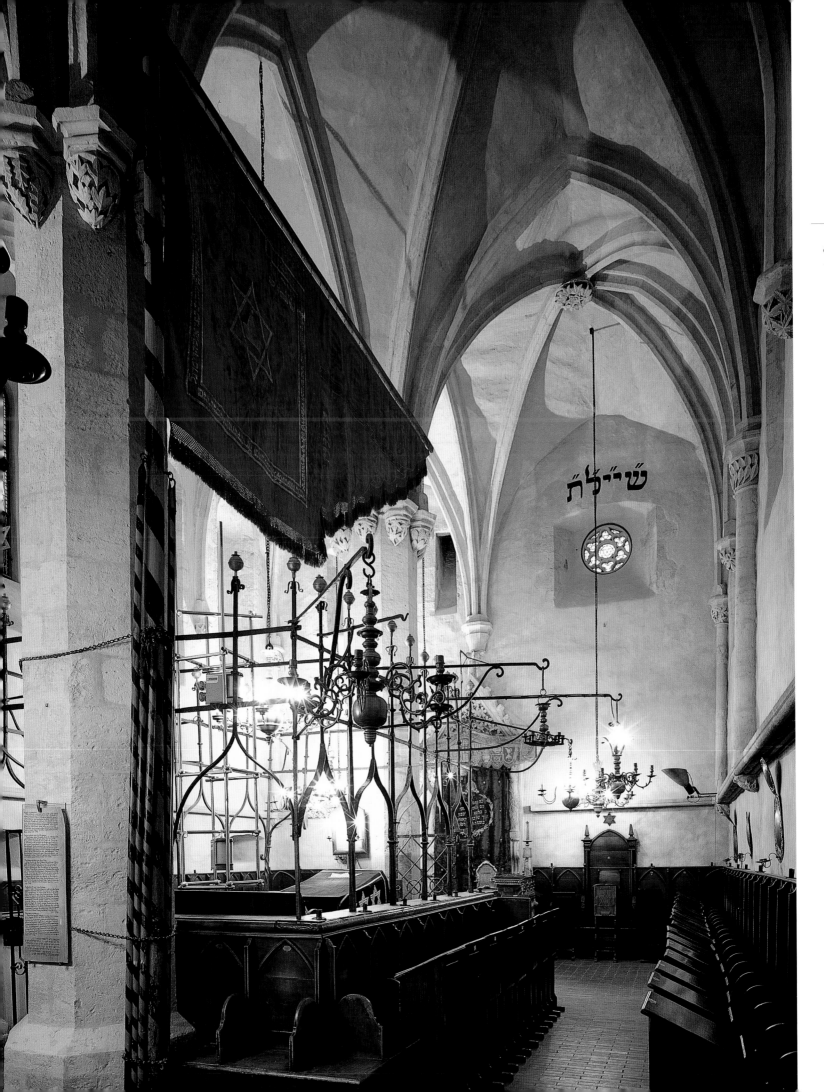

ABOVE View into the prayer hall of the Altneuschul through a slit in the wall of the women's gallery. Women are now admitted to services in the main hall, but they still sit separately.

LEFT A decorative Star of David adorning the wrought-iron bimah surrounds.
OPPOSITE Vault ribs and a carved wall corbel at the Altneuschul.

OPPOSITE Wrought-iron brackets
reach out from the bimah cage
to support lamps over the congre-
gants' seats at the Altneuschul.
BELOW LEFT Rows of wooden
seating.
BELOW RIGHT The ark.

FOLLOWING PAGES A view through
the network of the wrought-iron
bimah cage at the Altneuschul,
showing the axial piers and vault
springing.

religious Jewish schools today where pupils will not use a cross to make the plus sign in arithmetic: they use a T instead.

Another example of the way in which the ecclesiastical vocabulary of Gothic architecture has been adapted to Jewish sensibilities occurs at the entrance to the Prague synagogue. Here the tympanum between the door head and the richly moulded Gothic arch above displays vine leaves and grapes instead of some Christological extravanganza. The 12 bunches of grapes stand for the 12 tribes of Israel.

As at Worms, the bimah, which probably dates from the late fifteenth century, is sited between the two central piers. It is a stone platform, surmounted by a wrought-iron cage that incorporates long projecting brackets from which lamps and chandeliers could be suspended. The vine leaves in the tympanum over the entrance door appear again in the crocketed Gothic pediment over the ark, borne on stone half-columns. The present design is obviously a sixteenth-century Renaissance rebuild incorporating original Gothic elements. The high-level lancet windows that light the nave are splayed out towards the interior, a common medieval practice. Subsequent generations of congregants arose, however, who knew not their Gothic architecture, and shrewdly declared the detail to be in accordance with Solomon's Temple: 'And for the house he made windows broad within and

narrow without.' You will not find this translation of I Kings vi 4 in the Authorized or Revised Versions of the Bible; it is one that follows the Targum, an ancient Aramaic translation of the Hebrew text.

Do not conclude from this that the citizens of Prague were great students of the Bible; they were not. By the sixteenth or seventeenth centuries religious study amongst the Jews was almost exclusively concerned with exegesis of the Talmud. Knowledge of the Bible was restricted to the Pentateuch and Psalms. Beyond this, familiarity with the scriptures was limited to those passages that feature as *haph-*

torahs, the readings from the Prophets chosen to complement the weekly portions of the Pentateuch. The haphtorah to Exodus xxv-xxvii 19 (the specifications for the Tabernacle) contains this passage from the First Book of Kings, because its description of the building of the Temple was perceived to be a parallel to the construction of the Tabernacle. Even here, however, it was not all plain sailing, because some rabbis taught the opposite interpretation, namely that the windows of the Sanctuary were narrow within, and cut on a splay outwards. From this they deduced that the Temple needed no external light, but that, on the contrary, its spiritual radiance blazed out to illuminate the world beyond. Perhaps the post-Gothic congregants of the Altneuschul debated the point on *shabbes*, between the afternoon and evening services.

The Gothic splendours of the Altneuschul were reserved for its male congregants. Their wives and daughters were banished to an ancillary room abutted on the west side. From this barrel-vaulted chamber they could peer into the main shool through two slits in the wall. When the accommodation proved inadequate, another annexe was built on the north side in 1731. Here communication with the men's prayer hall was improved 100 per cent: instead of two slits, there were four. Nowadays the mighty Prague congregation, the *kehillah* which nourished Franz Kafka, Franz Werfel, Max Brod and Egon Erwin Kisch, has been reduced to the brink of extinction. Ladies who attend sabbath morning service, after the daily crowds of tourists from Tucson to Tokyo have been banished, are therefore admitted to the main hall, though they still have to sit at the back, lest the sight and sound of them should disrupt the *kavvanah* or sacred devotion of the ancient sages who pray there.

The history of the Jews of Prague is a disturbed one, with periods of comparative tranquillity alternating with periods of persecution and expulsion. After a pogrom in 1389 some of the Jews headed east. They found a ready welcome in Poland, a country where the early rulers of the Angevin and Jagiellon dynasties had formed the opinion that the presence of Jews might stimulate trade and commerce in their undeveloped realms. The emigrés from Prague settled in Kraków and in the nearby township of Kazimierz—now the eighth ward of Kraków itself. The Old Synagogue (Stara synagoga) built in Kazimierz at an uncertain date in the fifteenth century is of the same so-called double nave type as the Prague Altneuschul and the synagogue at Worms, but it is bigger. In fact, it is the largest known, measuring 58 feet by 40 feet (17.7 metres x 12.4 metres). It has the familiar twin columns on the long axis, with the bimah between them, not

oblong as in Prague, but polygonal, with a wrought-iron cage that rises to form a conical canopy. The columns are taller and slenderer than at the Altneuschul, and the prayer hall appears much more light and airy, an impression which has been reinforced by the plastering and limewashing its brick walls were subjected to in the 1959 restoration. As at Prague, women were accommodated in annexes built at subsequent periods. Where they would sit nowadays, however, is an academic question: the building is used as a Jewish museum.

In his book *The Jews*, the witty Anglo-Jewish writer Chaim Bermant, discussing the attitude of present-day Jews to their religion, observes:

> Synagogue attendance on a day like Yom Kippur [the Day of Atonement] has in modern times tended to be less of an affirmation of belief in God, than a belief in believing, and Yom Kippur itself (an occasion for moral stocktaking) is in a sense the Annual General Meeting of the Jewish people, at which the chairman, who has directed their fortunes for so long, is confirmed in office *nem. con.*

This modern idea of God as the old firm's chairman is perhaps a kind of rubbed-down version of the medieval Jewish attitude, described by Israel Abrahams as:

> a thorough-going piety which, seeing God everywhere and in all things, looked upon him as a partner in the business of life, rather than as a superior Being, to be approached with formal etiquette...It is not enough to say that the Jew's religion absorbed his life, for in quite as real a sense his life absorbed his religion. Hence the synagogue was not a mere place in which he prayed, it was a place in which he lived.

Although the medieval synagogue was more than just a house of prayer, it never descended to such uses as an indoor market, as the medieval church did. But any Jew who imagined he had a grievance against his fellow had the right to interrupt the synagogue service until he had a public promise of redress. Of course, this privilege was open to abuse, and in time the right was restricted and eventually abolished.

It was an ancient custom in several places for the shammas or beadle to announce every shabbes the results of law suits, and to inform the congregation that certain properties were on the market. 'The Jews,' remarks Israel Abrahams, 'did not exclude their every-day life from the sphere of religion, and felt rather that their business was hallowed by its association with the Synagogue, than that the Synagogue was degraded by the intrusion of worldly concerns.'

Lost articles were publicly cried in synagogue, and those who knew their where-

BELOW The interior of the double-naved synagogue at Regensburg, which dates from the thirteenth century. The bimah is placed between the two central columns. This engraving was made by Albrecht Altdorfer in 1519,

the year in which the city council issued a decree expelling Jews from the city and ordering the demolition of the shool.

OPPOSITE A fourteenth-century Spanish manuscript illustration showing the celebration of the Passover at home, with the seder table laid.

abouts but would not reveal them were threatened with a *cherem*, or ban. At the end of the thirteenth century, any Italian Jew who was about to leave his town had to declare the fact in synagogue and invite anyone with a claim against him to put it forward. From *responsa* sources, that is, from the written records of rabbinical decisions, we also know that in some medieval towns when a Jew wished to sell a plot of land, a proclamation was made three times in the synagogue: 'Whoever has any

claim on this land must lay his claim before the Beth Din' (the rabbinical court). After that, no claim was admitted, and a record of the threefold proclamation in synagogue was inserted in the deed of sale.

The officials of the medieval Jewish community were elected by ballot. The administrative structure was much the same as the one you would have found in New Testament times, or as you would find in Europe or America today. There was the president, or *parnas*; the treasurer, or *gabay* and sometimes special officers who looked after the sick and poor. There was a council, generally of seven men, plus a rabbi and two *dayanim*, or ecclesiastical assessors. After the thirteenth century, the rabbi and dayanim became salaried officers; other paid officials included the *shochet*, who slaughtered cattle in the traditional manner, a *chazan* or cantor, a teacher and a shammas. We have already encountered an occupant of this office in Greco-Roman times: the shammas at the Great Synagogue of Alexandria, waving his *keffiyeh* to elicit the responses of the distantly seated congregants. He was, in fact, the general factotum of the congregation, overseeing the synagogue, carrying out the sentences of the Beth Din and blowing the Friday afternoon trumpet from a rooftop to announce the approach of the sabbath.

Such, briefly, was the scene in Ashkenaz. But a parallel tradition had been developing at the same time in those other countries of the dispersion: Sefarad. It was to end in an expulsion, for Jews and Moslems alike, from what came to be looked back on in later years as a lost paradise.

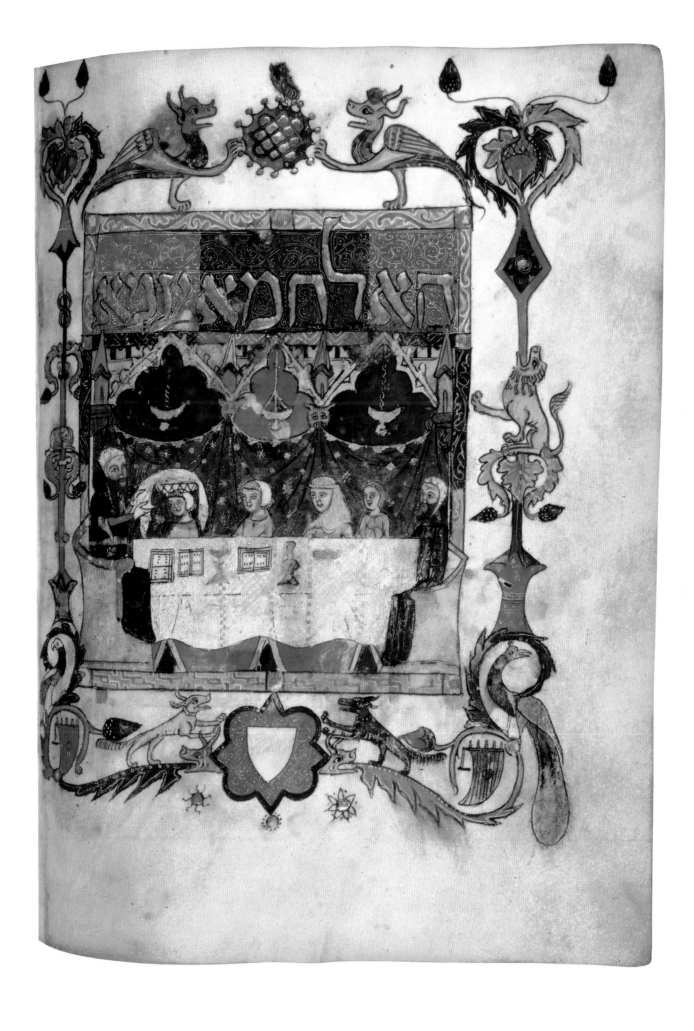

FIVE

THE ISLAMIC SYMBIOSIS

I remarked in the last chapter that the Jews had seen the Visigoths absorb the Romans in Spain, and had also been there when the Moors defeated the Visigoths. The later Romans were Christians, and so were the Visigoths, a Germanic people whose conquest of Roman Spain took place in the fifth century. Christians generally rendered themselves obnoxious to the Jews, and the Visigoths were no exception. Influenced by the insidious anti-Jewish tenor of the New Testament, as transmitted by those who could read and interpret it, the Visigothic rulers were irked by the presence of a people who rejected the dominant religion, and who wanted to be left in peace to practise their own. A thousand years before the Spanish Inquisition, Visigothic kings such as Sisebut, Chintila and Recceswinth ignored the pleas of St Isidore of Seville for tolerance and forbearance, until finally in 694 King Egica simply denounced his Jewish subjects as traitors, confiscated their possessions and enslaved them. By that time, however, the writing was on the wall for the Visigoths. Their kingdom was swept away by the Moslem armies which invaded Spain in 711 across the narrow straits from North Africa, and in seven years made themselves masters of nearly the whole peninsula.

Although the Moslem drive west was inspired by the doctrines of *jihad* or holy war, the Koran (2.256) forbids forced conversion, and the Prophet himself, according to Ibn Hisham, declared that 'no-one who belongs to either Christianity or Judaism is to be dissuaded from it'. The outcome was that under Islamic rule Jews on payment of a poll tax were by and large left in peace. Instances of forced conversion were extremely rare, 'no more than half a dozen over a period of thirteen

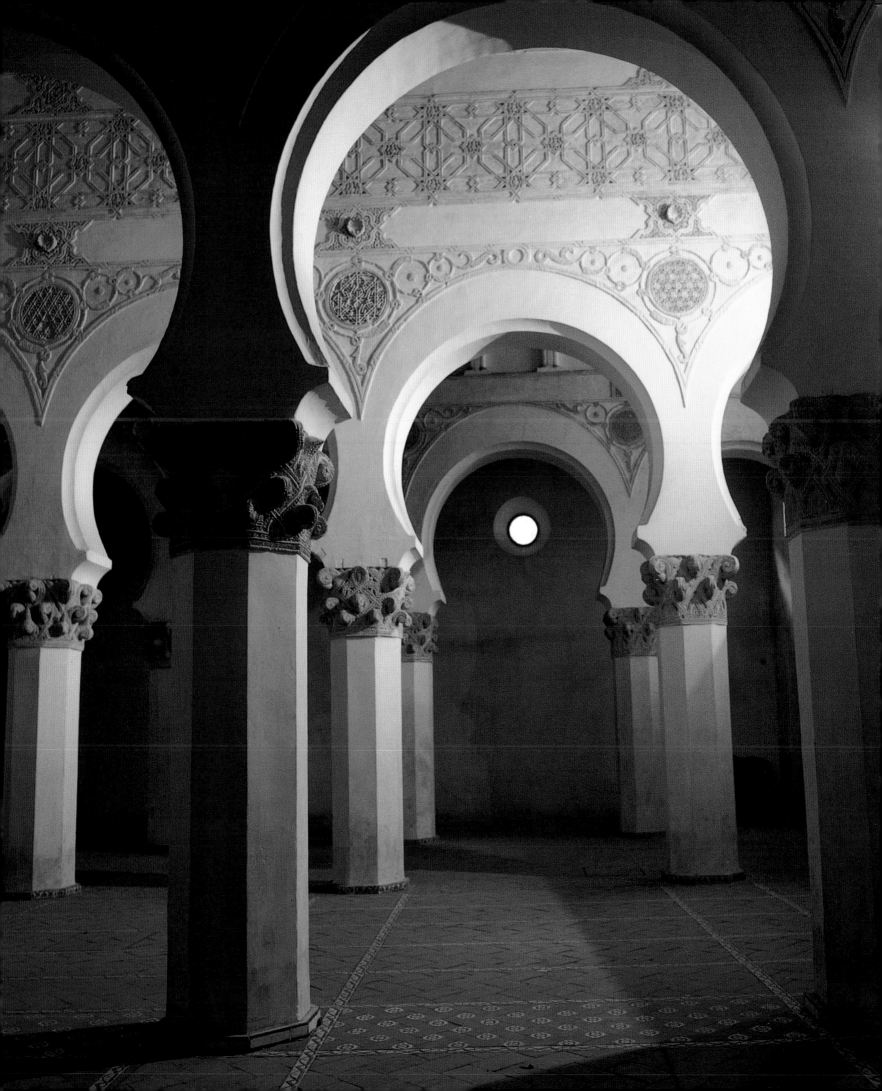

centuries', and all of those 'under heterodox fanatics', in the words of Professor Norman Stillman.

One of the reasons why the Jews have generally fared better under the Moslems than under the Christians is that they do not play as important a part in Islamic mythology as they do in the Christian one. Hence, under the Arabs, there have been none of the ghastly forced disputations and the inquisitions to which the unquiet spirit of medieval Christianity was addicted.

The Jews fared well in Al Andalus, that is, in Moorish Spain. It was the home of some of the greatest figures in Jewish literature and learning, men such as Maimonides, Ibn Ezra, Yehudah Halevi, Ibn Gabirol and Nachmanides. Jews served as ministers to the various Moslem princes, and were employed as physicians, scribes and financial advisers. At one point in the 11th century, Granada, under the Zirid dynasty, was virtually run by the Jewish vizier Shmuel ben Nagdela (993-1055), who led his sovereign's troops into battle.

Of more universal significance was the role played by Spanish Jewish translators in mediating Greek and Arabic science and philosophy to the Latin west. Scholasticism, the first awakening of European thought after the intellectual torpor of the Dark Ages, drew its system and its Aristotelian sources from Islam, 'and from Islam,' write Charles and Dorothea Singer, 'it was largely brought by Jews'.

Let us revert for a moment, however, to Shmuel ben Nagdela. He was the vizier I mentioned previously, whose palace is thought to have had the 'lions, in phalanx on its rim' supporting a brazen sea. This reminiscence of Solomon's Temple, celebrated in a poem by Ibn Gabirol, is perhaps the actual Fountain of the Lions which still stands in the Alhambra, Granada, today.

But why recall Solomon's Temple in a fourteenth-century princely palace in Spain? Because in medieval Jewish and Moslem legend, the King-Prophet Solomon had become the prince *par excellence*, and in the words of Oleg Grabar:

> from the moment of the establishment of the Muslim empire, a solomonic consciousness grew, and, sooner or later, slowly or rapidly, an automatic association with Solomon developed for all themes, myths and ideas which pertained to the life of the prince and to its setting.

Students of iconology have detected references to myths about King Solomon in the gardens of the Alhambra and its enchanting use of water, not to mention the rotating domes of heaven which roof the palace's chambers, 'like the palanquin of Solomon' in Ibn Gabirol's words.

So much for the Jewish influence on Islamic architecture. When it came to the building of synagogues, on the other hand, the situation was reversed. No synagogue in fact survives from the period of Moslem rule in Spain, though hundreds must have existed. From the time of the *reconquista*, the gradual roll-back of the Moorish occupation, we have pictures in a few illuminated *Haggadot* (Passover service books) that have come down to us, and three or four actual buildings. Two of these are in Toledo, the ancient capital of Spain, which is situated 40 miles (64 kilometres) south of Madrid. In the Middle Ages 15,000 Jews lived there; now there is only one, who serves kosher-style food at the Sinai restaurant in the calle Reyes Católicos.

This fourteenth-century illuminated manuscript illustration shows a reader in a Spanish synagogue reciting the Passover Haggadah to congregants unable to read the book at home. He is doing so from a high platform raised on columns.

Kosher-style means nearly kosher but not quite. There is an architectural equivalent to this: *mudéjar*. Mudéjar means Islamic style built under a non-Islamic régime. As the tide of Christian conquest rolled forward, Catholic monarchs found themselves ruling Moslem communities and, until the church under Ferdinand and Isabella finally succeeded in poisoning relations irretrievably, they often got on rather well with each other. Alfonso VI received an Arabic education and Alfonso X founded colleges for Arabic studies. Christian monarchs certainly appreciated the Moorish palaces they seized in the course of their advance, and were happy to exploit the ethnic skills available to build more of the same, culminating in the Alcázar of Seville (1366), which Bernard Bevan called 'the most perfect example of a Muhammadan palace erected for Christians'.

If a palace built in the Islamic style of architecture for a Christian monarch is mudéjar, the same adjective may be applied to an Islamic-style synagogue put up in a Christian kingdom in Spain. Of the three or four which survive, the earliest is the one in Toledo whose foundation around the year 1200 is sometimes attributed to Yosef ben Meïr ben Shoshan. Its present name, Santa Maria la Blanca, betrays its subsequent fate. On the outside it presents a discreet brick façade. Inside, four rows of sturdy octagonal columns march through it, supporting four horseshoe arcades. With its five aisles stretching away it looks like the

BELOW Stucco vine scrolls in the spandrels of the three inner colonnades of Santa Maria la Blanca, Toledo. Above this is a decorative frieze, on which stands a blind arcade reaching up to the roof.

OPPOSITE ABOVE The interior of Santa Maria la Blanca, depicted in a lithograph of c. 1840. Five aisles of horseshoe colonnades overlap and draw the eye into distant perspectives.

OPPOSITE BELOW Plan and cross-section of Santa Maria la Blanca.

Great Mosque of Córdoba—though that has 19 aisles in total. It is the articulated emptiness that does it: one looks automatically for the carpets, the hanging lamps, the mimbar. Where is the bimah, the ark, the women's gallery? Gone, if they ever existed. But Santa Maria la Blanca is far from devoid of elegant decoration. The column capitals, constructed in hard plaster, feature pine cones, some upright, some drooping, tied together with palm leaves covered with perforated arabesque designs that twist into volutes at the angles. Perhaps they were meant to recall the column caps in Solomon's Temple, which were decorated with 'networks, lilies and pomegranates' (I Kings vii 20). The arch spandrels of the three inner aisles are filled with decorative plasterwork displaying vine scrolls. Resting on the arch extradoses runs a frieze, on which stand rows of blind arches reaching up to the timber roof.

The horseshoe arches curve round and swell out over the splendid column capitals; the eye is drawn through them as overlapping colonnades retreat into distant

vistas. Did they really recite *mincha* and *meirev* here, shake the lulav and the ethrog on the Feast of Tabernacles, and fast all through the Day of Atonement?

Fewer doubts assail the visitor in Toledo's other surviving medieval synagogue. It was founded by Shmuel ben Meïr Ha-Levi Abulafia about the year 1357. Abulafia was the scion of a Spanish Jewish family which was distinguished from the twelfth century onwards, for the rabbis, poets, kabbalists, and communal leaders it produced. Abulafia himself was appointed treasurer to Pedro the Cruel, King of Castile, a career fraught with hazards which ultimately proved fatal. His synagogue finally became the Chapel of the Dormition of the Virgin. Its name in Spanish is Ermita del Tránsito de Nuestra Señora and so it is habitually referred to as the Tránsito Synagogue, a bizarre combination.

No arcades slice the synagogue up as is the case in Santa Maria la Blanca. On the contrary, it is a completely unobstructed rectangular chamber 75 by 31 feet and 39 feet high (23 x 9.5 x 12 metres). The interior struck Elie Lambert as being 'like the great hall of a palace'. Another contrast to la Blanca is that here everything speaks of a Jewish house of worship. The end wall, encrusted with arabesque panels in stucco, has a triple arcade inset on slender colonnettes. This is where the torah scrolls were once kept, presumably behind wooden doors. When the building

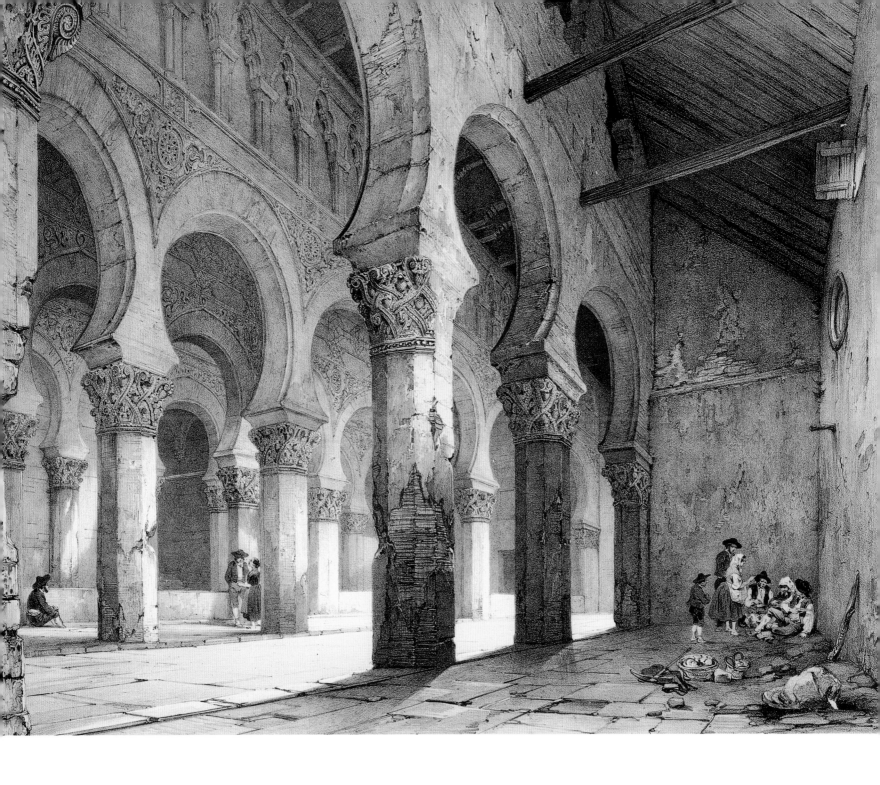

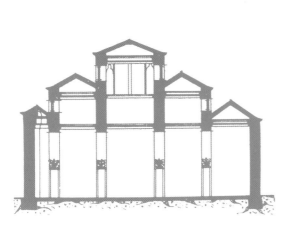
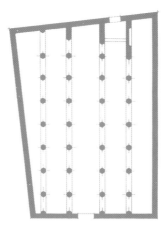

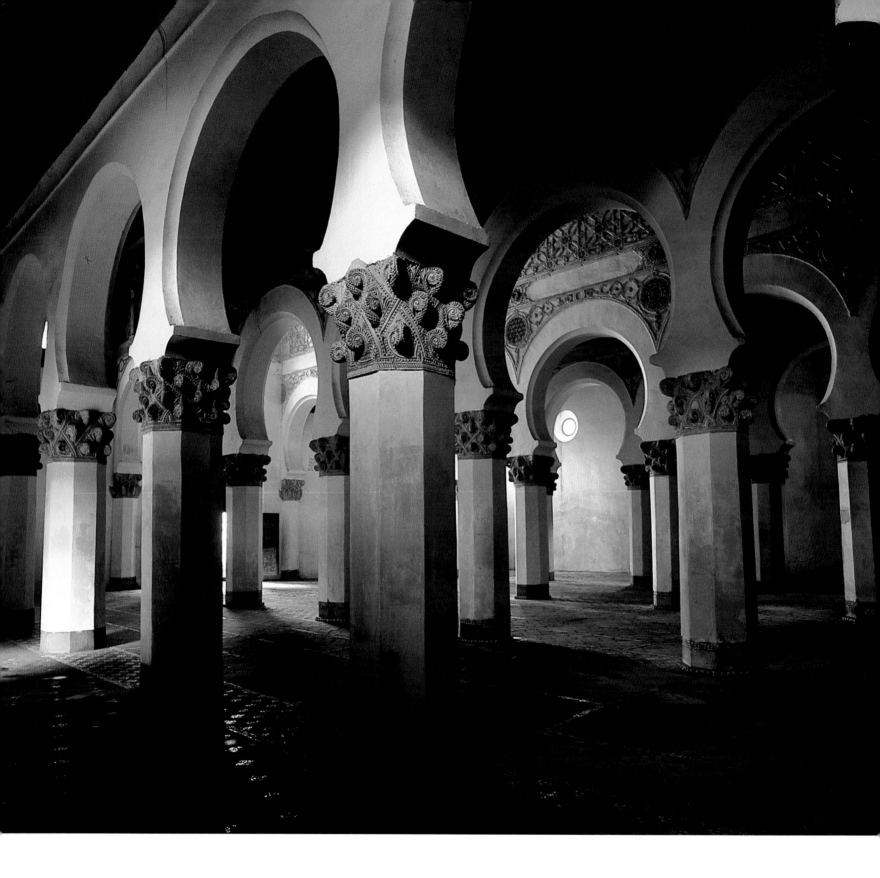

ABOVE The horseshoe arches curve and swell out over the column capitals at Santa Maria la Blanca.
OPPOSITE LEFT The exterior of the synagogue of El Tránsito, Toledo. The walls are of rubble stonework between brick *chaînes*. This view is taken from the garden of El Greco's house.

OPPOSITE CENTRE This artesonado ceiling in larchwood runs over the prayer hall of El Tránsito. It is divided into six bays by five pairs of tie-beams. The flat soffit in the centre is carved in a mudéjar pattern.

OPPOSITE RIGHT The east wall of the prayer hall of El Tránsito. The three arches mark the position of the ark; above them is a panel of ornamental plasterwork in a criss-cross pattern known as *ajaracas*; the side panel ornament is curvilinear. Cartouches at the base of the side panels contain a dedicatory

inscription by Samuel Levi. A stalactite cornice runs above the panels, and over this again is an arcade, blind save for the two central units which are pierced by windows. The frieze at the very top, which runs around all four walls, is a continuous line of quotations from the Psalms in Hebrew.

served as a church a high altar stood in front of the empty ark; it has now been dismantled and removed.

At the highest level on this end wall, high above the ark and just below the artesonado ceiling, is a pair of windows which may mark the position where the Tablets of the Law stood displayed—two stone slabs with the Ten Commandments inscribed on them. At first-floor level, in the south wall, large openings give on to the women's gallery. Below them are a couple of later insertions: a plateresque doorway and a Renaissance tomb. The latter is not a recommended feature for a syn-

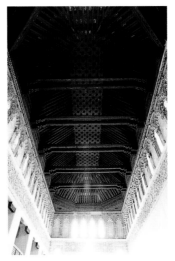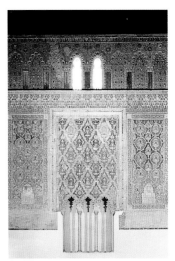

agogue, and its presence would make the re-use of the building for Jewish religious purposes problematical.

The panels on either side of the ark niche display elaborate inscriptions. Above the right-hand one is a shield with quartered arms featuring a castle and a lion, that is, Castile and León. The Hebrew inscription starts off: 'See the sanctuary that was consecrated in Israel, and the house Shmuel built, and the wooden tower [the lectern] for reading the law in the middle of it, and the scrolls and the crown...'

Running around the top of the walls is an elaborate stucco frieze. In the Moorish style, this is where you might expect to see a long quotation from the Koran in Kufic lettering. Instead there is a continuous text in square Hebrew characters: a set of verses from the Book of Psalms. Below this inscription there is a series of Moorish arches, some blind, some framing windows, each borne on twin columns with differently detailed caps and differently coloured shafts. Below this arcade, between further lines of Hebrew (also from the Psalms), is a stucco frieze of strap work bearing the repeated Arabic words for 'happiness and prosperity'. There are also badges, including one featuring a castle and three towers—probably the arms of the Levis.

This lower frieze, with its mudéjar decoration, Arabic slogans and feudal blazonry, framed by quotations from the Hebrew bible, is one of the most moving relics I

RIGHT The prayer hall at Córdoba. To the left is the south wall with three large openings at first-floor level which lead into the women's gallery. To the right is the west wall. Ataurique panels (stucco cut into complex arabesques) cover all four walls. The lower parts of the wall surfaces are in bare brick.

OPPOSITE The synagogue at Córdoba contains this splendid lobate arch over a niche in the west wall, surmounted by a stucco panel carved with a complex arabesque design. Much of the surrounding Hebrew inscription has been lost in the present century. It is thought that the niche may have housed the *amud* or desk from which the Torah was read.

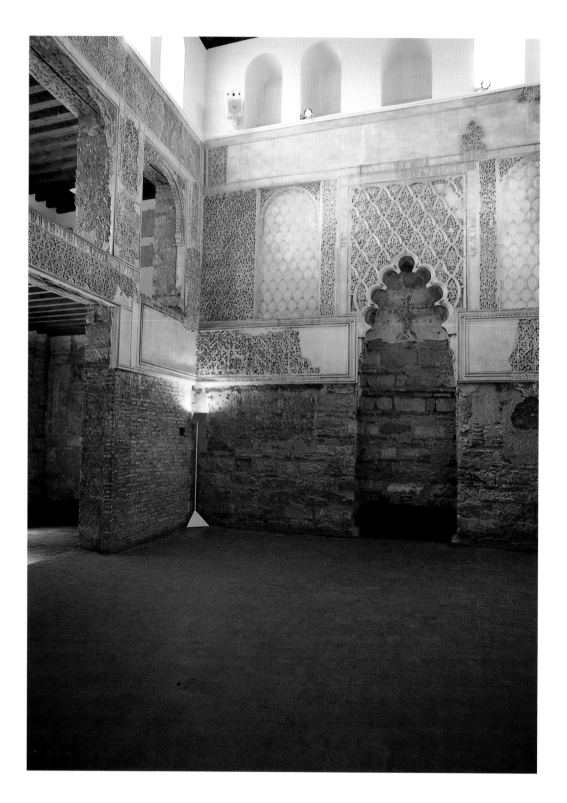

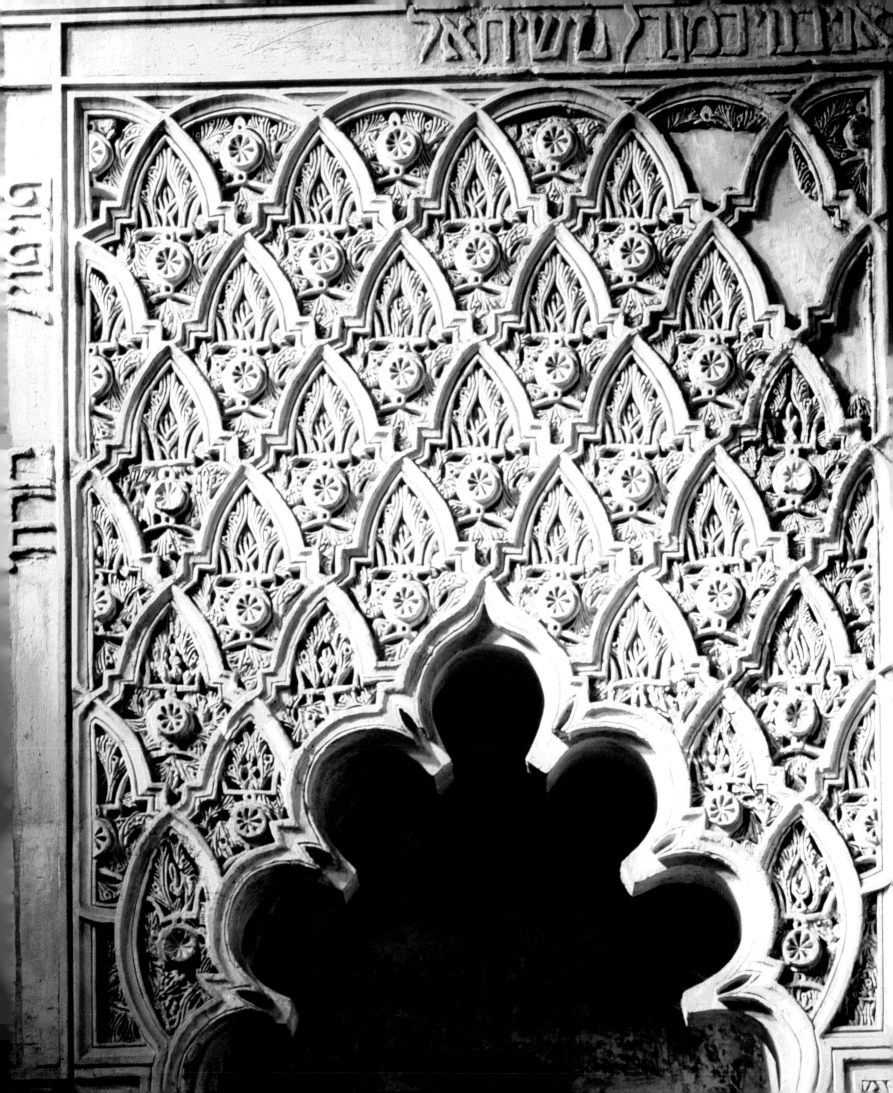

know of from the medieval Jewish past. It displays, like something trapped in amber, a precious moment in history, a moment when three traditions could interact peacefully—I should like to say innocently—to the advantage of all and the hurt of none. That moment passed, and even today it is not, in retrospect, viewed with favour by all. 'Have you ever been to Toledo?' I once asked a Moroccan Jew in Madrid. 'Yes, monsieur,' he replied, 'I've visited it once. After half an hour I had to scarper. *Je sentais quelque chose d'impur*. I felt something queer...' It was not the reaction I had expected.

The great prayer hall of Shmuel Ha-Levi's synagogue in Toledo may be palatial, but it nurses a fatal wound: the tomb, which was inserted by the Christian usurpers who turned it into a church. The small synagogue in Córdoba in Andalusia, however, is free of this taint. It was founded by Yitschak Moheb in 1314 or -15 and its prayer hall is a modest 23 by 21 feet (6.95 by 6.37 metres) in size. In May 1993, 500 years after its congregants had been driven into exile, carrying their Torah scrolls with them, it heard once more: 'the voice of mirth and the voice of gladness, the voice of the bridegroom and the voice of the bride' (Jeremiah vii 34) as the wedding of a Canadian Jewish couple was celebrated, in the presence of the Israeli and Canadian ambassadors to the court of Spain. No ark and no bimah has survived the long centuries in between, during which the little shool served first as a hospital for hydrophobes, and then, from 1588, as the shoemakers' church, opened for mass once a year on 25 October to celebrate the feast day of their patron saints, Crispin and Crispinian—Shakespeare's Crispin Crispian. It did not matter: the only liturgical equipment you need for a wedding is a *chuppah*—the canopy under which the betrothed stand—and it is not hard to improvise that.

The synagogue stands in Jews' Street—calle Judios—at the western end of the *judería*, the old Jewish quarter of Córdoba. It is found between the Almodóvar gate (which the Arabs called the *Bab al Yahud*, or the Jews' Gate), and the Plaza de Tiberíades, in which a bronze statue of Maimonides, a native of Córdoba, was placed in 1965. Jews' Street is a typical narrow Andalusian lane, running between high walls. At no. 20, you step through a gateway into a little patio. On the left is the caretaker's tiny house—perhaps coeval with the synagogue—and on the right the entrance to the synagogue itself.

The doorway is in the south wall. The mezuzah on its jamb was placed there in 1985, as part of the celebrations marking the eight hundred and fiftieth anniversary of the birth of Maimonides. We enter a broad vestibule, with a wooden staircase on

the right leading up to the women's gallery. A few more steps, and we are in the prayer hall itself. It is almost square. The lower part of the walls, up to 7.5 feet (2.26 metres) from the floor, is bare brick; perhaps it was originally tiled. Above this level, all four walls are covered with a complex pattern of mudéjar arabesques cut into stucco. The south wall, through which we have entered, has three large openings at first-floor level, which lead into the women's gallery. A recess on the east wall marks the position of the ark, while facing it on the west wall is a shallow lobate niche. Here an allusive Hebrew inscription suggests that the bimah must have been set up nearby.

There are also other Hebrew inscriptions cut into the stucco, running in and out of the *ataurique* panels that adorn all four walls. They are mostly quotations from the Psalms. But in a tablet to the right of the ark niche in the east wall there is a more personal statement. Here the Hebrew wording reads: 'Yitschak Mehab, son of the honourable Ephraim, has completed this lesser sanctuary and he built it in the year [50]75 as a temporary abode. Arise, O Lord, and hasten to build Jerusalem.' The 'lesser sanctuary' is an expression borrowed from Ezekiel xi 16 and is commonly used as a poetical synonym for 'synagogue'.

There are other remnants of medieval synagogues in Spain and Portugal. At Segovia, the church of Corpus Christi was originally a synagogue. Today its horseshoe arches set on polygonal columns, recalling Santa Maria la Blanca, are tricked out with decorative light bulbs in the manner of a fairground. At Tomar, in Portugal, the prayer hall survives of a synagogue in which four tall, slender columns support the vaulted ceiling of a nearly square (31 x 27 feet/9.5 x 8.2 metres) chamber, with details nicely judged by Professor Carol Krinsky to be 'vestigially antique...rather than incipiently Renaissance'.

The age of Spanish synagogues came to an abrupt end, as though someone had ruled a line across a page of human history. Retrospectively, we can think of that appalling term which the Serbs coined in the 1990s: ethnic cleansing. Two months after the fall of Granada, the last Moorish kingdom, the Catholic monarchs Ferdinand and Isabella signed an edict on 31 March 1492, expelling all professing Jews from Spain. Exactly 500 years later, on 31 March 1992, a ceremony of reconciliation took place in a Madrid synagogue, in the presence of King Juan Carlos of Spain and the President of Israel, Chaim Herzog. Kings do not apologize, and Juan Carlos did not do so. But there was much to regret. The largest Jewish community in the world had been liquidated, and 100,000 people sent into exile. 'Jews had never lived anywhere else as harmoniously or creatively as Spain', writes Abba

RIGHT The Ibn Ezra synagogue in
Cairo, where Maimonides wor-
shipped. Originally an Early Chris-
tian church, it was bought from the
Copts in the ninth century and
converted into a synagogue.
 The gallery at the top right led to
the *genizah*, the dump for old
books and manuscripts. Its con-
tents were removed to Cambridge
in the 1890s.

OPPOSITE The doors of the Ibn Ezra
synagogue, displaying 16 carved
panels. Probably dating from the
eleventh century, these doors are
now housed at the Israel Museum,
Jerusalem.

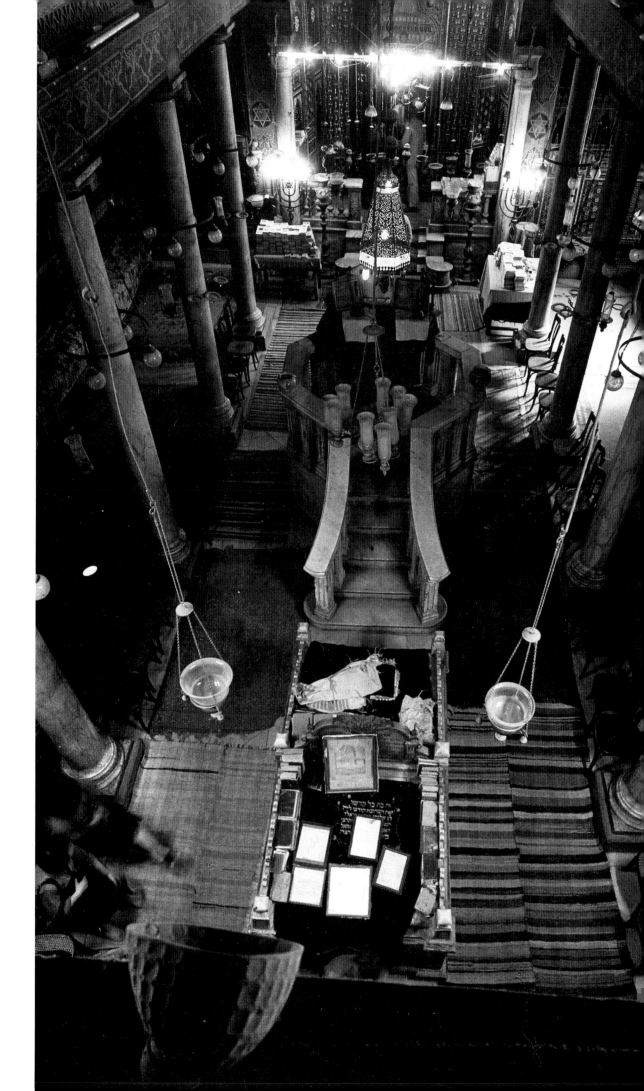

Eban. 'They had taken an active part in Spanish society while also cultivating their own particular legacy. They had been prominent in commerce, medicine, literature and the arts. One out of every ten Spaniards had been Jewish or had descended from Jews.'

At the instigation of Cardinal Ximenes, it was not long before the conquered Moslem population was to suffer a similar fate and be confronted with the choice of baptism or exile. The final dissolution of Al Andalus had as great a resonance in Islam as the banishment of its Jews did amongst world Jewry. It is said that there are families in Africa today who still keep the keys to their ancestral homes in Granada or Córdoba, against the day of their victorious return. The nostalgia for Moorish Spain, incidentally, has in its time run deep amongst those who are neither Moor nor Sefardi. The British orientalist Stanley Lane-Pool concluded his book *The Moors in Spain* (1887) with these incredibly bitter words:

> For a while Christian Spain shone, like the moon, with a borrowed light; then came the eclipse, and in that darkess Spain has grovelled ever since. The true memorial of the Moors is seen in desolate tracts of utter barrenness, where once the Moslem grew luxuriant vines and olives and yellow ears of corn; in a stupid, ignorant population where once wit and learning flourished; and in the general stagnation and degradation of a people which has hopelessly fallen in the scale of the nations, and has deserved its humiliation.

Having been expelled from Spain, and subsequently from Portugal, the Jews sought refuge in other Islamic countries. They received a particularly cordial welcome from the Ottoman Turks, who were skilled in warfare and had recently wiped out the Byzantine Empire, but were weak on finance and adminstration. 'Can you call such a king wise and intelligent?' asked Sultan Bajazet II, referring to Ferdinand of Aragon. 'He is impoverishing his country and enriching my kingdom.' Of course, this had happened to Jews before, when 'heterodox fanatics' (to recall Stillman's phrase) had seized power in parts of Al Andalus. The most famous such refugee was Maimonides, who fled his native Cór-

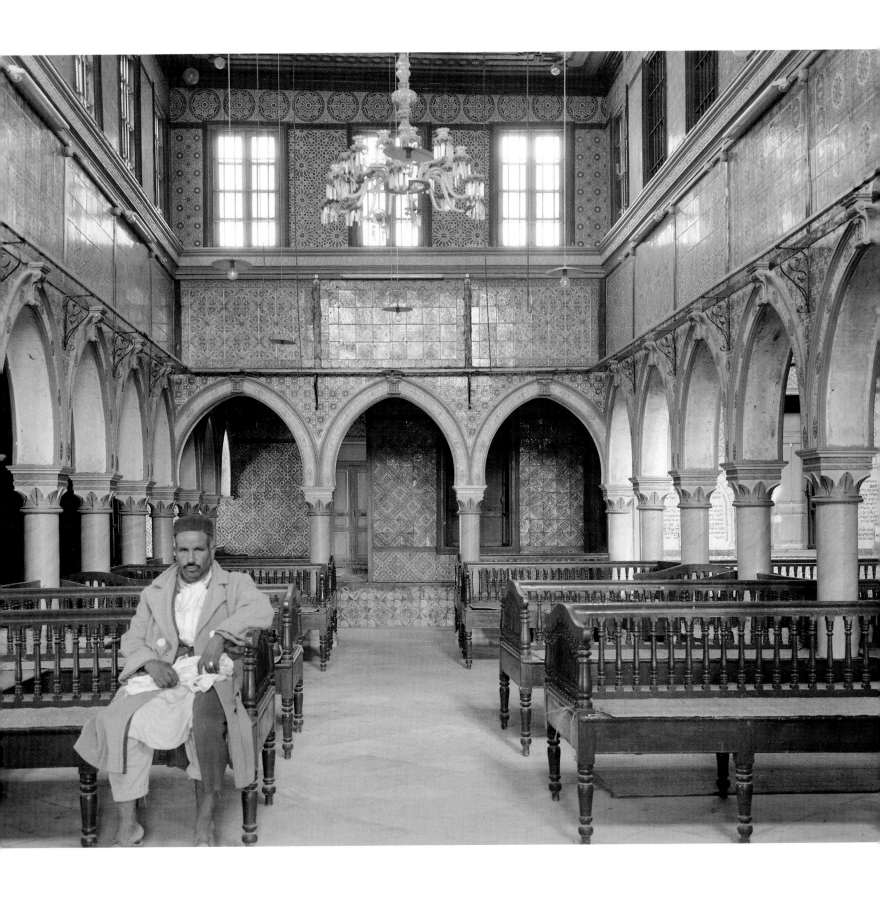

doba when it fell into the hands of a fundamentalist dynasty from North Africa. He ended up in Cairo, where he taught at the Ibn Ezra synagogue in Fostat. It still stands. It was originally an Early Christian church, which had been bought from the Coptic patriarch in the ninth century and converted into a synagogue. When James Aldridge visited it in 1966, 'a very excitable guardian' assured him that it was in fact built on the site of the original synagogue of the prophet Jeremiah. 'The Christians got the site,' he said, 'by a mistake when the Romans were defeated and Amr handed back all seized properties.'

What the Ibn Ezra is most famous for, however, is its *genizah*, a doorless chamber into which thousands of documents and old books had been tipped since the ninth century. They were

preserved due to a traditional Jewish disinclination to destroy anything written in Hebrew, or in Hebrew script. Access to this antiquarian lumber room was through a hole in the wall at one end of the women's gallery; when I saw it in 1987, it had been blocked up, but a patch on the wall betrayed its location. One day at the end of 1896 the Cambridge papyrologists Agnes Lewis and her sister Margaret Gibson winced to hear 'the crash of ancient vellum' beneath the feet of the shammas as (having scrambled up a crude ladder) he jumped through the hole. The ladies were present at the invitation of Solomon Schechter, lecturer in rabbinics at Cambridge University, who, by a combination of diplomacy and the liberal distribution of *bakhshish* (funded by the Master of St John's), succeeded in emptying the genizah and transferring its contents to Cambridge University Library. A century later, they are still being explored. The 100,000 texts include holograph letters from Yehudah ha-Levi, most of the lost Hebrew original of the Apocryphal book of Ecclesiasticus, hundreds of poems by the seventh-century Hebrew poet Yannai, and responsa by the illustrious Talmud scholar Saadiah Gaon. A prize find was a document signed by Maimonides himself, a signature that has been copied in regrettably crumbly stone on the plinth of his statue in Córdoba. But in addition to all the literary and religious works, a mass of private correspondence and commercial documents has emerged that sheds a brilliant light on economic and social conditions in the medieval Near and Middle East.

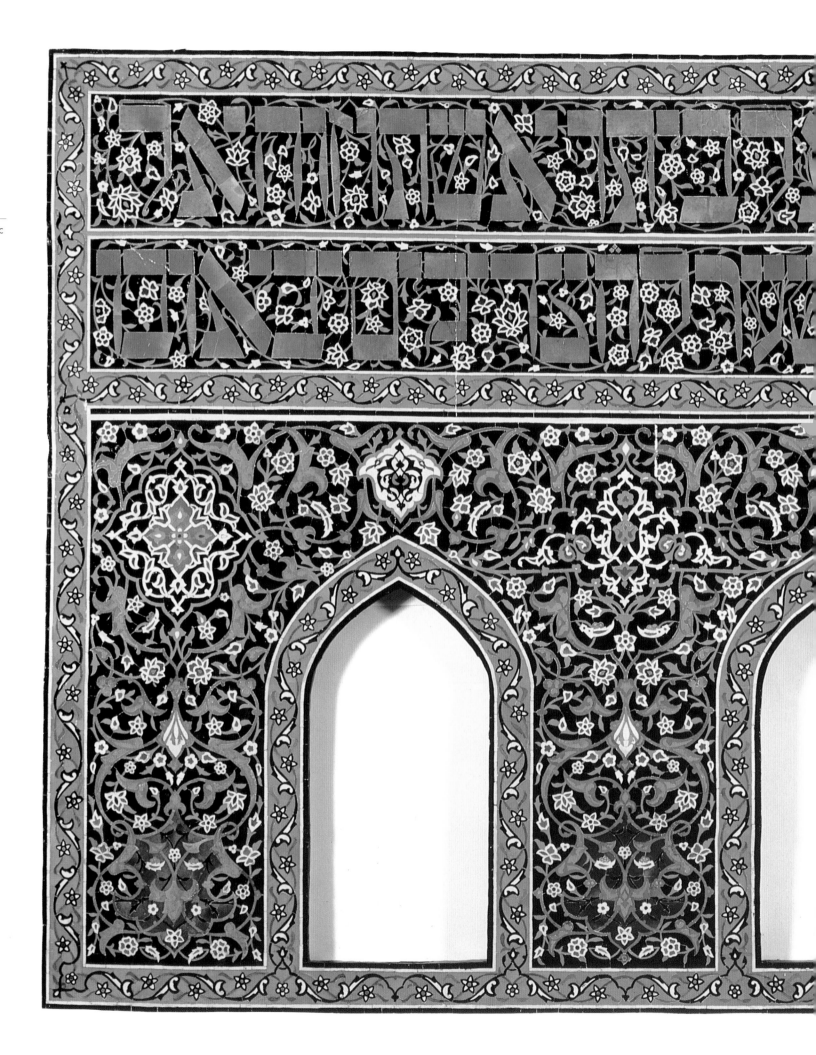

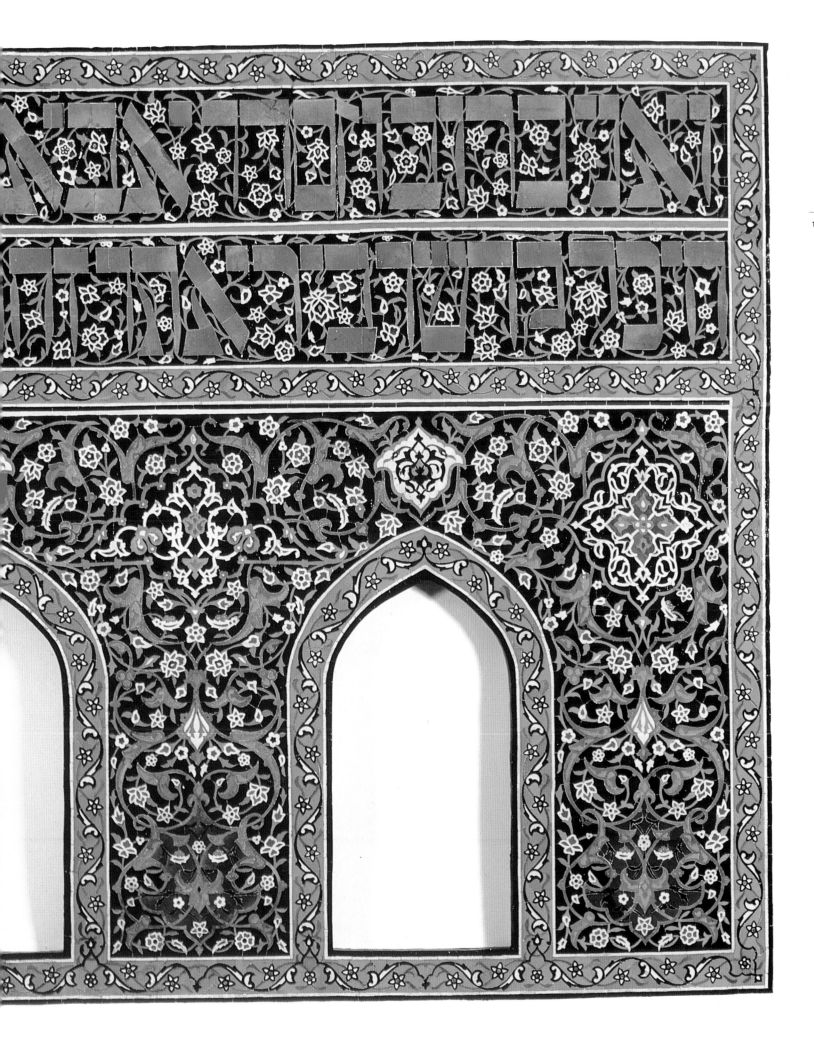

Ibn Ezra had been converted, without much difficulty, from a basilica into the semblance of a normal synagogue, with the usual ark-bimah bipolarity. Elsewhere in the Arab world, however, synagogues were built which seemed to adapt themselves, sometimes rather oddly, to the architectural conventions of the mosque. The most notable example of this genre was at Aleppo, in Syria, where the congregation sat in a porticoed courtyard. In the middle of the courtyard stood the bimah, under its own little roof, in the place where the ablutions well of a mosque would be located. The ark was set in a niche, which some writers have compared with the qibla of a mosque, though Islamic practice would not site such a feature in the courtyard. The Jewish traveller Benjamin of Tudela, in the twelfth century, described the great synagogue of Baghdad as a columned hall, like the great mosque of Córdoba, adorned with bands of ornamental Hebrew lettering. It opened onto a courtyard, in the manner of a mosque.

A more amenable adaptation of Islamic style was to be found in Persia, and in particular at Isfahan, where Benjamin of Tudela estimated the Jewish population to number 15,000 at the time of his visit in 1166. When the Safavid dynasty made Isfahan its capital in 1598, a period of prosperity opened up for its Jewish citizens, many of whom worked as craftsmen and artisans.

The most characteristic achievement of the Persians in architectural ornament is the development of the coloured tile for cladding walls, inside and out. The technique of creating the *kashi*, or faience mosaic panel, was thought at one time to have been lost, but it has been revived again this century, especially in Isfahan. It involves chipping shapes with an adze-like hammer out of square tiles of glazed faience with such deftness that the glaze is not broken. Complex floral and geometrical patterns are created by fitting the cut shapes closely together. Beautiful examples of this work from eighteenth-century Isfahani synagogues may be seen (divorced from their context, of course) in the Jewish Museum, New York, and the Israel Museum, Jerusalem. Some of them perpetuate the Judeo-Islamic tradition of incorporating calligraphy into the decorative scheme by featuring quotations from the scriptures in beautiful square letter Hebrew characters, boldly superimposed in white on a dark blue background strewn with flowers.

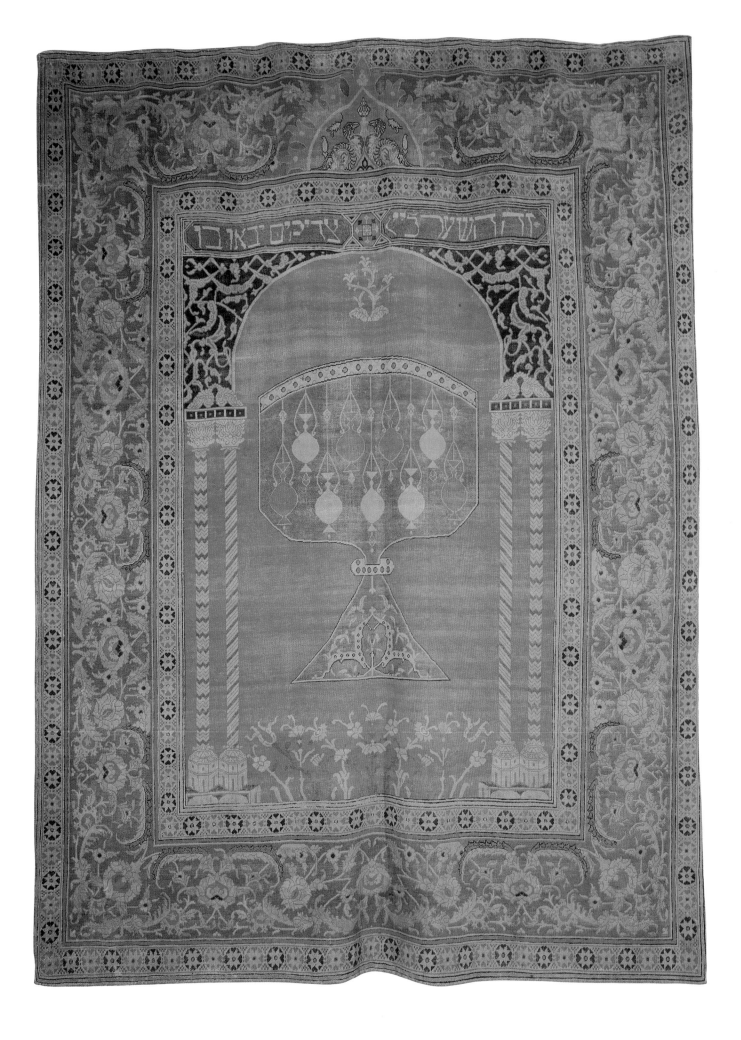

OPPOSITE The Scola Spagnola in Venice (1655) has a typical Sefardi layout with the ark (visible here) and the bimah on opposite end walls. The straight runs of the women's galleries down each side are linked at the end in a semicircular curve.

120

Padua, Northern Italy, 23 miles (37 kilometres) inland from Venice. The rabbi leant out of an upper window in Via San Martino e Solferino and threw down a bunch of keys. I unlocked the street door and my wife and I mounted a staircase. In a moment we found ourselves in a synagogue unlike any we had seen before. It was long and narrow, like an ancient stadium, with panelled seating down the long sides. In the middle of the long west wall—in the place of the emperor's box, so to speak—was the bimah, reached by long twin curving staircases. Directly facing it, just a few feet away on the opposite wall, was the ark. But it was not just the synagogue's layout that caught our attention. It was the fact that the whole panoply of North Italian Mannerist and Baroque architecture was displayed there. The ark was embellished with an ornate broken pediment, borne on marble Corinthian columns. The undulating parapet of the bimah served to support half a dozen more columns which held up a baldacchino. The central bay of the ceiling, which ran from bimah to ark, was arched up in a barrel vault, its soffit patterned with coffering filled with rosettes. The other ceiling bays—two on either side of the barrel vault—were each divided into three panels by heavy cross members. At one of the short ends of the hall, a women's gallery could be glimpsed at an upper level. This interior combined the patinated splendour of four and a half centuries with a reassuring intimacy. '*Qui si può pregare*', said the rabbi. 'You can pray here. The big shools of Florence and Rome, on the other hand, are like churches, like cathedrals.' I recalled the saying of St John of the Cross: churches where the senses are least likely to be entertained are most suitable for intense prayer.

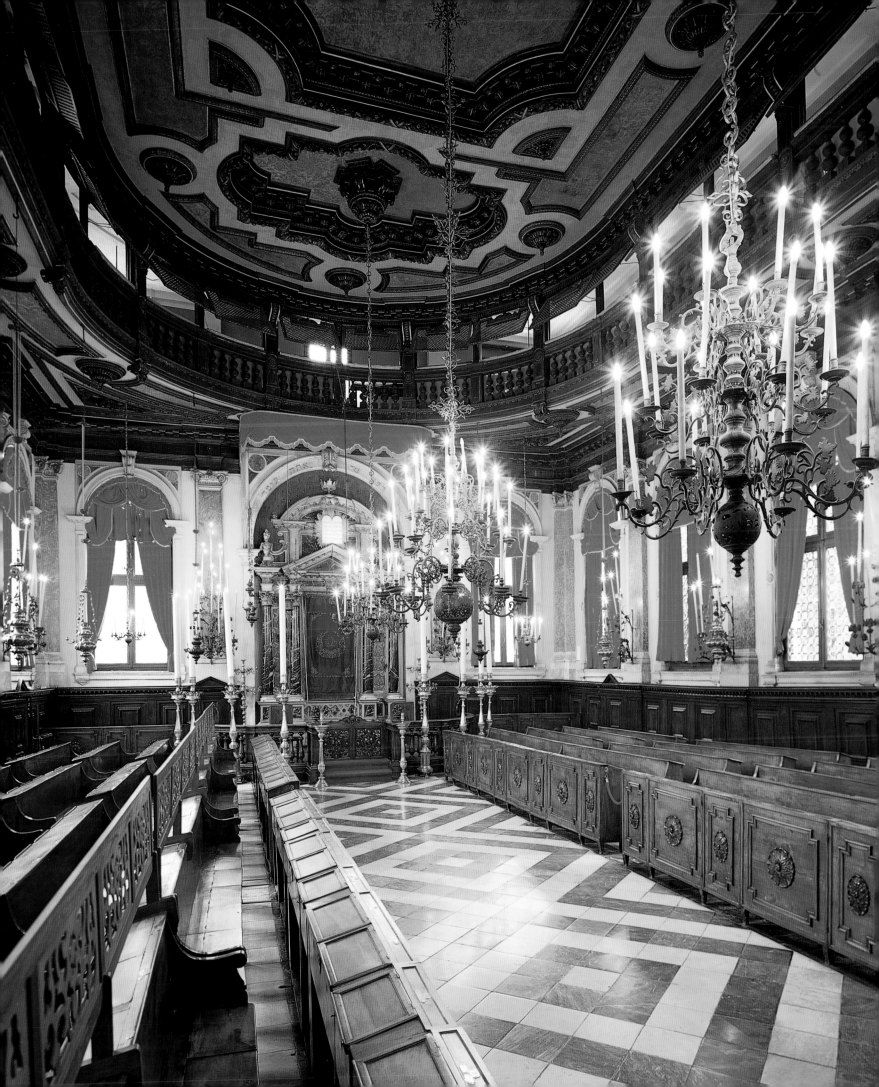

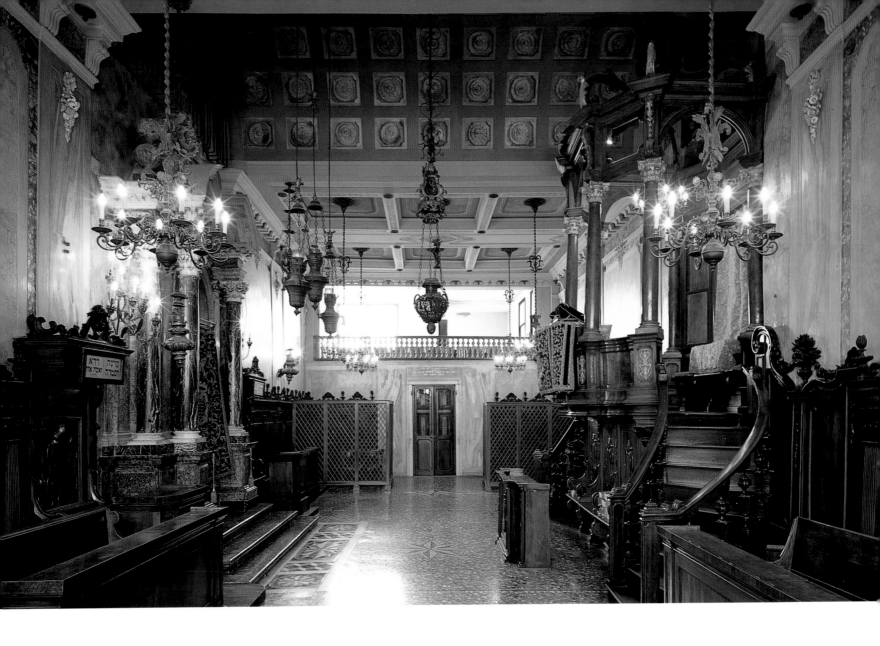

ABOVE The Scola Italiana in Padua was founded in 1548. Its layout is unusual in that the bimah (right) and the ark (left) face each other on the long walls, instead of on the shorter end walls. The central bay of the ceiling swoops up in a barrel vault to link bimah and ark.

RIGHT The exterior of the Scola Italiana in the Via San Martino e Solferino in Padua, a typically arcaded north Italian street.

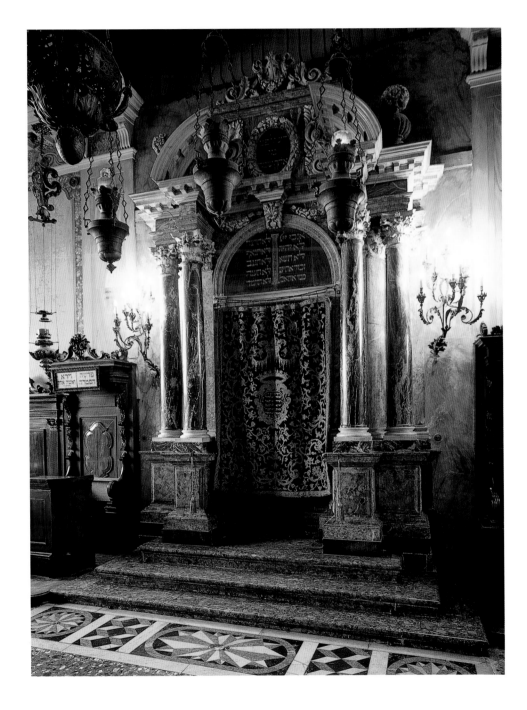

ABOVE Detail of the richly ornate ark curtain, with its depiction of the Ten Commandments.
LEFT The ark of the Scola Italiana, surmounted by an ornate broken pediment carried on marble Corinthian columns.

The axis of power. A coffered
barrel vault spans the narrow gap
across which ark and bimah
confront each other at the Scola
Italiana, Padua.

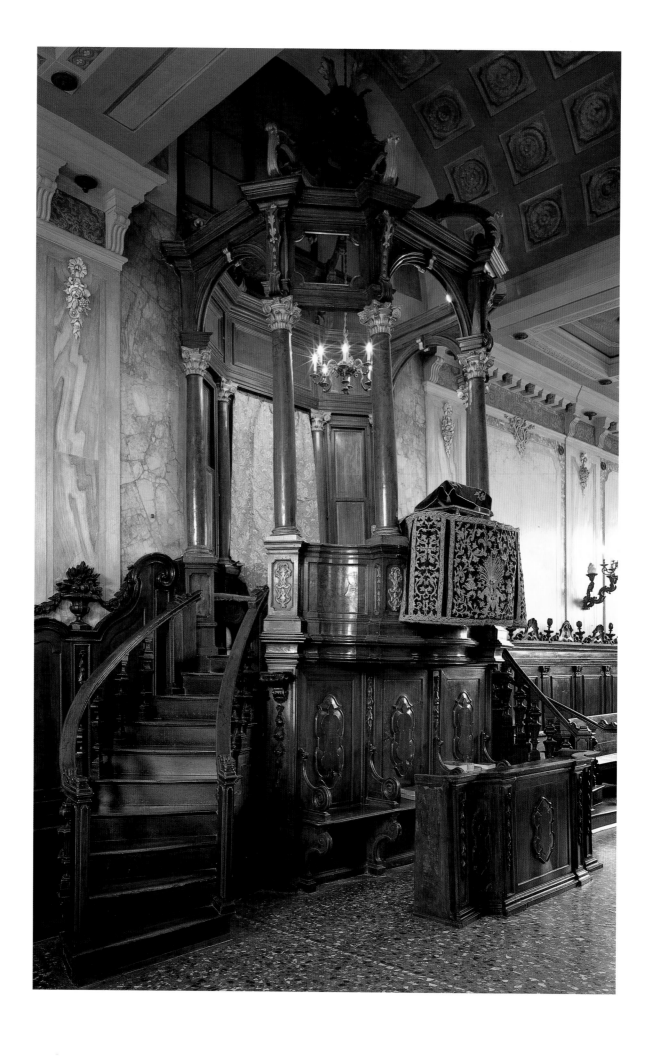

OPPOSITE The bimah, reached
by twin curving staircases, in the
Scola Italiana.
BELOW The Square of the Five
Synagogues in Rome. In 1555 the
anti-semitic Pope Paul V confined

the Jews of Rome to a ghetto,
where they were only allowed to
have one synagogue. Differences
of practice and liturgy demanded
more than this number, however,
and the Jews were accordingly

permitted to accommodate five
synagogues in a single building,
which was erected between 1573
and 1581. The five-synagogue
block was demolished in 1910.

It cannot be denied, however, that the senses *are* likely to be entertained in an Italian synagogue, however modest it may be. The aesthetic appeal of the Renaissance, which began in Italy, proved irresistible to the Italian Jews, some of whose communities are of immense antiquity. (Those in Rome actually predate the Christian era.) The blossoming of art and literature that came about with the new enthusiasm for Greek and Roman civilization affected Italian Jews profoundly. Even the responsa of their rabbis, 'expressed in impeccable literary style', convey a Renaissance spirit and reveal a familiarity with the classical learning so eagerly pursued by their gentile contemporaries. Wealthy Jewish bankers commissioned portrait medals and, before the spread of printing, had their books copied by the best scribes and illuminated by outstanding artists. When it came to architecture, a comparable sophistication is apparent. In his book on the Temple in Jerusalem, written in Hebrew and published in Mantua in 1612, Abraham Portaleone quotes from the

ancient Roman writer Vitruvius whose treatise on architecture, the only one to survive from antiquity, was studied with an intensity sometimes bordering on desperation by all Renaissance architects. Portaleone (1542-1612) was court physician to the Duke of Mantua, a colleague of Rigoletto, so to speak. He belonged to a class of professionals who were at home in Latin and had studied medicine and philosophy at the local university. At the same time they were learned in the Torah to the extent that they served as rabbi to their communities—thus displaying a combination of disciplines sanctified by the example of Maimonides.

No Early Renaissance synagogues survive in Italy. There had been one in Palermo, Sicily, built in 1467, which was described in exuberant detail 20 years later by Rabbi Obadiah da Bertinoro. His description includes the almost traditional commendation that the synagogue 'has not its equal in the whole world', a remark that recalls Rabbi Judah's observation on the synagogue of Alexandria. Yet the Palermo building vanished after the Spaniards came to power in Sicily and expelled the Jews in 1492. In this connection, a distinction must be made between the large monarchy in the south of Italy, and the numerous petty states in the north. As Cecil Roth has pointed out, when you were expelled from a big powerful kingdom you tended to stay expelled. When you were pushed out of a little duchy or republic, you slid over the border into the neigh-

BELOW LEFT The Campo del Ghetto
Nuovo in Venice.
BELOW RIGHT Detail of the Venetian
ghetto, from a 1500 map by
Jacopo de Barbari. The name is
supposed to derive from two dis-
used foundries (in Venetian *getto*),

an old and a new, where cannon
were cast; these provided the sites
for the quarters into which the Jews
were herded.

OPPOSITE An eighteenth-century
Venetian marriage contract
(*ketubah*). The decorative details
include the signs of the zodiac,
and a view of Jerusalem with the
Dome of the Rock masquerading
as the Temple.

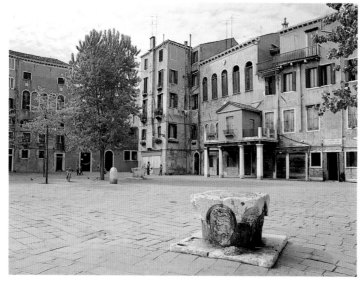

bouring statelet and awaited the next in-
surrection, or the death of the relevant
anti-Jewish bishop.

When expulsion time came in Venice,
however, which it did in 1527 and 1571,
the community did not have to slip over
the frontier: they bargained with the Sen-
ate instead. Conditions were different in
Venice. Here the ruling class was intense-
ly mercantile: if the price was right, you
had a deal. And it was the aristocratic
merchant class who ruled, not the
church. Ecclesiastical pomp, it is true,
was second to none; the split choirs of St

Mark's tossing Gabrieli motets back and forth to each other were the marvel of
Europe, but the church was kept in its place. This drove some popes mad. Sixtus IV
excommunicated the whole city in 1483, while Paul V placed it under an interdict
in 1606. The Venetians paid no attention, however, and business continued as
keenly as ever. This meant that the Jews were sheltered from the interfering and
fanatical bishops and the occasional anti-semitic pope, who were a hazard else-
where in Italy. Yet the Jews did not escape altogether. The Senate, which was used
to controlling everything, from the number of guests you could have at a banquet
to the disposal of the gifts received by its ambassadors abroad, thought it desirable
to control its Jews as well. From 1576 it confined them to a specific district of
Venice, the *ghetto nuovo* or new foundry. The Jews were only restricted to the ghetto

from the point of view of residence. They
could go anywhere they wanted during
the day, but at night the gates were
locked, like an Oxford college.

Within the ghetto, five Mannerist/Ba-
roque synagogues were built, all of which
survive today. They were more fortunate
than their congregations because, as an
inscription set into the façade of the Lev-
antine synagogue recalls:

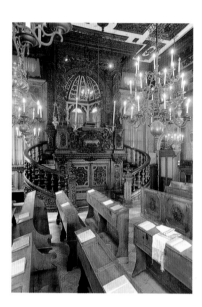

1939–1945
TWO HUNDRED JEWS OF VENICE
EIGHT THOUSAND JEWS OF ITALY
SIX MILLION JEWS OF EUROPE
BY BLIND BARBARIC HATE
IN DISTANT LANDS
DRIVEN FORTH, MARTYRED, SUPPRESSED.
MAY THE MEMORY OF THIS MOST
MONSTROUS ATROCITY
TO HUMAN CIVILIZATION
RECALL ALL MEN
TO THE HOLY LAW OF GOD
WHICH ISRAEL FIRST PROCLAIMED
AMONGST THE NATIONS.

The synagogues of Venice are all long and narrow, like the one at Padua, but unlike the Paduan example, they do not have the ark and bimah facing each other in the middle of the long walls. Instead, they call to each other, so to speak, from the short walls at the opposite ends of the prayer hall, on what has been dubbed the two-pole pattern, while the congregants sit facing each other on benches running lengthwise down the room. Between there is a clear space, down which the cantor can process to and from the ark with a Torah scroll on his arm.

These synagogues were perched on the upper floors of existing buildings, since the ghettoes to which the Jews were consigned were already substantially built-up. The bright side of this arrangement was that the Talmudical precept could thereby be observed of siting a place of worship in a more elevated location than its secular context. The existence of this context, however, posed problems for the architect, and considerable ingenuity was required to shoehorn the synagogues in. The oldest surviving one, the Scola Grande Tedesca or Great German Synagogue of 1528, for the Ashkenazi rite, is unavoidably asymmetrical—trapezoidal in fact—because of these constraints, but the eye, seduced by the decorative elegance of the interior, scarcely takes this in.

The exterior of the Scola Grande Tedesca does not announce itself as a house of worship. It is part of the continuing wallscape of a square typical of a south European *quartier populaire*, and old photographs actually depict a line of washing strung

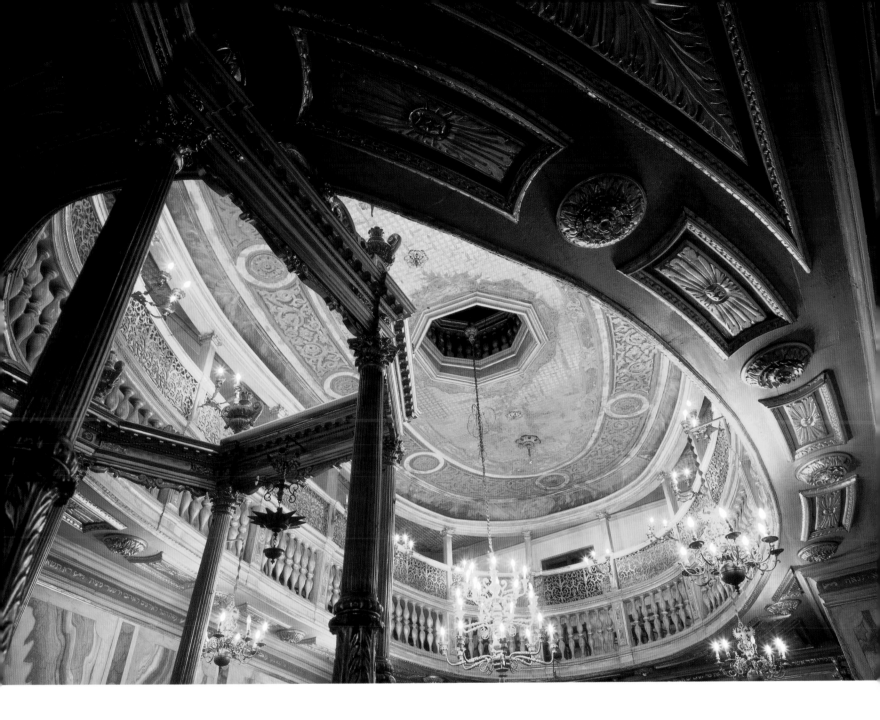

OPPOSITE The bimah in the Scola Levantina in Venice is surmounted by a Baroque *baldacchino* by Andrea Brustolon (1662-1732). It displays 'Solomonic' twisted columns, with, behind, a half-hexagonal apse that projects out of the short end wall.

ABOVE View up through the octagonal cage of the bimah at the Scola Tedesca in Venice. This originally stood in the centre of the hall, as with all Ashkenazi shools,

but was subsequently displaced to an end wall in the Sefardi manner. The slight cant of the oval gallery masks the trapezoidal shape of the plan.

LEFT The ark in the Scola Tedesca. It was presented by Rabbi Menahem Cividale in 1666. The lettering visible on the inside of the door is inlaid in mother-of-pearl.

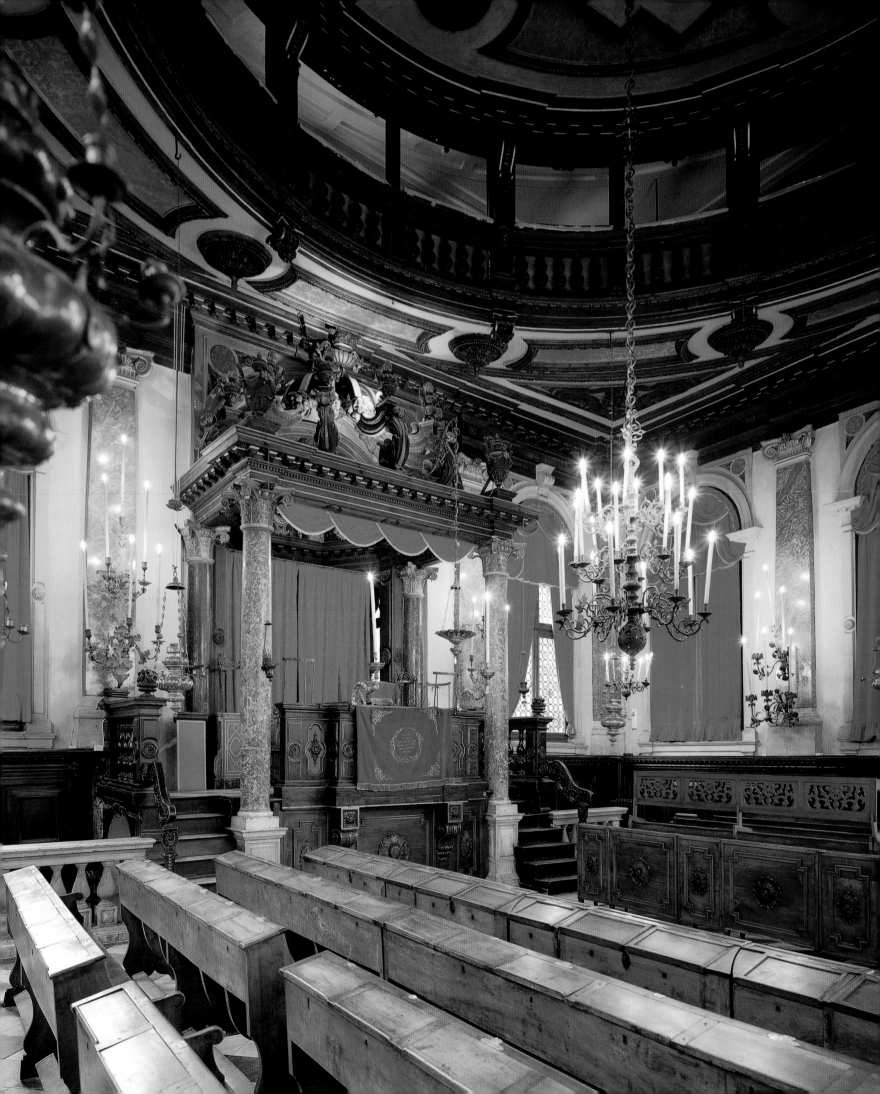

OPPOSITE & BELOW The bimah in
the Scola Spagnola, Venice. The
simplicity of the unfluted columns
provides a sharp contrast with the
riot of scrolls and other impedi-
menta placed on the roof in the
nineteenth century.

across the façade by a denizen of one of the lower floors. The third storey, how-
ever, displays a row of five windows, the two intermediate ones blind. These light
the prayer hall, which is in fact two storeys high.

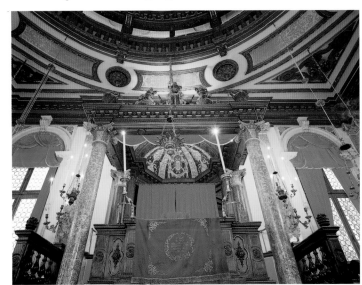

This hall is reached up narrow flights of steep stairs, the flanking walls enlivened
with inscriptions commemorating the pious, learned and generous congregants of
bygone days. You enter the hall on one of the
long sides, near the ark. The layout is the usual
Venetian style, with the bimah and ark on the
short walls opposite each other. Why should an
Ashkenazi shool do something so untypical?
Detective work by architectural historians on
the rather oddly foreshortened octagonal
bimah suggests that originally the bimah was
placed in the middle, as Nature intended. In
the course of time, however, the Ashkenazim
gave way to the general trend, and pushed the
bimah up to the end wall. Another thing that
has changed is the accommodation for women.
Under the original dispensation they were
probably diverted to a separate room. Now their oval gallery, probably introduced
in 1666, constitutes one of the most visually important features of the interior, its
slight cant on plan reconciling the eye to the trapezoidal shape of the hall.

Relocating the bimah, inserting a gallery: are these the signs of a congregation
prepared to move with the times? Only up to a point. The universally popular
Friday evening hymn, *Lecha dodi*, that welcomes the sabbath in as a bride, was
not sung at the Scola Tedesca. Although the man on the Golders Green omni-
bus thinks of the hymn as something handed down to Moses on Sinai, com-
plete with four-part harmony, it was in fact composed by Solomon Alkabez in the
mid-sixteenth century. Hence it dates from some years after the foundation of the
Scola Tedesca, whose congregants always regarded it as a modern intrusion into
the liturgy and as such quite unacceptable.

I say regarded, because the Scola Tedesca has no congregants now. The only
ghetto synagogue that does is the Spanish one, the largest in Venice, which was
founded in 1555. Like the other ghetto synagogues, it sits on the upper floors of a
tenement block and is almost rectangular in shape. Unlike the Ashkenazi syna-
gogue (the Tedesca), which only has three windows in one short end—augmented,

OPPOSITE This tripartite Baroque
ark from Vittorio Veneto, a town to
the north of Venice, is now in the
Israel Museum in Jerusalem.

it is true, by skylights—the Scola Spagnola is filled with windows: six down each long side representing the 12 tribes of Israel, and more on the return walls. Again the plan is bi-polar: the ark and bimah stand at opposite short ends, with the congregants on long rows between them, facing inwards. Above, is the women's gallery—not the slightly displaced oval of the Tedesca, but a simpler version, with two straight runs joined by semicircles at the ends.

You enter the prayer hall by stairs which emerge at either side of the bimah, on the west wall. The platform of the bimah is surmounted by a scrolled canopy on four Corinthian columns that classicizes a *chuppah* into a *baldacchino*; if the columns were spiral, we should indeed have a mini St Peter's. All this glory, according to Umberto Fortis, is the outcome of a nineteenth-century restoration. Professor Carol Krinsky, on the other hand, appears to accept it as the work of Baldassare Longhena, the great Venetian architect. It is claimed that Baldassare took time off from supervising work on Santa Maria della Salute, at the entrance to the Grand Canal, to remodel the interior of the synagogue in 1655. Be that as it may, the canopy served for 150 years and more to frame an organ, donated by a congregant in 1830. The monstrous presence of this device is alien and unsettling in an orthodox synagogue. It has now been removed and the bimah's proper function reinstated. Complex and Baroque, the ark has four black marble columns supporting an inflected entablature, crowned in the centre by a triangular pediment bearing the Tablets of the Law at its apex. Behind this, on the rear wall, a white stone substructure supports a segmental pediment, set against the blue tympanum of an arch formed by a semicircular architrave, borne on an outer pair of pilasters that frames the whole confection. What does all that remind you of? For Professor Krinsky, it recalls—but only faintly, she admits—the two-level altarpiece in the Vendramin chapel at the church of San Pietro di Castello, designed by Longhena. More apt to strike a spark of recognition is her reference to the 'firmament of chandeliers' at the Scola Spagnola, where a wealth of many-branched hanging lights—a forest of tall candles—fills the upper air; everlastingly tall, because they are now converted to electricity. When the red curtains are drawn across the great round-headed windows, and the lights are lit, they illuminate a richly exotic vista of panelled hardwood, moulded cornices and enough brass candelabra filled with wax candles—real ones—to grace a cardinal's exequies. A major order of Ionic pilasters marches above the mahogany dado. The bays between them are pierced by windows, their jambs enlivened by a minor, uncanonic order of thin pilasters which sets up a counter-rhythm to the major one. This glamour has an unsettling

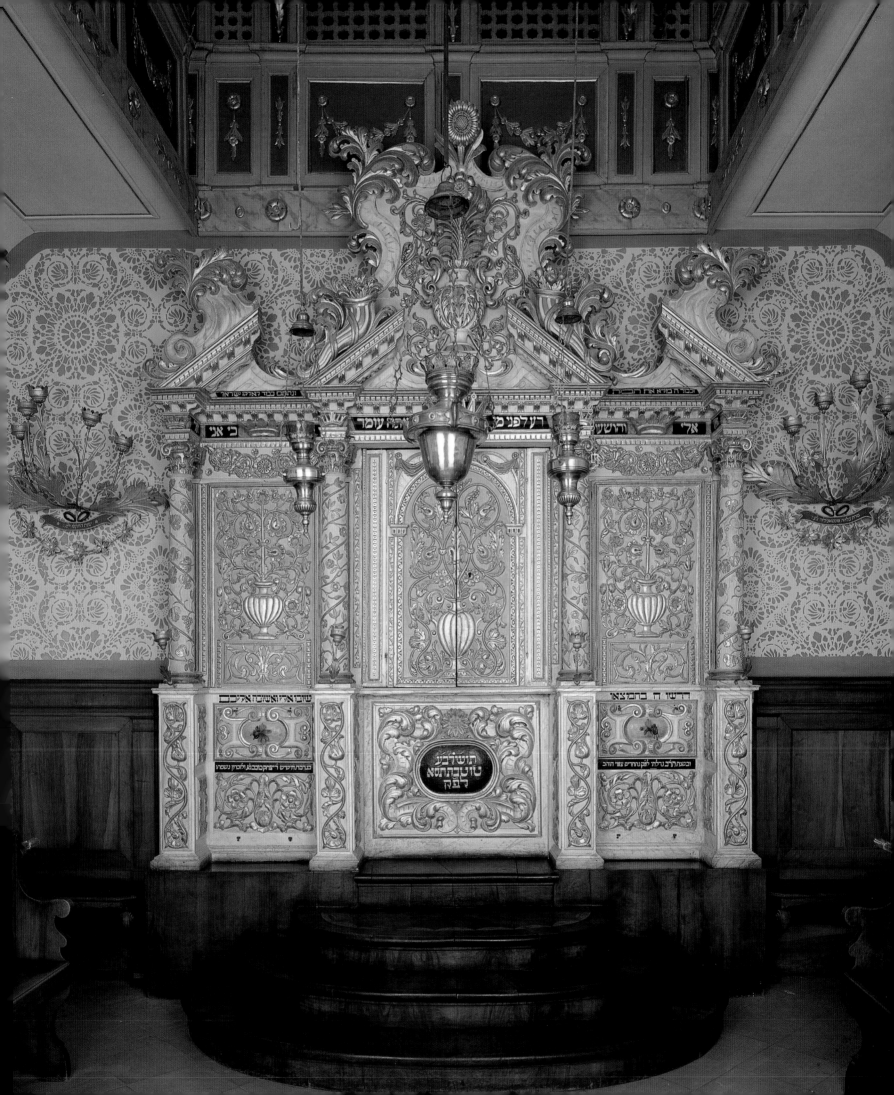

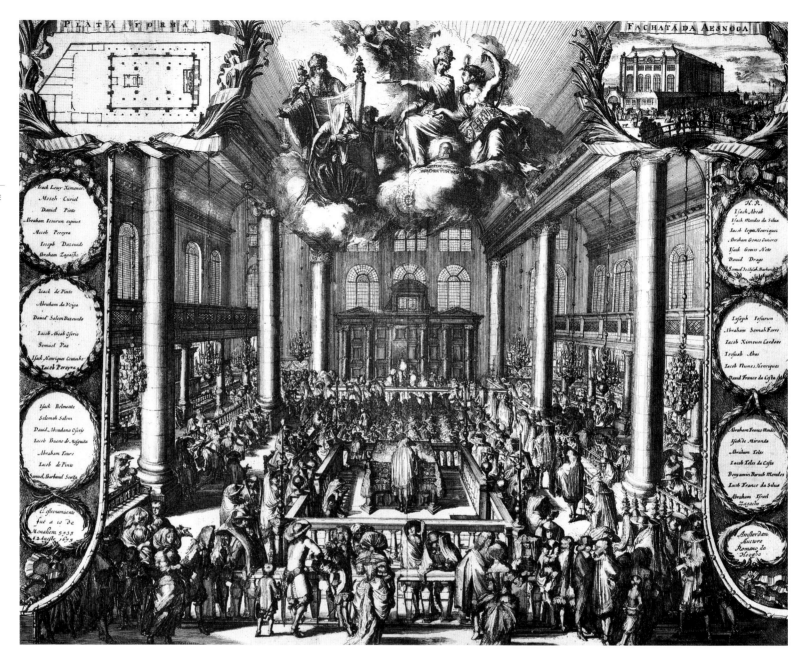

effect on some visitors. It is, as Carol Krinsky delicately phrases it, 'unfamiliar to Jews raised in modest synagogues or the dignified temples of Reform'. When Rebbetsin Carlebach, from Belfast, was sitting in the ladies' gallery of the Scola Spagnola one shabbat morning, she gazed wide-eyed, as the sefer torah was unwrapped. When the piece of cloth that holds the two parts of the scroll together on their rollers was loosened, it was handed to a small boy, who took it and ran up to the gallery, where the ladies kissed it avidly. When the cloth came round to Mrs Carlebach, she passed it on without kissing it. The whole performance seemed too Catholic for an Ulster rabbi's wife...

BELOW The exterior of the Portuguese Synagogue in Amsterdam, seen from the Jonas Daniel Meijerplein. Low-rise community offices appear in the foreground.

137

RENAISSANCE & BAROQUE

The development of synagogue architecture sometimes recalls the curves on a graph, tracing the evolution of some mathematical process: one line represents the wanderings of the Jews, the other the spread of an architectural style. The point at which they cross shows where a synagogue was erected, and explains why it looks the way it does.

The Renaissance style of architecture originated in Italy. It was based on a new-found urge to rediscover the vocabulary and rules of classical architecture and to adapt them to the requirements of a different age and culture. The style passed through a number of phases: High Renaissance, Mannerism, Baroque, Rococo and Neo-Classicism, before finally succumbing to anti-classical revivalism. As it developed, it spread to other countries, where the subtle system of modular proportions that underlies Renaissance and Baroque composition was not appreciated at first. The new way of building from Italy was initially regarded as a novel range of motifs, to be applied at will to traditional structures.

So it was in the Netherlands, where essentially Late Gothic structures were embellished, at the start, with Italianate decorative motifs on the outside. That was in the early sixteenth century. By the end of the seventeenth century, however, Dutch architects and master builders knew all the rules of classic style and were producing a sophisticated Classical architecture that was clearly in the mainstream of European post-Renaissance development, while also retaining a distinctive national character.

This accomplished architecture was but one of the outward signs of a triumphant burgher republic, whose citizens, having overthrown a typically repressive Spanish administration, were enjoying a period of great commercial prosperity and cultural brilliance. The tolerance that had been denied them by the Spaniards (to whom their country had been delivered by dynastic marriages) was

OPPOSITE ABOVE Romeyn de Hooghe's engraving of the Portuguese Synagogue in Amsterdam pictures the scene on 2 August 1675, the day it was dedicated. A plan of the synagogue and an external perspective are shown in cartouches at the top left and right respectively.

OPPOSITE BELOW This engraving by Bernard Picart shows the scene in the Obbene Sjoel, an Ashkenazi shool dating from 1685, on the Day of Atonement.

FOLLOWING PAGES In the Portuguese Synagogue in Amsterdam every seat has its own candlestick, besides the chandeliers for general lighting. The women's galleries were designed as an integral feature of the synagogue, the earliest instance of its kind.

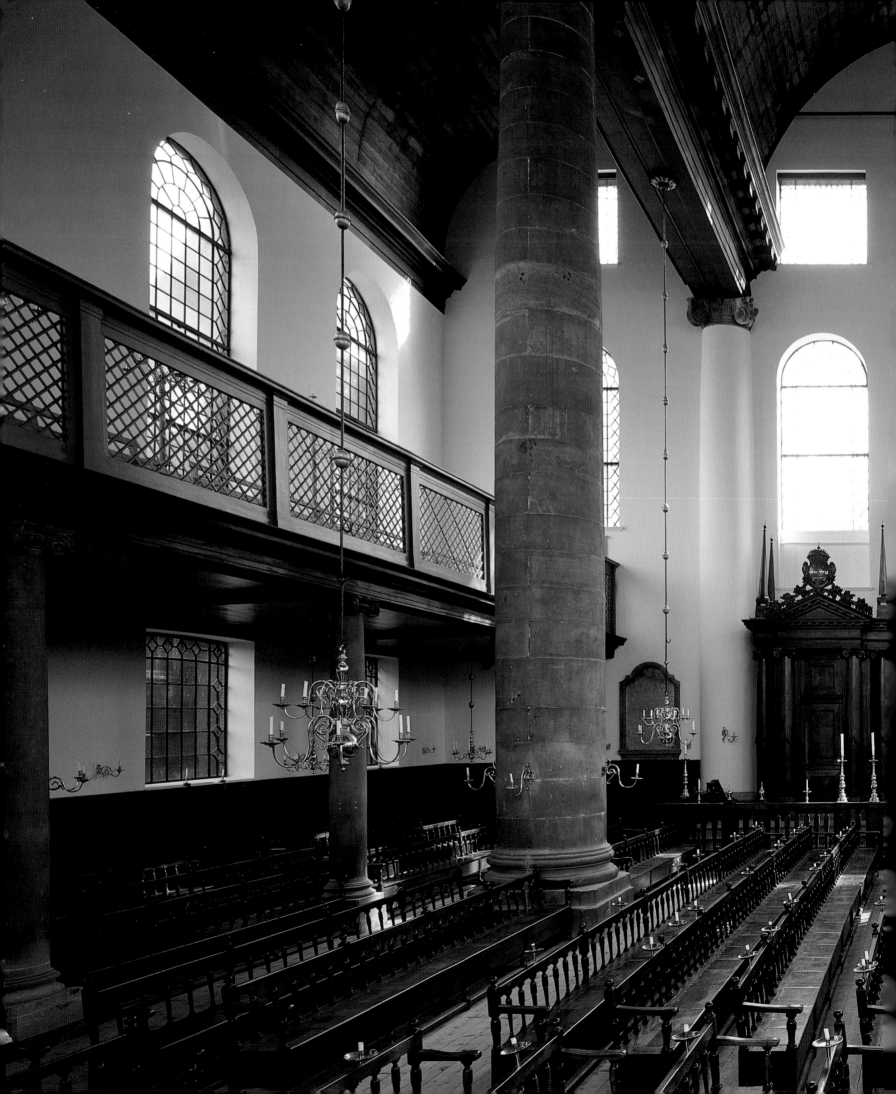

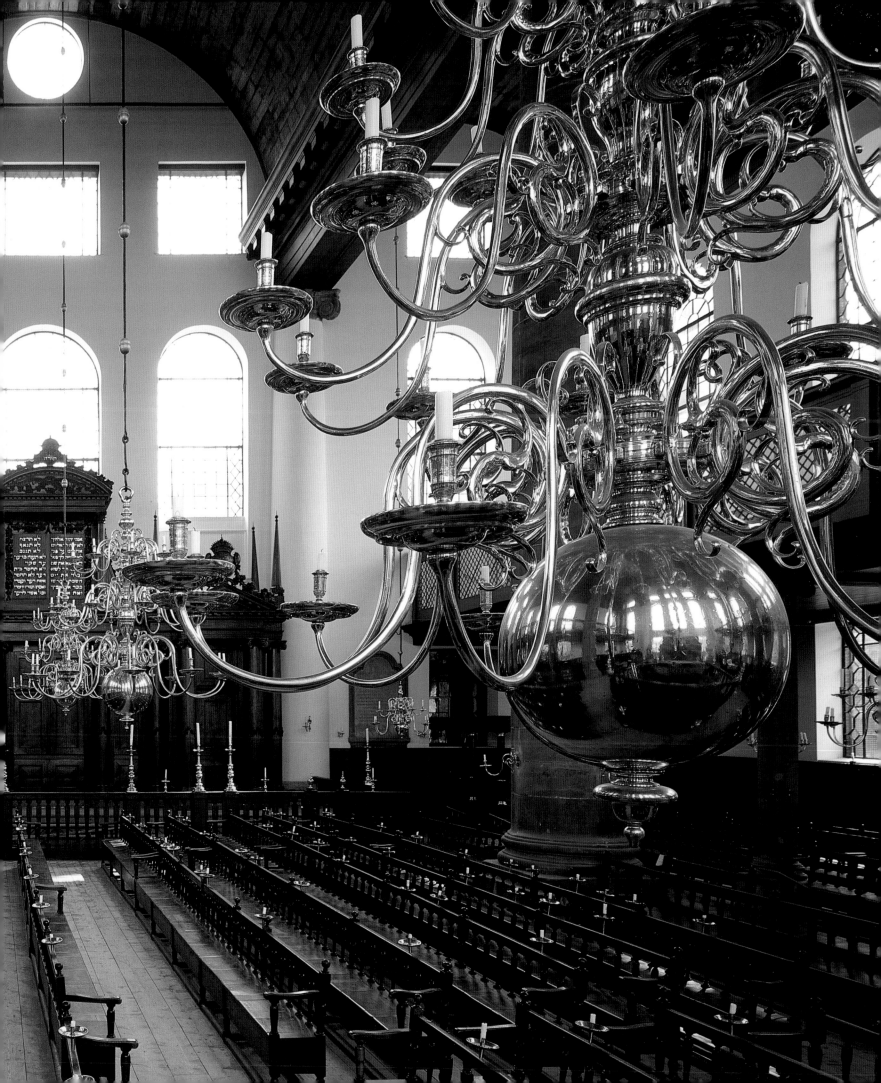

RIGHT The Decalogue over the ark
in the Portuguese Synagogue in
Amsterdam.
OPPOSITE The view towards the ark
from one of the women's galleries
in the Portuguese Synagogue.

now extended by the Dutch to all comers. These included the Huguenots from France, and Jews from Spain and Portugal, who since 1590 had sought refuge from the Inquisition in Holland. To survive in the Iberian peninsula they had had to accept the outer forms of Christianity. In Holland, on the other hand, they could practise their religion without hindrance. Folk tales of the 'urban myth' variety depict 'bishops' rushing ashore down the gangplanks of Spanish ships in Dutch ports crying 'Are we in time for mincha?' (the afternoon service) as they stripped off their episcopal gloves and tossed their mitres into the sea.

The graph line of Dutch architectural excellence and Sefardi prosperity crossed at Amsterdam in 1671, when the foundations were laid for the Great Portuguese Synagogue. Four great magnates of the community set the cornerstones. One of them was the Ilustríssimo Dom Jeronimo Nuñez da Costa, known to his friends, though, as Mosseh Curiel; he was the financial agent of the King of Portugal.

It took four years to build the synagogue, following the design of the contractor, Elias Bouman, who was not Jewish. The total cost was 186,060 florins, 2 styvers and 8 pence. The dedication service started on 2 August 1675 and continued for several days. As well as a choir, there was an orchestra: extraordinary evidence of the inroads of acculturation. The façades of the huge rectangular brick building are articulated by a giant order of pilasters that rises through all the storeys to support a thin entablature beneath a balustrade masking the roof. The relationship of these vertical features to the windows in the bays they embrace is very nicely judged.

Here at last the Jews could raise a building that towered above every other—'the glory of the Amstel and its senate' was what Romeyn de Hooghe called it—in compliance with the Talmudic ruling about the necessary pre-eminence of synagogues. For the poet Jacob Israël de Haan this synagogue evoked the image of the Temple in Jerusalem 20 centuries earlier:

Stout bouwt het Huis der Joodse Portugeezen
Gelijk de Tempel twintig eeuw voor dezen.

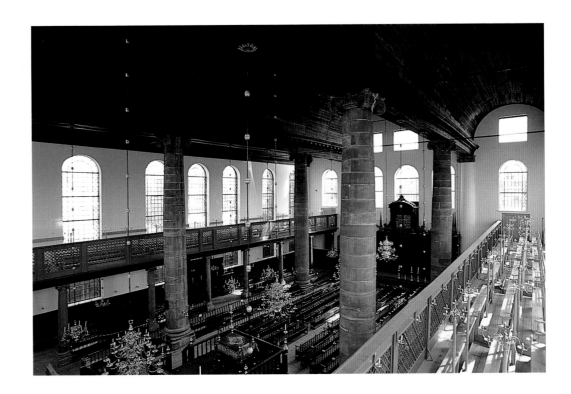

This likeness was deliberately reinforced by Bouman's use, on the exterior, of a concave buttress at the foot of each pilaster, doubtless to conform with a detail invented by Rabbi Yakov Yehudah León, a member of the Amsterdam community, for the famous model he made of the Temple.

The interior of the synagogue, 125 by 85 feet (38 x 26 metres), accommodates 1,227 men and 440 women. Its impact is stunning. Four colossal unfluted Ionic columns of Bremen stone, with a pair of engaged columns on each end wall, support an amply detailed entablature, from which springs a central barrel vault in wood that runs the length of the hall. A minor order of columns set back in the slightly lower aisles, which are also barrel-vaulted, supports the ladies' galleries—said to be the first example of an integrated design for this feature, at least since antiquity. Romantic antiquarians have seen in it an attempt to recreate the *diplostoon* at the Great Synagogue of Alexandria. A more conscious recollection is the deliberate omission of a length of moulding from the gallery parapet, a practice derived from the Talmudic ruling (Baba Bathra 6ob) that no new Jewish building should be perfect or complete before the Temple is restored.

Four great candelabra with huge reflecting balls hang down in a line along the

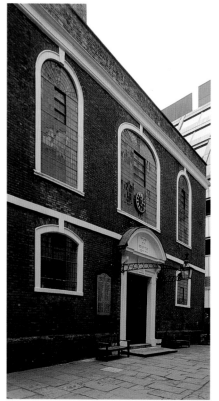

centre of the hall; there are four lesser ones in each of the two side aisles, and beyond that, under the galleries, a further seven on each side. They all hold wax candles, not electrical glass imitations. The same is true of the candlesticks at each congregant's place, those on the bimah, on the balustrade of the tripartite rosewood ark, and on the wardens' box, not to mention in the sconces on the columns and elsewhere. The Esnoga, as the Sefardim call their synagogue, is rarely, if ever, filled now. The scene on the day it was consecrated has been recorded for posterity by the artist Romeyn de Hooghe in a broadsheet published at the time, which shows the great nave thronged with the *beau monde* of Amsterdam, while emblematic figures—the High Priest with a sefer torah, the Dutch Republic and Freedom of Conscience—float above in a Baroque cloud, borrowed for the occasion from the Father, Son and the Holy Ghost.

The synagogue courtyard is surrounded by various low buildings. One of them is the *beth ha-medrash* or minor synagogue. I attended a service for the inception of the sabbath there, one Friday night in March 1952. Prayers for the Queen of the Netherlands were recited in Portuguese by a minister dressed like a seventeenth-century cleric. Next door was a library, where the pages of the register of congregants were turned back to show me Baruch de Spinoza's name, struck through when the great philosopher was excommunicated by the Beth Din, the rabbinic court, on 27 July 1656. This *cherem*, or ban, has never been revoked, though the congregation does admit to a rueful pride in its sceptical member. I was also shown a copy of a Hebrew book printed in Amsterdam 'in the first year of the Saviour', that is the false messiah Shabbatai Tsvi. This was a souvenir of the year 1666, when grave burghers from Hamburg to Amsterdam snipped off their sidelocks, the better to hear the angels sounding the last trump, an event that was thought to be imminent.

The Great Portuguese Synagogue of Amsterdam came to be regarded as the mother synagogue of the western Sefardim. One of her most personable offspring is the Bevis Marks Synagogue, found in the street of the same name, which runs parallel to

OPPOSITE ABOVE The front elevation of the Bevis Marks Synagogue (1699-1701) in London. The simple classical detailing with stone trim set off against brickwork recalls Wren's City churches; not surprisingly, since both were influenced by Dutch precedent.
OPPOSITE BELOW Capital of one of the Corinthian columns flanking the ark in Bevis Marks.
BELOW The tripartite design of the ark in Bevis Marks recalls the Amsterdam Esnoga. The upper level, displaying the Tablets of the Law, is linked by scrolls to the lower range in a way that recalls the façades of Renaissance and Baroque churches.

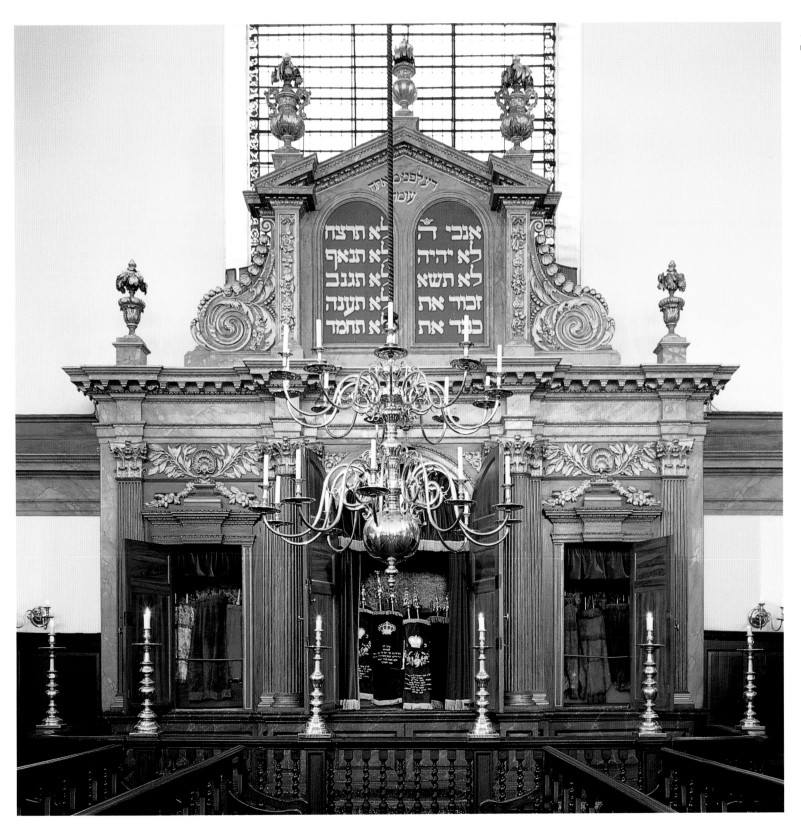

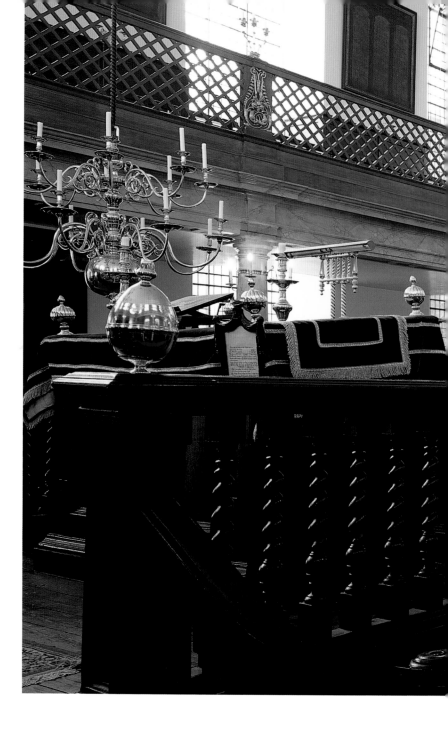

ABOVE TOP The calendar beside the ark.

ABOVE Detail of the lattice parapet of the ladies' gallery. This ornate finial holds a candelabrum.

OPPOSITE ABOVE The interior of the Bevis Marks Synagogue shows the characteristic Sefardi layout, with the bimah (left) and the ark (right) facing each other on opposite walls.

OPPOSITE BELOW The galleries are borne on Tuscan columns, while the chandeliers recall those at Amsterdam.

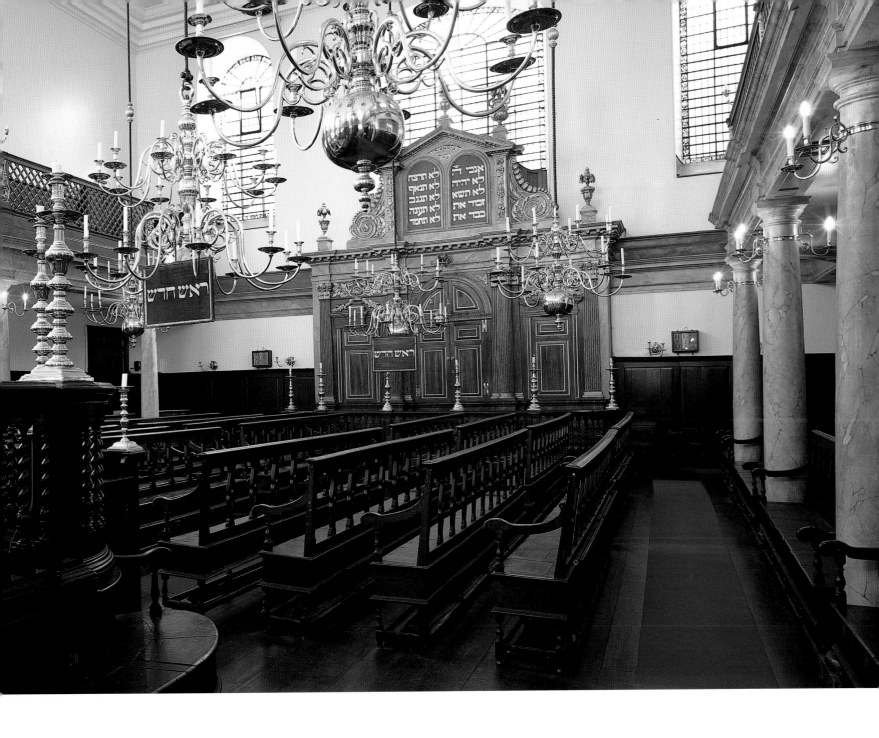

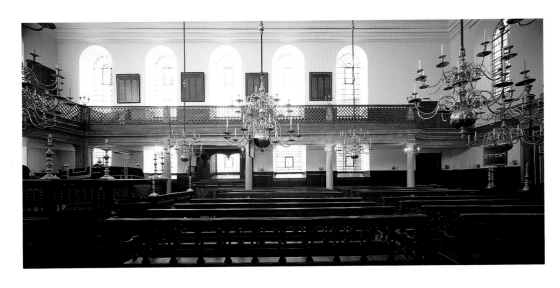

Houndsditch in the City of London. This synagogue was built by the Sefardi community less than half a century after Oliver Cromwell had readmitted the Jews to England, whence they had been expelled by Edward I in 1290. Their first place of worship, established in 1656, was the upper floor of a house in Creechurch Lane, a site now heavily sat on by Cunard House. In 1663 Samuel Pepys paid it a visit during the festival of *Simchas Torah*, the Rejoicing of the Law, when the annual reading of the Pentateuch is concluded, and immediately started again at Genesis i 1. Pepys was greatly taken aback by the horseplay that traditionally takes place on that occasion, for which the staid Anglicanism of his time had not the remotest equivalent, at least in church.

By 1701, the merchants and brokers of the Jewish community had done well enough to afford the £2,650 due to Joseph Avis, a carpenter and joiner, for designing and building the new synagogue. Avis had previously worked as a contractor for Robert Hooke, whom Sir John Summerson characterized as Christopher Wren's closest architectural associate. There is a long-standing tradition in the community (although it has no documentary evidence) that an oak beam from a ship of the Royal Navy was incorporated in the roof of the synagogue, while another relates that Mr Avis 'returned to the wardens on the day of the opening such profit as he had made, refusing to take financial gain from the building of a House of God'.

Bevis Marks is a rectangular brick structure, lit by a series of tall round-headed windows. It has a ladies' gallery with a lattice parapet, borne on an entablature supported by 12 wooden Tuscan columns, with square-section angle piers. All these features recall Amsterdam, though the Dutch synagogue's gallery columns defer to a major order which supports three barrel vaults. Bevis Marks is far more modest: there is no colossal order of columns, and the ceiling is flat. But the familiar brass chandeliers hang down, and there is the usual Sefardi bi-polar arrangement with the bimah banished to the west end of the nave. The ark has the tripartite disposition of the Amsterdam Esnoga, with an upper level over the central bay featuring the Tablets of the Law. Having said this, it must be admitted that the restrained classical style of Bevis Marks is very much at home with contemporary London church building. And why should it not be? The style of Wren's city churches, which were still being erected at the beginning of the eighteenth-century, was probably influenced by Dutch protestant church building: Sir Christopher had no English precedents to go on save Inigo Jones's St Paul's, Covent Garden, and his additions to Old St Paul's Cathedral.

Eighteenth-century English pattern books and architectural treatises, together with congregants' memories of Bevis Marks, were the sources for Peter Harrison's design for Temple Yeshuath Israel, popularly known as the Touro Synagogue after its first rabbi. It was built at Newport, Rhode Island, which was then a British colonial possession, between 1759 and 1763—thus making it the oldest surviving synagogue in North America today. Its tall round-headed windows recall Bevis Marks, and beyond that the Amsterdam Esnoga, though to Sir John Summerson it was 'a plain box on the lines of [James] Gibbs's St Peter, Vere Street', London (1721-24). The interior has two tiers of columns, Ionic below, supporting the galleries and Corinthian above, holding up the coved ceiling. The inspiration here, according to Summerson, was Inigo Jones' Banqueting House in Whitehall, London (1619-22), a design which Harrison could have quarried from William Kent's 1727 book on Jones.

Funds towards the building of the Touro synagogue were contributed by the congregants of Curaçao, an island in the West Indies which the Dutch relieved the Spaniards of in 1634. The splendid synagogue called Mikve Israel, which its wealthy merchants erected there in 1732, still stands. It has an exterior four storeys high in the Dutch colonial style. This tall façade is articulated in three bays by pilasters, reminiscent of the Esnoga, standing on an entablature which caps the ground floor. The pilasters peter out, supporting nothing but themselves, between the second and third floors, but the stuccoed façade rises above them to conclude in three curvilinear features analogous to the Cape gables of Dutch South African architecture.

The interior recalls Amsterdam in several respects, notably in the colossal order of columns that flanks the clear space of the nave between the bi-polar arrangement of bimah and ark, and the minor order behind it, holding up the galleries. Remote from the European feel, however, is the habit of spreading sand on the floor. Some far-fetched explanations have been advanced for this practice, but it is in fact one that is shared by the churches of this tropical region.

The style of classical architecture that originated in Florence in the early fifteenth century passed in the course of 400 years through many phases, from Early Renaissance to Neo-Classicism, via stages such as Mannerism, Baroque and Rococo. As it developed, this reborn classical architecture crossed the frontiers out of Italy, establishing itself in various national guises throughout the world, from Russia to the Americas. Not every country exhibits the whole range of evolving classical styles, nor can synagogues be found which exemplify them all. Sometimes

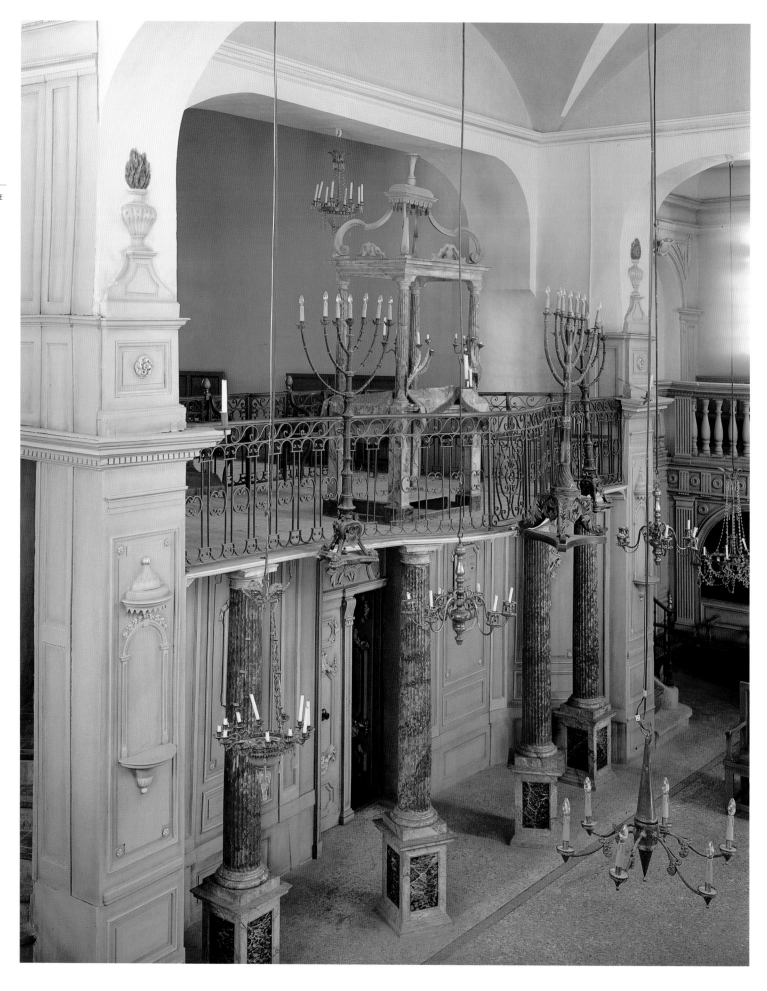

too when a synagogue survives from a particular period, we find that its design has not been adapted from the church architecture of its time, but has been based on a different contemporary building type, such as a refectory or a town hall.

A curious example of the exploitation of contemporary but non-ecclesiastical architecture for a Jewish house of prayer is to be found in two celebrated eighteenth-century synagogues of Provence, in the south of France. The synagogues at Carpentras (1741) and Cavaillon (1772), while their plans and sections are scarcely those of a Louis XV *hôtel particulier*, or town mansion, nevertheless employ the type of decor to be found in its *salons, salles d'assemblée* and *grands cabinets*, with panelled walls, wrought-iron work and classical orders. A striking feature is the elevated bimah, up at gallery level, supported by fluted columns: Roman Doric at Carpentras, Corinthian at Cavaillon. This feature, H. Strauss suggests, derives from the 'duke's gallery' in churches, whence the ruler could watch the celebration of mass. Here an aliyah really was an aliyah: when you were called up on shabbat morning, you had to do some serious climbing before you reached the table on which the sefer torah lay, while the reader stood with his silver pointer, ready to involve you in his public recitation of the never-ending story.

OPPOSITE The elevated bimah on a gallery supported by Roman Doric columns at Carpentras in France. An aliyah here involves some serious climbing.
ABOVE A Rococo grille (1798) at the bimah in the Pinkas Synagogue in Prague. The synagogue itself is medieval.

I adore the old Baedeker guidebooks. Most of them are based on railway journeys that criss-cross the country under review, with greater or lesser amounts of information proffered at each stop. Itinerary 52 in the rare and delectable *Russia* (1914) proposes a tour for which Messrs Thomas Cook probably received few enquiries, 'From Warsaw to Kiev and to Odessa via Zhmerinka'. Turn to page 375 as the train chuffs south and east and you read: 'Berdítchev...contains 77,000 inhab., of whom 80 per cent are Jews... Zhitómir: Pop. 93,000, half of whom are Jews ...Uman, with 42,000 inhab., more than half of whom are Jews.' How long had this demographic trend been building up? Numbers began to increase in the sixteenth century, when the centre of world Jewry moved incontestably to Eastern Europe, 'the cradle', as Lucy Dawidowicz puts it, 'of almost every important Jewish cultural, religious and national movement, and, the area where Jewish faith, thought and culture flourished unsurpassed. Thence came the impetus and vitality that preserved the Jewish people intact in prosperity and adversity.' When this enormous reservoir of humanity began to spill out, from the 1880s onwards, it found its way to the ends of the earth: to western Europe, the Americas, South Africa and Australasia. The offspring of generations of Talmud students left this Jewish heartland for ever. When their descendants turned from Torah study to secular matters, their achievements were extraordinary. They won more Nobel prizes than any other ethnic group on earth, advanced the frontiers of science and scholarship, and built empires in commerce and industry. It is these same people, the dispersed Ashkenazim, who constitute the majority of world Jewry today, and yet in 1939 there were still three million

left in Poland, a tenth of that country's population. The Germans massacred them with such manic diligence, however, that barely 30,000 survived the Second World War.

Where had these Polish Jews come from? Bernard Weinryb details two main hypotheses and eight subsidiary ones, with three folk legends thrown in for good measure. His general conclusion is that the bulk of Polish Jewry was of German-Bohemian origin, and that the initial movement into Poland occurred mainly in the thirteenth and fourteenth centuries, as part of a widespread German immigration into the Slavonic lands, when 'there was no centralized authority to stop them'. But the Jews also came in response to direct invitations from such Polish monarchs as Boleslav V and Casimir III, who thought the immigrants would promote commerce and trade.

There was a golden age of Jewish prosperity in the Polish-Lithuanian state under the Jagiellonian dynasty and its successors. This was during the sixteenth and early seventeenth centuries, although some authorities pin it down more precisely to the years 1580-1640. The Jews acted as factors for the nobility, traded internally and abroad, bred livestock, sold timber and manufactured flour and spirits. From 1580 to 1764 they managed their own affairs in the Council of the Four Lands, which, as Simon Dubnow wrote, 'gave a people without a state a surrogate for national political activity'. This period of autonomy promoted an incomparable flourishing of Jewish religious culture typified at its culmination in the persons of two great eighteenth-century contemporaries, the Vilna Gaon, a Talmudic luminary and polymath, and the Baal Shem, the charismatic and, in a sense, anti-intellectual founder of Chassidism.

Gradually, however, conditions deteriorated in Poland. The Jewish role as agents of the landowning nobility caused resentment amongst the peasants. Ultimately too the introduction of an elective kingship made the country unstable and ripe for partition by predatory neighbours. This is in fact precisely what happened. Poland was divided between Prussia, Austria and Russia, the latter acquiring the most numerous Jewish population. Despotic Russian rule and the concomitant Pale system, which restricted Jewish rights of residence, led to the progressive impoverishment of the Jewish masses, and kept Russia economically backward. The Jewish condition on the eve of the discriminatory May Laws of 1881, which precipitated the great emigrations, was summarized in a letter that Uri Kovner wrote to Dostoevsky in 1877, reproaching the great novelist for his anti-semitism. 'When you speak of the Jews,' he said, 'you include in this term the whole terribly

Gravestones built into a wall by students at the Remo Synagogue (1556–7) in Kraków .

153

THE OLD COUNTRY

wretched race of three million Jews in Russia, of whom at least 2,900,000 lead a desperate struggle for an unfortunate existence.' Nearly 70 years later, Maurice Samuel looked back on this phase with mellower hindsight. 'They managed to survive,' he wrote, 'and even to flourish. But their prosperity was spiritual rather than material. They maintained a remarkable civilization, with values which the world cannot spare. Simply as a demonstration of character in adversity, that civilization should not be forgotten.'

In its heyday, Eastern European Jewry built itself some remarkable synagogues. There were two main kinds: masonry structures in brick or stone, and, in well-forested areas, timber buildings. Many of the masonry shools have survived, but as the Germans succeeded in wiping out 99% of their congregants, they markedly outrun the current requirements of Jewish worship in Poland today. The indefatigable Carol Krinsky has checked out their locations and present uses. The synagogue at Biecz is a hotel, that at Chęciny a cinema. Gorlice is used as a bakery, Józefów as a wheat silo, while the Zassanie shool at Przemysl now serves as a garage.

The wooden synagogues, including such extraordinary masterpieces as that found at Wolpa, in Belarus, are all gone. The Germans torched them all. (I say Germans, not Nazis, as I have no data about their political affiliations, if any.) An extremely brief and infinitely tantalizing glimpse of a wooden synagogue in use may be had in Norman Jewison's 1971 film version of *Fiddler on the Roof*. Here (at

BELOW The fortress-type synagogue at Belz, with its characteristic 'Polish attic'. This synagogue was destroyed during World War I, but the Belzer Chassidim have followed its design for their shool in Jerusalem.

OPPOSITE In the four-pier synagogue at Łańcut a central tabernacle of powerful columns provides support for the vaulting that roofs the hall. The bimah is sited between the columns.

heaven knows what expense) a frescoed interior was created for a panning shot which comes to rest on the Rabbi of Anatevka concluding a *shiur*, or Talmudic disquisition.

Most synagogues were built by Jewish communities to meet their growing needs. Sometimes, however, synagogues were erected by wealthy individuals, as had already happened in Prague. The shool which Isaac Nachmanowicz built in Lvov in 1582, supposedly to the designs of the Italian architect Paolo Romano, completely overshadowed the community synagogue. It was erected in the teeth of complaints addressed by the local archbishop to Rome itself. Occasionally synagogues were erected to serve great scholars. The most notable example of a synagogue of this genre is the one built at Kraków in 1556-7 by his proud father for Rabbi Moses Isserles, a prince of the Torah, whose notes on the *Shulchan Aruch* in effect adapted to Ashkenazi use this authoritative Sephardi compendium of Jewish law. To this day it is the work most often consulted for immediate guidance on all questions of orthodox practice and belief. The Remo synagogue (an acronym for R Moses) was reputedly the first masonry synagogue in the Polish Renaissance style. It was a barrel-vaulted hall with a central bimah and no intermediate columns; round-headed windows were set high up in the walls. The Germans burnt it out in 1940, although it was rebuilt after the war.

The most interesting plan type encountered in the masonry synagogues of Eastern Europe is the one that Szymon Zajczyk dubbed the nine-vault synagogue, a design scheme which originated at the end of the sixteenth century. Four columns or piers stand in the middle of a square hall of nine bays (three rows of three) and form the internal supports for the groined vaults which roof the surrounding bays.

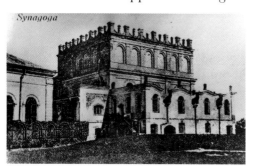

Synagoga

The central space defined by the four columns serves to accommodate the bimah and to make it an integral part of the building, rather than an adventitious fitting. Synagogues of this type included those at Rzeszów (New Town), Łańcut, Pinsk and Lvov Vorstadt (the latter two destroyed), all of them dating from the seventeenth century. The internal views afforded by this arrangement were very striking, and were remote from anything suggestive of a church. The central position of the bimah, in fact, was recommended by Maimonides (*Mishneh Torah*, Tef. xi 3). If you lifted your eyes from your Pentateuch during the recitation of the

Torah, you could work all kinds of symbolic meanings into the architecture: for example, the way the vaults rose and spread out from the four central columns might recall the biblical verse 'for out of Zion shall go forth the law and the word of the Lord from Jerusalem' (Isaiah ii 3).

The aesthetic appeal of these centralized buildings did not escape the notice of discerning Polish artists. Franciszek Smuglewicz (1745-1807), who headed the first Department of Painting at Vilna University, had spent 20 years in Rome, 15 of them during the lifetime of the visionary architect and engraver G B Piranesi. Some

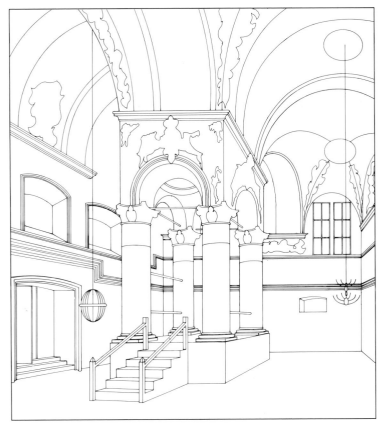

scholars have detected the influence of Piranesi's looming interiors in the painting Smuglewicz executed around 1800 showing the Great Synagogue at Vilna, in which colossal Tuscan columns frame a free-standing central bimah. The bimah's pavilion roof is supported on a minor order of 12 columns, while congregants toil up and down a lengthy flight of stairs that leads to the celebrant's deck. The undersizing of the human figures to force up the scale is another Piranesian touch, but to me there is more than a hint of Rembrandt's Temple interiors.

In marcher country, that is, in lands lying open to attack across loosely defined frontiers, all masonry buildings were regarded as defensible strongpoints. Synagogues were no exception. Many masonry synagogues featured the so-called 'Polish attic', high parapets articulated by blind arcading or by pilasters in a crude Renaissance style. These could serve as fortifications, especially when pierced by gun-loops, as those at Lutsk in Ukraine are. The provision of gun-loops, in fact, was called for in the licence to build the synagogue, which was granted by the crown in 1626. This licence also stipulated that a garrison should be maintained in the shool at the congregation's expense. Other fortified synagogues may be found at Pinsk, Tykocin and elsewhere, while the congregants at Rzeszów, between Kraków and Przemysl, were specifically bidden, in 1627, to stock up with harquebuses and ammunition.

BELOW The shool at Lutsk, showing
its Polish attic. The licence to build,
dated 1626, requires the provision
of gun-loops and the maintenance
of a garrison at the congregation's
expense.
OPPOSITE The Brody Synagogue at
Lvov. The design resembles that of
the shool in the Galician town of
Brody.

With their high parapets, East European synagogues often stood very tall, a circumstance that vexed the church authorities, who were usually quick to take offence. In 1529, for example, the Synod of Gniezno referred balefully to the erection of 'vast new synagogues in brick...comparable to churches'. A mediating device that cushioned the impact of such grandeur at street level was the low-rise annexe, which offered a discreet form of entrance. We have already encountered early examples of this feature further west, in Worms and Prague. Sometimes, however, the temptation to beautify the annexes themselves could not be resisted. A notable example is to be found at Zolkiew, in Ukraine, where King Jan Sobieski's court architect, Peter Beber, was commissioned in 1692 to regularize the west range of annexes. His solution featured, amongst other curiosities, three round-headed portals with heavily rusticated surrounds, each surmounted by a dizzily Baroque cresting made up of three superimposed lengths of segmental pediment supported by progressively taller strips of pilaster.

Concomitantly with masonry synagogues, and in many cases preceding them, wooden synagogues were built. Timber houses and churches are a common phenomenon in the forested lands of Eastern Europe, and the practice of building

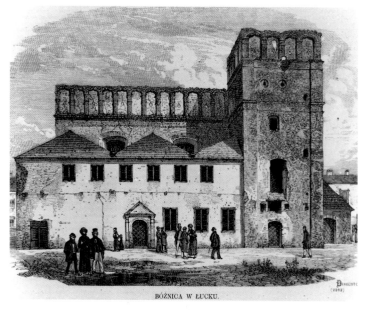

BÓŻNICA W ŁUCKU.

them continued right across the old Russian Empire, from its western frontiers, through Siberia, with its 'slumbering forests', as the *byliny* or old heroic poems call them, to the Pacific shores. The Poles looked on wooden architecture as typical of their country, yet foreign visitors were astounded by the beautiful workmanship and surprised by the very fact that timber was used for important buildings. When it came to churches, the Polish tendency was to imitate in wood the features of the stone or brick prototypes—a curious reversal of classical practice, where the masonry features of ancient Greek architecture are supposed to betray their origins in the characteristic details of archaic timber construction.

If the Jews were lucky enough to hire real carpentry craftsmen and not those to whom Maria and Kazimierz Piechotka delicately refer as 'independent jacks-of-all-trades who practised carpentry as a side line', they would often find themselves in

fortunate possession of very individual buildings indeed, in which the properties of timber were exploited to the utmost to produce vaulted ceilings shaped in a way that could scarcely be matched in stone. In the finest examples, these towering halls were covered by multi-tiered hipped roofs, reminiscent of Chinese pagodas; cousins, perhaps of the *zakomary* or *kokoshniki*, those stepped arches developed by a similar impulse for the roofs of orthodox churches. These extravagant roofs dominated any annexe, corner pavilion or other subsidiary structures that might be appended below. Inside, the walls of the synagogue were covered with bright vernacular frescoes, often showing flowers amid luxuriant vegetation, or animals which excused their presence in a Jewish house of worship by performing symbolic acts: two bears climb a pole to steal honey—but is not the Torah the sweetest of honey? In the middle of the hall, at the angles of an octagonal bimah, Corinthian columns might support an entablature from which soared the curvilinear brackets that held up a fantastic canopy reaching upwards into the dimly perceived heights where bizarre squinches leaned forward from the walls, twisting and wriggling to hold polygonal galleries in place.

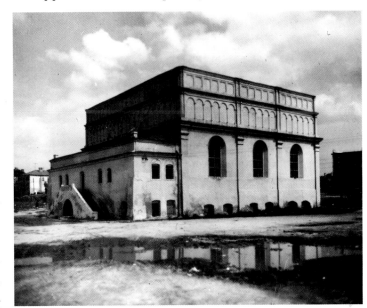

It would, I suppose, go against the grain to recall in this context the words of a book published in London in 1620 in which the anonymous author spoke of 'all possible inventions to catch men's affections and to ravish their understanding'. Against the grain, because the writer was referring to Jesuit churches. Nevertheless, it must have been a memorable experience to have been present at *ne'ilah*, the closing service of the Day of Atonement, at one of the great wooden synagogues. One would have watched the most honoured member of the congregation draw the ark curtain back, revealing the rows of Torah scrolls dressed in white satin and surmounted by glittering silver crowns. The ark itself was an exuberant confection of openwork columns, fretted panels, and, at an upper level, the Tablets of the Law—stone made wood—summarizing Judaism's message to the world in the Ten Commandments.

Travellers in the territories of the old Pale of Settlement, before the Holocaust, used to remark on how the Yiddish language would change in intonation and

BELOW Eaves details of the wooden synagogues, taken from the Piechotkas' book.

OPPOSITE Painted ceiling from the synagogue at Horb (1735) in southern Germany, designed by Eliezer Sussman, an itinerant artist from Poland. After ceasing to function as a synagogue, the building was used as a hay barn. In 1914 it was dismantled and moved to the Municipal Museum in Bamberg, which has lent it to the Israel Museum in Jerusalem.

ABOVE An exploded view of the
synagogue at Grodno, after 1750.
The main hall is nearly square and
covered by a two-tier octagonal
cupola. The transition between these
two shapes is achieved by penden-
tives supporting exuberant coved fea-
tures. The women's sections are
wrapped round in single-storey
blocks with lean-to roofs; an upper
range also ran over the vestibule.
RIGHT The ceiling of the main hall of
the synagogue at Przedbórz,
c.1760. An ornamental tracery of
laths and S-shaped timbers form
ogee lunettes which rise from corbels
at the bottom.
OPPOSITE ABOVE View of Grodno
from the north-west. The three-tier roof
has a mansard framing. The topmost
part has panelled gables. A swoop-
ing cove follows to the lowest tier,
which displays strongly projecting
eaves. The two-storey corner pavil-
ions are covered with swept wooden
shingles.
OPPOSITE BELOW View of Przedbórz
from the north-east. The gabled roof
is intersected by a small roof over the
women's annexe, which is separated
inside from the main hall by a para-
pet and bars.

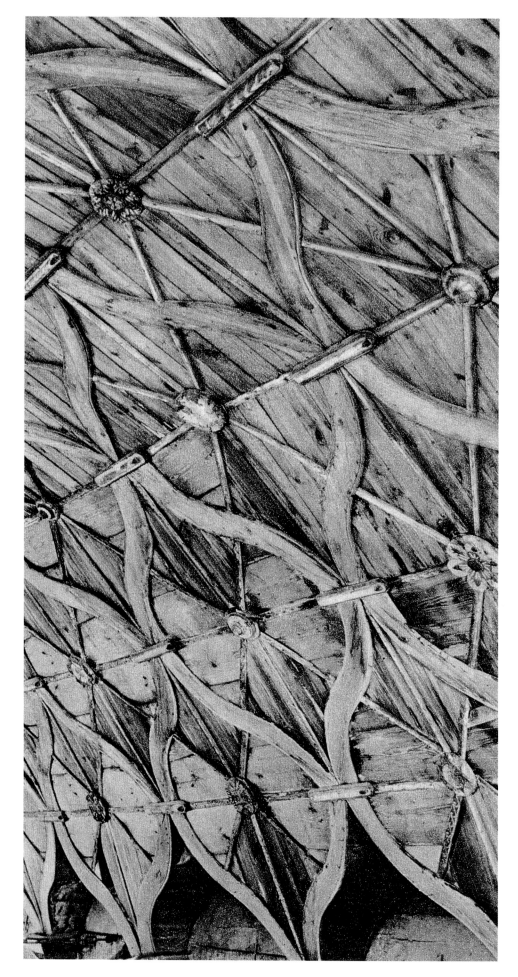

accent from district to district, almost from village to village: thus, 'butter' in Lithuania became 'pitter' in Galicia. The architecture of the wooden synagogues modulated in a similar fashion. The way the timber of the main block was handled structurally, for example, varied from horizontally laid logs to horizontal boards braced by posts and faced externally with vertical planking.

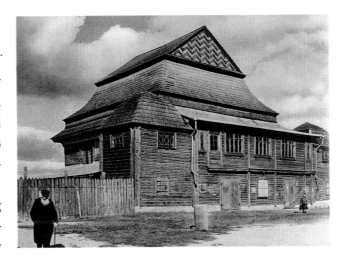

The oldest known wooden synagogue, dating from 1642, was at Chodorów, near Lvov, a village celebrated in Baedeker only for its railway restaurant. Chodorów's prayer hall had a two-tier roof, the lower part hipped, the upper part half-hipped. Inside this read as two deep superimposed coves leading up to a barrel vault, the whole a riot of polychrome decoration. The centrepiece of the vault was a double-headed eagle, painted within an elaborate circular frame which was surrounded by the signs of the zodiac. The artwork has been attributed to Israel ben Mordechai Lišnicki of Jaryczów, known, according to the Piechotkas, in the mid-

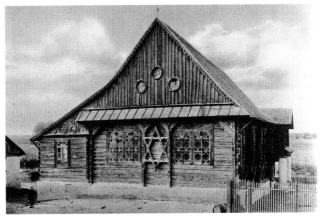

seventeenth century, though he never made it to that pantheon of art biography, Thieme-Becker's *Allgemeines Lexikon*. And anyway, would he have painted a double eagle then? It was the emblem of Austria, which did not help itself to Galicia until 1772 when Poland was first partitioned. Poland's emblem was a single eagle.

Of similar vintage to Chodorów was the wooden synagogue at Gwoździec. It, too, had a two-tier roof, hipped below, half-hipped above, over a square plan. Later on, an annexe was constructed on two sides, to house a school and a women's section. The lean-to roof over this feature added an even lower tier, like a skirt, to the two above. Originally, a timber barrel vault covered the prayer hall, but in the early eighteenth century this was replaced by an elaborate timber ceiling, rising up like the inside of a marquee in two concave sweeps and a convex one. To accommodate this new ceiling, some of the roof trusses had to be cut away and this ultimately led to the roof sagging. The perspec-

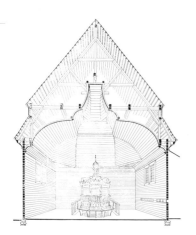

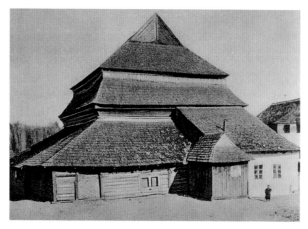

ABOVE An exploded view of the interior of Gwoździec Synagogue. The original barrel vault was replaced *c.* 1700 by the tent-like multi-tiered ceiling shown here; it was painted by Mordechai Lisnicki of Jaryczów in 1729. The octagonal kiosk-type bimah is set halfway between the entrance and the bimah steps.

ABOVE RIGHT The exterior of Gwoździec, from the west. The roof has a gabled summit peeping over two hipped tiers, with a lean-to range around two sides.

tive line drawing in the Piechotkas' book is enchanting, vividly illustrating what Professor Jan Zachwatowicz meant when he wrote that Poland's wooden synagogues represented 'an architecture that was highly original in form and construction, and offered inimitable bold solutions of spatial problems'.

An octagonal kiosk-type bimah was placed in the centre of the shool at Gwoździec. It was surmounted by a canopy, capped in turn by a lantern whose finial pointed straight up to the billowing folds of the roof into which the prayers of the congregation were funnelled and passed straight up to heaven. The Chodorów painter, Lišnicki, was active here, together with his *Landsmann* Isaac ben Yehudah Leib. They covered the synagogue's walls with plants and animals, together with edifying inscriptions in ornate painted frames.

At Olkienniki (1768), four massive timber piers in the centre of the hall helped to support the lower portion of the vaulting, converted into an octagonal dome by the bold use of pendentives. The converging segments created an open octagon in the centre, framed by a balustrade. Through the opening there was a view upwards to the soffit of a higher octagonal dome: a Baroque device which elsewhere might have afforded the spectator a glimpse of some painted epiphany such as a sunburst or the dove of the Holy Ghost. Here the congregants had to make do with the sight of the boss into which the apexes of the upper dome webs descended.

The supreme achievement in the field of timber synagogue architecture was to be found at Wolpa, a *shtetl* unknown to fame, near Grodno in White Russia (or Belarus as it is called today). Experts have speculated that this synagogue might have been the achievement of the carpenters working at the court of the local dignitary, Prince Sapieha, whose clan had originally invited the Jews to settle in the district.

The plan of the synagogue, which was built in the early eighteenth century, was square, with three tiers of roofs. The lower two were hipped, while the top one had gables at each end, displaying the profile of a bell. But the main elevation, the west front, disguised the façade of the high-rise square prayer hall with a pair of corner

pavilions embracing a low half-hipped vestibule between them. The whole design, when viewed centrally, built up to a magnificent triangular composition. The eye swept over the two-tiered roofs of the twin pavilions, thrust apart visually by the deep cornice of the prayer hall roof's lowest tier, underlined as it was by the pitch black shadow cast by a huge overhang. Below it, in the centre, the half-gable of the low vestibule block pointed upwards like an arrow, redirecting your gaze over the shingled tiers of the prayer hall roof to the entrancing bell-shaped gable that crowned the elevation. The details were intriguing, none more so than those found on the corner pavilions, each of which featured a first-floor balcony with turned balusters, and columns with exuberant capitals that rose through the balustrade to support the roof. Between each pair of columns an unsupported capital hung down from the eaves as a decorative pendant. I have to admit, at the risk of sounding facetious, that these jolly domestic-scale verandahs irresistibly recall the one at Mrs Alte Recreation's guesthouse in the suburbs of Kasrilevke, where, according to Sholem Aleichem, the habitués would drag out the old samovar and sit drinking Wisotsky's tea. And what a verandah it was! 'It could accommodate three dozen tea-drinkers with ease. Not all at once, of course. One at a time.'

The interior of the Wolpa synagogue was extraordinary. Our only evidence consists of photographs and drawings, and it is difficult to know which to admire more: the chocolatey photogravures in the Piechotkas' book, or the stunning drawings, especially the cutaway perspective, made by M Kuzma for the Institute of Polish Architecture. Both reveal a square wooden hall, lined by horizontal boarding and masked below by the painted courses and marbling of fake masonry, like an Irish pub façade. In the centre, four square timber piers, each 36 feet (11 metres) tall, surround the bimah. Their vertical impetus is imperfectly restrained, at 26 and 36

BELOW LEFT & RIGHT Olkienniki Synagogue, dated after 1750. The square hall has four piers, fanning out above the capitals to support an octagonal dome. This is open in the middle to give a view of a farther range of vaulting. The roof of the bimah is surmounted by an extravagant turret, from the pinnacle of which a crowned eagle—the single eagle of Poland—prepares to take off.

feet (8 and 11 metres) respectively, by the insertion of thin but wide capitals. These piers support the topmost stage of an ascending series of hammer beams and hammer posts, which ingeniously support the three-tiered roof while making room inside for a succession of curvilinear spandrels which tumble down like a wooden cascade, to

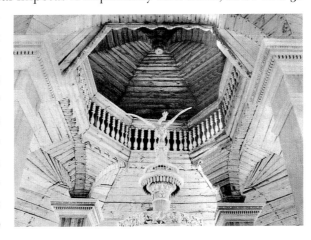

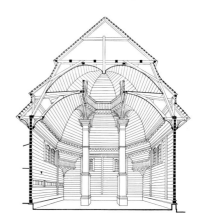

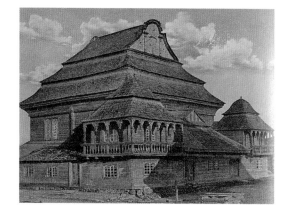

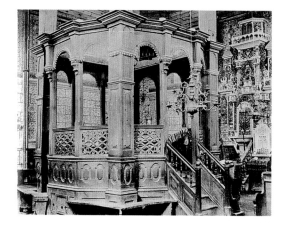

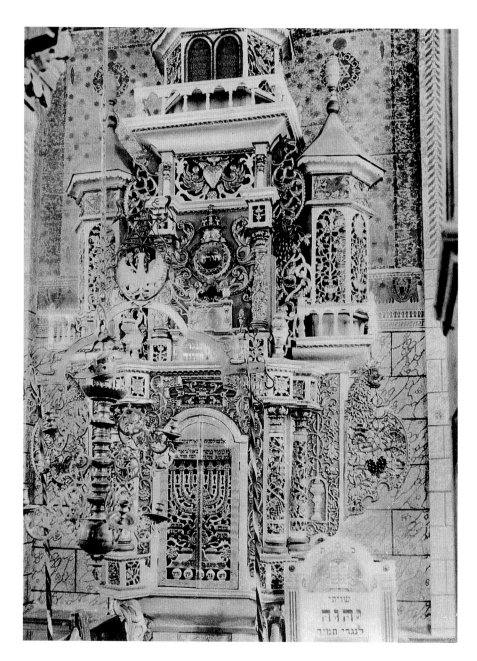

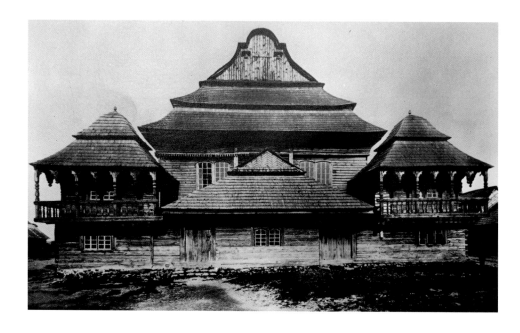

support ever-widening octagonal openings, framed by balustrades until they finally come to rest on elaborate pendentives in the corners of the hall, pendentives which afford the transition to a square plan. Of course, you can read the story the other way round, with your gaze tracking upwards, passing tier beyond tier (who, or what, is lurking behind those mysterious balustrades?) until it disappears through the topmost hole into an octagonal dome; but you will find no overwhelming Baroque *quadratura* there, just a display of virtuoso carpentry.

The other startling cynosure of the interior was the ark, a stupefying Baroque device that rose upwards from the gates (fretted to resemble a seven-branched can-

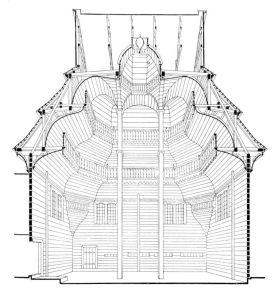

delabrum) through storey by dizzy storey of columns, vine scrolls and medallions until it reached a half-hexagon inset with the Tablets of the Law and fronted by something that suspiciously resembled a benediction loggia. Beyond the outer carved panels of the ark's ground storey a huge fret-work bird—crowned head, ruffed neck and one wing—projected on each side over the adjacent Irish pub walls. Presumably this was a double-headed eagle, split neatly down the centre line and parted by the width of the ark. Yet the fairy-tale nature of the whole amazing structure makes one think, before anything, of the *zolotóy petúkh*, the golden cockerel of Russian folklore, immortalized by Pushkin and Rimsky-Korsakov.

OPPOSITE Views of the early eighteenth-century synagogue at Wolpa showing the ark flanked by the two halves of a double-headed eagle (right) and the bimah placed between the four central piers (left below). The main elevation is a powerful triangular composition, building up from the corner pavilions to the bell-shaped gable at the apex. LEFT The glory of the timber interior at Wolpa in which a succession of curvilinear spandrels tumbles down like a wooden cascade.

The synagogues in the Pale of Settlement in Eastern Europe were used not only for worship, but also for study, which Jewish tradition esteems as highly as prayer. Sometimes this took place in the main hall—as memorably captured in the brief shot in *Fiddler on the Roof*—and sometimes in the *bethmedresh*, the minor synagogue-cum-study room attached to a larger establishment.

This devotion to study, chiefly to studying the Talmud, was an extraordinary phenomenon. My late brother-in-law recalled that at the Jewish Students' Society of Liverpool University in the mid 1930s, they used to sing, to a jolly tune, a Yiddish song from the Old Country that, if translated into English, would go something like this:

See the peasant run into the inn
to snatch a drop of brandy;
See the Jew run to the bethmedresh
to snatch a page of torah.

The verse is comparing like with like: Polish peasants and Jewish waggoners, fishmongers, tailors and petty traders. 'The Jews,' argues Maurice Samuel:

> were no more a nation of scholars than they were a nation of priests; but among no other people was there such universal interest in scholarship, or such an interpenetration of the masses with the slang of scholarship. The logical technique of the Talmud, the phraseology of its ratiocination, belonged to the conversation of the market place, and was parodied in popular jokes.

It was the descendants of these 'masses interpenetrated with the slang of scholarship' who, in the context of an open society, went on to win all those Nobel prizes.

The importance of the East European synagogue in the lives of its congregants has often been remarked on. A typical comment is that of Dr Stephen S Kayser, sometime curator of the Jewish Museum in New York: 'if there ever was a truly close relationship between a house of worship and its populace, it lay in the affection which the inhabitants of an Eastern European community felt for their synagogue, the house of their souls. Their love and devotion built it, embellished its interior, flocked around it and felt divine protection under its shadow in time of peril.'

It goes without saying, however, that synagogues such as the one at Wolpa represent the *crème de la crème*, and demonstrate, as Dr Kayser puts it, that 'the symbiosis of the Jewish population with their Polish neighbours was much more intense than the outer signs of its historic development may suggest'. But not every congregation enjoyed such apotheoses of architecture; for some, their synagogue may have afforded spiritual relief from a humdrum daily existence, but it provided little aesthetic delight. Any Yiddish novel set in this period will illustrate the point. In his most famous book, *The Brothers Ashkenazi*, Israel Joshua Singer, elder brother of Nobel Laureate Isaac Bashevis Singer, speaks of the weavers' synagogue in Balut, a district of Lodz, describing it as 'a dilapidated hut jammed in between factories and coal yards'. Reb Chaim Ashkenazi, the Chassidic owner of a mill, has an even handier arrangement: he turns one of his stockrooms into a synagogue, a domestic chapel, so to speak. There is a lectern and a small candelabrum, so that his workers

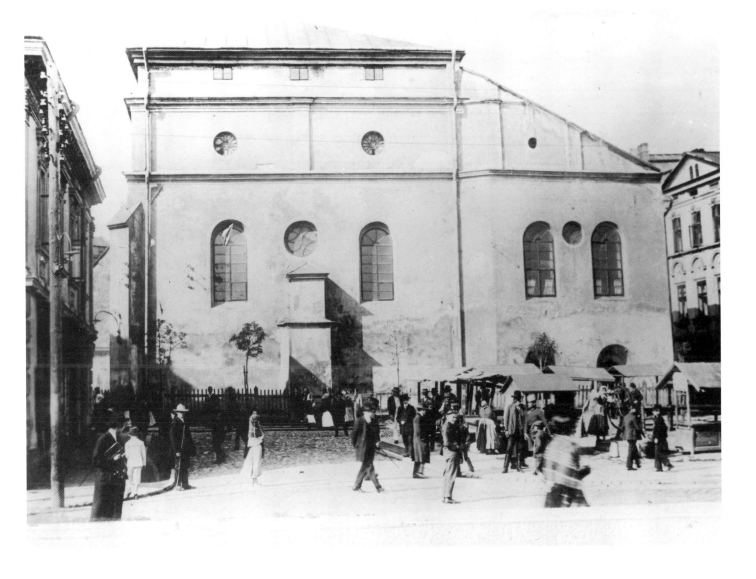

ABOVE & LEFT The synagogue at Przemysl (1592-95) is of the four-pillared tabernacle type with the bimah placed between four central columns.

RIGHT An itinerant hat seller in
Kraków, c.1938.
OPPOSITE Vignettes from Kraków.
The shool (top left) is the Old Syna-
gogue in the suburb of Kazimierz,
built in the early sixteenth century
and remodelled in 1570 by
Matteo Gucci. The 'Polish attic' is
decorated with blind arcades.

'can say their afternoon and evening prayers with some degree of formality. This has two advantages, the one spiritual, the other material. The workers can indulge in group prayer, which is so much more acceptable to the Almighty; also they don't have to go out of the factory to a synagogue.'

The workers are in their *shtiebel*, or chapel of ease, on Saturday afternoons, too, when a teacher employed by Reb Chaim teaches them *The Ethics of the Fathers* in summer and 'special prayers from the Psalms' in winter. On summer Saturdays, the sabbath 'goes out' much later, as daylight fades. When it does, the workers troop out of the synagogue room and back to the factory floor, to work until midnight at least, thereby making up for lost time: Sunday, of course, will be an ordinary working day. Their employer appears and wishes them a *gut voch*, the traditional greeting at the end of the sabbath and the start of another week:

'A happy week to all of you,' says Reb Chaim as he steps into the factory. 'A happy week to all of you and to all Jews.' Suddenly activity breaks out in the long, dim-lit room. The elderly Jews, who have been talking casually about one thing or another, but chiefly about their daughters, whom it is so difficult to marry off these days, turn hastily to the looms. They push down from their foreheads the spectacles which most of them wear, they stretch their lean, thick-veined hands to the looms, they work the treadles with their tired feet, they rock right and left on their seats. 'A happy week to you, Reb Chaim,' they answer in chorus.

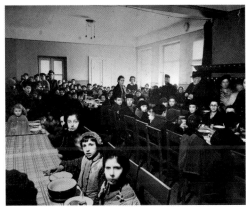

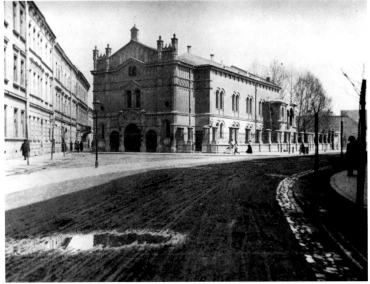

The history of any human activity is human history seen from a particular viewpoint. If an archaeologist, 5,000 years from now, were to retrieve *A History of Pigeon-Breeding* from a well-stratified context as the sole surviving item of English literature, it would still be possible, with the exercise of some ingenuity, to derive a good deal of information about the history, manners and material culture of Britain from a scrutiny of the rise of the Improved English Pouter and the wane of the Turbit and Frill-back. How much more light, then, might be shed by a study of architecture, a field of activity that is at the heart of world civilization? If we concentrate our attention on a particular building type, such as the synagogue, we may learn something about the development of architecture in general, the ideologies that inspired it, the social progress of the Jews and the emergence of divisons within Judaism itself.

The various classical styles of architecture derive from a reborn fascination with antiquity that surfaced at the beginning of the fifteenth century. These styles continued developing, driven by their own creative impetus, for 400 years, and only began to encounter competition from other sources towards the end of the eighteenth century. This competition came from the revival of various medieval styles, at first Romanesque and Gothic; later, for the real connoisseurs, Byzantine and Celtic. This phenomenon in architecture was concomitant with the rise of the Romantic Movement in literature and art, though to confuse those who like simple formulas, Sir Nikolaus Pevsner has placed Neo-Classicism in architecture firmly within the ambit of the Romantic Movement.

Whatever the fine arguments of the architectural theorists, historic revivalism

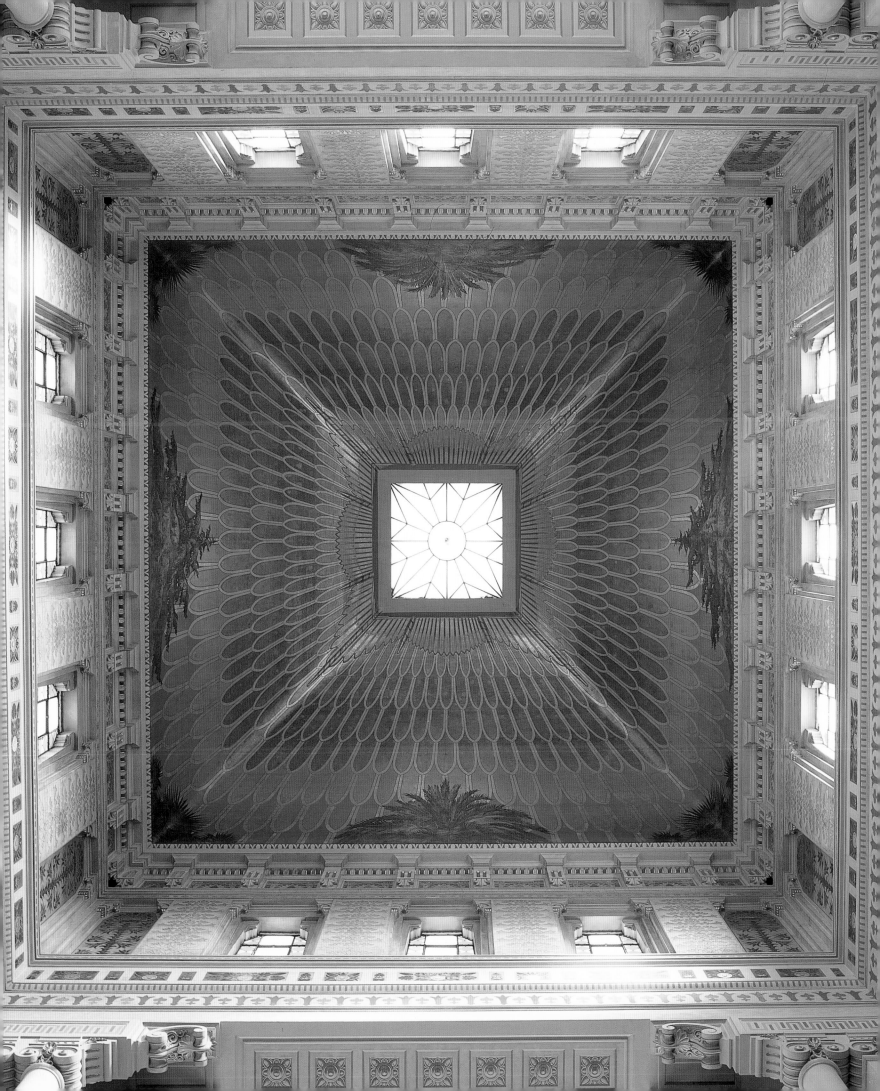

was on the march. The first man prepared to live where his taste lay, as opposed to erecting cute 'Gothick' pavilions to look at, was Horace Walpole. In building his villa, Strawberry Hill at Twickenham (1750-70), he drew on the whole panoply of Gothic architecture, basing his fireplace designs, for example, on the shrines in medieval English cathedrals. Walpole's house became famous all over Europe, and the style began to spread. Even countries that had no 'Gothic' past to speak of joined in. By 1775 Catherine the Great of Russia was commissioning a Gothic Revival palace at Tsaritsyno, though her enthusiasm had left her before the building was completed.

The emergence of the Gothic Revival was concurrent with the last phase of the classical tradition: Neo-Classicism, which as we have seen, some scholars also regard as a Romantic phenomenon. Classical buildings in Romantic settings were an invention of eighteenth-century English landscapers, and this combination was greatly admired and copied abroad. A German example may be found in the Duke of Anhalt-Dessau's park at Wörlitz. The inspiration was perhaps Stourhead in Wiltshire, where ornamental buildings were (in Summerson's words) 'placed in groves or beside lakes...to be seen as beautiful or curious incidents in a scene of controlled wildness'. This is the effect that Duke Leopold Friedrich Franz and his architect Friedrich Wilhelm von Erdmannsdorf aimed for at Wörlitz, laid out between 1765 and 1802. You wandered through the grounds and encountered a

Gothic house, the Grotto of Egeria, the Wolf's bridge, Luisa's rocks, a Temple of Flora, the Pantheon and (can I believe my eyes?) a circular synagogue done up like a tempietto. This round temple is 36 feet (11 metres) in diameter, reminiscent of the Temple of Vesta at Tivoli, except that Tivoli's free-standing peripteral columns have become broad applied pilasters, with round windows set in between them high up. The internal arrangements, with a central bimah, were somewhat awkward. The object of the exercise, however (though I may be

doing His Grace an injustice here) was less to accommodate a congregation than to be picturesque. English milords even paid 'hermits' to occupy designer-ruined fanes in their parks. It would not have been out of keeping if Anhalt-Dessau had maintained a bearded Talmud student *in situ* to pore over a folio and thereby add interest to the scene.

One of the last manifestations of the continuous, but evolving, classical tradition, was the synagogue built in the Seitenstettengasse, Vienna, in 1826 for a 'moderate Reform' congregation. The Reform movement began in Germany in the first decade of the nineteenth century. It was a by-product of emancipation, the gradual acquisition of civil rights by Jews, which had started in America but achieved wider resonance in Revolutionary France. Emancipation gave easier access to secular education and hence to acculturation. From modest beginnings, with sermons and some prayers in the vernacular, the Reform movement has grown enormously. Sects have succeeded sects, each one departing ever further from orthodoxy: organs in synagogues, mixed seating, bare heads, optional adherence to the dietary laws, the demotion of the Oral Law and gay congregations. All of this was undreamt of when the wealthy, reform-minded congregants were planning the new regime at the Seitenstettengasse synagogue, though the idea of an organ did cross their minds. The rabbi and the cantor rejected the suggestion, however, and they were supported in this by Giacomo Meyerbeer. Ladies were still restricted to the gallery that ran in two tiers between a ring of Ionic columns which supported the entablature of a handsome oval hall, roofed by a dome. The architect was Josef Kornhäusel, an eminent practitioner who had built Weilburg Palace for Archduke Karl at Baden-bei-Wien. So that the sight of good Catholics should not be affronted, the synagogue was concealed in a courtyard reached via a passageway between nos 2 and 4 Seitenstettengasse. These were five-storey apartment blocks, also built by Kornhäusel; the synagogue was actually integrated with the rear of no. 4. The plan shape has elicited suggestions that it derives from the Pantheon in Rome, but there were in fact many circular churches under construction at the time, most notably Pietro Bianchi's San Francesco di Paola (1817-46), facing the Royal Palace in Naples across the Largo del Palazzo Reale, now called the Piazza Plebiscito.

Two years after the dedication of the Viennese synagogue, a book was published in Karlsruhe under the title *In welchem Style sollen wir bauen?* (What style should we build in?). The author was Heinrich Hübsch, a prominent architect and prolific writer. The question he posed had not been asked for many centuries, not since

'the cheerful modern style', as Michelangelo called it, had ousted Gothic architec-
ture. Hübsch was advocating a return to the round-arched manner, the *Rundbogen-*
stil, of Byzantine and Romanesque architecture, on the grounds of economic and
structural rationality rather than historic appeal. The later medieval development
called Gothic architecture was the one to find favour in England. It was, said John
Ruskin, 'not only the best but the only rational architecture as being that which
can fit itself most easily to all services, vulgar or noble...It can shrink into a turret,
expand into a hall, coil into a staircase, or spring into a spiral with undegraded
grace and unexhausted energy—subtle and flexible like the fiery serpent, but ever
attentive to the voice of the charmer.'

Medievalism was back; it was, as they say, up and running. But was it suitable for
synagogues? Opinions were divided. 'The German Jew living in a German state
should build in a German style' said Edwin Oppler, and proceeded to do so in his
recommended Rundbogenstil. The English Jewish architect Nathan Joseph was
more cautious. 'Gothic architecture', he wrote, 'is scarcely admissible, being essen-
tially Christian in its forms and its symbols.'

Whether real medieval Gothic can be labelled a Christian type of architecture is
debatable. What put Joseph off was probably the attitude of people such as Augus-
tus Welby Pugin, who equated Christianity with Gothic and then went on, in Pevs-
ner's words, 'to transfer the equation into architectural theory and practice'.

Be that as it may, a threefold path was opened up for synagogue architecture as
a result of the battle of the styles. Some designers followed Oppler into
Romanesque and Gothic, while others went Nathan Joseph's way. He contin-
ued the remarks quoted above by saying: 'For an ecclesiastical edifice like
ours the Moresque seemed to me to be that which recommended itself on the
score of its dignity, its Eastern origin, its elasticity of adjustment to internal
requirements [shades of Ruskin!] its economy of space and even economy of mate-
rial.' And the third path? The third path was a golden mean, an attempted com-
promise between east and west, which, while not disrupting the townscape, still
gave notice that something not quite Christian was going on inside. It was seen at
its most eclectic in an example constructed at Karlsruhe in 1791 where a huge
Gothic archway between two Egyptian pylons led to a pedimented building in
Neo-Classical style.

The first real post-classicist synagogue was built at Kassel in 1836-9 to the
designs of the *Oberlandbaumeister* August Schuchardt. The bureaucratic manoeu-
vrings behind the scenes which ultimately gave rise to the project have been exten-

sively researched and cast much light on the history of taste, the social attitudes and the departmental intrigues at a small German court of the epoch. They need not detain us here. Schuchardt's front elevation, constructed in what he referred to as Rundbogenstil, displayed the typical schema of a German Romanesque church façade. Like the west front of Speyer Cathedal, its three bays were marked off by pilasters and it had hanging arches beneath the eaves. The central gable, however, was cranked up at a shallower rake than was customary in the German lands, showing a closer link in fact to Italian Romanesque practice. There were two storeys of round-headed windows and, on the frontispiece, a third storey of bull's eyes. The interior was a barrel-vaulted basilica with round-headed nave arcades.

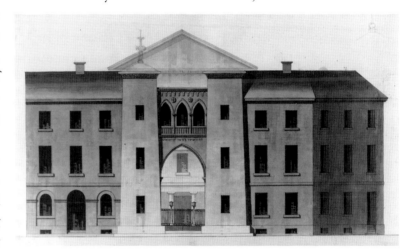

The original site proposed for the Kassel synagogue, one which had been suggested by the *Landgraf* himself, would have closed a vista in the developing townscape. The congregation nervously declined, preferring to keep a low profile as far as their contribution to civic architecture was concerned. A decade earlier, their co-religionists in Vienna, as we have seen, had been obliged to conceal their fine synagogue in a *Hinterhof*, in effect a back yard off the Seitenstettengasse. Fast-forward the video of history to the 1860s, however, and the scene is transformed. Huge and imposing synagogues have risen, or are rising, on the best streets of Berlin and Budapest, and *faute de mieux*, on a less notable thoroughfare in Paris. Even the most reactionary régimes were granting Jews civil rights, and with the freedom to vote, trade and study, Jewish communities were expanding, prospering and reaching into the upper echelons of commerce and the professions.

There is a crude Central European saying that goes *wie es sich christelt, so judelt es sich auch*. Equally crudely translated, this means: the way that it Christians, so does it Jew. The implication is that Jews tend to take on the national characteristics of their host nations. British Jews, though for the most part not remotely orthodox, still attend orthodox synagogues and eschew Reform because they have a British distaste for upheaval and a British preference for compromise. Their affiliation remains orthodox, but they do as they please: shool on Saturday morning, with

BELOW LEFT The synagogue in rue de la Victoire (1861–74), Paris: a stunning Romanesque cathedral in a humdrum urban context.
BELOW RIGHT Moulding stop on the facade of the rue de la Victoire synagogue.

OPPOSITE Moulding stop and column capital between the first-floor windows on the façade of the synagogue in rue de la Victoire.

FOLLOWING PAGES View towards the ark in the rue de la Victoire synagogue. The triforium range above the nave arcade has been monstrously expanded to house the ladies' gallery.

176

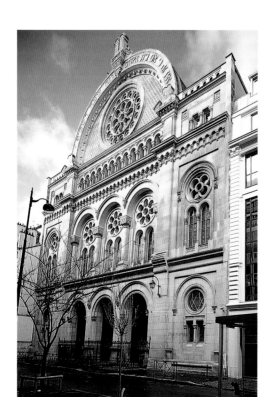

sex-segregated seating and the service all in Hebrew, Manchester United in the afternoon. Hungarian Jews were comparably Hungarian, at least in the nineteenth century. Do you recall the famous lines of the national bard, Sándor Petőfi?

If the earth is the cap of God,
Then Hungary is the feather in the cap.

That kind of national conceit had to be reflected in the Jewish community, and it was. The Jews of Budapest built a synagogue to seat nearly 3,000 people at the corner of Tanács Körút and Dohány utca. Consecrated in 1859, it is the largest in Europe—a feather in somebody's cap, if not God's.

It was not for want of trying that the Jews of Paris did not erect a synagogue in a prominent part of the city. They were allegedly frustrated in their endeavour by the Empress Eugénie's confessor ('reputedly a converted Jew'). I cannot imagine how he put his oar in, but then a surprising variety of things can be traced back to Eugénie, who was born in Granada. It was she who supposedly told Prosper Mérimée the story of Carmen...

On se recule pour mieux sauter. To gather strength, the community withdrew to the somewhat secluded rue de la Victoire, where a private synagogue existed at no. 44, and between 1861 and 1874 they inserted a stunning Romanesque cathedral into

the humdrum urban context. The front elevation (no sides are visible from the street) is a translation into Romanesque Revival of the early Renaissance façade of Santa Maria dei Miracoli in Venice, complete with semi-circular pediment and rose window.

On viewing the interior, a twelfth-century abbot would have been gratified at first glance, then puzzled. Here are the barrel-vaulted bays, the soaring piers, the domed apse...but what has happened at the sides? The nave arcade, though richly embellished with guilloches and other Romanesque trimmings, is dwarfed by a soaring triforium storey, rather than the other way round. In a Romanesque basilica or

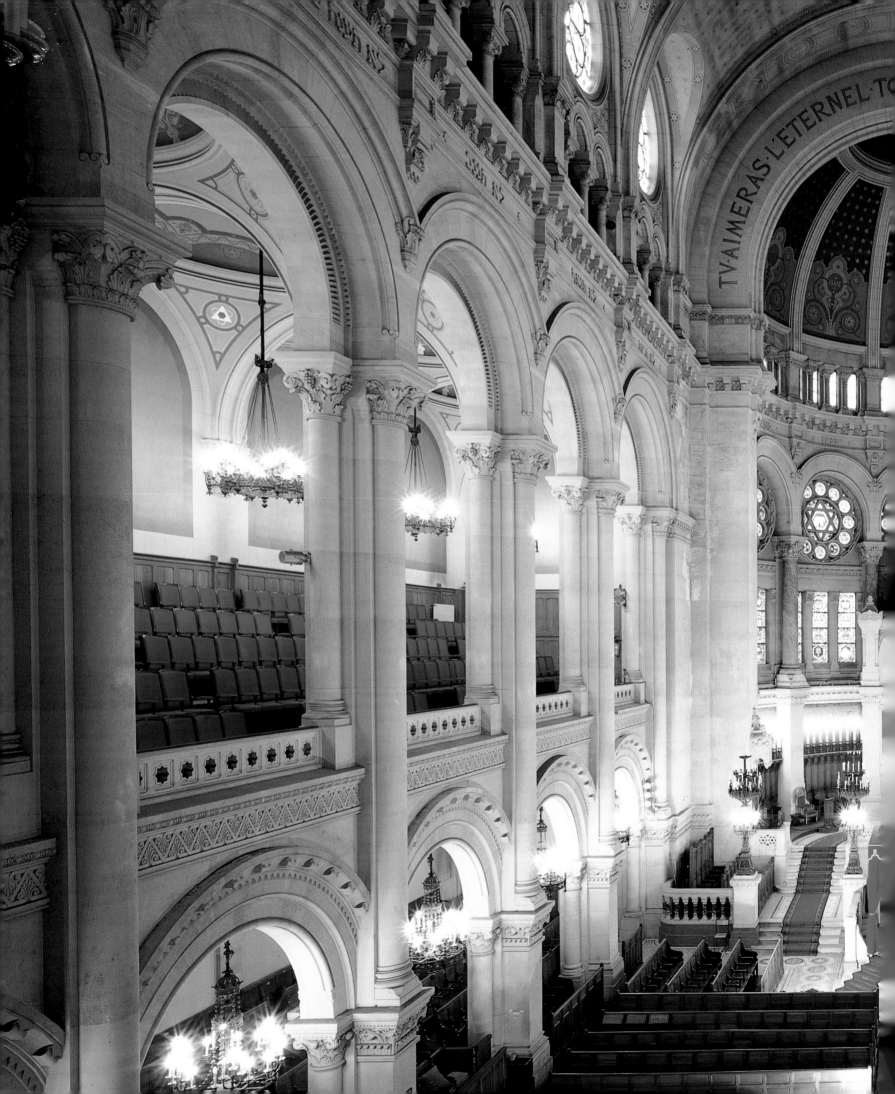

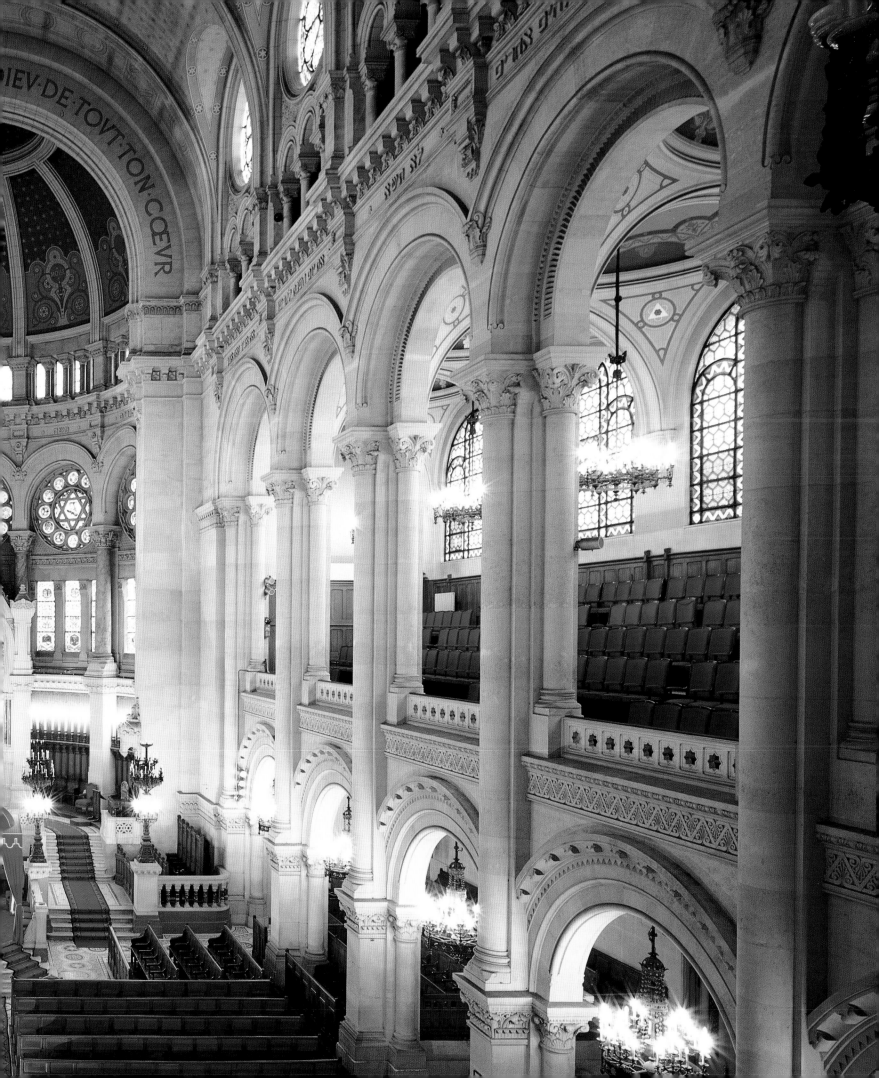

Gothic cathedral a triforium is really so much waste space, an unused gallery over the aisles along which Quasimodo might creep for a glimpse of La Belle Ferronière at mass. But the triforium in the synagogue which the Jewish architect Alfred Aldrophe designed was intended to accommodate a ladies' gallery, where the *mondaines* of Parisian Jewish society would sit, arrayed in the latest modes; hence the inversion.

The synagogue in rue de la Victoire became the seat of the Chief Rabbi of Paris and the Consistoire. It is, in a sense, the cathedral synagogue of Paris. If the President of the Republic ever attends a synagogue service, this is where he goes. German genocide, population shifts and secularism have made inroads into attendance numbers, but services are still conducted with pomp. The *shammasim* wear a special uniform topped by a three-cornered hat sporting a tricolour cockade. The head shammas, *le chef du corps des chammasim*, is further distinguished by a chain of office, like that of a sommelier, which hangs round his neck.

I first visited rue de la Victoire in 1937, taken by my Uncle Alex, a Parisian by adoption. Typically, he got us there just in time for the last verse of *Adon Olam*, the concluding hymn of the sabbath morning service, but not too late for me to sustain a twofold culture shock: the sound of an organ rumbling and the sight, at the entrance, of two clean-shaven American rabbis, in sharp grey suits, discussing the prospects of Chicago's White Sox.

The organ no longer rumbles at rue de la Victoire, except for weddings, though on High Holy Days the choir is said to be reinforced by recruits from the *Opéra*. The sound is marvellous, but the atmosphere a little cold. It is positively fervid, however, in comparison with that which prevails at the last exercise in Romanesque, the Temple Emanu-El, built in 1929 to the designs of Kohn, Butler and Stein on Fifth Avenue and 65th Street, New York. Here your twelfth-century abbot might have greeted some of the external features with surprised recognition, but the interior, with its undertones of the picture palace, would have left him queasy. The congregation is Reform.

OPPOSITE The Temple Emanu-El
(1929) stands on Fifth Avenue and
65th Street in New York. It repre-
sents the last gasp of synagogal
Romanesque.
LEFT The interior of the Temple
Emanu-El. Sainte Foi goes to Holly-
wood.

181

THE AGE OF
HISTORICISM

Male worshippers go bare-headed; they are the nearest existing approximation to that paradoxical concept, Jewish WASPs.

Romanesque was not the style perceived by English architectural revivalists such as Pugin or the enthusiasts of the Camden Society as the divinely appointed mode in which to build churches. Their choice fell on Gothic, ultimately narrowed down to one specific period, the Decorated. The consequent neglect of the Romanesque by ecclesiologists led some Jews to conclude that this style was, in fact, an oriental phenomenon. The Shaaray Tefila synagogue on Wooster Street, New York (1846-7), 'a neat essay in the Romanesque Revival style' as Mr De Breffny characterizes it, was confidently thought by its cantor to recall the Golden Age of Saracenic Portugal.

Gothic, however, was seen by Jews as being inescapably churchy. In some cases the identification was exact. On the lower reaches of Cheetham Hill Road, Manchester, the population shifts of the early twentieth century led to the sale, for use as a synagogue, of a Roman Catholic church ('west tower with an octagonal top', says Pevsner, 'transept, dormer windows. All crudely done'). I attended a service there once, and received distinctly alien vibrations. But synagogues in the Gothic style *were* built occasionally. In Australia, remote from the theological frets of Europe, the pointed arch, clustered pier and plate tracery reigned supreme at Syd-

ney Great Synagogue, built in 1878; they still do, as the Great continues in use today.

Sydney, however, was a remote sideshow. Most Jews in the nineteenth century lived in Europe, and European Jews were becoming architecturally conscious. If Romanesque and Gothic recalled Christian traditions to a greater or lesser extent, was there perhaps another direction in which to turn? There was. The European Middle Ages were not the only epoch to have its architecture revived and adapted. In England, for example, apart from Turkish mosques and Chinese pagodas erected for fun in the Romantic landscape parks of great houses, a start was made with inhabitable Indian buildings.

At Sezincote, Gloucestershire, S P Cockerell's 1803 house for his brother, sometime servant of the East India Company, displayed onion domes and multifoil arches. The apotheosis came with John Nash's Royal Pavilion at Brighton for the Prince Regent. Built from 1815 onwards, it is Indian outside and Chinese Gothick within.

Another fertile source of exotic inspiration was Ancient Egypt. Although Piranesi's exploitation of Egyptian motifs in the 1760s had drawn some attention, powerful stirrings of interest were first revived in Europe by the imposing folios of the *Description de l'Egypte* and its splendid illustrations, a work sponsored by the French Government as a scholarly by-product of Napoleon's Middle Eastern campaign. The impact of Egyptian art was considerable, but it was evidenced more in furniture and decor than in architecture. London, however, did see an Egyptian Hall in Piccadilly, built to the designs of P F Robinson in 1811–12, and there have been occasional manifestations of Egyptiana in the form of masonic lodges, factories and cinemas down to the 1930s.

Was it a possible style for synagogues? Hardly. Although we have seen that some features of the Tabernacle remind scholars of a pharaonic camp, conscious imitation of Egyptian manners runs counter to Jewish tradition, where the delivery of the Children of Israel from Egyptian bondage is gratefully recalled in prayer every day.

Egyptian touches did nevertheless find their way into synagogue designs. Friedrich Weinbrenner produced a strangely eclectic elevation for Karlsruhe in

OPPOSITE Impressive detailing within the Lungotevere Cenci synagogue in Rome (1904). At this junction between two arms of the cruciform plan consoles jut out above an angle pilaster to support coupled colonnettes, which in turn hold up the drum below the dome. Did this ponderous detailing inspire the Italian designers of the Babylonian episode in D W Griffith's epic silent movie *Intolerance* (1916)?

ABOVE The main elevation of the Lungotevere Cenci synagogue designed by Luigi Costa and Osvaldo Armanni. The square aluminium dome makes a striking impression when viewed from across the Tiber, which flows past the south front of the synagogue.

OPPOSITE Inside the Rome syna-
gogue there is a semi-hexagonal
apse containing the ark. At the
upper level pilasters support
triglyphs embellished with exotic
details, while framing a range of
seven-branched candelabra.

1798 that featured an entrance flanked by Egyptian pylons. In 1825 the Mikveh
Israel synagogue in Philadelphia used Egyptianate columns, while the King of
Bavaria donated palm-leaf capitals in white marble for the columns that supported
the galleries of J-B Métivier's 1826 Neo-Classical synagogue in Munich. In the
early 1830s the Landgraf's building officials could hardly wait to have an Egyptian-
style synagogue designed and erected to provide an amusing incident in the town-
scape of Kassel. In a later age these bureaucrats would have found their niche in
the projects office of Disneyland. The Jewish community of Kassel managed to
evade this official prepossession, however, and settled for the early example of syn-
agogal Rundbogenstil that has already been described.

Eventually two tiny communities did produce Egyptian Revival synagogues: the
first was in Hobart, Tasmania (1843) and the second in Canterbury, Kent
(1846–8). The Hobart scheme, still standing, comprises a rectangular chamber
with a curious clip-on frontispiece. The aim of the design was to enable the
synagogue, when viewed centrally, to present the illusion of having battered
side walls, that is, walls that slope inwards as they rise, in the manner of Egyptian
temple pylons. This elevation is crowned with a cavetto cornice, featuring the
canonical gorge mould, duly underlined by a torus or cable mould which continues
on, down the edges of the front wall. The portal is distyle *in antis*, that is to say, a
pair of lotus columns are placed within its slightly projecting side walls, and these
help to support an entablature, again capped with a gorge mould. The expected
winged globe over the door is replaced by a Hebrew epigraph, but what really
destroys any illusion of authenticity is a pair of tall windows flanking the portal.
These have bizarrely battered jambs, for which there is no precedent in real Egypt-
ian architecture.

The Canterbury synagogue opens up the whole façade into a loggia with two
lotus columns. The solecism here is the cornice, articulated with Italianate brackets
in place of a gorge mould.

If Egyptian Revival had little appeal, because the Egyptian experience, in bibli-
cal times, had eventually turned sour, what about Moorish Revival? Moorish
Spain had ended in tears, too, for the Jewish people, but it was the Catholics who
caused them, not the Moors. Under the latter's enlightened rule the Jews had, at
times, flourished abundantly. On the artistic problem nineteenth-century opinion
was not united. Otto Simonson, writing in 1858, was strongly in favour of the
Moorish style for synagogues. He described it as 'the most characteristic', by which
he presumably meant the most characteristic of the Middle East, or the Semitic

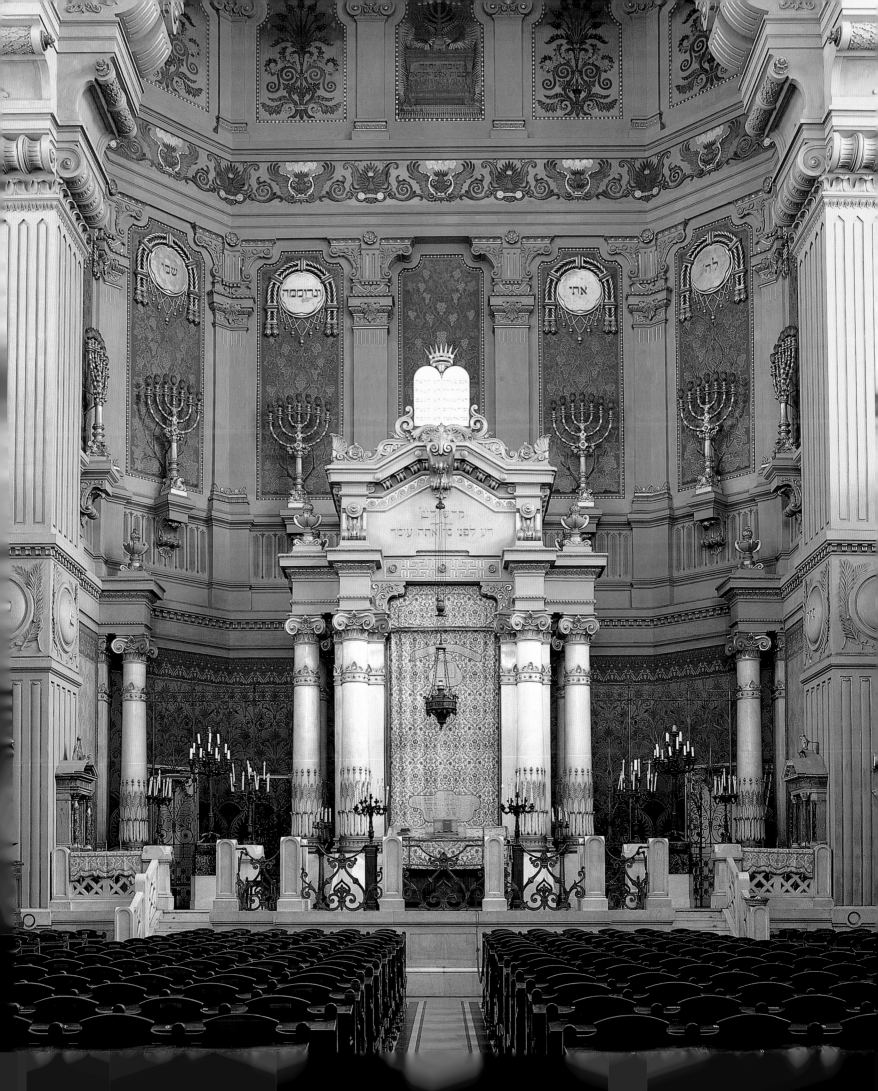

ABOVE The Moorish-style syna-
gogue in Leipzig, designed by
Otto Simonson in 1855.
BELOW The Saracenism of the
Leipzig shool's interior is discreetly
hinted at by the slightly nipped-in
shape of the arches surmounting
the pilasters along the walls.
OPPOSITE This 1922 watercolour
by Richard Moser shows Ludwig
von Förster's synagogue (1853–8)
in Tempelgasse, Vienna. The east-
ern wall is articulated by a monu-
mental arch reaching the whole
height of the building.

genius. He went on to claim that using this style 'does not mean blind imitation but rather an adaptation of available motifs to the requirements of the age'. He evidently foresaw none of the difficulties the English revivalist laboured under, who, according to Kenneth Clark, 'when he set out to build a Gothic railway station, was forced...to employ the style of the Angel Choir at Lincoln'. Simonson's sanguine view was disputed by Albrecht Rosengarten, who had assisted August Schuchardt on the Romanesque shool at Kassel. The Moorish style, he declared, was entirely unsuitable for synagogues; there was nothing to beat Romanesque for spiritual edification. Simonson's point of view, however, was adopted by Nathan Joseph, whose views on the 'Moresque' I quoted earlier in this chapter. Finally, in this brief glimpse at a battle of styles, if not a *Kulturkampf*, I cannot resist citing a remark that Professor Krinsky, deep in the stacks, has quarried from the *Archives Israélites* of 1874. Monsieur B Lévy, contemplating in his '*Causerie parisienne*' column the interior of the synagogue at rue Notre Dame de Nazareth, newly redecorated in the fashionable Moorish style, felt impelled to describe the taste as 'café-concert Alcázar'.

When architects came to use the elements of Islamic architecture in their schemes, they were operating in unfamiliar territory. The classical styles had long been underpinned by the treatises of Serlio, Vignola and their innumerable successors. The Gothic revivalists had actual examples of genuine Gothic buildings all around them, which scholars such as Kugler, Pugin and Viollet-le-Duc analyzed and explained in their books, inventorizing the genre and tracing its development. The study of Islamic architecture, on the other hand, was not pursued with such

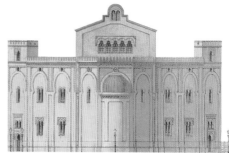

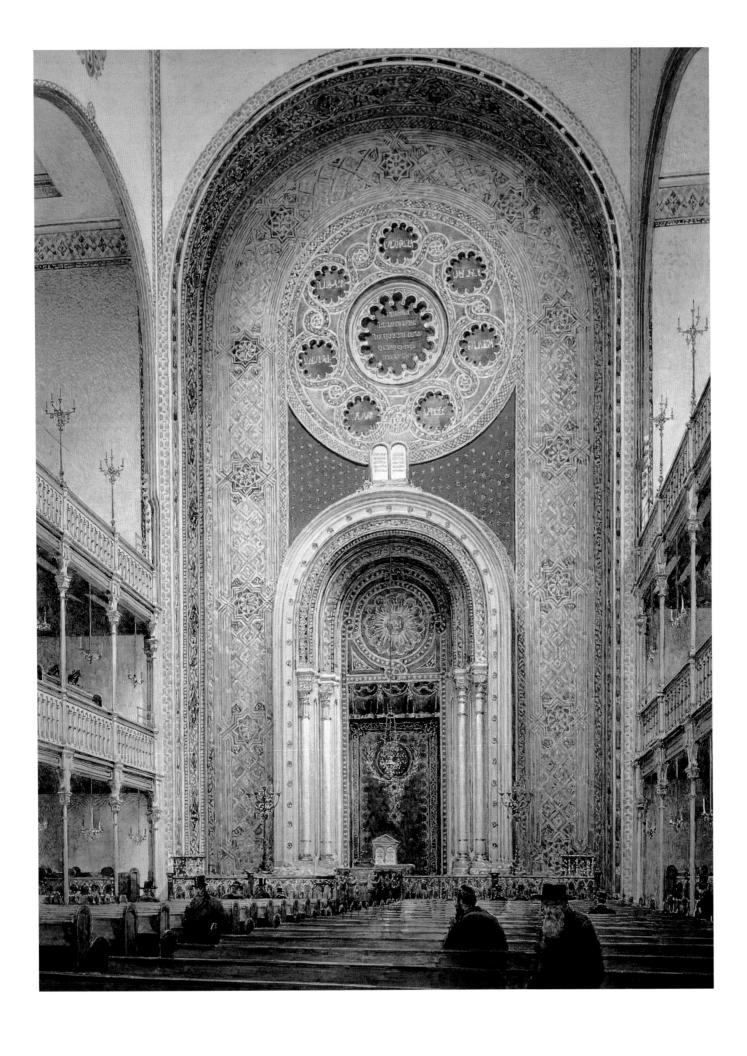

BELOW The synagogue in Dresden
was built between 1838 and
1840 by Gottfried Semper and
stands as the first notable use of
Moorish detailing. The deep
impost block over the column in
the foreground is imitated from the
Alhambra in Granada.
OPPOSITE Ernst Zwirner was the
architect responsible for the Glock-
engasse Synagogue (1861) in
Cologne. It displays minarets with-
out and horseshoe arches and
wiry cast-iron columns within.

thoroughness in the nineteenth century, and material for re-use in historicist designs was gathered from whatever sources came to hand. This was sometimes done with little regard for consistency of epoch and region, or the appropriateness of context, though examples certainly exist in which architects of powerful creativity have used a generalized oriental vocabulary of style in strikingly original works.

The first notable appearance of Moorish detailing was in the synagogue which the great German architect Gottfried Semper built in 1838–40 for the community at Dresden. Outside it was Romanesque, indeed positively Carolingian, with hints of the Minster at Aachen. Inside, however, Semper employed an order of columns with deep impost blocks, imitated from the Alhambra at Granada, to support the lower of two tiers of galleries. Although the gallery beam passes over the columns in simple trabeation, that is, as a straight lintel, not arcaded, Semper imitated the effect of the foliated intrados of an arch by the use of fretted wooden profiles that spanned from impost block to impost block.

Semper's interesting building lasted 100 years. It was burnt down on Kristallnacht, 1938. Four years later the Germans returned to the charge, and deported the remnants of the congregation to the death camps.

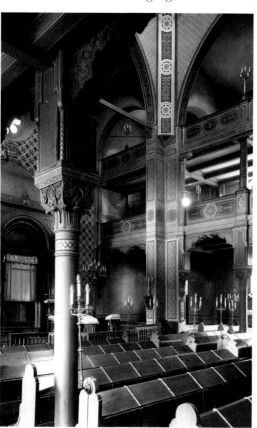

The Jewish architect Otto Simonson was a student of Gottfried Semper at the Dresden Academy. At the age of 24 he was commissioned by the Leipzig community to design a new synagogue. He filled it with Moorish motifs, most strikingly with horseshoe arches. His pulpit looked like a mosque pulpit or *mimbar*, while the ark reposed in a niche that resembled a *mihrab*. Simonson also made use of cast iron: not the first time it was used in conjunction with orientalist architecture, since John Nash had employed it for the cupola over the middle section of the Brighton Pavilion (1818), but probably a first for synagogues. After Leipzig, Simonson went off to Russia, redesigned the banqueting hall of the Shuvalov Palace, on

the Fontanka in St Petersburg, using a wealth of Gothic Revival joinery, and disappeared from history after being invited to work on public buildings in Tiflis. He published a folio album, however, about the Leipzig synagogue, illustrated with six engravings, and this drew widespread attention to his design, as did the reports brought back by the numerous Jewish merchants from all over the world who attended the spring and autumn fairs at Leipzig.

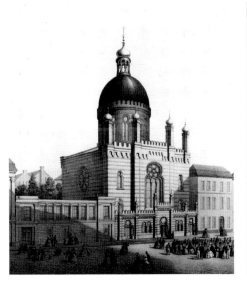 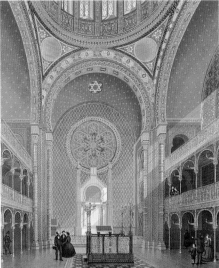

Horseshoe arches and wiry cast-iron columns were the order of the day at Ernst Zwirner's Cologne synagogue (1856–61), but it was Ludwig von Förster who exploited the style with exuberant pomp at Vienna and Budapest, a decade before the inauguration of the Dual Monarchy. At Vienna-Leopoldstadt (1853–8) the foliated arch runs riot within, supported on spindly clustered columns in cast iron. The eastern wall is articulated with a monumental arch, which reaches the whole height of the building and would rival the *pishtaq* of an Iranian mausoleum. The external treatment, however, is inescapably churchy in a modified *Rundbogen* way, with corbel tables at the eaves and quatrefoil windows at gallery level. When apprehensive congregants asked the architect if the turrets that marked off the nave bay on the main elevation were not a little reminiscent of the twin towers that were a common feature of a church's west front, he replied that they were in fact meant to recall Jachin and Boaz, the twin columns that stood before the Temple in Jerusalem. If you can believe that, you can believe anything. They believed it.

The Jachin and Boaz story was produced once more to explain the features that soar up from the lateral bays on the front of von Förster's splendid synagogue on Dohány utca, Budapest (1854–9), but to no purpose. They are indisputably twin minarets, surmounted by onion domes. Inside, once again, thin foliated arches, as at Vienna, curve over the gallery bays or swing across the nave as transverse binders, but the great arch on the eastern wall has been completely opened up to reveal a further space beyond. This is like the sanctuary of an orthodox church; access to it is denied by a domed tempietto sited at the entrance,

ABOVE Budapest is the home of the Dohány utca synagogue (1854-59) by Ludwig von Förster. These lobate arches adorn the outside.

OPPOSITE Ornamental details within the Dohány utca synagogue. The ark is contained within a domed sanctuary and approached beneath a foliated arch. An impost block displays exotic details and the floor tiles glitter with decorative Moresque patterns.

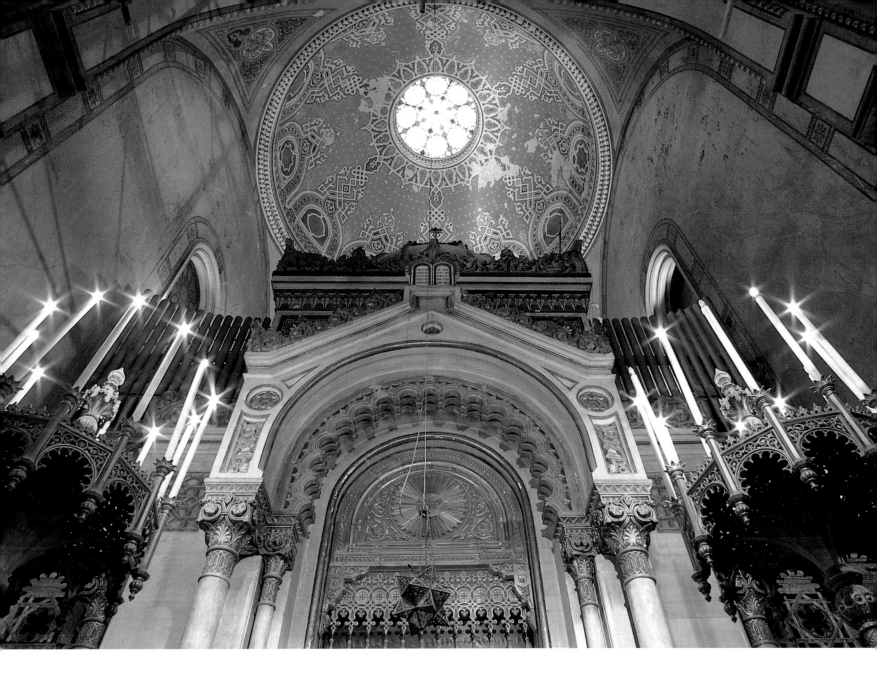

with wings that reach out like the panels of an iconostasis. This tempietto houses the ark.

An orientalizing style was used again for one of the most imposing synagogues ever built. This is the Neue Synagoge at no. 30 Oranienburgerstrasse in the old Jewish quarter of Berlin. It was erected to the designs of Eduard Knoblauch between 1859 and 1866, though neither Knoblauch nor his colleague August Stüler lived to see the scheme completed. Like the narrow façade of Somerset House, in the Strand, London, the Oranienburgerstrasse elevation gives no hint of the depth and complexity of the plan that lies behind it. The disposition of the site available means that the main axis of the layout swings over to the right, beyond the great 12-sided vestibule, a circumstance which the polygonal character of the hall disguises.

Beyond the vestibule was a square room used for board meetings. Having passed through that and through the *bethmedresh*, or minor synagogue, you were confronted with the mighty impact of the great prayer hall, 187 feet (57 metres) long and 75 feet (23 metres) high. Iron galleries were supported on slender iron columns and a wonderland of Moorish cusped arches was visible above. Semicircular arches spanned the nave arcade high over the galleries, while compound arches made the transverse leap over the nave itself. An apse at the end, the same width as the nave and colonnaded at gallery level, embraced the domed ark and found room for an organ and choir. Gaslights were installed in the spaces between the panes of the double glazing, clear outside and coloured within. Ventilating ducts were cunningly incorporated to carry off the heat and fumes. Baedeker's *Berlin* (1910) records: 'During the evening-service (Fridays at dusk) the "dim religious light" from the stained glass and the cupolas produces a remarkable effect.' The main dome is over the dodecagonal vestibule by the entrance: to have set it further back, over the prayer hall, for instance, would have rendered it invisible from the street. As it is, it rears up above an exotic drum set slightly back from the front wall, and is framed between two domed tempietti that crown the projecting side wings—an effect imitated from Sant'Agnese in Piazza Navona, Rome. There Borromini has achieved what Michelangelo wanted to do at St Peter's, but which never happened: to present a magnificent dome between a pair of framing towers. The spectator at Sant'Agnese feels himself drawn in, however, because the side towers swing forward at the end of a pair of curved blocks. In contrast, Knoblauch's elevation is essentially planar. Twenty years after it was built, in fact, the Russian art critic Vladimir Stasov compared it to a block of flats surmounted by a dome. But what a dome! It seems to have been borrowed from Nash's Royal

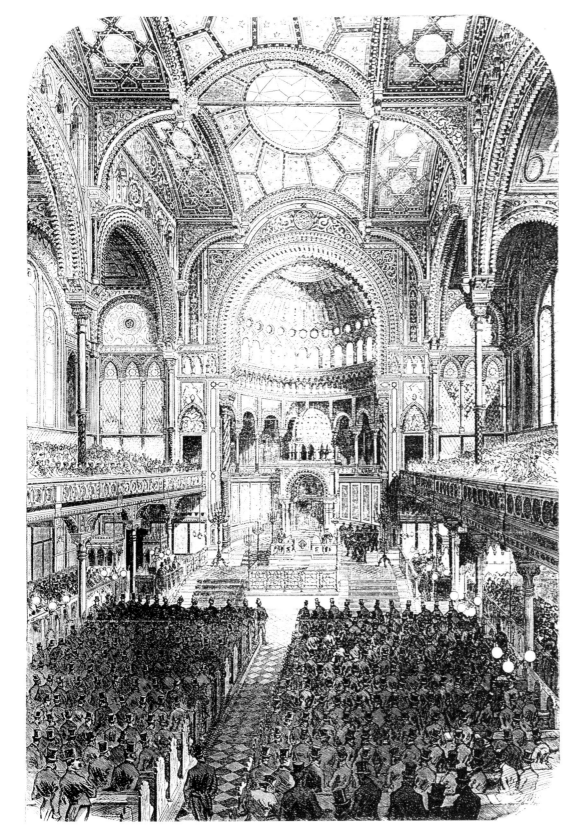

A wonderland of Moorish cusped
arches, the Oranienburgerstrasse
synagogue (1859-66) in Berlin was
designed by Edward Knoblauch.
Gaslights were installed in the
spaces between the double glazing
panes.

BELOW Moorish details on a Gothic carcassing are the significant features of the B'nai Jeshurun synagogue (1866) on Plum Street, Cincinnati. Its architect, James Keys Wilson, designed the synagogue for Rabbi Isaac M Wise.

OPPOSITE The Central Synagogue in New York was designed by Henry Fernbach and dedicated in 1872. 'The style is mainly Moorish,' the architect told *Harper's Weekly*, 'although the arrangement is Gothic.'

Pavilion at Brighton, with Nash's ring of seed-pod windows round its girth supplanted by a series of bull's eyes.

The Germans burnt out the Oranienburgerstrasse synagogue on Kristallnacht, and it was extensively damaged during the allied bombing of Berlin. It lay in ruins for 50 years, finding itself after the war in communist East Berlin but, following the fall of the German Democratic Republic, efforts to restore it were set in motion. If the beautiful Frauenkirche in Dresden can be put together again—and it will be—

why not the Neue Synagoge? May I live to see the day when I can walk into that 12-sided vestibule, check my umbrella there, as the top-hatted congregants did in the 1860s, and, swerving slightly to the right, move on through to the great prayer hall.

Americans standing on tip-toe used to line the quayside in New York harbour awaiting the ship that, amongst other things, brought over the weekly instalments of Charles Dickens' novels. 'Is Little Nell dead?' they would shout to the crew, as the vessel drew alongside. A similarly eager welcome, though perhaps not on tip-toe, was given to another cultural import from Europe: Moorish synagogue design. Two such schemes were unveiled in 1866—the Temple Emanu-El in San Francisco, and the Isaac M Wise Temple on Plum Street, Cincinnati, both of which applied Moorish details to Gothic carcassing. The trend developed and spread. The minarets of the Central Synagogue, Lexington Avenue, in New York (1872) are crowned with finials in the shape of three-dimensional seven-pointed stars. They stand out against the featureless glass cliffs that surround them, giving human value in an ambience that reduces men to the scale of ants.

The new style was not always well assimilated. On East 67th Street, between Lexington and Third, 'the synagogue of the Congregation Zichron Ephraim', writes Kate Simon, 'had simple architectural needs; all it wanted was everything—Moorish, Gothic, a campanile, blind arches, open arches, carvings and a rose window—and got it, as did the Cathedral of Orvieto, where the mixtures work magically. Here they do not.'

The ten years from 1865 to 1875 in fact saw a great increase in synagogue building in the United States, as small communities grew and prospered. In 1840, there were only 15,000 Jews in America; by 1860 this had grown to 150,000. Entire Bavarian Jewish villages upped sticks and emigrated *en masse*. Jews traversed the

continent, especially along the route of the Erie Canal, and settled wherever it seemed possible to make a living as small tradesmen and craftsmen. The enterprise of these early settlers sometimes laid the foundations of mighty commercial empires. Adam Gimbel was a Bavarian immigrant who peddled drapery along the Mississippi before opening a shop in Indiana in 1842. His sons founded the Gimbel Brothers department store chain. Similar tales attend the birth of Macy's emporium and Levi Strauss, of denim jeans fame.

E ntry into the United States was unimpeded; barely 1 per cent of would-be immigrants were turned back. There were indeed occasional hazards. Ulysses S Grant, by General Order N°11 of 17 December 1862 decreed the expulsion of all Jews 'as a class' from the Department of Tennessee within 24 hours, an order which President Lincoln swiftly countermanded.

Reform Judaism made great strides in the United States during the 1870s and 1880s; both the Plum Street synagogue in Cincinnati and the Central Synagogue, New York, with their Islamic fantasies, were Reform establishments, where mixed seating, prayers in English and curtailed services prevailed.

For the most creative and consistent use of Islamic architecture in synagogue design, however, we must return to the Old World. Between 1874 and 1882, in

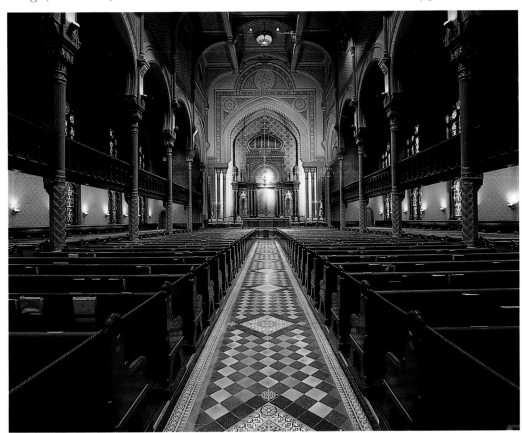

RIGHT The most creative and con-
sistent use of Moorish architecture
in synagogue design is seen in the
Tempio Maggiore (1874-82) in
Florence. The architects were
Falcini, Michele and Treves. The
alternating courses of Travertine
and granite recall the stripes of
Siena Cathedral, but are also
consistent with the Islamic *ablaq*
manner, which uses the same
effect.

OPPOSITE Every inch of the
Tempio Maggiore is covered with
coloured designs, although a
restricted palette has been used.
The plan is a domed Greek cross,
with galleries in the cross arms.

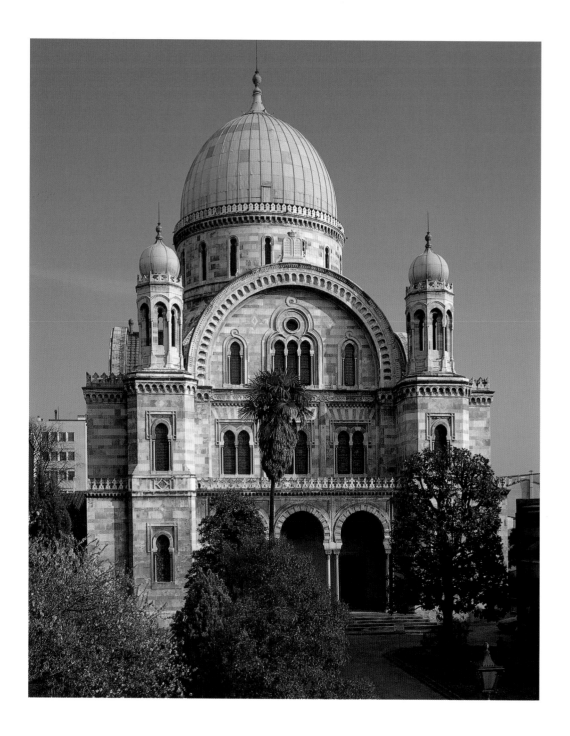

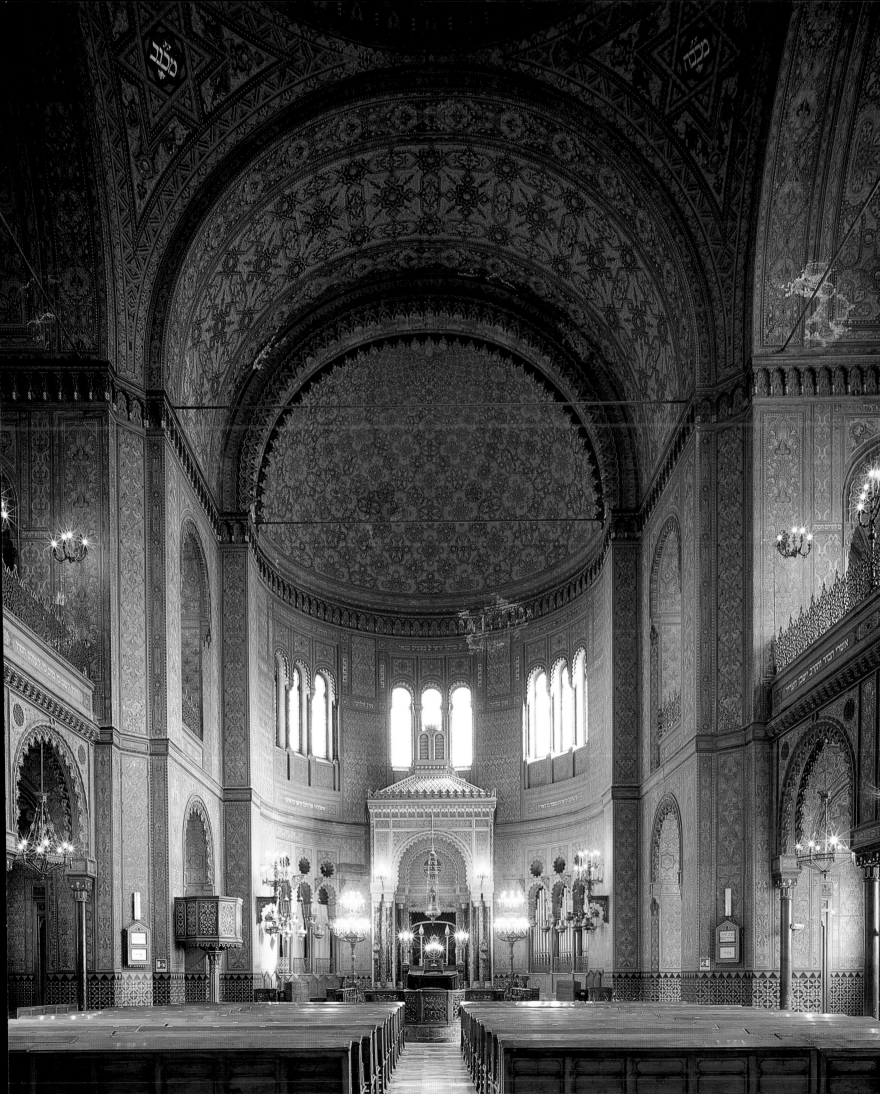

what was then the outskirts of Florence, its community erected an extraordinary building that reconciled the traditions of Islam and Italy. The architects were Mariano Falcini, Professor Vincente Micheli and Marco Treves, who was Jewish. The plan is a Greek cross, with a dome over the centre. The masonry is striped, in alternate courses of travertine and granite, in the Islamic *ablaq* manner, yet this device is not alien to Italy, as witness Siena Cathedral. The old Alinari photograph of the exterior, which must have been taken 100 years ago, shows an aggressive contrast between the tan and red stripes, which have now substantially faded.

Corner towers embrace the main elevation, which is capped by a great semi-circular cornice, like Santa Maria dei Miracoli in Venice, or its more recent epigone at rue de la Victoire, Paris. The entrance is through a three-bay horseshoe arcade. Above this, at first-floor level, are three twin-light windows of the Moorish *ajímez* type, but, again, not so remote from the *bifore* of the Palazzo Medici in the city centre.

The prayer hall is almost square, with galleries on three sides borne on colonnades with Moorish cusped arches. The bimah stands in the eastern arm of the Greek cross, beyond which the ark is accommodated in a mighty apse. Every square inch of exposed surface is covered with coloured designs (albeit of a restricted palette), which must have exhausted the pattern books of abstract Islamic configurations. The elegant railings that front the ladies' galleries are articulated with seven-branched menorahs above the coupled columns of the arcade below.

Otto Simonson, writing about his Moorish Revival synagogue in Leipzig, had said that its style was not 'a blind imitation but rather an adaptation of available

LEFT View of the Tempio Maggiore in Florence, looking down from the Cathedral.
OPPOSITE Creative use of Islamic design patterns in the interior of the Tempio Maggiore.

motifs to the requirements of the age'. The Moorish detailing of the Florence syna-
gogue was well integrated into an original concept. Elsewhere, however, where
architects faced with an unfamiliar building type leafed through their history man-
uals for inspiration, the outcome might prove to be something of an anthology.
Professor Ivan Shaposhnikov's synagogue in Ofitzérskaya Street, St Petersburg,
completed in 1893, can be deconstructed from the top down. The dome on a drum
with elaborate canted corners is apparently from the Qayt-bay Mausoleum, Cairo,
but what of the curved reeding of the dome? The Madrasa of Ilgay al-Yusufi, per-
haps? And so on.

It is not size and pomp that guarantee success in design. The little Sephardi syn-
agogue on Cheetham Hill Road, Manchester, by Edward Salomons (1874), is a
jewel. The hexastyle Moorish arcade at first-floor level, the *mashrabiyya* latticework
in the entrance doors, are an inducement to explore the delights within, where the
original polychromy of the columns that support the galleries is currently being
restored, as and when funds allow. While all the other synagogues in this former
Jewish district have been destroyed, Salomons' little building has been saved for
use as a Jewish museum, thanks to the enterprise and foresight of the late Werner
Mayer, a German refugee who 'defected' to the Sephardim, with the happiest
results.

There was, I have suggested, a third path in historicist design: a compromise
between east and west, something eclectic. If this is not done well, the outcome
may be unfortunate, as at Karlsruhe in 1791, or Zichron Ephraim, New York, a
century later. One of the most curious incidents in the history of synagogues is that

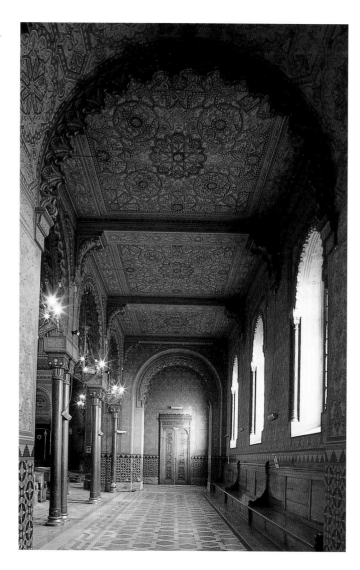

ABOVE An aisle beneath the gallery of a cross arm in the Tempio Maggiore. The nave arcade (left) features cusped arches borne on twin columns.

RIGHT The pulpit and bimah in the eastern arm of the Greek cross layout. The bimah, raised on a platform, is only three steps high. In the background is the ark, a Moorish aedicule flanked by candelabra.

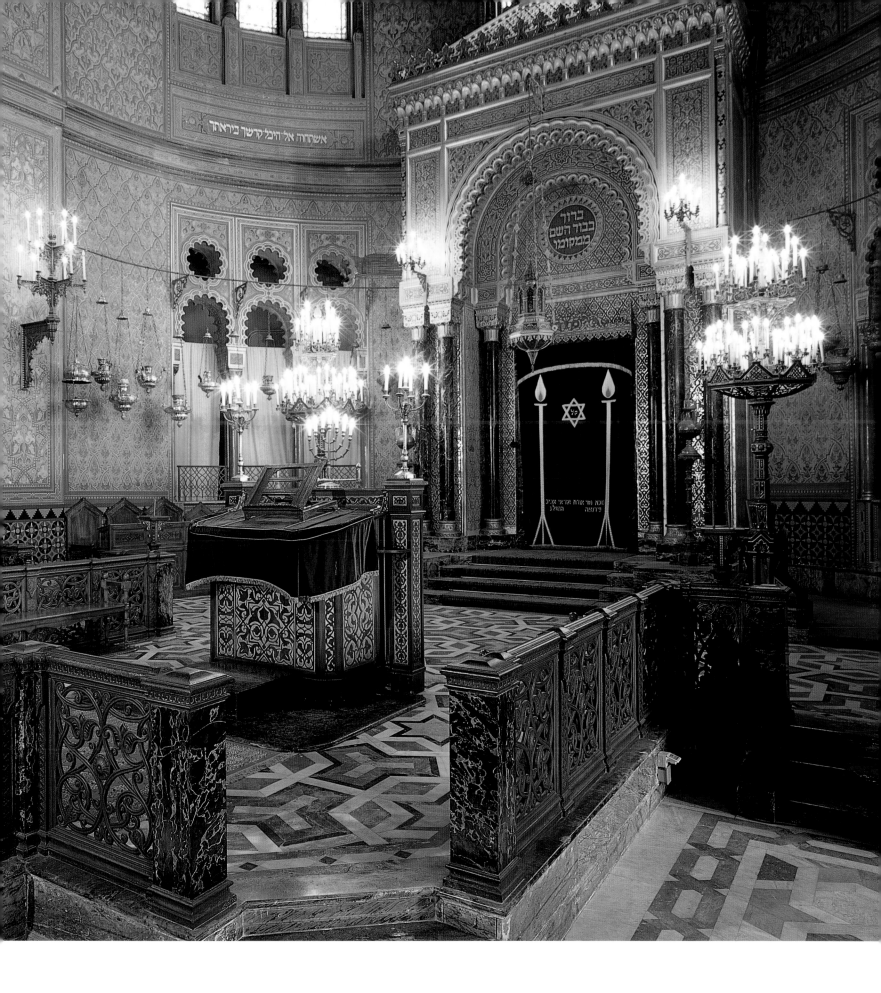

RIGHT The little Sefardi synagogue
(1874) in Cheetham, Manches-
ter, designed by Edward
Salomons, now serves as a Jewish
museum. The discreet use of
horseshoe arches, particularly on
the first-floor arcade, suggests the
congregants' remote provenance
from Moorish Spain.
BELOW RIGHT The ark and recently
restored rose window of the
Cheetham synagogue.
OPPOSITE The Mole Antonelliana
in Turin was begun in 1865 as a
synagogue, following the designs
of Alessandro Antonelli. It rose
relentlessly until it outgrew the
community's ability to pay for its
completion.

of the eclectic design that got away. It happened in the 1860s at Turin, which for four glorious years (1860–4) was the capital of Italy. The community, armed with full civic rights since 1848, intended to put up something that would express their eternal gratitude, civic pride, and architectural discernment. A quarter of a million lire was available, in the days when a lira was worth something. A limited competition was held, but none of the four contenders was deemed to have been successful. Recourse was had, instead, to the ingenious and ambitious Alessandro Antonelli, an architect and engineer. He had added an idiosyncratic 397-foot (121-metre) high dome and spire at the crossing of the seventeenth-century church of San Gaudenzio at Novara, and was (secretly) determined to do even better at Turin. The job, he said, would cost only 280,000 lire, which the community thought it could manage without too much exertion. The plans were approved and work began in 1865. The scheme was to provide accommodation for 1,500 worshippers, classrooms for a Hebrew school, a *mikvah* or ritual bath, flats for the rabbi and caretaker and even a viewing gallery for the merely curious, who might creep in quietly to look even while a service was in progress.

A Neo-Classical base raised no eyebrows, but then Antonelli got the bit between his teeth. A third level, not apparent on the clients' drawings, was 'raised slowly and almost stealthily'. A 20-column peristyle supported the ladies' gallery; walls rose as storey succeeded storey. In 1864 Turin had yielded to Florence as the capital of Italy. Jews started to slip away to be once more in the centre of things in the new metropolis and later, if the truth be told, to avoid fresh and onerous levies imposed by an apprehensive congregation.

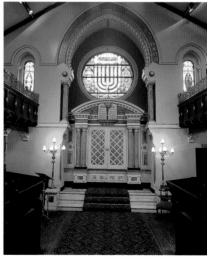

The skyline of Turin began to be pierced by an elongated, four-sided dome, like a curved pyramid. Money ran out. The congregation sold off silver candlesticks and duplicate Torah breastplates; they melted down the gold trim from cloth hangings. By 1876, having spent 692,000 lire, they decided to call it a day. The general public, however, had now become involved with this *monstre sacré*. Eight thousand *Amici del Monumento* petitioned for the city to take over the structure and complete it, do something with it, anything: turn it into a museum of the *Risorgimento*, even. This was done. The Jewish community was paid off, and retired, trembling and perspiring, to build a nice uncomplicated Moorish synagogue. Meanwhile, Antonelli, given his head, completed the curved pyramid of a dome, reinforced internally with interwoven iron beams, and sat a platform on its truncated apex. On top of this he placed a two-storey peripteral temple, pedimented on all four sides, and from the midst of it he extruded an enormously tall spire, which started off with three superimposed circular tempietti of progressively diminishing size, but ended with a feature like a radio-transmitting aerial surmounted by a winged figure representing the genius of the House of Savoy. Her head is 548 feet (163.55 metres) above ground level, or was in 1888, when she was placed there. Wind, weather and the fall of the monarchy have wrought changes, but the Mole Antonelliana itself ('Antonelli's pile') still surges above the skyline, the logo of Turin, like the Eiffel Tower in Paris. And they did put a museum of the Risorgimento in it.

Does no eclectic design survive that is neither bizarre nor eccentric, but gathers its elements from disparate sources and blends them into a harmonious unity? Yes, of course, there are many; but let one stand for them all. He who has not seen the interior of Princes Road synagogue in Liverpool has not beheld the glory of Israel. It was built in 1874 to the designs of W and G Audsley, for a thrusting and cultured congregation that a few years later was to commission the Kol Nidrei variations for cello and orchestra from Max Bruch.

The district in which the synagogue lies is Toxteth; in 1874 high bourgeois, now the nadir of urban blight and the scene of occasional riots by Liverpool's savage underclass. The Jewish population has long since departed, but cannot abandon its treasure. It thus remains the only orthodox synagogue I know of that has an official

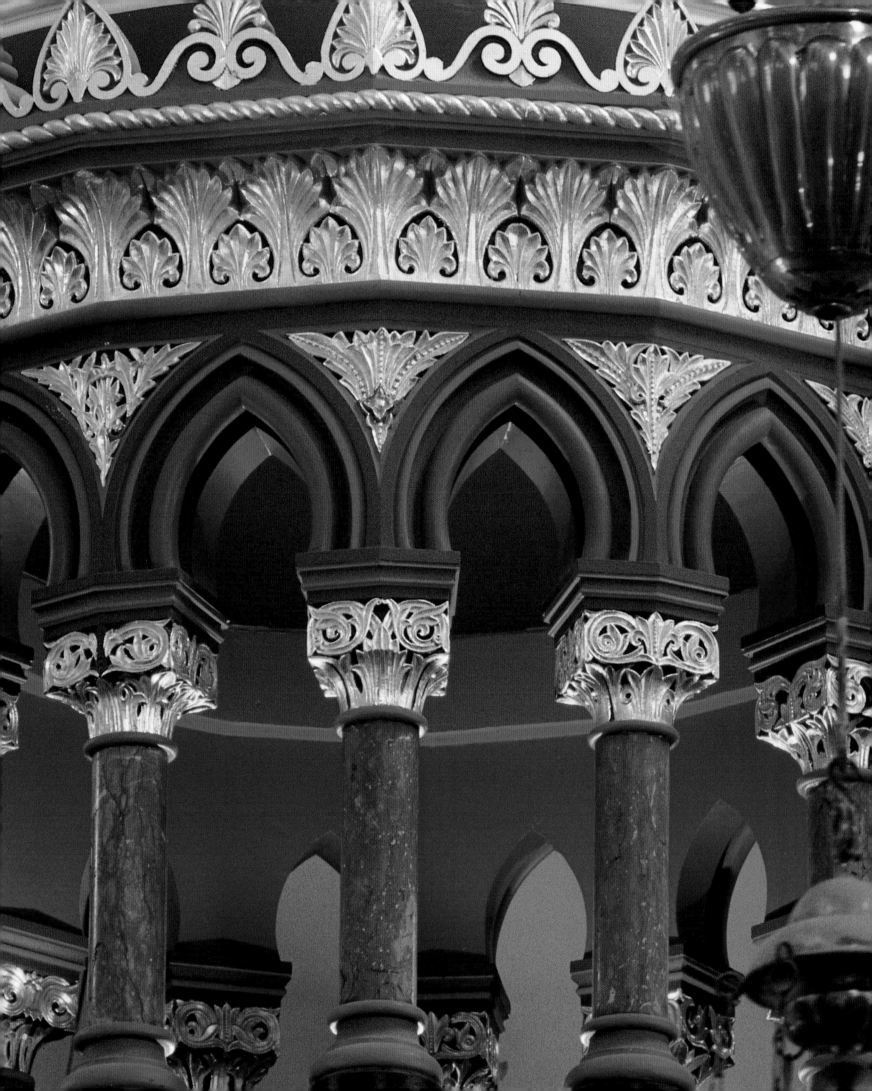

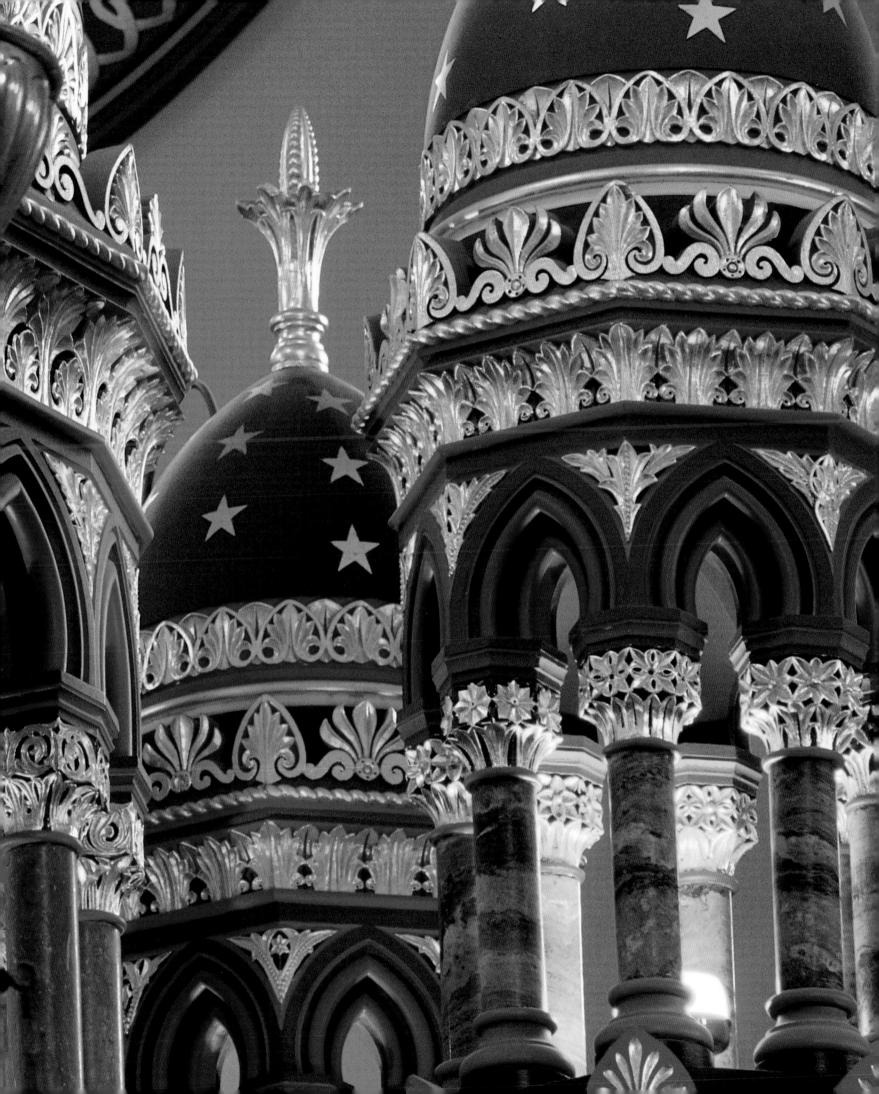

car park attendant on Saturday mornings to protect congregants' vehicles from the attention of the indigenes.

A book published on the centenary of the synagogue's dedication reprints what it calls the architects' description. It must be a description at one remove, however, since the third paragraph starts: 'We are informed that many hints were derived from the architectural remains brought to light in Jerusalem', which sounds more like the report of an interviewer than a text written by the building's designers. However direct the line of transmission may be, the following remarks appear:'The Moresque style, which has almost universally been adopted for modern synagogues, is in the building entirely absent, the architects believing that this style is both unsuggestive and inappropriate for a Jewish place of worship.' The architects declare instead that the synagogue's features have been 'selected from both Eastern and Western schools of art, and blended together with enough of the Eastern feeling to render it suggestive, and enough of the Western severity to make it appropriate for a street building in an English town'.

Where then is the eastern feeling supposed to come from? The architects were being disingenuous. There are in fact Moorish hints everywhere, some blatant,

while others are indirect. The brick façade has an Early English portal, but the pointed arches of its four orders are tweaked inwards over the column capitals in a subtly Arabian manner. The octagonal turrets that flanked the west gable, and the four square ones that terminated the lateral wings (all taken down in 1960 because they were unsafe), may well have been detailed in a mixture of styles, but they were undoubtedly meant to suggest minarets.

The interior is stunning. It is laid out like a Gothic basilica, with the seats on each side turned inwards towards the centre. The nave arcade strides east on tapered octagonal columns, painted green, with spreading foliate capitals in gold. The impetus is towards the ark, which sits at the entrance to a sanctuary, the presence of which, at the end of the nave, is marked by a huge Moorish horseshoe arch at high level. Viewed from the gallery over the entrance opposite, this arch seems neatly to embrace the rose window set in the east wall, several yards behind it.

The ark is a glittering *tour de force*, a miniature Byzantine church with a central dome over an open arcade and four miniature echoes of it at each corner. The

domes are picked out in blue with silver stars, and the corner piers of the whole structure are in striped marble.

The nave is roofed with a plaster tunnel vault, with round transverse arches marking off each bay. The bay vaults are deeply penetrated to admit light from clerestory windows. The marble bimah, which after a few years replaced an original oak and rosewood feature, sits on stubby *verde antique* columns, their caps carved with foliage to suggest Ionic scrolls. The soffits of the nave arches are picked out with floreate patterns in green and purple.

On the rare occasions that I visit Princes Road, I cannot concentrate on the service. My attention is caught by the way the mouldings of the bimah balustrade replicate those of the pilaster capitals flanking the rose window, or I find myself gazing at the manner in which the lowest mouldings of the ark cornice are picked out in red, white and black, and contemplating what this does to the gilt anthemion leaves on the next moulding above. I think of Rabbi Jacob's dire warning in *Ethics of the Fathers*: 'He who is walking by the way and studying, and breaks off his study and says, How fine is that tree, how fine is that meadow, him the Scripture regards as if he had forfeited his life.' I think of it, and I know I am doomed. The habitués are used to it, and only seem to give this fantastic display a passing glance, but I keep on looking. It is all too much. The time was surely ripe for something more austere.

OPPOSITE The Beth Shalom synagogue (1959) in Elkins Park, Pennsylvania, by Frank Lloyd Wright has been called 'a travelling Mount Sinai'.

'*Schafft's immer neu, Kinder!*' Richard Wagner used to urge the cast at Bayreuth: 'make it new every time'. Wagner was addressing interpretive artists, but the challenge can be put to creative ones as well. From the early fifteenth to the early nineteenth centuries, the architectural vocabulary of classicism prevailed. Yet these four centuries elicited variations that defy belief on an architectural system that had its origins in Ancient Greece and Rome. The epoch of historicism that followed was much shorter and, though not lacking in ingenuity, did not develop such fantastic metamorphoses of its Gothic prototypes as the Baroque and Rococo masters had worked on classicism. Historicism, too, passed away, in the wake of newly invented structural forms such as steel frames and reinforced concrete. It seemed illogical to hang historic elevations—in effect a form of fancy dress—on such radically new load-bearing systems.

Whether Edmund Körner was a keen Wagnerian is not attested, but he certainly made it new when he designed the Steelerstrasse synagogue (1908-14) in Essen, and he inspired at least one critic with Wagnerian images. R Klapheck must have been thinking of Parsival when he likened the shool to a Temple of the Holy Grail. The congregants, as may be imagined, were not flattered by the comparison.

The synagogue is located on a triangular site at the junction of Steelerstrasse and Alfredstrasse. It retreats from this junction in progressively rising blocks, which repeat, with variations, a motif encountered at the very entrance: flanking turrets. A pair of these, opening on to the street, frames a courtyard and admits to the colonnades that line it. Beyond the courtyard is a gabled vestibule block with

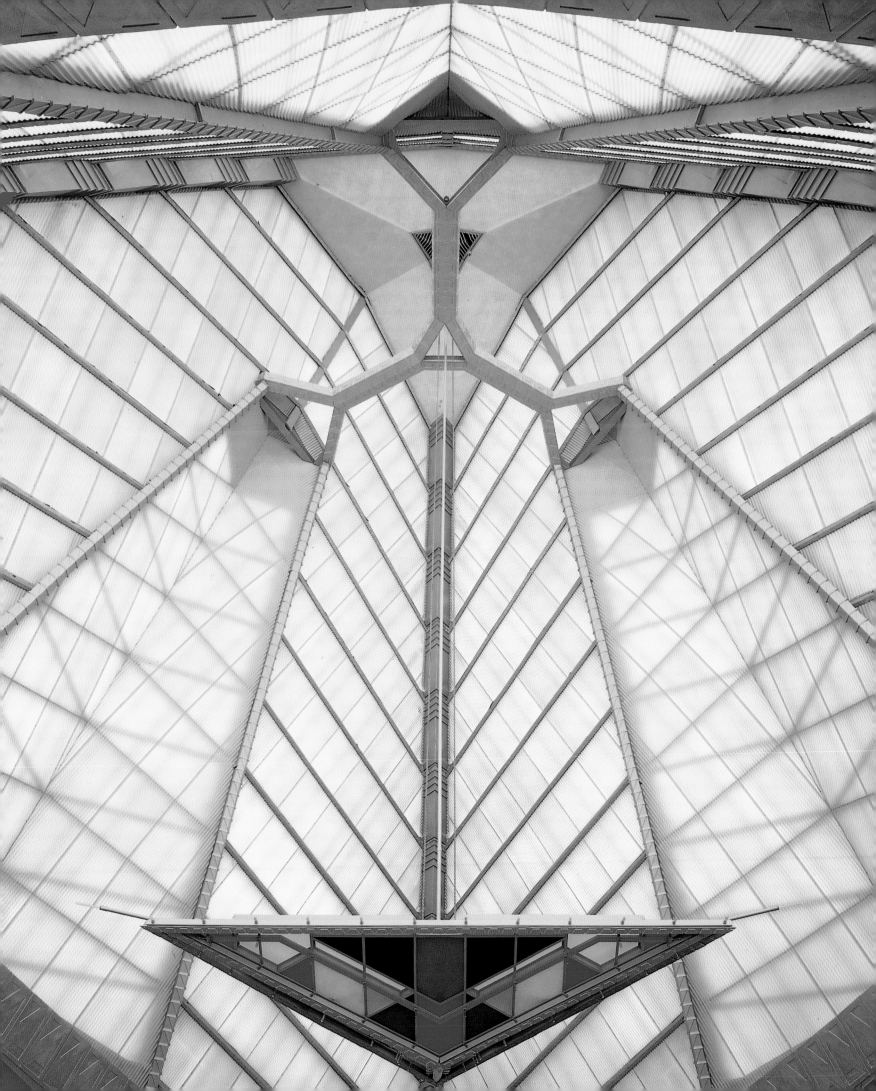

BELOW The Steelerstrasse syna-
gogue (1908-14) in Essen,
designed by Edmund Körner.
The transverse oval of the prayer
hall is enclosed by side walls
which dissolve into huge round-
headed windows.

OPPOSITE Exterior and interior views
of Hector Guimard's synagogue
(1911-13) in rue Pavée, Paris. The
Art Nouveau façade is character-
ized by spindly columns, while the
seat backs in the long narrow nave
rise and fall in gentle waves.

a pitched roof, and an elevation inflected at the corners by hipped-roof staircase
turrets. Behind the vestibule soars the transverse oval of the mighty prayer hall,
capped by a polygonal drummed dome, which is echoed by the miniature domes
that roof *its* flanking turrets. The stone walls are constructed in random rubble
built to courses. External volumes vaguely suggest a Carolingian minster abutted
on a Byzantine cross-domed church, but the forms are simplified, and the eye is
distracted by the modulations of the turret theme. Historicism is still dimly there,
but it is in transition to something new and different. The great domed prayer hall
has its curved side walls dissolved into huge, tall, round-headed windows, sepa-
rated by deep piers.

The first real post-historicist movement in architecture was Art Nouveau,
the origins of which lay in other arts, such as furniture. Its lifespan was short—
lasting roughly from 1890 to 1914—but the recurrent fascination of its use of
natural forms, those sinuous interlacing lines derived from leaves and creep-
ers, is attested by the steady sale today of Alfons Mucha posters and by the
revival of Art Nouveau decor in cafés and bars.

One of Art Nouveau's most notable practitioners was Hector Guimard, whose
Paris Métro entrances are characteristic examples of the genre. It was Guimard
who was commissioned by a congregation of Yiddish-speaking immigrants to
design a synagogue on a narrow site in the rue Pavée, just off the Pletzel, the Jewish
quarter of Paris. The resultant building, constructed between 1911 and 1913, has a
curious façade articulated by a rapid succession of immensely long spindly
columns, between which an equivalent number of tall narrow windows are
squeezed in on each of the three upper floors. The façade is dished inwards
towards the centre, and rises to a gently curved roofline. It is an Art Nouveau paro-
dy of Borromini's façade at the Oratory of St Philip Neri in Rome (1640). The inte-

rior of the synagogue is long and
narrow, with the aisle spaces
beneath the two tiers of galleries
needed for seating, in addition to
the area of the nave. Seat backs
are inflected in a wave pattern,
and other decorative Art Nou-
veau designs are featured on the
gallery fronting, the bimah and
the ceiling.

Just as the excesses of Rococo in the eighteenth century led to the reaction known as Neo-Classicism, so did the coiling tendrils of Art Nouveau provoke a counter-movement. It can be seen already in the work of later Art Nouveau practitioners. Charles Rennie Mackintosh's Glasgow Art School (1898–9) has metal stalks with coiling, twisting scrolls at their head that lean back at the great first-floor windows, but the masonry is bare and linear. The library wing, built ten years later, displays straight slender window shafts which are unlike anything in the historic styles. They proclaim a new, cubical manner with idiosyncratic ornament, on a par with the bare structures that Auguste Perret was designing in France and Frank Lloyd Wright in America. A pioneer of German modernism was Peter Behrens, whose own house in Darmstadt (1901) 'already shows', says Pevsner, 'a hardening of the tender curves of Art Nouveau'. Such giants of the Modern Movement as Walter Gropius, Le Corbusier and Mies van der Rohe all worked in Behrens's office before the First World War. It was during this period that he built the AEG turbine factory in Berlin, one of the key monuments of early modern architecture. Behrens did not have the opportunity to design a synagogue until 1928 when he built one for a Reform community at Žilina in Slovakia. It is a rectangular concrete box with stepped-up corner parapets, from which extremely discreet Stars of David were displayed on thin rods. Wrapped around at ground level are stone walls in random rubble built to courses, a contrast in colour and texture with the smooth concrete surfaces. Le Corbusier was to push this contrast to a more telling extreme at the Swiss Hostel in the Cité Universitaire, Paris, a year or two later. A copper-clad dome presides over the structure, originally sporting a Star of David on top, where a mosque would display a crescent. This dome, unmediated by a drum, sits inside, for want of spandrels, on an open disc supported by reinforced concrete beams that rest, in turn, on concrete piers. The walls were striped with terracotta paint, and the soffit of the dome was picked out

with a bold design in gold line that incorporated a curvilinear Star of David.

Those of the 450 men and 300 women of the Žilina congregation who did not succeed in fleeing Slovakia were killed by the Germans and their local helpers. Only the building survived. It was restored and, minus its Stars of David, now serves as the assembly hall of a University of Transport and Telecommunications. It thus escaped the fate of its contemporary, the synagogue at Plauen, Saxony, which was destroyed. Plauen was built for a Reform congregation to the designs of Fritz Landauer, between 1928 and 1930. It was a soul-garage, if ever there was one, with a tall gaunt interior like a machine shop stripped of its industrial plant. There was nothing in the architecture to lift the human spirit, save for a few dim scratch-ings on the walls of the cavernous ark recess.

A more humane use of the Modern Movement was made by Felix Ascher and Robert Friedmann at their scheme in the Oberstrasse, Hamburg, built for a Liber-al Reform congregation in 1929–31. It is laid out in three blocks: a dominant prayer hall to the rear, and two low-rise blocks in front housing the minor syna-gogue and lecture hall respectively. The visitor passes between these blocks and up a broad flight of steps. Complete symmetry prevails on the main elevation, as seen from the street, but it is a simple composition involving only three units, in nicely judged proportions. A far more complex usage is to be found at Hendon, London,

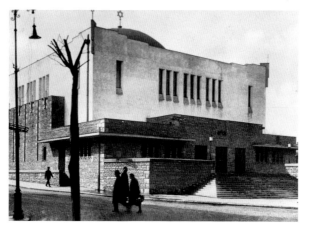

built by Bovis in 1935 for the United Synagogue to the designs of C J Epril. Here there is a grad-ual build-up in height from the cloakrooms at the front to the prayer hall at the back, but blocks insert themselves, rise up, recede, project, defer, prevail. There is not a curved line in sight: one imagines the T-square and set square sliding and click-ing on the architect's drawing board, while his compasses and S-curves are ban-ished to a drawer. The effect is humanized to some extent by the use of brickwork, a technique which flourished in the 1930s especially in Board of Works Georgian Revival post offices and telephone exchanges.

The linearity that prevailed in British Early Modern was eschewed in Israel, or Mandatory Palestine as it was then. This breakaway movement is clearly seen at

the Yeshurun synagogue on King George Avenue,
Jerusalem (1934) by A Friedmann, M Rubin and
E Stolzer. In this building a seductively curved
prayer hall abuts a rectilinear administration
block. In accordance with British town-planning
regulations for Jerusalem, the medium is the gold-
en-brown local stone, here pierced with a staccato
line of tall, narrow window slits, in deference to the
powerful sunshine that so often prevails.

The struggle to break away from pure linearity was resumed at Dollis Hill,
London, in 1937, when Sir Owen Williams, famous for his Boots factory at
Nottingham, ingeniously folded the walls of his synagogue in accordion pleats.
This device, thanks to the ingenious statics involved, permitted the ladies' gal-
leries to run through without obstructing the hall with columnar supports. But
the T-square and set square still slid and clicked: the accordion pleats required no
curved lines, and even the windows were hexagonal.

While leisurely experiments in architectural style were being made in Western
Europe, great changes were under way on the world Jewish scene. The balance of
population gradually swung over, until the USA superseded Russia as the country
of greatest Jewish settlement. Pogroms, discrimination and economic pressures,

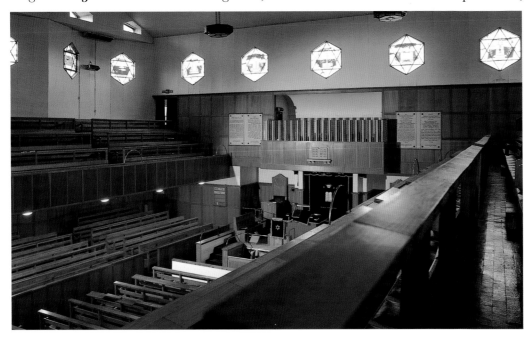

OPPOSITE Torah curtain for B'nai
Israel synagogue, Millburn, New
Jersey. Designed by Adolf Gottlieb
in 1950-1, it was sewn by mem-
bers of the congregation, using
velvet, appliquéd and embroi-
dered with metallic threads.

compounded by rising population numbers, all conspired to provoke a massive exodus. Between 1880 and 1925, when legislation brought a cut-off, 2,378,000 Jews entered the United States. New York, which as New Amsterdam had received its first 23 Jews in 1654, harboured 350,000 in 1915. Most of them were concentrated in a small area on the Lower East Side, where 40 cents an hour could be earned by working in little clothing factories from dawn to midnight. Conditions were, if anything, worse than those depicted in I J Singer's *The Brothers Ashkenazi*. Religious outlets for these 'huddled masses' were in the form of shtiebels, or conventicles, often frequented by *Landsmannschaften*, congregants from the same town or village in the Old Country.

Generation by generation the Jews shook off their poverty in a country that placed few limits on enterprise. Jewish population numbers have levelled out at about 6,000,000, which represents about three per cent of the American population, but as Abba Eban puts it with terse understatement, 'this does not reflect the real weight and scope of their presence'.

As American Jews rose unerringly to the top in commerce, the professions and the liberal arts, they built themselves splendid synagogues in ever leafier suburbs. But how authentic was the Judaism dispensed in these places of worship? And why were Jews abandoning religion in increasing numbers and marrying out of faith? The shattering effects of the Holocaust played some part in this phenomenon. Six million Jews, perhaps two million of them children, were murdered by the Germans. Could religious faith survive this disaster?

But inroads into belief and practice had been noted well before the Second World War. The Chofetz Chaim (Rabbi Israel Meïr Kahan, 1838–1933) had anticipated defection from the faith when, in a guide he wrote in 1894 for prospective emigrants, he urged them, in effect, to take the money and run. He advised them to make their fortunes in America and then return to the Old Country and live a prosperous life of *torah* and *mitzvos*. Those who did, or their descendants, perished. Those who stayed became assimilated. Their situation was analyzed by Rabbi Mordecai M Kaplan, of the Reconstructionist Movement, in his book *Judaism as a Civilization*, first published in 1934. Kaplan came to the conclusion that with free access to art and literature and the leisure to enjoy them, 'there was a far greater variety of opportunities for the satisfaction of the human spirit than the limited range of beliefs and practices identified as traditional Judaism'. For the less sophisticated, indeed, Kaplan implied that the cinema, the radio and sport might serve as an effective replacement for the traditional preoccu-

BELOW *Stained-glass window depicting* The Journey of a Mystic *by Abraham Rattner. This window is found in the Loop Synagogue (1960) in Chicago.*

OPPOSITE *Marc Chagall was responsible for designing the stained-glass windows at Joseph Neufeld's Hadassah Hospital, Ein Kerem, Jerusalem (1961). They depict the 12 Tribes of Israel.*

pations of the Jewish way of life. As for prayer, he appeared to be conducting no more than a rearguard action. Kaplan recommended that 'men should be induced to absent themselves from their businesses for an hour, once every three or four weeks'. Instead of the traditional view of Judaism as devotion to *torah* and *mitzvos*, which some authorities considered to be a full-time job, precluding a secular occupation, Kaplan proposed that the synagogue should become an all-embracing centre of Jewish social and cultural activity, in which a Jew would spend most, if not all, of his leisure time.

One did not have to be a Reconstructionist to pursue this policy. Attempts were made to exploit synagogue space for purposes other than prayer. When the congregation B'nai Amoona, of St Louis, Missouri commissioned the great German Jewish architect Erich Mendelsohn, designer of the visionary Einstein Tower at Potsdam, to build a synagogue for them in 1945, he employed a system of movable walls. These could open up the 600-seat prayer hall to accommodate congregations of 1,500 on High Holy Days, and by the same token reduce it, throwing its space into that of the foyer and community hall. Mendelsohn used comparable devices in his schemes at Grand Rapids, Michigan (1952), and St Paul, Minnesota, completed posthumously in 1954.

Effects other than those derived from the manipulation of space have been exploited by many architects to enhance the religious character of their buildings. The American Percival Goodman has been prodigal in his use of sculpture and artwork of various kinds to create an impact that sometimes outruns that of the build-

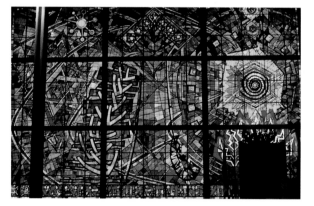

ing to which they relate. Most notable in this respect is his synagogue for the congregation B'nai Israel, New Jersey (1951), where a huge sculpture of the burning bush is mounted on a gable that thrusts through the centre of an otherwise banal elevation.

Exuberant use of artwork has also been made internally. A striking example is Ben Shahn's mosaic mural, *The Call of the Shofar*, found in the vestibule of Temple Oheb Shalom, at Nashville, Tennessee. The *shechinah*, in the form of a red flame from which a blue hand emerges, presides like the heavenly register of a Baroque painting over an enormous *shofar*, or ram's horn, which is being blown by a figure on the right. Beneath it processes a row of heads from different racial groups, reflecting

the universalist message of the Hebrew prophet Malachi (ii 10) that Shahn has typically chosen. The most effective use of artwork in America is perhaps to be found at the Loop Synagogue, Chicago (1960), where the stained-glass window in the east wall behind the ark was designed by Abraham Rattner. It bears the title *The Journey of a Mystic*, but you can interpret this abstract display in any way you choose. When the sun shines through it, the multicoloured reflections on the north wall, modulated by passing clouds, are distractingly beautiful.

The most famous example of artwork in a twentieth-century synagogue is to be found neither in America nor Europe, but in Israel. Twelve round-headed stained-glass windows, each measuring 10 by 8 feet (3 x 2.5 metres), and set three to a side in a central lantern, illuminate Joseph Neufeld's square synagogue at the Hadassah

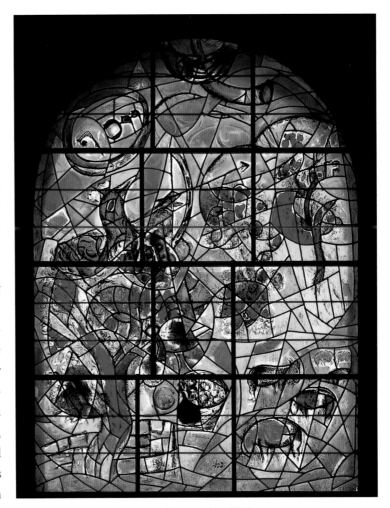

Hospital in Ein Kerem, Jerusalem. Dating from 1960-1, they are the work of Marc Chagall, and depict in his characteristic style and colours the 12 tribes of Israel, as expressed in the symbolic language of Jacob's prophecy (Genesis xlix) and the blessing of Moses (Deuteronomy xxxiii). These windows have become icons of our time, and are to be found as miniature reproductions, decorating Jewish homes all over the world.

Some of the greatest architects of the twentieth century have been recruited to design synagogues. I have already mentioned Behrens and Mendelsohn. The names may also be cited, in America, of Louis Kahn and Walter Gropius, the founder of the Bauhaus. Kahn's Mikveh Israel at Philadelphia (1962) has a towered exterior that resembles the walls of Ávila. Here, however, the towers are not intended to keep the Moors at bay but to filter in the daylight. The equivalent fea-

BELOW The startling exterior of the
Temple Oheb Shalom (1960) in
Baltimore, Maryland, designed by
Walter Gropius. Is it a turbine
house or a giant representation of
the Tablets of the Law?
OPPOSITE Philip Johnson is the

architect responsible for the Con-
gregation Tifereth Israel (1954) in
Port Chester, New York. The long
walls feature five courses of stone
slabs, laid in a staggered bond
with glazed gaps between the
verticals.

ture at Gropius's Oheb Shalom in Baltimore (1960) is represented by a series of
bays on the side elevations, shaped like Tablets of the Law. Since God only handed
down two of these to Moses, while Gropius proffers four a side, another source of
inspiration should perhaps be sought. Avram Kampf suggests a turbine house. The
interior belies this, though a deathly Constructivism is invoked to clad the ark wall,
which is articulated with a framework that resembles the endlessly repetitive cur-
tain walling that Gropius pioneered.

Philip Johnson was another outstanding architect engaged to design a syna-
gogue, a curious commission perhaps, for someone who was, in his day, a keen
admirer of the Brownshirts. Johnson produced an interesting scheme, nevertheless,
for the Tifereth Israel congregation at Port Chester, New York (1954). The main
block features five courses of stone slabs, laid in a staggered bond with glazed gaps

between the verticals. The impression
conveyed, from the outside, is of a
piano roll standing on one of its long
edges.

Frank Lloyd Wright's last executed
commission (1959) was a synagogue.
The rabbi of the Beth Shalom congre-
gation at Elkins Park, 9 miles (15 kilo-
metres) north of Philadelphia, invited
Wright to design 'a travelling Mount
Sinai', whatever that might be. The

result was an extraordinary triangular design that heaves itself into a translucent
three-sided mountain above the ark. Its external ribs are articulated by one of
Wright's idiosyncratic decorative inventions, a motif that blends Art Deco with
patterns from the civilization of the Mayas. The mystical translucency seems to be
a suburban adaptation of the light afforded by the canvas windows used by Wright
at his home, Taliesin West, in Arizona. The canted-up horns of the concrete base
on which the glass mountain sits have triggered Professor Vincent Scully's memory
and excited him to prodigies of recondite scholarship. He has turned up a coin, or
a reference to a coin, of the Emperor Macrinus, who reigned for 14 months in the
years 217-8. This coin displays on its obverse what Scully calls, without further
comment, 'the cone of Astarte in her horned enclosure at Byblos'. It looks not
unlike Beth Shalom, perched on the roof of a peripteral temple. Far-fetched? Scul-
ly is ready for you. 'It hardly matters,' he avers, 'whether Wright knew of Byblos or

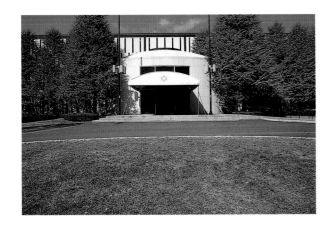

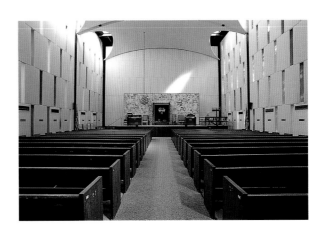

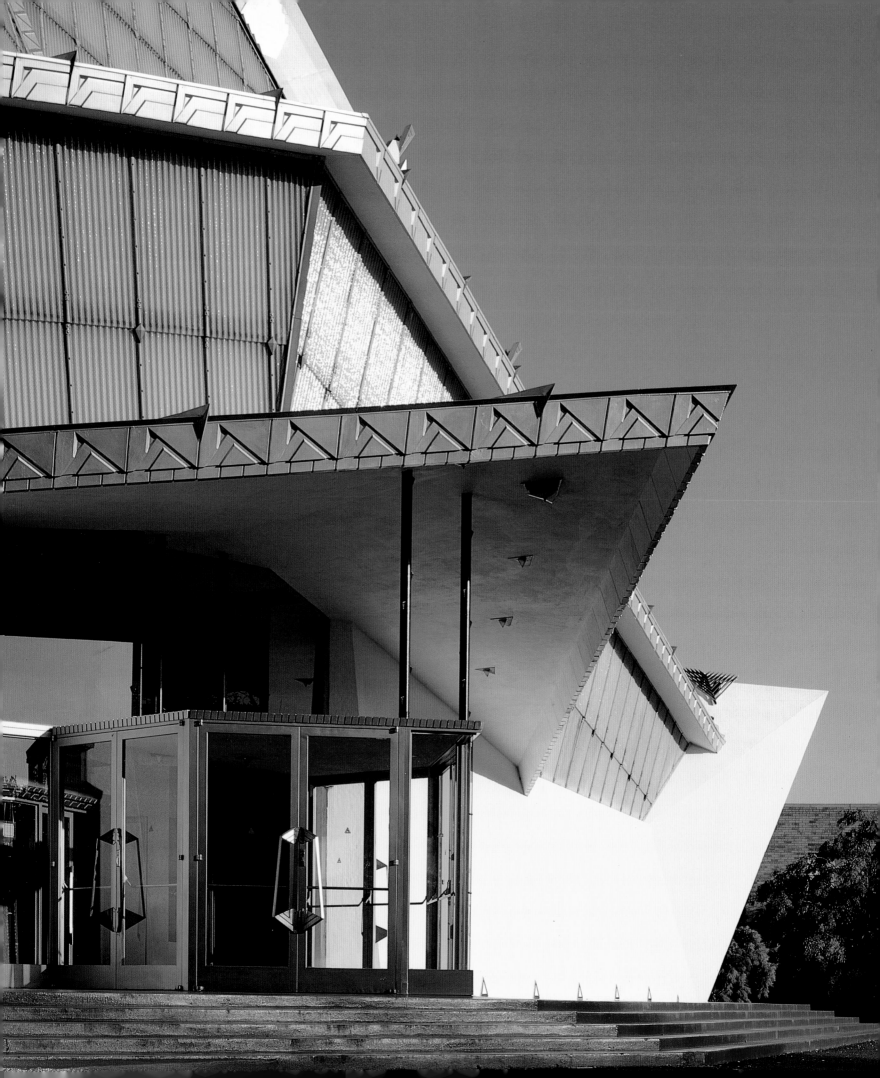

BELOW & OPPOSITE At the Elkins
Park synagogue in Pennsylvania
Frank Lloyd Wright has combined
influences ranging from Art Deco
to Maya. From the outside, it
looks like a three-sided mountain
on a base with canted-up horns.

Some claim that it was inspired by
the coin of the Emperor Macrinus
which shows the cone of Astarte.
In this view of the interior, looking
towards the ark, is the light a mys-
tical translucency or a suburban
adaptation of Taliesin's light?

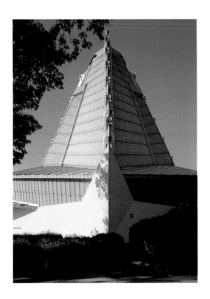

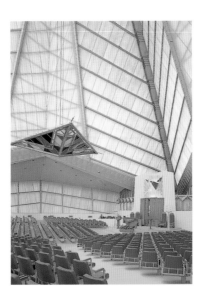

not. He instinctively went to the tradition which meant most to him, that of the sanctity of the earth and of its female forms.' There's no answer to that.

The synagogues of pre-war Germany were destroyed or badly damaged on Kristallnacht, 9 November 1938, and many suffered further damage through bombing in the course of World War II. A small number of Jews survived the war in Germany itself, and others returned from abroad. The community which existed at Essen when its great stone synagogue was built amounted to 4,500 souls. When building began on a new small synagogue to cope with their needs in 1958, they numbered 254. Modest but interesting schemes were also initiated at Bonn, Düsseldorf and elsewhere. The only German city in which numbers have picked up considerably is Berlin, which has seen an influx of immigrants from Eastern Europe, and particularly from the former Soviet Union.

The Berlin Community House was built to the designs of D Knoblauch and R Heise in the Fasanenstrasse, off the Kurfürstendamm, in the Good Old West End as it was called. It includes a synagogue lit by three low domes, commemorating the three drummed domes of the imposing Fasanenstrasse Tempel that was erected on this site in 1912. This original building was burned down on Kristallnacht. My late wife saw it in flames when she looked out of the window of a Stadtbahn train as it crossed over Fasanenstrasse on the morning of 10 November 1938. Tears filled her eyes, but a fellow passenger leaned forward and said quietly: 'We're not all like that, you know.'

Knoblauch and Heise's 1959 scheme is designed in the linear style typical of its time. It does incorporate some fragments of the 1912 Reform synagogue, however, in particular its domed portal, whose style contrasts piquantly with its new context. The

Germans have a special word for this kind of feature. They call it a *Mahnmal*, which the big Duden dictionary defines as a memorial to remind one of something that, it is to be hoped, will not recur. The Germans need a lot of *Mahnmale*. The West Berlin postal authorities lent added publicity to this one when they reproduced it on a 30 Pfennig stamp in 1965.

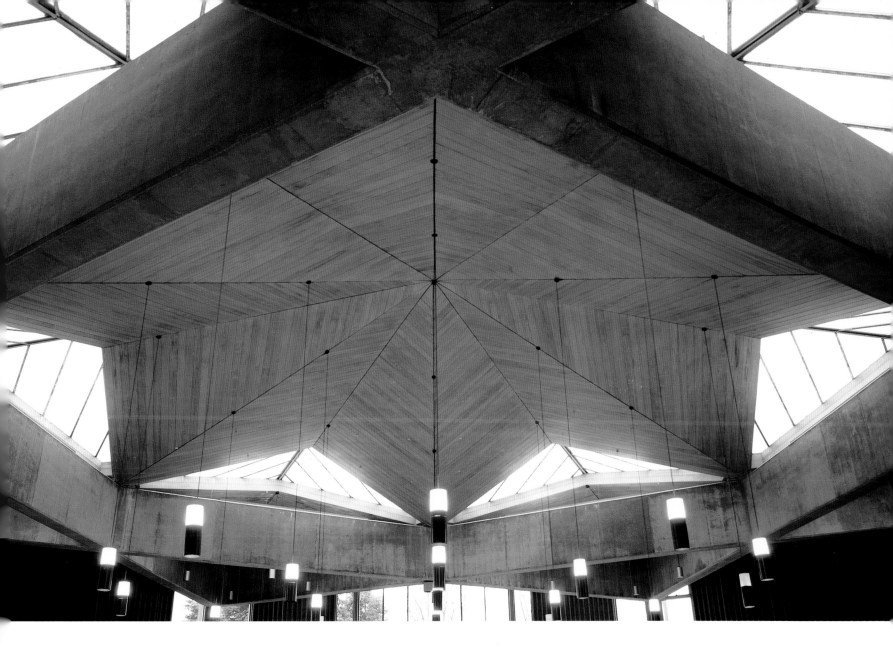

OPPOSITE ABOVE The entrance to the Berlin Community House, by Knoblauch & Heise (1959). The domed portal comes from the 1912 Fasanenstrasse Tempel which stood on the site and was destroyed on Kristallnacht, 1938.
OPPOSITE BELOW Stamp issued by the West Berlin postal authorities in 1965, showing the whole front elevation of the Community House. The vertical feature at the far end is one of the two clustered piers that framed the central block of the 1912 shool.

ABOVE The Belfast synagogue was designed by Yorke, Rosenberg and Mardall in 1964. This splendid interior, with its folded Star of David roof, has been ruined by the intrusion of low-rise structures to house communal offices, thus destroying the integrity of the circular plan.
LEFT The ark wall in Belfast, fronted by a menorah by Nehemiah Azaz.

One of the most sophisticated small synagogues in the United Kingdom was built in Belfast, Northern Ireland, to the designs of Yorke, Rosenberg and Mardall in 1964. The circular prayer hall, in silver grey brick, was linked to a rectangular cloakroom block by a glazed vestibule, and was reached by a broad flight of stairs. The layout of the prayer hall was traditional, with a central bimah, but in lieu of a gallery the women sat in a slightly elevated area on the perimeter of the circle, sep-

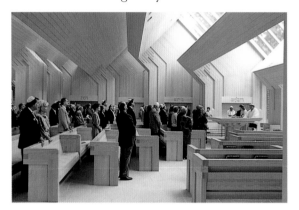

arated from the men by an unobtrusive *mechitzah* rail. The ark, with rolling metal gates, was set in a stone-clad wall, graced by a cantilevered bronze menorah, the work of the Israeli artist Nehemiah Azaz. The walls were articulated by six reinforced concrete stanchions. These supported deep concrete beams which flew across the hall, free of any intermediate supports, to create a structural network in the shape of a Star of David. Within the central hexagon which this formed was another Star of David, in a folded wooden construction, cranked upwards over its supporting beams to admit light from triangular windows.

The consecration in October 1964 was an event of some pomp. It was at the hands of the Chief Rabbi of the United Kingdom and British Commonwealth of Nations, in the presence of the Prime Minister of Northern Ireland and most of his cabinet, the Lord Mayor of Belfast and innumerable dignitaries, including the millionaire philanthropist Sir Isaac Wolfson. Sir Isaac's munificence subsequently endowed a further range of buildings: a minor synagogue, classrooms, a boardroom and a caretaker's flat. The synagogue and its ensemble enjoyed five years of glory, and then in 1969 the IRA insurrection broke out. It has continued with intermittent fury ever since. In 1977 an IRA gang drove up the Antrim Road and machine-gunned the homes of several prominent Jewish businessmen, a favour they were said to have promised the Libyans in return for the supply of weapons and explosives.

Not surprisingly, the Jewish population began to decrease, as people left for calmer destinations. From 1,500 souls in 1964, the numbers have now declined to less than 300. It became impossible to maintain the establishment. The Wolfson buildings were sold off,

LEFT & OPPOSITE ABOVE The Gates
of the Grove (1987) by Norman
Jaffe at Easthampton, New York.
The wooden walls evoke the lost
heritage of Poland's wooden syna-
gogues, with the series of skylit
gables on the outside recalling the
cascading Polish roofs.
OPPOSITE BELOW On the Givat
Ram campus of the Hebrew Uni-
versity in Jerusalem stands the
Israel Goldstein Synagogue by
Heinz Rau. Could it be said to
symbolize prayer as a cerebral
activity?

227

THE MODERN
MOVEMENT

and the splendid circular prayer hall was invaded, to half its extent, by the equiva-
lent of Portakabins, providing, on a diminished scale, the accommodation that was
once lavishly available elsewhere. The entrance was moved to the opposite side of
the vestibule, facing away from its alienated patrimony, and as a final degradation,
the metal window frames were painted an abrasive blue. It is still possible to
glimpse the full extent of the monumental roof structure over the tops of the rooms
that have intruded, but the glory of Israel has departed, and those who seek it need
visit Belfast no longer.

Is there a specifically Jewish architecture? Not really. Even the builders of the
great wooden synagogues of Poland were, in effect, just pushing the techniques
of Polish church architecture a little bit further, unencumbered as they were
by the rulings of the Council of Trent. In the Land of Israel itself, no consistent
tendency is discernible. Heinz Rau's Hebrew University synagogue inescap-
ably resembles a brain pan, a more cerebral development, so to speak, of the
sweeping concrete dome of the 1961 Beersheba synagogue, whose concrete *brise-
soleil* betrays its Mexican inspiration. In the hexagonal Great Synagogue of
Jerusalem, dedicated in 1982, a stained-glass window in five tall panes is virtually
the only distraction from the sober panelling. In contrast, at the synagogue of
Hechal Shlomo, the Jerusalem headquarters of the two chief rabbinates, the eye
rests gratefully on the rococo bimah and Baroque ark, brought in from the Scola
Spagnola in Padua.

The Paduan details are the genuine relics of an artistically gifted past. An indi-
rect appeal to another such epoch is made in the synagogue built by Norman Jaffe
at the Gates of the Grove, Easthampton, New York (1987). Here the cascading
roofs of the Polish wooden synagogues are consciously evoked in a series of skylit
gables. Jaffe's synagogue is a product of the Post-Modern style, which is a subver-
sion and denial of the Modern Movement. Its prophet was Robert Venturi who, in

OPPOSITE The dramatic arched
form of Sidney Eisenstat's Temple
Mount Sinai (1962) at El Paso,
Texas, seems to raise a voice of
prayer against the desert sky.

his manifesto *Complexity and Contradiction in Architecture* (1966), politely denounced modernism and its slogan 'Form follows function'. The architecture Venturi favours is not simple and honest but complex and allusive. Many of the buildings erected under the banner of Post-Modernism have been reinterpretations of Classicism. Sometimes they are jokey, sometimes ponderous, a description which Venturi's own Sainsbury wing (1991) at the National Gallery in London does not escape. But Jaffe's synagogue is not jokey; it is reminiscential. It does not copy the Polish synagogues in the way that the Gothic Revivalists sought to copy medieval churches, and it has no relics to display as the Berlin Community House does. His synagogue evokes the past in a reinterpretive manner, and heightens that evocation by the use of wooden walls.

A theory has been advanced that the religious insights of the two Semitic peoples, the Jews and the Arabs, were the results of living in a desert setting. Here man is confronted with the vast imponderabilities of nature: wind, sand and stars, as the phrase has it. Desert sites, it appears, can also produce extremes in architecture. The soaring arched shell of Sidney Eisenstat's Mount Sinai Temple, at El Paso, Texas (1962), seems to raise a voice of prayer against the desert sky. On the other hand, Zvi Hecker's little synagogue for the Israel army officers' training school at Mitzpe Ramon, down in the Negev, is a crystalline block painted green, yellow and grey, à propos of nothing in particular. If all around is wilderness, you can respond to it with sympathetic organic structures, or you can stand and shout your protest on the desert air.

The Negev desert! What about that lost patrol? All you need is a few prayer books, *talleisim*, phylacteries and a compass to show the direction of Jerusalem. If it is one of the days for reading the Law, it would also be nice to have a War Department field ark, troops for the use of, Mark I. Synagogue walls, the windows, the galleries, the robing rooms, the splendid artwork, are not required. In the immense vastness, with gently undulating dunes spread out in all directions, there is nothing to impede your prayers: they will surely go straight upwards to God.

GLOSSARY

abacus (Latin, from Greek) The flat slab on top of a column capital.

ablaq (Arabic) In Islamic architecture, masonry laid in courses of different colours, giving a striped effect.

aggadic (from Hebrew *aggadah*) In Talmud, narrative text as opposed to legalistic matter.

ajimez (Spanish, from Arabic) In Moorish architecture, two-light window with central colonnette.

aliyah, pl. **aliyot** (Hebrew) 'Call-up' (to bimah) in synagogue, to participate in reading of the Law.

amidah (Hebrew) Central element in every prayer service, recited standing, with the feet together.

ark The cupboard in which the scrolls of the Law are kept.

artesonado (Spanish) Timber panelled ceiling shaped like an inverted trough.

Ashkenaz (Hebrew) Name of biblical origin applied to German-speaking areas of Europe; sometimes, by extension, also to those areas further east where Yiddish is spoken.

ataurique (Spanish, from Arabic) Plasterwork incised with patterns of flowers and leaves.

Av (Hebrew) Fifth month of the Jewish calendar, normally occurring in July/August.

baal tefillah (Hebrew) Precentor, prayer leader.

baldacchino (Italian) Canopy over an altar, door etc.

basilica (Latin, from Greek) Originally, a Roman colonnaded hall; later applied to churches where the form is generally oblong, with nave, aisles, galleries and an apse at the end opposite the entrance.

Beth Din (Hebrew) Jewish religious court.

beth ha-medrash (Hebrew), **bethmedresh** (Yiddish) Minor synagogue attached to a major synagogue. Used for prayer and study.

bifora, pl. **bifore** (Italian) Two-light window.

bimah (Hebrew, from Greek) Platform in synagogue from which the service is conducted.

bittul torah (Hebrew) Wasting time that might be devoted to religious study.

bouleuterion (Greek) Council chamber.

brise-soleil (French) Sun break.

byliny (Russian) Old Russian heroic poems.

Chanukah (Hebrew) Winter festival celebrating the successful revolt against the Seleucid Greek Monarchy in Judaea led by Judas Maccabaeus in the 2nd century BCE.

chazan (Hebrew) Cantor.

cherem (Hebrew) Religious ban.

chevra (Hebrew) Fraternity.

chuppah (Hebrew) Canopy. Most frequently, that under which a marriage ceremony is performed.

colonnette A small column.

daven (Yiddish) To pray.

dayan, pl. **dayanim** (Hebrew) A rabbinical judge.

devir (Hebrew) The Holy of Holies in the Temple at Jerusalem.

diplostoon (Greek) Building that features a double colonnade.

droshoh (Yiddish, from Hebrew) Sermon.

esnoga (Portuguese) Synagogue.

ethrog (Hebrew) Citron. One of the 'four species' involved in the celebration of the Festival of Tabernacles (see Leviticus xxiii 40).

gabbay (Aramaic) Honorary officer of a synagogue; treasurer.

gematria (Aramaic, from Greek) Method of discovering the hidden meaning of a Hebrew text by means of the numerical equivalents of the Hebrew letters that compose it.

genizah (Hebrew) Depository for worn-out books and other Hebrew writings.

Haggadah, pl. **Haggadot** (Hebrew) Book used at the service at home, including a meal, on the first two nights of Passover.

hajj (Arabic) Pilgrimage [to Mecca].

haphtorah (Hebrew) Passage from the Prophets read after the sabbath recitation of the weekly portion of the Law.

hekhal (Hebrew) Main chamber of the Temple at Jerusalem, beyond which lay the Holy of Holies.

jihad (Arabic) Holy war.

kaddish (Aramaic) Doxology [liturgical formula of praise to God].

kavvanah (Hebrew) Wholehearted concentration in prayer.

kashi (Persian) Faience mosaic panel.

kehillah (Hebrew) Congregation.

keffiyeh (Arabic) Head-cloth.

keresh (Hebrew) Frame; modular unit of Tabernacle wall.

kokoshniki (Russian) In medieval Russian architecture, tiers of small decorative arches.

Kunstwollen (German, lit. 'art wish') Term coined by Alois Riegl (1844-1924) in connection with his theory that abandonment of classical style was not due to lack of ability but to change of will, i.e. what men wanted.

Landsmann (German) A person from the same home town or district.

Landsmannschaft, pl. **Landsmannschaften** (German) Society of persons from the same home town or district in Eastern Europe.

Lecha dodi (Hebrew, lit. 'Come, my beloved') Hymn sung on Friday night welcoming the advent of sabbath.

lulav (Hebrew) A closed frond of a date palm; see under *ethrog*.

maftir (Hebrew) Passage read from the scroll of the Law for the last person given an *aliyah*.

mashrabiyya (Arabic) Interlaced latticework in wood set in doors and shutters.

mechitzah (Hebrew) Divider of wood, metal or cloth between men's and women's section of a synagogue.

meirev (Hebrew) Evening service.

menorah (Hebrew) Candelabrum. A seven-branched one was used in the Tabernacle and in the Temple at Jerusalem.

mezuzah (Hebrew) A small roll of parchment containing certain biblical verses, generally inserted in a case, and affixed to the doorposts of Jewish houses (see Deuteronomy vi 9 & xi 20).

mincha (Hebrew) Afternoon service.

minyan (Hebrew) Quorum for public prayer: ten males aged 13 or over.

Mishnah (Hebrew) Collection of Jewish legislative writings, completed about 200CE by Rabbi Judah ha-Nasi. The basis of the Talmud, which comprises an extended commentary on it.

mitzve (Yiddish), **mitzvah** (Hebrew) Literally, the commandments contained in the Torah. Colloquially (a) any religious duty; (b) a good turn.

mudéjar (Spanish, from Arabic) Islamic style architecture built for Christians in Spain.

ne'ilah (Hebrew) The last section of the service for the Day of Atonement.

oikoumene (Greek) The inhabited world.

parnas (Hebrew) Lay leader of a Jewish community.

pendentive Form of corner bracket between two walls to permit a circular or polygonal storey to be built over a square one.

Pentateuch The Five Books of Moses (Genesis, Exodus, Leviticus, Numbers, Deuteronomy) with which the Bible begins.

phylacteries English term for *tephillin*.

pishtaq (Persian) Monumental portal.

Plateresque Florid architectural style popular in Spain in the sixteenth century.

qibla (Arabic) In Islam, the direction of prayer, viz towards Mecca.

quadratura (Italian) Illusionistic painting, especially in churches, which appears to carry up the lines of the real architecture to sublime heights.

Reconquista (Spanish) The reconquest of Spain by the Christians from the Moors, ending with the conquest of Granada in 1492.

sakhrah (Arabic) Rock on the Temple Mount, Jerusalem, over which the Caliph 'Abd al-

Malik built the sanctuary known as the Dome of the Rock in 690–2 CE.

Sefarad (Hebrew) Biblical name later appropriated to signify the Iberian peninsula.

Sefardi (Hebrew) Follower of the Spanish/Portuguese rites of Judaism.

Sefer torah (Hebrew) Scroll of the Law; parchment on which the *Pentateuch* has been written by a scribe. Mounted on two rollers and housed in the ark.

shabbes (Yiddish), **shabbat** (Hebrew) Sabbath: from sundown on Friday to sundown on Saturday.

shabbat shalom (Hebrew) Sabbath greeting: 'good sabbath'.

shammas (Aramaic) Synagogue factotum.

shechinah (Aramaic) The presence of God.

shewbread In the Temple, 12 loaves placed 'before the Lord' every sabbath on a table beside the altar of incense.

shiur (Hebrew) Talmudic disquisition.

shochet (Hebrew) Ritual slaughterer.

shofar (Hebrew) Ram's horn, sounded on the High Holy Days (cf Exodus xix 16).

shool (Yiddish) Synagogue.

shtetl (Yiddish) Small town in Eastern Europe.

shtiebel (Yiddish) Conventicle.

Shulchan Aruch (Hebrew, lit. 'Prepared Table'). Standard manual of Jewish religious practice, compiled by Rabbi Joseph Caro and first published in 1555.

siddur (Hebrew) Prayer book.

Simchas Torah (Hebrew, lit. 'Rejoicing of the Law') Festival celebrated on the day when the annual reading of the *Pentateuch* is concluded in the synagogue and is immediately started again from the beginning.

spandrel Term used here to denote the segments of the coved tiers of vaulting at Wolpa.

tallis, **pl.** *talleisim* Stole or mantle worn by men at morning prayer. It is of silk or wool, white in colour, with blue or black stripes at the ends and fringes at the four corners.

Talmud (Hebrew) The encyclopaedic work of Jewish belief and practice. It exists in two recensions, the Jerusalem (completed c.425) and the Babylonian (c.500).

Targum (Aramaic) Aramaic translation of various books of the Bible.

tekiah gedolah (Hebrew) Great blast (on *shofar*).

tephillin (Aramaic) Phylacteries; small leather boxes containing scripture passages, worn by men on head and left arm at morning prayers, save on sabbath and festivals.

Terumah (Hebrew) One of the 54 weekly portions of the *Pentateuch*. It contains the specifications for the Tabernacle.

Torah (Hebrew) Strictly speaking, the Pentateuch, but frequently understood as the whole of Jewish canonical literature, viz the Hebrew Bible, Talmud and ancient commentaries.

Tosefta (Aramaic) Ancient compilation elaborating the *Mishnah*.

tsettel, pl. *tsettelen* (Yiddish) Slip of paper.

tympanum Infill of a pediment or of an arch above a lintel.

'ulam (Hebrew) The porch or vestibule of the Temple in Jerusalem.

Völkerwanderungen (German) The migrations into Europe of tribes from the east that heralded the break-up of the Roman Empire.

yishuv (Hebrew) The Jewish pioneer population of Palestine, later Israel.

zakomary (Russian) Arched gables.

BIBLIOGRAPHY

ABRAHAMS, Israel. *Jewish Life in the Middle Ages*. London: Edward Goldston, 1932.

AGOBARD. *De insolentia Judaeorum*. [Patrologia Latina 104]. Paris: J P Migne, 1864.

ALDRIDGE, James. *Cairo*. London: Macmillan, 1969.

AMMIANUS Marcellinus. *The Roman History*. London: William Heinemann Ltd [Loeb Classical Library].

BAEDEKER, Karl. *Berlin*. Leipzig: Karl Baedeker, 1910.

—— *Austria-Hungary*. Leipzig: Karl Baedeker, 1911.

—— *Russia*. Leipzig: Karl Baedeker, 1914.

BARNETT, Richard and A Levy. *The Bevis Marks Synagogue*. [London]: The Society of Heshaim, (1970) 1987.

BERMANT, Chaim. *The Jews*. London: Weidenfeld & Nicolson, 1977.

BEVAN, Bernard. *History of Spanish Architecture*. London: B T Batsford Ltd, 1939.

BOECHER, Otto. 'Die alte Synagoge zu Worms' in *Der Wormsgau*, Beiheft 18 1960.

BOËTHIUS, Axel and J B Ward-Perkins. *Etruscan and Roman Architecture*. Harmondsworth: Penguin [The Pelican History of Art], 1970.

BREFFNY, Brian de. *The Synagogue*. London: Weidenfeld & Nicolson, 1978.

CANTERA BURGOS, F. *Sinagogas españolas*. Madrid: (1955) 1984.

CASSUTO, Umberto. *A Commentary on the Book of Exodus*. Jerusalem: Magnes Press, 1953.

CICERO, Marcus Tullius. *Oratio pro Flacco*. London: William Heinemann Ltd [Loeb Classical Library].

CLARK, Kenneth. *The Gothic Revival*. (London: Constable, 1928) Harmondsworth: Penguin, 1964.

DAWIDOWICZ, Lucy. *The Golden Tradition*. London: Vallentine Mitchell, 1967.

DROSDOWSKI, Günther. *Duden. Das grosse Wörterbuch der deutschen Sprache*. Mannheim: Bibliographisches Institut, 1976-81.

DUBNOW, Simon. *History of the Jews in Poland and Russia*. Philadelphia: Jewish Publication Society of America, 1916.

EBAN, Abba. *Heritage: Civilization and the Jews*. London: Weidenfeld & Nicolson, 1984.

FELTZ, Vanessa. 'Acute Angle' in *Jewish Chronicle*, 20 November 1992.

FORTIS, Umberto. *Ebrei e Sinagoghe*. Venice: Edizioni Storti, 1973.

FRIEDLANDER, Gerald. *Laws and Customs of Israel*. London: Shapiro, Vallentine, 1934.

GARDINER, Edmund. 'Religious Institutions' in L Whitby, ed. *A Companion to Greek Studies*. Cambridge University Press, 1931.

GRABAR, Oleg. *The Alhambra*. London: Allen Lane, 1978.

GROTTE, Alfred. 'Deutsche, böhmische und polnische Synagogen-typen' in *Mitteilungen der Gesellschaft zur Erforschung Jüdischen Kunstdenkmäler*, VII/VIII 1915.

HAAN, Jacob Israël de. *Verzen*. Quoted in J Meijer, *Den Tempel der Jooden in Amsterdam*. Amsterdam: Portugees-Israëlitische Gemeente, 1947.

HANCOCK, Graham. *The Sign and the Seal*. London: Mandarin, 1992.

HERZ, Joseph, ed. *The Pentateuch and Haftorahs*. London: Soncino, 1938.

HILL, Derek and O Grabar. *Islamic Architecture and its Decoration*. London: Faber & Faber, (1964) 1967.

HIRSCH, Samson Raphael. *The Nineteen Letters on Judaism*. New York: Feldheim, 1959.

HÜBSCH, Heinrich. *In welchem Style sollen wir bauen?* Karlsruhe: 1828.

HUDALY, David. *Liverpool Old Hebrew Congregation 1780-1974*. Liverpool: The Liverpool Old Hebrew Congregation, 1974.

IBN GABIROL, Solomon [*Verses*] in F Bargebuhr. *A Cycle of Studies on the Eleventh Century in Moorish Spain*. Berlin: Walter de Gruyter & Co, 1968.

IBN HISHAM. *As-Sira an-Nabawiyya*. Cairo: 1375 [1955].

JOHN OF THE CROSS, Saint, *Obras de San Juan de la Cruz*, ed. S. de Santa Teresa. Burgos: 1929-31.

JOSEPH, Nathan. [*Report*] in the Central Branch Synagogue Report for 2 February 1868 in United Synagogue archives, cited in Krinsky, Carol q.v.

JOSEPHUS, Flavius. *Contra Apionem*. London: W Heinemann Ltd [Loeb Classical Library], 1926.

JOSEPHUS, Flavius. *Antiquities of the Jews*.

London: W Heinemann Ltd [Loeb Classical Library], 1930-65.

——— *The Jewish War*. London: W Heinemann Ltd [Loeb Classical Library], 1928 (2 vols.).

KAMPF, Avram. *Contemporary Synagogue Art*. New York: Union of American Hebrew Congregations, 1966.

KAPLAN, Mordecai. *Judaism as a Civilization*. (New York: The Macmillan Company, 1934) Philadelphia: Jewish Publication Society of America, 1981.

KAYSER, Stephen. 'Introduction' in Piechotka, Maria and K Piechotka, *q.v.*

KLAPHECK, R. 'Die neue Synagoge in Essen a.d. Ruhr' in *Architektur des XX Jahrhunderts*, Sonderheft 1913.

KOLLEK, Teddy and M Pearlman. *Jerusalem: Sacred City of Mankind*. London: Weidenfeld & Nicholson, 1968.

KRINSKY, Carol. *Synagogues of Europe*. Cambridge, Mass. and London: MIT Press, 1985.

LAMBERT, Elie. *L'art en Espagne et Portugal*. Paris: 1948.

LANE-POOLE, Stanley. *The Moors in Spain*. London: T Fisher Unwin, 1887.

LEON, Harry. *The Jews of Ancient Rome*. Philadelphia: Jewish Publication Society of America, 1960.

LEVY, Isaac. *The Synagogue. Its History and Function*. London: Vallentine Mitchell, 1963.

LEWIS, Agnes. *In the Shadow of Sinai*. Cambridge: Bowes & Macmillan, 1898.

LEWIS, Agnes and M D Gibson. *Palestinian Syriac Texts from Palimpsest Fragments in the Taylor-Schechter Collection*. London: C J Clay, 1910.

MEEKS, Carroll. *Italian Architecture 1750–1914*. New Haven and London: Yale University Press, 1966.

MEYER, Franz. *Chagall*. New York: Abrams 1963.

MILLER, David. 'Traditionalism and Estrangement' in P Longworth, ed. *Confrontations with Judaism*. London: Anthony Blond, 1967.

MINISTRY OF RELIGIOUS AFFAIRS. *Bet ha-Knesset: Ma'amorim uMasot*. Jerusalem: Government Press, 5715 [1955/6].

MÜNZER, Zdenka. 'The Old-New Synagogue in Prague: Its Architectural History' in O K Rabinowicz, ed. *The Jews of Czechoslovakia* Vol II. Philadelphia: Jewish Publication Society of America, 1971.

NAMENYI, Ernest. *The Essence of Jewish Art*. London and New York: Thomas Yoseloff, 1960.

OBADIAH DA BERTINORO. *Michtovim*. S Sachs, ed in *Jahrbuch für die Geschichte der Juden* 1863 iii 195–224.

ORLINSKY, Harry. *Essays in Biblical Literature*. New York: Ktav, 1974.

PELÁEZ DEL ROSAL, Jesús. *La Sinagoga*. Córdoba: Ediciones El Almendro, 1988.

PEPYS, Samuel. *Diary*. London: J M Dent & Sons Ltd [Everyman's Library], 1906.

PETŐFI, Sándor. *Összes Költeményei*. Budapest: Szepirodalmi Könyvkiado, 1960.

PEVSNER, Nikolaus. *Pioneers of Modern Design*. New York: Museum of Modern Art, 1949.

——— *An Outline of European Architecture*. Harmondsworth: Penguin, (1943) 1970.

——— *South Lancashire*. Harmondsworth: Penguin [Buildings of England], (1969) 1979.

PIECHOTKA, Maria and K Piechotka. *Wooden Synagogues*. Warsaw: Arkady, 1959.

PLAUT, Gunther, ed. *The Torah. A Modern Commentary*. New York: Union of American Hebrew Congregations, 1981.

POPE, Arthur Upham. *An Introduction to Persian Art since the Seventh Century AD*. London: Peter Davies, 1930.

PORTALEONE, Abraham. *Shiltei haGibborim*. Mantua: 1612.

REISZ, Matthew. *Europe's Jewish Quarters*. London: Simon & Schuster, 1991.

RENAN, Ernest. *Histoire du Peuple d'Israël*. Paris: Calmann Lévy, 1893.

RIEGL, Alois. *Die spätrömische Kunstindustrie nach den Funden in Österreich-Ungarn*. (Vienna: [1901] 1927) Darmstadt: 1973.

ROSENAU, Helen. *Vision of the Temple*. London: Oresko Books, 1979.

ROTH, Cecil. *History of the Jews in Venice*. (Philadelphia: JPSA 1930) New York: Shocken Books, 1975.

——— *A Short History of the Jewish People*. (London: Macmillan, 1936) Rev. ed. East and West

Library, 1959.

———'Jewish society in the Renaissance environment' in HH Ben-Sasson and S Ettinger, eds. *Jewish Society through the Ages*. London: Vallentine Mitchell, 1971.

ROTH, Joseph. 'Juden auf Wanderschaft', in *Werke 2. Das journalistische Werk [1924-1928]*. Cologne: Kiepenheuer & Witsch, 1990.

RUSKIN, John. 'The Nature of Gothic' in *The Stones of Venice* Vol 2. London: J M Dent & Sons Ltd [Everyman's Library], 1907.

SAMUEL, M. *The World of Sholom Aleichem*. (New York: Alfred A Knopf, 1943) New York: Schocken Books, 1965.

SCHAPIRO, Meyer. *Israel: Ancient Mosaics*. New York: New York Graphic Society, nd.

SCHECHTER, Solomon. 'A Hoard of Hebrew Manuscripts' in *Studies in Judaism* second series. London: A & C Black, 1908.

SCHERMAN, Nosson, ed. *The Complete Artscroll Siddur*. New York: Mesorah Publications, (1984) 1986.

SCULLY, Vincent. *Frank Lloyd Wright*. New York: George Braziller, (1960) 1990.

SHOLOM ALEICHEM. 'Zomerdiga Romanen: der Purim mit'n "Tisha L'Av"', in *Fun Kasrilevke*. New York: Sholom Aleichem Folksfond Oisgabe [Complete Works, Vol. I] (1917), 1920.

SIMON, Kate. *New York. Places and Pleasures*. London: Macgibbon & Kee, 1964.

SIMONSON, Otto. *Der Neue Tempel in Leipzig*. Berlin: 1858.

SINGER, Charles and D W Singer. 'The Jewish Factor in Medieval Thought' in E R Bevan and C Singer, eds. *The Legacy of Israel*. Oxford: The Clarendon Press, (1927) 1948.

SINGER, Israel Joshua. *The Brothers Ashkenazi*. Trans. M Samuel. London: Putnam & Co, 1936.

STEPHENS, J L. *Incidents of Travel in Egypt, Arabia and the Holy Land*. New York: 1837.

STILLMAN, Norman. *The Jews of Arab Lands*. Philadelphia: Jewish Publication Society of America, 1979.

STRAUSS, Heinrich. *Die Kunst der Juden im Wandel der Zeit und Umwelt*. Tübingen: Ernst Wasmuth, 1972.

SUMMERSON, John. *Architecture in Britain 1530-1830*.

Harmondsworth: Penguin [Pelican History of Art], (1953) 1969.

TCHERIKOVER, Victor. *Hellenistic Civilization and the Jews*. (Philadelphia: JPSA, 1959) New York: Atheneum, 1977.

THIEME, Ulrich and F Becker eds. *Allgemeines Lexikon der bildenden Künstler*. (Leipzig: E A Seeman Verlag 1907-50) Munich: Deutscher Taschenbuch Verlag, 1992.

VENTURI, Robert. *Complexity and Contradiction in Architecture*. New York: Museum of Modern Art, 1966.

WEINRYB, Bernard. *The Jews of Poland*. Philadelphia: Jewish Publication Society of America, 1973.

WELLHAUSEN, Julius. *Prolegomena zur Geschichte Israels*. Berlin: (1878) 1905.

WELLS, Herbert George. *A Short History of the World*. London: Penguin, 1936.

WIGODER, Geoffrey. *The Story of the Synagogue*. London: Weidenfeld & Nicholson, 1986.

WITTKOWER, Rudolf. *Art and Architecture in Italy: 1600-1750*. Harmondsworth: Penguin [Pelican History of Art], 1958. Fourth edition: New Haven and London: Yale University Press, 1994.

WISCHNITZER, Rachel. *The Architecture of the European Synagogue*. Philadelphia: Jewish Publication Society of America, 1964.

WOUK, Herman. *Marjorie Morningstar*. London: Jonathan Cape, 1955.

ZACHWATOWICZ, Jan. 'Introduction' in Piechotka, Maria and K Piechotka, *q v*.

ZAJCZYK, S. *Architektura barokowych bóżnic murowanych w Polsce*. Warsaw: Polish Institute of Architecture of the Warsaw Polytechnic, 1933.

INDEX

Page numbers in *italic* refer to the illustrations.